THEATRE

Its Nature, Its Variety, Its Development

Kendall Hunt
publishing company

ROBERT LEWIS SMITH

www.kendallhunt.com
Send all inquiries to:
4050 Westmark Drive
Dubuque, IA 52004-1840

Copyright © 2014, 2019 by Robert Lewis Smith

PAK ISBN: 978-1-5249-8576-9
Text Alone ISBN: 978-1-5249-8577-6

Published in the United States of America

ABOUT THE AUTHOR

ROBERT LEWIS SMITH is an associate professor of Theatre at Kutztown University of Pennsylvania, part of the Pennsylvania State System of Higher Education (PASSHE), where he has taught for more than twenty years. Over the decades at several institutions, he has taught Introduction to Theatre, History of Theatre and Drama, Acting, and the full range of theatre design and production courses. He served as Department Chair and as Associate Editor for Scenic Design for the United States Institute for Theatre Technology's (USITT) *Theatre Design and Technology (TD&T)*. He has authored several dozen books, articles, and conference presenta-tions. He is an All-Category member of United Scenic Artists 829 (USA) and as a professional Scenic and Lighting designer has designed nearly two hundred productions for the academic theatre and the professional theatre. Professional theatre companies include ACT in Seattle, AMAS Musical Theatre in New York City, Syracuse Repertory Theatre, Arkansas Repertory Theatre, and Arrow Rock Lyceum Theatre. He holds degrees in theatre from Emerson College (BS), University of Washington (MA), New York University's Tisch School of the Arts (MFA), and he completed doctoral course work at the University of Missouri—Columbia (ABD).

ABOUT THE AUTHOR

CONTENTS

ACKNOWLEDGMENTS TO THE 1ˢᵀ EDITION

Publishing a book requires help and input from many individuals. Professor Roxane Rix of the Department of Communication Studies and Theatre at Kutztown University of Pennsylvania provided innumerable comments and suggestions from her close reading of significant portions of the manuscript. Those comments were instrumental in helping me to clarify and focus the book's contents.

I also want to thank two individuals at Kendall Hunt Publishing for their help. Sarah Flynn, the book's editor, amiably and carefully chaperoned me through the process of turning a manuscript into a published book. I express my thanks to Matthew J. Blue, an acquisition editor at Kendall Hunt, for helping me to formulate the book's original proposal.

There are two individuals at Composure Graphics I want to thank. I especially want to thank Woodeene Koenig-Bricker, the book's copy editor, who suggested countless improvements in the text. A special thank you goes to Lizzy Lovas for her design and layout of the book's interior.

My thanks go to Dr. William Mowder, Dean of Visual and Performing Arts, at Kutztown University of Pennsylvania for a grant that helped to underwrite part of the funding for the pictures included in the book.

My thanks go to Don Weinstein for supporting and encouraging me to undertake the writing of this book. Michael Fessenden Smith was most helpful in providing me with a student's perspective on the text. Last, but certainly not least, is my gratitude to my darling wife, Barbara Smith, who patiently and painstakingly read every chapter, and all revisions of those chapters, as the book developed over the course of a year.

I'm certain some errors have still slipped through, despite the input of those who helped. Ultimately, the contents and any errors are my responsibility alone. Please direct any issues about errors, confusion, or suggestions to my attention at Kendal Hunt for consideration in the 2ⁿᵈ edition.

INTRODUCTION TO THE 2ND EDITION

This text is laid out in the format I have used in teaching Introduction to Theatre for the last 25 years. I object to Introduction to Theatre texts that start with the classical Greek Theatre period and work forward in time. The Nature of Theatre is difficult enough to understand without imposing a 2,500 year barrier to that process. Accordingly, this text starts with an understanding of the Nature of Theatre in our own time, first by examining its artistic background and its relationship to the other arts. Then the Nature of Theatre is examined through a careful deconstruction of its components and the individuals who produce theatre. The seemingly endless Variety of Theatre presentations available in the United States and around the world is then considered. Last, a historical survey of the Development of Theatre is presented. After students have a solid understanding of the Nature of Theatre and significant awareness of the Variety of Theatre, then they will be better equipped to begin studying theatre in its Historical context. Some professors who teach Introduction to Theatre with a studio component may decide that the Theatre History section may easily be eliminated without any loss in understanding the Nature of Theatre.

There are a number of improvements in the second edition. Several typographical errors have been fixed. (Despite an author's and a publisher's best intent, a couple of typos may still have slipped through.) A couple of factual errors have been corrected. In some cases, touring the historic locations provided better data than that found in standard research books. Because of the responses of students to Work Book Exercises, a significant amount of rewriting was done to hopefully make clearer those ideas that apparently had not been sufficiently clear in the first edition. Dozens of new photographs and charts have been included. Most of those new photos were taken on location by the author at the historical Theatres. A new section "21st Century Theatre" was added to Chapter XI, Contemporary Theatre, and a new section "Jukebox Musicals" was added to Chapter XIII, Musical Theatre. An "Impact of . . ." section has also been added to most of the Development of Theatre chapters.

The digital age has affected how college textbooks are distributed and how they are used. *Theatre: Its Nature, Its Variety, Its Development* is also available online in a digital format. Even for those students who still want a hardcopy to read, a copy in which to make notes, or a copy to keep in a personal library, there are still some digital applications. The Work Book Exercises may be removed from the hardcopy of the text and handed in to your professor. Or it is also possible to go to the Kendall Hunt website and fill out the Work Book Exercises there. Then you may print out the Exercises or simply submit them electronically, depending upon the preference of your course professor. In addition, all students may access the various "In Depth" essays that are available at the website.

I also need to acknowledge the help that I was given for the second edition. I want to thank Nick Carolan of Kendall Hunt for his careful supervision and support throughout this process. Last, but certainly no least, a great Thank You is extended to my wife for her extensive proofing of the text and her checking of my rewrites for clarity.

PART I.
THE NATURE OF THEATRE

To have a fuller understanding of the art of theatre, we need to examine some characteristics of Art in general and then apply those observations to a closer study of how Theatre functions. Using a deconstruction technique, we will examine three components of Theatre: **Audience**, **Performer**, and **Space**. In deconstructing Performer, we will examine Playwrights, further deconstructing that into the two chapters on Dramatic Structure and Genres. The study of how theatre is put together will continue with an examination of Directors, Actors, and Designers.

THE NATURE OF ART AND THEATRE

Chapter 1

Art is imagining—conceiving of something that does not yet exist, even if you are looking at something that you wish to interpret through art. The artist creates an image in his or her mind of what that object would be. To some extent, art is mimetic or imitative—it is either imitating what exists in reality, or what may be abstracted from reality. Some kinds and periods of art were based on the artist's ability to faithfully replicate nature, as for example in classical Greek sculpture or Italian Renaissance painting. Contemporary arts focus more on abstracting and presenting the "essence" of the object rather than copying nature.

It seems evident, but largely without absolute proof, that art's initial applications millennia ago were part of ritual. The reason we can't prove it one way or the other is because there were no historical recordings of when art was first created. We do know that much of very early art was applied to rituals because many early and primitive cultures that have been observed have ritualistic activities such as body painting and adornment to make the body "better" or more "attractive." From that, we know that the ritualistic application of art lasted for millennia. We also can identify in some cultures when nonritualistic art arose. Let's examine some considerations relating to the development of art.

HOW OLD IS ART?

Art has traditionally been defined as a uniquely human activity—one that has been around for as long as we have been humans. **Artifacts** of human artistic expression are multiple millennia old as may be seen in examples of Greek and Roman architecture, which date back before 500 BCE. Examples of Egyptian architecture date back to about

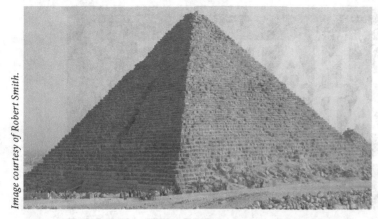

Image courtesy of Robert Smith.

Figure 1.1 *The pyramids at Giza were built about 2,600 BCE. For a sense of scale, note the people at the base of the pyramid.*

3,000 years BCE (Figure 1.1). Archaeological remnants of other Middle Eastern cultures date back even further. A musical instrument also exists from about 3,000 years BCE.

As old as these artifacts may be, they pale in comparison to the age of the **Lascaux, France cave paintings**, which have been variously dated to be between 20,000 and 25,000 years BCE. More accurate dating through carbon-14 dating is not possible as the pigments do not contain any carbon (Figure 1.2). Recent discoveries of new cave paintings in the last two decades as in the Blombus cave in South Africa push cave paintings back to around 100,000 years BCE. By any aesthetic standard, some of the cave paintings in Europe are exceptional artistic expressions.

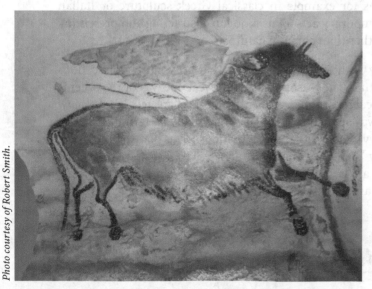

Photo courtesy of Robert Smith.

Figure 1.2 *By any artistic standard the cave paintings at Lascaux, France, from 20,000 to 25,000 BCE are very sophisticated.*

Many scholars are of the opinion that most of these paintings contain some degree of shamanistic ritual, in that they depicted hoped-for-events related to the hunt. On the other hand, some of the paintings suggest an aesthetic expression that surely goes beyond mere wish fulfillment.

In sculpture, the Venus of Hohle Fels, from the region of the German Alps dates back to 40,000 BCE. That figurine was carved in mammoth ivory so it clearly may not be dismissed by naysayers as happenstance. Only about 2 feet from the

Hohle Fels sculpture a flute made from an animal bone was discovered. Another flute dating from 65,000 BCE was discovered in northwest Slovenia. That leaves us with the logical inference that some form of artistic expression is probably an innate quality of human beings. However, that the dates are between 40,000 and 65,000 years BCE raises questions about whether these artistic artifacts were created by *Homo sapiens*, our own species. There is a question about whether *Homo sapiens* had even gotten to Europe by 40,000 BCE. Moreover, the 100,000 BCE date for the South Africa cave is long before *Homo sapiens* arose, even in Africa. Thus, we are left with the possibility that artistic expression is an innate characteristic of Hominids, not just *Homo sapiens*.

Certainly, drumming, dancing, chanting or singing, storytelling, or their various combinations must have existed earlier, even though, understandably, there can be no artifacts of those activities. Thus, we should not infer that human art did not exist before the dates noted earlier just because we don't have artifacts for earlier time periods.

WHO DOES ART?

Clearly, *Homo sapiens*, Neanderthals, and earlier humans did art. Thus, we may conclude that artistic activity is inherently human—but is it uniquely human? Most authors write that art is uniquely human, yet there is ample evidence to the contrary. Some people might suggest that the artistic look of an orb spider's web makes the spider an artist. However, a healthy orb spider is unable to do any other kind of web; its ability to construct an orb web is genetically installed in its DNA—the orb spider has no choice (Figure 1.3).

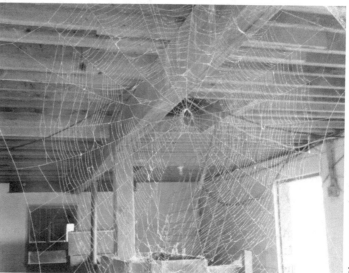

Photo courtesy of Robert Smith.

Figure 1.3 *The web of an orb spider may be seen as artistic, but it is not considered Art as the individual spider has no control over what type of web it spins.*

Thus, we need to consider those species where choice may be a factor. There are a number of candidates. It is common knowledge that chimpanzees and gorillas have

been involved in creating "art" that is sold by some zoos and nature institutions primarily for fundraising. Probably, the best illustration of art in animals is the female gorilla known as **Koko** (1971–2018). She was taught sign language, and she painted, clearly demonstrating preferences for particular colors and brushes. In addition, she may be credited with an aesthetic sense. At one point because Koko's handlers contemplated breeding her, they showed her photographs of a number of prospective male gorillas. She was given photographs of several potential mates and she carefully studied each one. However, there was one photo that she quickly skipped over. When asked why she passed over that one so quickly, she signed the word "ugly." A male gorilla, Michael, at the same institute as Koko also liked to paint. He also liked to play with a black and white dog called Apple, each of them running around the gorilla's enclosure on opposite sides of the fence. Michael's painting of his dog-friend, which he himself entitled "Apple Chase," consisted primarily of streaks of black and white, the most meaningful expression of how he must have perceived the black and white dog during their chases.

Nonprimate species have also been involved in the creation of art. For example, some elephants have been involved in painting. Additionally, around the 1970s, the creativity of dolphins or porpoises was tested. The animals would be rewarded with fish, their favorite treat, only if they created an original movement—that is, one that hadn't existed before. This meant the animals had to bear in mind what moves their bodies could make, how to combine the moves into a new pattern, and whether that movement and/or pattern had been shown to the handlers before. Some animals clearly demonstrated their ability to create something new—an essential element of the artistic impulse.

Thus, we are left with a debate. Many believe art is a uniquely human activity. However, others accept that as a higher intellectual function, some animals are capable of creating art.

ART VERSUS ARTISTIC

As noted earlier, in order to be art the creation must be by choice and it must be intentional. Therefore, a beautiful sunset is not art, but capturing a specific sunset in a photograph is art. The particular characteristics of a sunset are a function of the angle of the sun below the horizon, the characteristics of the clouds, and the quantity of particulates in the air such as dust or water vapor—none of which are under the conscious control of an artist. However, the action of composing a photograph and/or selecting a particular part or moment of the whole sunset makes it art—the photographer has abstracted from the whole and the act of abstracting makes it art. A similar kind of situation applies to finding a piece of driftwood. The actual

configuration of the piece of driftwood is a function of the species of wood, the configuration of its root system, happenstance, the circumstances of its weathering and decaying, and how long it has been weathering or decaying—activities that are not under any conscious control. However, by selecting a part of the whole or "composing" the piece of driftwood and giving it a specific orientation—that is, by abstracting from the whole, it becomes art. Thus, the sunset may be quite beautiful and/or artistic, the piece of driftwood lying on the beach may likewise be beautiful and/or artistic, but until it is composed and/or abstracted by a human being it does not become art.

ART IS PROBLEM-SOLVING

All art is created to solve a problem. In dealing with art, part of the issue of art appreciation and art criticism is determining the nature of the problem the artist wished to address. At one level, it may be nothing more complex than the artist wishing to express a feeling or attitude. An example is Pablo Picasso's (1881–1973) painting *Guernica* (1937). Guernica was a small Spanish village that was bombed during the Spanish Civil War. Picasso and many others were repulsed by the bombings, and Picasso in particular wanted to express his feelings about the senseless bombing and maiming of humans and animals. To accomplish that, he drew distorted, disoriented, and fragmented images of human and animal body parts, which was his way of conveying the disturbing imagery.

An example from the **applied arts** might also be instructive. In 1859, Michael Thonet (1796–1871) perfected a new way of constructing a chair. It had been discovered that by heating a piece of wood in a steam cylinder, it would become supple and could easily be bent into a shape that would be impossible to achieve otherwise without breaking the piece of wood. When the wood cooled and dried it was as if the wood had grown that way. The resulting chair was a bent-wood-chair—a strong, simple, and for the time period, elegantly refined wooden construction. The ubiquitous bent-wood chair, still made by the Thonet Company, is everywhere—consequently it's hard to still consider it art with a capital A. However, the elegant lines, simplicity, strength, and functionality of the original chair made it a special work of art at the time (Figure 1.4).

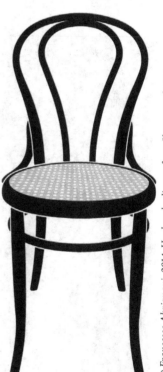

© Francesco Abrignani, 2014. Used under license from Shutterstock, Inc.

Figure 1.4 *The simplicity and elegance of the original Thonet company chair made it a work of art, albeit applied art.*

FUNCTIONS OF ART

Johan Wolfgang von Goethe (1749–1832) postulated **three functions of art**, functions that may be applied to art in general or equally well to a specific art such as theatre. His terms have been translated as **Entertainment, Edification**, and **Exaltation**. These three functions, in various combinations, account for all works of art.

Entertainment: Entertainment is the pleasurable attribute of experiencing the art. In theatre, for example, this could range from a mildly pleased disposition to overt laughter. The emotional purging often associated with tragedy may be equally pleasing—hence entertaining.

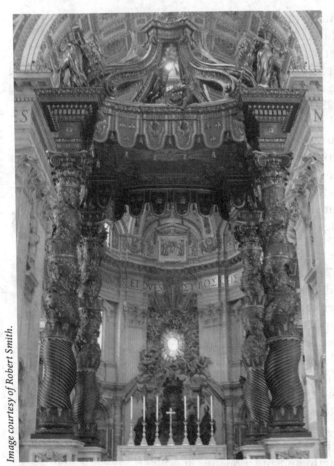

Image courtesy of Robert Smith.

Figure 1.5 *Gian Bernini's Baldacchino was intended to exalt and praise the Roman Catholic Church and its God by the size and magnificence of its structure.*

Edification: Other words equivalent to edification are enlightenment and education. All of this relates to the sense of instruction or enlightenment that one receives from the work. Merely watching and observing how characters in a play react to the dramatic events of the play is a form of instruction. The question might be, "Is that how I would behave if I were in that situation?" In some time periods, edification was considered the more important function of theatre.

Exaltation: Exaltation may be perceived as equivalent to praise. In much of the Western tradition, praise was directed at the gods or civic institutions, in part, because the work of art was often commissioned by or for religious or civic institutions. Part of the praise was also directed toward the artist or artists who created the work of art and part was praise for the magnificence of the human spirit that could achieve such levels of creation and expression. Much of early art was generated for

some ritualistic function, often but not invariably related to religion. Gian Lorenzo Bernini's (1598–1680) Baldacchino (1633) (Figure 1.5) in St. Peters in the Vatican is a good example of this. The structure rises majestically to 95 feet above the floor. It still overwhelms as it was intended to do. Part of the exaltation is directed toward the God it honors. Even today, one is awed by the realization that it was built almost four hundred years ago. In general, only after the Renaissance does the Western world begin to enter a period in which it is sufficient for art to be its own justification—it no longer needs to be done for religious or civic institutions.

Economy: Economic consideration was NOT one of Goethe's functions, but it is very important today in a way that really wasn't relevant in Goethe's time. Most visual and musical artists in previous centuries were employed to create art for religious or civic purposes. In Goethe's period, even theatre was typically done for civic purposes. It was not until around the Renaissance that artists were sometimes employed to create art for individuals—albeit for wealthy individuals. While some of that art was intended to have religious and/or civic purposes, some was intended for personal consumption. Today we are accustomed to the notion of artists creating art on speculation. That is, they create the art without some prior commitment to have it purchased. They create the art on speculation that someone will want to purchase it. This is most easily seen and understood with pop songs and other similar forms of mass media.

EXPERIENCING ART

SENSES

It is axiomatic that we perceive art through our **five senses: sight, sound, touch, taste**, and **smell**. As soon as it is stated, it probably appears intuitive that there must be at least one art devoted exclusively to each sense and at least one art devoted to each possible combination of the senses. Thus, we have painting and drawing that use only sight. Music may be perceived exclusively through sound. Admittedly, when some people go to the symphony orchestra, they also appreciate seeing sections, such as the violins, all working in unison. However, when we listen to a recorded piece of music there is no sight component and the art is perceived exclusively through sound. Touch is most closely related to sculpture and to some extent to jewelry. When the author was an undergraduate, one was permitted to rub his or her hands over sculptures to get a sense of the sculptor's skill in rendering various textures in stone or metal. The discovery that the oils on human hands were deposited on works of art, and subsequently caused their deterioration, put an end to that practice. Consequently, one is no longer permitted to touch statues in museums or other venues. Now, we must only "feel" with our eyes. A different sense of "feel" applies to architecture. In architecture, the feeling is the psychological feeling that one experiences as one moves about and through the work of architecture. The best example for taste is

haute cuisine. However, in order for haute cuisine to function effectively, it is essential to combine taste and smell. At the same time, the look, or presentation, of the food is also important. It probably is more difficult to imagine an art devoted exclusively to smell, but there is one—the art of perfume. Another art that is a combination of smell and sight is floral arranging, though here again some touch is typically included. It will be left to the reader to consider other art forms that incorporate various combinations of the five senses.

DIMENSIONS

Just as there are several senses or their combinations through which we perceive the arts, so too is there a range of dimensions through which art is expressed. There are **four dimensions** that are relevant to a discussion of the arts: the three spatial dimensions of width, length, and depth and the fourth dimension of time. Perhaps the easiest art to understand is two-dimensional art, that is, art that is perceived as having a length and a width. Two-dimensional art includes painting, drawing, fabric, photography, and so on. In recent decades, some painters have built up the surfaces of their paintings, but other than these relatively inconsequential additions of a third dimension, the work may generally be perceived as essentially two dimensional (Figure 1.6).

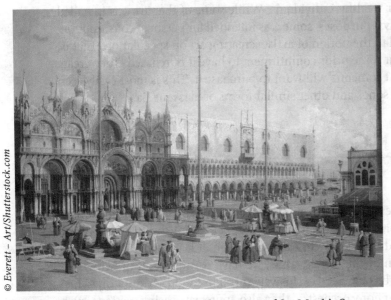

© Everett – Art/Shutterstock.com

Figure 1.6 *This two-dimensional painting of St. Mark's Square in Venice was done during a period when an artist's talent was defined by whether he could recreate a realistic three-dimensional image.*

It is important to note that while many arts exist in two dimensions only, there is nothing that exists exclusively in the second dimension. Sculpture and architecture are clear examples of three-dimensional spatial arts (Figure 1.7). Again, while many arts exist in three dimensions, nothing exists exclusively in the third dimension.

There are a number of arts in which time is an essential component, such as dance, theatre, and music. Another group of arts that might not initially come to mind

as requiring a time component includes all of the literary arts. Because it takes a discrete amount of time to work through a novel, poem, or short story, they may be perceived as existing only in the fourth dimension. When we talk of time for an art, we are referring to the time the performance lasts, not the amount of time it took for the original authors to create the art. Students might initially think that the art of the novel contains a three-dimensional spatial component. While it is true that the novel, the book, is a three-dimensional spatial object, the book is not the art. The book is merely the **artifact** that is used to create the art. Generally, the actual art of the novel is only in the mind of the reader. We can apply a similar kind of logic to the art of music. One might mistakenly believe that seeing the orchestra playing the musical instruments is the art. In actuality, the instruments

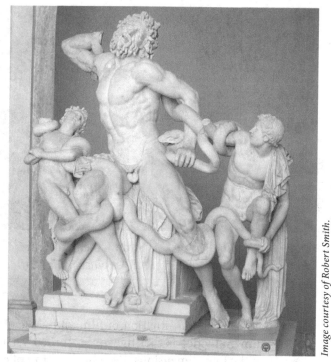

Figure 1.7 *The Roman statue known as Laocoon Group is a three-dimensional sculpture that was sophisticated in its ability to intertwine the several figures in twisting evocations of motion.*

and the manuscripts the musicians are using are merely the artifacts that are being used to create the art, which literally is nothing more than the sound waves hitting the ear and being interpreted by the brain. Thus, for both music and all of the literary arts, we may see that the art itself exists exclusively in the fourth dimension of time, even though the artifacts for producing the art are in the three physical dimensions.

A cursory review shows we have discussed some arts and all of the various dimensions, including those that exist only in the fourth dimension. What we have not done yet is deal with an art that does not exist in the physical dimensions nor in the time dimension. That art is the art of the perfume. Clearly, we perceive the art of perfume through smell and the molecules that attach to the nerve receptors in the nose. In everyday human scale, we do not perceive of molecules as having three-dimensional attributes, even though we intellectually understand from our classes in chemistry that molecules do have three dimensions, albeit finitely small. Thus, we may conventionally say that perfume has no size and does not exist in a physical dimension; hence it is an art that exists exclusively in the first dimension. Again, there are no arts that exist exclusively in the second or exclusively in the third dimension.

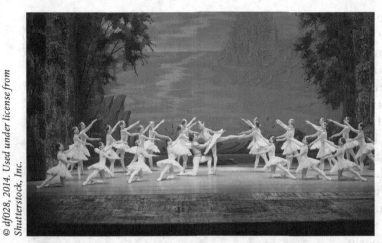

Figure 1.8 *A ballet, such as* Swan Lake, *is a three-dimensional performance that takes place in time, thus using all four dimensions.*

A particular combination of dimensions for the performing arts must be discussed. All of the performing arts have a fourth dimension or time component and most of them consist of all four dimensions. The general exception is music, the form in which the art itself exists exclusively in the fourth dimension of time, but for which the artifacts exist in the other three dimensions—unless of course we're talking about a recording. The performing arts consist of singing, dancing, theatre, opera, and the special situation of film and video (Figure 1.8). A general characteristic of film and video is that they are recorded versions of what had been done elsewhere in the four dimensions. Even here, a kind of exception exists today when computer-generated images are created for film or video without three-dimensional objects having ever existed.

PERMANENCE

We need to discuss the permanence of the art and the permanence of the artifacts that are used to create the art. Some arts are permanent and some are impermanent. For example, sculpture, painting, architecture, graphics, and so on are permanent. What the viewer sees today is not significantly different from what the art looked like when it was created. At the same time, we have to make some allowance for fading of colors, the accumulation of dirt, and minor damages. Thus, when we look at Michelangelo's (1475–1564) *Pieta* (1499) in St. Peters in the Vatican, we essentially are seeing exactly the same work that was created by Michelangelo—it is permanent (Figure 1.9). A basic exception to this is classical Greek and Roman sculpture. The impression that many people have is that Greek and Roman sculptures were presented in white stone. Actually, the stone typically was painted, but the paint has worn off over the millennia. We know this because some sculptures still have small bits of paint on them.

On the other hand, the art of the novel has no permanence, due primarily to the fact that the art exists totally within the brain of any individual. Thus, the image created by a fifth-century Greek reading Homer's (c. 850–800 BCE) *The Iliad* (eighth century BCE)

in no way is identical to the image created by a twenty-first-century college student reading the same work in a literature class. And to go even further, the image created in the brain of one such student is never identical to that in the brain of another student in the very same class, even though there may be lots of similarities. However, the artifact, that is the book that is used to create the art, is, generally speaking, unchanged and permanent. A similar kind of aesthetic also applies to all of the performing arts. The art is not permanent, even if the artifacts are permanent. There are some exceptions, but they are due exclusively to issues of recording. Thus, a recording of a piece of music is permanent; it exists and no changes occur from one playing to the next

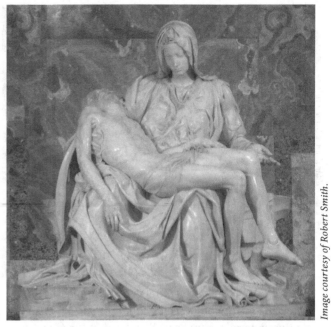

Figure 1.9 *Michelangelo's* Pieta *is not significantly different today than it was when it was first carved.*

playing. Likewise, a film or a video has permanence because both will be identical from showing to showing, if the equipment is in proper working condition.

REPEATABILITY

Repeatability of an art in some ways is analogous to the permanence of the art. Again, using Michelangelo's *Pieta*, every individual who views the *Pieta*, physically sees the same object, whether separated by 3 feet of space or three centuries of time. What might change is the cultural context in which that viewing takes place and the perceptions that the individual viewer brings to the viewing, but the physical perception itself is essentially identical.

As was stated about permanence, any art that has a fourth dimension component is not repeatable, regardless of how hard the artist tries to do an exact repeat. The very nature of arts with a fourth dimension component is the variability from performance to performance. When a play, dance, opera, or symphony is produced, the artists involved and the common shared thematic viewpoint they adopt for their production, almost by definition, are different from any previous or future production of the same work—and consequently the work is not repeatable. Even with two different performances of the same production, there are differences that make repeatability impossible. One typically hears from various performing artists that they are always getting something new out

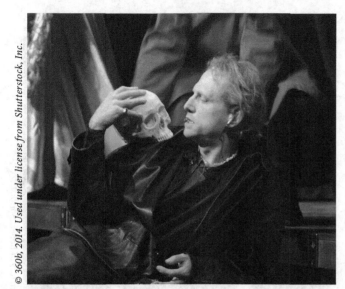

Figure 1.10 *The performing arts lack repeatability. Often the attraction of seeing different performers do the same role, here Scott Shepherd in the title role in* Hamlet, *is to see what new insights a different performer brings to the work.*

of each performance (Figure 1.10). Likewise, each audience reacts differently to a performance. Thus, the small differences that exist between the performers' enhanced perception of the work and the different audiences' reactions to the performance inevitably create a variability that cannot be eliminated. Only in the case of recordings is it possible to have absolute repeatability among arts that have a time component.

At the same time that we talk about the repeatability or nonrepeatability of the art, we must be aware that the artifacts used to create the art generally, but not invariably, are repeatable. For example, play scripts and novel texts are identical, hence repeatable, for a period of several centuries, or until the definitions of words change. On the other hand, sometimes even the scores for music may not be repeatable. We have a tendency to think that music with its specific time notation would make a symphony repeatable. However, in some time periods, the notation of pitch and time in music was not fixed as we are inclined to think today. Even a work as recent as Beethoven's (1770–1827) *Fifth Symphony* (1804–1808) is subject to this issue of changing time signatures. Thus, even if the score for the first performance of the *Fifth Symphony* were the same as the score used for this year's performance of the same work, the fact that the time signatures were not fixed insures that the two performances would not really be the same even if they are using the same score. As if that weren't enough, conductors, instrumentalists, and singers typically add on their individual interpretation of how to vary the time even if the time was fixed in the original composition.

The issue of repeatability must be addressed also with regard to the repeatability of the perception of a work of art. Just as one may never actually enter the same river twice, because the molecules of water have moved in the interval, so too one may never have repeatability in the perception of any work of art. Just as the performing artists gain new insights about a work of art through repeated presentations, so too does the viewer gain new insights from each exposure to the same work of art. Several things are likely to have happened between the two viewings. The accumulation of life experience between the two will automatically create a new context

in which to view the art the second time. Education might also have taken place between the viewings to increase the intellectual basis for understanding the art. In any event, regardless of what else may have happened, the first viewing on its own automatically informs the second. Thus, it is never possible to repeat the perception of a work of art for the first time. This is even truer in the performing arts where the art itself is not the same because it has different performers.

CATEGORIES OF ART

Human beings categorize things—and art is no exception. We generally divide art into two divisions, the applied arts and the **fine arts**. The applied arts, by their label, imply that artistic skills or principles are applied to a particular sphere of activity such as the healing arts, mechanical arts, industrial arts, and military arts (Figure 1.11).

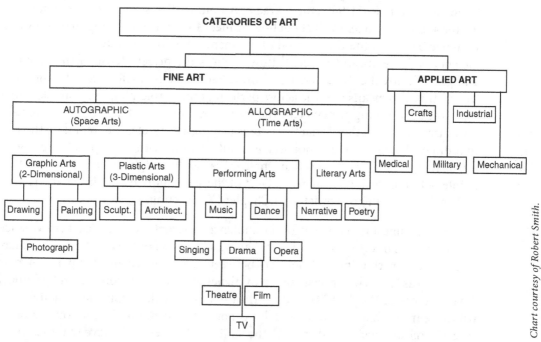

Chart courtesy of Robert Smith.

Figure 1.11 *The two major categories of arts are fine art and applied art.*

The other division is called the fine arts and they are perceived as having an essentially aesthetic characteristic. Within the fine arts we make a distinction between those that include the fourth dimension of time, called **allographic** arts, and the physical or space arts, called **autographic** arts. Within the autographic arts we distinguish between graphic arts, that is, those with only two physical dimensions, and plastic arts, those with three physical dimensions. Within the allographic arts, we distinguish

between the literary arts, which include narrative and poetry, and performing arts that include dance, music, drama, and opera. Drama is further divided into several categories, based upon the method of delivery: theatre, film, and video, wherein film and video are recorded and theatre is live.

THEATRE AS ART

Now we will address the specific characteristics of theatre. The distinguishing characteristic between theatre and storytelling is that storytelling "narrates" or tells us about the action and theatre actually "presents" the action. Aristotle (384–322 BCE) in *The Poetics* (c. 335 BCE) defines tragedy as being an "imitation of an action," as a way of distinguishing it from storytelling or narrative. This makes theatre an activity that aesthetically only takes place in the present tense. Thus, in Peter Shaffer's (1926–2016) *Amadeus* (1980), the character Antonio Salieri starts the show by addressing the audience and telling it about how he met Mozart. He then stops narrating and we move back into the time period of his memory with him and now perceive the memory as if we are in the actual time—that is the present tense of the memory. This gives theatre the characteristic of immediacy—the characteristic of taking place "now." This also means that the actors perform, that is, role-play, the characters that are in the action being presented by the theatre performance. One of the distinguishing characteristics of this is that the actor is playing a character different than the self. In ordinary human activity, individuals in interactions with other people are always role-playing. The distinction is that whatever variability might exist from interaction to interaction in real life is merely a facet of the same individual. This characteristic will be discussed in greater detail in Chapter IX on acting.

At the same time it is necessary for the audience to accept the theatrical performance as taking place in the present—that is, having an illusion of the first time. This characteristic of entering into a "contract" between the audience and the performers is referred to as "**the willing suspension of disbelief,**" an expression coined by Samuel Taylor Coleridge (1772–1834) in 1817. Theatre is a virtual, or ephemeral, activity, by which we mean that it is not real and it is not permanent. But, by the convention of "the willing suspension of disbelief" the audience "agrees" to believe that the events and actions presented on stage are real for the duration of the performance, even though the audience members know the action is not real. This childlike acceptance is essential to the art of theatre. This "suspension of disbelief" creates some degree of **aesthetic distance** that permits the audience to watch without the sense of being immediately involved in the actions on stage.

Taken together, these characteristics represent minimal needs for theatre: Performer, Space, and Audience. Though we use the singular of Performer, theatre typically has or involves a plurality of performers. We also need to understand the term refers to

all "performers" in a theatrical production, whether or not they are actually on stage. Thus, playwrights, directors, designers, and so on, are all subsumed in the word Performer. Space is the second consideration. Because theatre presents the action rather than simply describing the action, there clearly needs to be a three-dimensional space in which that action may be presented. At its purest, there is no specific conformation that the space must have, even though today we generally call that performance space "theatre." The third consideration is Audience. If there is no audience, it is not theatre. But note that no context is suggested about where, how, or what must be the size of the audience. The audience must provide feedback, which is immediately incorporated into the details of the performance. This of course is impossible in the case of recordings.

There are a number of components that are not essential. Probably, the easiest to understand are the physical accoutrements of scenery, lights, costumes, and so on. At the same time that that statement is made, we understand that it is not possible to do theatre without some absolute minimum of all three of them. The mere requirement of having Space, *ipso facto*, provides an environment—hence scenery, in which the action takes place. Likewise, if there is no light the production cannot be seen, it may only be heard. And at its extreme, even a naked performer still has a "costume." Another nonessential characteristic is dramatic structure. The mere doing of anything inherently creates structure. In many activities, we glibly refer to the activity as having a beginning, middle, and end—thus structure. Over the millennia of doing theatre, various cultures and time periods have developed particular structural formats that each culture and time believes is "better" for its time.

HUMAN CONCERNS

Plays and theatre are only about humans. Performers are involved because a particular statement is generally being made about the human condition. The audience is involved because of various levels of interaction with other humans—either the real humans of the actors and other audience members or the virtual humans of the characters. At first blush, one might suggest that Andrew Webber's (1948–) musical *Cats* (1982), Mark Rozovsky's (1937–) drama *Strider* (1979), Disney's film *Bambi* (1942), and Disney's film and stage play, *The Lion King* (film 1994, play 1997) are about animals. This is not the case. Most everyone is familiar with *Bambi*, in which the animals arrive to "adore" the new "Prince." The skunk comes in and Bambi calls him "Flower," to which Thumper, the rabbit, replies, "He ain't a flower; he's a skunk." Thumper's mother says, "Thumper, what did your father tell you this morning?" Folding his front paws behind his back and kicking at the ground, Thumper says, "If you can't say something nice, don't say nothing at all." Because animals are perceived to be warm and cuddly, audiences, whether composed of children or adults, will generally react in a more positive way. However, it is important to understand that the work is not about animals at its core. In nature, different species do not congregate

together—they tend to isolate themselves for self-preservation. Rabbits are not able to fold their front paws behind their backs and kick at the ground. Male rabbits are not involved at all in the rearing of their offspring. And as far as we know, animals are not capable of the moral sentiment expressed in Thumper's last line. In *The Lion King*, Rafiki, the baboon, holds up Simba, the baby lion, for the adoring assembly of animals. Lurking in the background is Scar, the baby's uncle, intent upon usurping Mufasa's "throne." In real life, the baboon would normally be a prey animal of lions and hence keep his distance from lions. The same applies to the assembly of animals that ordinarily would keep significant distances between themselves and the lions. Uncle Scar would not be an outsider—brother lions almost always form a coalition to jointly lead a pride. Moreover, lionesses choose males with the darkest manes with which to mate and to lead their prides—thus, the lionesses would have chosen Scar over Mufassa.

The question then becomes, "What is the point of these films?" Clearly, *Bambi* is a coming of age tale, and it clearly is focused on the development of preadolescent or adolescent humans. We may apply a similar analysis to *The Lion King* with the same result—it is also a coming of age story. What is gained by doing a piece of theatre or film about animals? If humans are the thematic objects to begin with, why not simply do the productions about humans? Rather than being overt and direct, the points being made may be more effectively delivered in a subtle and covert fashion. It is equivalent to Mary Poppins singing "A spoonful of sugar helps the medicine go down."

The issue of aesthetic distance is an important concept in theatre as well as other art forms. A nonanimal example is Arthur Miller's (1915–2005) play *The Crucible* (1953), set in 1692 Salem, Massachusetts, during what historians call the Salem Witch Trials. However, examining the play in the context of when it was written makes clear that the real subject is the witch-hunt conducted by Wisconsin Senator Joseph McCarthy (1908–1957), who was "searching" for communists in America during the 1950s. Had Miller directly attacked the McCarthy witch-hunts, the play likely would have been rejected outright by some audience members and ignored by others. However, by seeming to remove the play from its contemporary context—by giving it additional aesthetic distance—the play was presented without initially telegraphing its theme. In contemplation after seeing the play, some audience members understood Miller's theme on their own.

Because human beings are social animals, theatre takes place in a social context of both the group and the individual. In general, all human beings want to be perceived as members of the group, while at the same time not wanting to become so homogenized into the group that one loses individuality. Thus, in theatre performances, the members of the audience are sharing a social event with other human beings. In addition, an activity such as theatre allows an individual to gauge his or her "likeness" with other human beings—that is, the extent to which the individual sees himself or herself as "like" other people.

There is an aesthetic significance for theatrical activity—an exaltation or appreciation for the work as an example of art. It is not possible to view a particular theatre event without making some, however slight, comparison or measuring against other theatrical events that the individual has experienced. To some extent, there is a greater or lesser degree of judging the particular theatrical event as being good, bad, or indifferent. For example, it would be hard to see a modern production of Sophocles' (c. 496–406 BCE) *Oedipus, the King* (c. 429 BCE), without at the same time being aware, to some small degree, that this script has been valued through twenty-five centuries of theatrical criticism and theatrical productions. It probably is one of the top ten on almost any theatre scholar's list of the best tragedies produced in all of western theatre during the last 2,500 years.

A last point in this discussion deals with the issue of entertainment, a characteristic that is an essential function of art. Thus, to some extent, theatre must have some degree of entertainment in order to hold the audience in the theatre and to attract new audiences. In practical terms, it is relatively easy for theatre professionals to tell when an audience is being entertained or being enthralled by a production—no one in the audience is coughing or making other incidental noises.

Some degree of discussion about the distinction between theatre, film, and video is necessary. Decades ago this distinction was related to scale. Theatre was human scale. Film was large scale because it was possible to have a single face or even an eye 30 feet wide or as large as the screen. Video was small scale because the tube of a television screen was relatively small. In the 1960s, a 17-inch diagonal TV screen was a large screen. With video screens increasing in size (In 2019 commercially available screens were up to 152 inches on the diagonal—that's almost 13 feet or the size of one wall in a normal room.) it seems clear that the issue of scale will eventually disappear. Thus, we probably will be left with the distinction that theatre is live and film and video are recorded.

In our culture, many aspects of life are referred to as "theatre." Military people get those small colorful ribbons to pin on their chests that note the various "theatre" locales that person has been in. Rock bands do "theatrical" production numbers instead of just playing music. Weddings become "theatre." For students in colleges and universities today, it may be instructive to compare theatre and sports, in order to see a number of commonalities and some differences between them. At a fundamental level, both are clearly theatrical and both are essentially entertainment. But there are some other common factors too. Both have rules or conventions. In sports, the rules are typically rather precisely defined in a rule book. In theatre, though there is no "rulebook," there is still an extensive collection of conventions that will be discussed in greater detail in Chapter II. Both employ scenery and costumes—in sports they are called "the field" and "uniforms," respectively. Both are events taking place in all four dimensions. Both have structure—in theatre, we often refer to the divisions as acts or scenes; in sports, we might call them quarters, sets, or

matches (Figure 1.12). There are however a number of differences. The sporting event is a real event and a real contest. The theatrical event onstage is imaginative or virtual, even if it does depict an historical event, while the production is itself a real event. The last consideration is outcome. With minor exceptions, all theatre productions of the same script have the same fixed result. However, unless the game is rigged, the outcome of a sporting event is unknown.

Figure 1.12 *Sport performers, like actors, also have costumes, performance space, and rules.*

Key Names, Venues, and Terms

Aesthetic Distance

Allographic

Applied Art

Artifact

Autographic

Fine Art

Five Senses: Sight, Sound, Touch, Taste, Smell

Four Dimensions

Goethe's Functions of Art: Entertainment, Edification, Exaltation

Koko

Lascaux Cave Paintings

Permanence

Repeatability

Theatre Essential Components: Performer, Space, Audience

Theatre Significances: Human, Social, Aesthetic, Entertainment

Willing Suspension of Disbelief

Additional Reading

Deutsch, Eliot. *Essays on the Nature of Art*. Albany, NY: SUNY Press, 1996.

Gardner, Howard. *The Arts and Human Development*. New York: Basic Books, 1994.

Langer, Suzanne. *Problems of Art*. New York: Scribner, 1957.

AUDIENCE AND CRITIC

Chapter II

The Audience is one of the three essential components for theatre—the other two being Performer and Space. The audience has several functions as both a collective and as individual audience members. The "community" of audience members satisfies several social functions, including **vicarious experience**, **sense of community**, **reaffirmation of social cohesion**, and **feedback**.

VICARIOUS EXPERIENCE

By vicarious we mean "experiencing" the situation emotionally without literally experiencing it. The big excitement of horror films is the opportunity "to be scared out of our minds"—to get that adrenaline rush—in an environment that is totally safe. The same holds true for roller coasters and similar rides at amusement parks. Generally speaking, theatrical performances are much more nuanced in their offerings of vicarious experiences than amusement parks. Watching a performance allows the audience members to literally or subliminally ask themselves, "How would I behave if I were in the situation that is presented on stage?"

SENSE OF COMMUNITY

As social animals, we want to be considered members of our individual group—that is, to give us the sense of belonging. Theatre is merely one way we have of sharing experiences that give us a sense of socially belonging to a group of similarly inclined individuals creating a sense of community.

REAFFIRMATION OF SOCIAL COHESION

Most people seek some degree of confirmation of their position in the group, even though most of us don't want to believe that we are that psychologically needy. When we are with a group, such as in a theatre audience, we can validate our membership in the group by affirming our individual areas of agreement with the group. This means we feel reassured when we, as individuals, laugh in a similar way and at the same time as the rest of the audience. Most of us are discomfited and embarrassed if we are the only one laughing—though sometimes in theatre, theatre scholars are the only ones who get the inside joke. An example from Tom Stoppard's film, *Shakespeare in Love*, (1998) will illustrate this. In that film, the character of Shakespeare comes out of the theatre and runs into a young boy torturing a rat. When the boy identifies himself by name, theatre scholars are let in on the joke that the young boy will grow up to write particularly macabre revenge tragedies. Having referenced this film, it is now necessary to point out that the film is a work of fiction and not a historically accurate depiction of Elizabethan theatre practice. In the film, Shakespeare's female love interest disguised herself in order to play the role of Juliet for a performance that Queen Elizabeth I happened to attend, presumably in disguise herself. Women were not permitted on the English public stage in that time period, even if in disguise, and Queen Elizabeth I would never appear in a public theatre, whether in disguise or not. Queen Elizabeth I sponsored Shakespeare's theatre company through her Lord Chamberlain. That sponsorship existed so that Elizabeth could "request" a performance at the palace and thus she had no need to be in a public theatre.

FEEDBACK FUNCTION

Perhaps the most important function for the audience, in terms of the actual theatrical performance, is to provide feedback to the performers. The most frequent feedback performers receive from the audience is applause and laughter. Applause is the most common conventional method the audience uses to express appreciation and/or recognition for the work of the actor—though in some cases even the set design receives an ovation when the curtain goes up. Applause might also be given at the first entrance of a famous star, as a way of acknowledging the star's status. In some cultures, hissing, booing, or stamping the feet are ways to convey displeasure. In other situations, displeasure is indicated by simply getting up and walking out. The audience uses laughter as a signal for its understanding of, and appreciation for, the humorous point being made in the production. On the other hand, nervous laughter indicates the audience's discomfort. One does not think much about overt feedback for serious drama, but it is there nevertheless. Performers perceive this based upon how quiet the audience is during serious moments. Actors are motivated in part by the feedback they receive from an audience and this may induce them to heightened levels of performance.

AUDIENCE DEMOGRAPHICS

Perhaps two-thirds of Americans see a live theatre production each year, but that includes attendance at high school and local community theatre productions. It is not possible to predict if any particular individual is likely to attend live theatre productions on a recurring basis, but it is possible to make projections for groups of people based upon a number of significant characteristics, such as income, education, age, and gender.

- Income: The expense of attending live theatre is significantly greater than that for attending film. In a region where a film ticket might cost around $7.50, a ticket to a community or academic theatre production is likely to be in the $15.00 to $35.00 range. A ticket for a professional theatre, such as a dinner theatre or a regional theatre production, is likely to be in the $35.00 to $55.00 range. Prices may be slightly lower on a per ticket basis when tickets for professional theatre companies are purchased as a season subscription. Ticket prices for Broadway shows start in the neighborhood of $100 for a good seat and can climb to around $450 for a prime seat to a hit show on short notice of say a day or two. For the musical hit *Hamilton* (2015), top seats are about $200 each and premium seats are nearly $850 each. Therefore, people with higher incomes are more likely to buy and attend live theatre productions.

- Education: There is a general correlation between education and income, but in regard to theatre, it is not just the higher income due to education that is an indicator. Often it is related to the type of education. For example, people with liberal arts degrees are more likely to attend live theatre than those who earned an engineering degree.

- Age: Because income is likely to increase with age, attendees at live theatre productions are more likely to be middle aged or older, rather than a 20 or 30 something. Older people seem to have more "discretionary time" than younger people, who may have significant time constraints due to child-rearing and employment. Physicians are less likely to attend live theatre than members of other professions because of less discretionary time due to the demands of patient care.

- Gender: Women are more likely to attend theatre than men. There are two major reasons. One is that women are perceived as more interested in the fine arts and men are perceived as more interested in sports. The second reason is that women typically have a longer life span and as age increases, there simply are fewer and fewer men in the population. For this reason, theatre professionals often refer to the Wednesday matinee audience as the "blue-haired-crowd."

In the United States, live theatregoers are overwhelmingly Caucasian. With the changing racial diversity in the United States, the prevalence of blacks and Hispanics in entertainment and sports has significantly increased since the 1950s. Due to the burgeoning of diverse professional theatre companies in the last twenty to thirty years, the racial composition of theatre audiences is changing. Obviously, these general audience characteristics are not deterministic, and many individuals outside the general demographics attend and enjoy live theatre. However, on a national basis, only 1 percent to 3 percent of the general population attends live theatre on a regular basis. Professional theatre companies use this percentage range for gauging whether there are enough people in their service areas to support live theatre companies.

THEATRE CONVENTIONS AND BEHAVIOR

There are rules, or conventions, that apply to theatre. Some of these are expectations the audience has of other audience members, expectations the audience has of performers, and expectations the performers have of the audience.

AUDIENCE EXPECTATIONS

Most people are not overtly aware of the typical theatrical expectations that relate to the audience. Audience members have expectations of other audience members as well as of the performers and staff. There is no written code of conduct for theatre performances or behavior at other artistic functions, just as there typically are no written codes for many human activities. However, despite the fact that there is no written code, there is an implicit understanding that gets promulgated through a culture. There is an implicit expectation that the theatre will supply a safe, clean, and pleasant environment with appropriate amenities such as convenient parking, appropriate concessions, and clean restroom facilities. On the other hand, the performers and staff have their own expectations of the audience.

AUDIENCE OF AUDIENCE

The first thing we expect of other audience members is to be on time. It's inconvenient, inconsiderate, and very distracting for someone to come fifteen minutes late and disturb other audience members, and even the performers, as the late attendee gets into a seat in the middle of a row. Related to this is how we enter a row. In the United States, we typically face the stage, but in England one typically enters a row facing the seated patrons in the row of seats. Other considerations are that we expect people in the seat next to us to use only half the armrest and not to hog all of it—or

even worse, to drape their arm in our lap. We expect the people behind us not to kick or bump the back of the seat. We expect the people in front of us to not wear headgear and/or hair arrangements that block our view. We expect those around us to have observed good personal hygiene so we don't smell their body odor. We also don't want them to smoke cigarettes, cigars, or to be chewing anything else that might generate an odor problem. Because some individuals have sensitivities to strong perfumes and colognes, such fragrances should not be worn to the theatre. We expect people who have colds to stay home rather than contaminate us with their germs. Generally, we don't want strangers striking up a conversation, or in some other fashion invading our personal space. Moving a little further away, we expect audience members to refrain from using their cell phones because it is rude and distracting both for audience members and for performers. We don't want other audience members to be chattering, whether it relates to the play or not. It's bad enough to be sleeping in the theatre, but we particularly don't expect people to be snoring. If one has a candy wrapper or something of a similar nature, we would really prefer that it be taken care of before the show starts so that we don't have to listen to the crinkling of wrappers during the performance. If other audience members have children with them, we expect the children to be kept quiet and not be allowed to run around the theatre. Unless the productions are specifically intended for children, children under the age of 5 to 7 should not be at theatre productions anyway. Children under the age of perhaps 13 should not be at productions that deal with adult themes, action, or language.

AUDIENCE OF PERFORMERS

The most important one here is that the audience expects performers to do their jobs in a professional manner. At the minimum, we expect them to know their lines, to not break character, and to be fully committed to their performances. Generally, we do not appreciate performers who seem "to have phoned it in," an expression that denotes minimal effort. We expect performers to project to the back of the house and to have clear and crisp diction. (It seems to the author that many of today's television actors do not have the good diction that was common only thirty or forty years ago.)

PERFORMERS OF AUDIENCE

Though one generally does not think of it that way, performers have expectations of the audience. The audience as a whole is expected to be knowledgeable of the many conventions of theatre. A discussion of one small set of conventions involving who may "hear" what is being said on stage will illustrate the concept. The convention on "hearing" includes the **aside**, the **soliloquy**, the **stage whisper**, and the **direct address**.

- Aside: Generally, an aside is a comment directed by one character to the audience, yet other characters on stage presumably do not hear the comment. It gets its label by the fact that the actor typically turns his head sideways to the audience to deliver the comment. This convention is needed because every member of the audience, even those in the rear of the upper balcony, needs to hear what is being said, while at the same time the other characters on stage presumably do not hear. There is a minor variation of this convention in which one character delivers an aside and another character asks what was said. The humor of that interaction is in the comment the first character creates to cover the original line and to placate the second character, typically accompanied by significant laughter from the audience.
- Soliloquy: A soliloquy is used when one character is on stage alone and thinking out loud. That character is thinking to himself, but of course, in order for the audience to hear the line, the character must speak out loud. This problem is generally not faced in film or video where a voice-over is typically done. Another convention of the soliloquy is that it contains only truthful statements from the character's point of view.
- Stage Whisper: The stage whisper is similar to the aside, but may be recognized because it is often done with unvoiced speech. Again, because the person in the back of the upper balcony needs to hear the line, the projection needs to be loud enough to fill the theatre. By convention, the character to whom the first character is whispering hears the comment, but the other characters on stage are "unable" to hear. Again, there is a variation in which a third character asks what was said, and again the humor is in how the first or second character creates a cover for the original comment.
- Direct Address: During most of the modern drama period, realism was the prevailing style. There was a conceptual "fourth wall" between the performers and the audience—hence, the conventions noted earlier. However, in postmodernism, there was no longer insistence on "realistic" ways of talking. Consequently, for a number of scripts, the playwright had some characters make direct addresses to the audience.

Audience members are expected to have a general understanding of theatrical style and a basic understanding of how theatre functions. If a Shakespearean production is being done in a professional company, there is an expectation that the audience has some degree of familiarity with Shakespearean language. Performers would like to think that in the case of revivals, the audience is familiar with the script, and might even have read it beforehand. Of course this is not possible with original scripts, as is often the case on Broadway, where most productions are world or national premieres.

THE CRITIC

We deal with the critic in this chapter, because the critic may be perceived as a specialized audience member—as an audience of one. There are three functions for the critic: to observe, to analyze, and to comment.

The critic must **observe** the work, essentially in the context in which it was intended to be displayed. He or she needs to be experienced and/or educated enough about theatre to correctly interpret what is being presented. The theatre critic must also have done sufficient previous observation of theatre to be able to place this specific production in the context of the prevailing theatrical style and to also place the production in the larger context of theatre history.

It is not sufficient to merely observe the work and comment on simply having seen it. We expect the critic to **analyze** the work—in a sense, to tell us the significance of the work or about this particular production. It is conceivable that a theatrical production may be analyzed in isolation; however, this is rarely as useful as putting the individual performance in a context that relates to other theatrical productions. Whether the production works or does not work, it is important that the critic have the ability to analyze why it works or why it does not work—perhaps even to go so far as to suggest how the work could be improved.

If the critic keeps the result of the analysis to himself or herself it has no great consequence. Therefore, we expect the critic to **comment**, typically in writing but perhaps in speech for radio or TV. It is not sufficient to say, "It was good. You should see it." We expect the critic to say, "It was good. You should see it, and here's why." Clearly, the "why" is the most important part of what the critic has to say. Equally clearly, the critic must have the skills to effectively and efficiently communicate the results of that analysis to a wider public. The critic also needs an expansive vocabulary to be able to communicate nuances of meanings to a public with individuals of varying intellectual and theatrical abilities.

There are two general modes that the critic uses: a review and criticism. The function of a review is to quickly and efficiently convey a relatively brief perception of the effectiveness of the production. Such reviews typically appear in newspapers or magazines, but in some cases may also be disbursed through television, radio, or the Internet. Generally, the critic sees the production and writes the review for the next day's publication in the case of newspapers, or for the next issue for a magazine. Because of the short turnaround time between performance and review in the daily paper, the critic has difficulty getting much beyond the basic who, what, when, where, why, and how. In the case of online reviews, the turnaround time may become an even bigger issue. Review critics are sometimes prone to try to incorporate catchy phrases such as the following that have appeared in reviews of real Broadway

shows: "Show XYZ opened on Broadway last night. It shouldn't have." "The scenery for XYZ was some of the ugliest scenery to appear on a Broadway stage. The lighting for XYZ made the mistake of being turned on." "The actress ran the emotional gamut from A to B." "The cast did the best it could with the material it was given." The critic is also expected to tell us something we didn't know, or might not have considered about the show. In American's half dozen largest cities, it's likely a critic is exposed to a couple thousand shows in a ten-year period. That wealth of exposure permits those critics to draw upon a greater reservoir of knowledge than a typical audience member when the critic makes comments about the show being reviewed.

Generally, theatrical criticism is much more extensive than a simple review. During the middle half of the twentieth century, drama critics for *The New York Times* and other New York City area newspapers typically did their reviews under severe time constraints. In some instances, critics were unable to see the complete show before having to leave the theatre to write the review to make the press deadline for the next day. In such situations, the critic might decide to see the show again and write a much more extensive criticism for the newspaper's *Sunday Magazine* than could have been included in the original review.

There are two basic approaches that might be taken in criticism, one is descriptive and the other is prescriptive. The descriptive presentation is an explanation of what was done. The prescriptive, or evaluative, approach indicates what should have been done to make a better production.

Theatrical criticism is not confined to commentary on recently mounted productions. Theatre scholars are continually writing various forms of criticism to be published in the hundred or more publications related to theatre. The criticism might compare productions by different playwrights, discuss the acting roles of a particular actor, examine the career development of an individual scenic designer, compare the production style of two different theatre periods, or discuss the shifting characteristics as one theatrical style evolves into another style.

QUALIFICATIONS FOR A PROFESSIONAL CRITIC

While one might imagine an almost endless list of qualities that a professional theatre critic should have, the following list identifies some major areas:

- The critic must be fair-minded. The critic is not expected to display favoritism because of previous perceptions of the performers' work. Each individual production must be fairly evaluated on its own merits, but it is equally fair to compare the current work with the work performers have previously done.

- While we certainly expect the critic to be fair-minded, we also expect the critic to be accurate. Accuracy refers to an objective standard to which other reasonable minds would also subscribe. We expect the critic to report what was produced without unduly embellishing it or unwarrantedly bashing it.

- A theatre critic is expected to be experienced in theatre and in the activity of theatrical criticism. A critic, who has never personally experienced being involved in a theatrical production, whether as a professional or an amateur, probably does not have sufficient insight about the workings of theatre to provide meaningful insight in the criticism of a particular production.

- The education of a critic needs to be global, that is, as wide ranging as is possible. The good critic must understand music, literature, visual arts, film, and popular culture in order to effectively put the criticism of the individual production into its wider cultural context.

- We expect the critic to be passionate about the arts in general and theatre in particular. While comments from an individual who does not like theatre may be interesting, they generally are not useful in understanding and comprehending the contributions of an individual production, or the individual performer.

- That the critic is knowledgeable about theatre is taken as axiomatic. It is expected that the critic will have and apply his or her knowledge of other scripts, other time periods, other productions of the same script, and other approaches to theatrical production to the given production.

- Regardless of how brilliant a critic may be, if the critic is not an effective communicator then the rest is irrelevant. The critic must have a way with words, whether written or spoken, and have the ability to communicate efficiently with the public. It is implicit that the critic must have a large vocabulary in order to convey nuanced comments about the production.

GOETHE'S THREE QUESTIONS

Johan Wolfgang von Goethe provided a significant guide to the critical process by identifying three questions. Goethe was eminently qualified to offer guidelines on theatrical criticism. He was a Renaissance man, meaning an individual whose skill sets in many areas approach those of a master. He was a diplomat, having been trained as a lawyer. He was a scientist. Some of his writings on color theory were still included in art school instruction at least through the late twentieth century. Starting in 1775, he was appointed to the directorship of the Weimar Theatre, one of the important German theatres at that time. In addition, Goethe is recognized as a world-class playwright, probably best known outside Germany for *Faust I* (1808) and *Faust II* (1832). *Faust I* was the source for Charles Gounod's (1818–1893) opera, *Faust* (1859).

Goethe developed three significant questions that should be part of any theatrical criticism. The three questions are the following:

1. What were/are they trying to do?
2. Did they succeed?
3. Was it worth doing?

The core of question 1 relates to understanding what was attempted. In theatrical criticism, it is only fair to criticize the production for the quality of what it attempted. It is unfair to criticize a production for not doing something it never intended to do. A simplistic example will make this clear. If a production is mounted as a serious play, it is not fair to criticize the production for not being a musical. Obviously, in order to fairly address question 2 the critic must honestly and accurately determine an answer to question 1. The last question is the most important, because that question provides an evaluation of what was done. In theatrical criticism, it is probably not uncommon to be able to say, "I know what they were trying to do; they succeeded in doing it, but it wasn't worth the effort, because play XYZ did a much better job 35 years ago." In this regard, it is instructive to examine Henrik Ibsen's play, *An Enemy of the People* (1882), in which a single individual fought for the moral good against the arrayed opposition of the whole town. The plot showed up again with a new twist in Arthur Miller's play, *All My Sons* (1947), but in that play, the enemy was a US war profiteer—thus, we have a new perspective on the old plot. That same basic plot showed up again in the film, *Jaws* (1975), this time the enemy was a scientist trying to protect tourists from the threat of a great white shark, in opposition to the greedy business people depicted in that film, who didn't want to give up their income from the tourists' dollars.

THEATRE CRITICS

A few representative theatre critics from the last two millennia or so may be instructive about the contributions of past theatre critics.

Aristotle (384–322 BCE), the first theatrical critic, wrote *The Poetics* (c. 335 BCE), in which he analyzed, with a combination of descriptive and prescriptive techniques, how to write Greek tragedies. He wrote the work in part because Socrates before him and Plato, his own teacher, both felt that theatre could not really be analyzed because the poets who wrote the tragic plays could not be truthful, since the very act of writing and performing a play was an untruthful practice. Clearly, Aristotle's work demonstrated the error of Socrates' and Plato's thinking. Aristotle's work is so seminal that it is still a major pillar of theatrical criticism today.

Goethe, referred to above, was one of many qualified critics who wrote about theatre between the classical period of Aristotle and contemporary critics.

George Bernard Shaw (1856–1950) was an Irishman who moved to England when his mother left Ireland to teach music in London. Shaw started his career as a music critic and expanded into theatrical criticism. Shaw was not reticent about informing the English playwrights at the end of the nineteenth century how he thought they should be writing their plays. He expressed this quite fervently in his pamphlet, *The Quintessence of Ibsenism* (1891). At some point, one or more individuals, who were sufficiently irritated with Shaw's condescension, suggested that he should write a play to demonstrate how contemporary playwriting should be done. As they say, "The rest is history." Shaw did start writing plays, his first being *Widower's House* (1892), with the result that today he is considered one of England's most important playwrights, second only to Shakespeare.

Robert Brustein (1927–) will serve as a representative of twentieth-century American scholarly criticism. For a number of years, Brustein was dean of the Yale School of Drama, one of the most highly regarded graduate theatre programs in the United States. While there, he founded the Yale Repertory Theatre in 1966, a theatre company that developed a reputation for producing some of the best and most innovative regional theatre productions in the United States. Later, because of a technical glitch in his contract, he was terminated at Yale University. In an ironic twist of fate, Harvard University invited him to come there, where he founded the American Repertory Theatre in 1980. The irony stems from the fact that George Pierce Baker (1866–1935) was a famous professor of playwriting at Harvard University, where he had trained many of the new American playwrights at the beginning of the twentieth century in his English Workshop 47. When the Harvard University theatre that he was using burned down, Harvard University refused to rebuild it, whereupon Yale University essentially said, "If you come to Yale we'll build a theatre to your specifications." Thus, the Yale School of Drama was founded in 1925. Over the course of Brustein's career, he wrote or adapted nearly twenty plays. To date, he has written sixteen books on theatre and society, including, *The Theatre of Revolt: An Approach to Modern Drama* (1964), *Reimagining American Theatre* (1991), and *Rants and Raves: Opinions, Tributes, and Elegies* (2011).

NEW YORK NEWSPAPER CRITICS

The newspaper critics in New York City had a greater impact on American theatre criticism than other newspaper critics because Broadway is located in New York City. For almost two centuries, after displacing Philadelphia, New York City has been the center of theatre activity in the United States. During much of that time, the out-of-town tryouts that started in Boston were used to test shows before they got to New York. Each city's audiences and critics along the route from Boston to New York were instrumental in improving the productions to get them ready for their opening on Broadway. Following a successful Broadway run, a Broadway show would

again tour, but this time to the rest of the nation. Consequently, what the New York drama critics wrote was most important, with particular emphasis on *The New York Times*. There were a number of important New York City drama critics during the twentieth century.

Brooks Atkinson (1894–1984) was the most important drama critic for *The New York Times* from 1925 through 1960. Brooks Atkinson's critical opinion and consequential power were greater than almost any other theatre critic during the twentieth century in America. Brooks Atkinson's comments were of such stature that his negative review of a Broadway production, by itself, could close the production overnight—an event that happened more than once. While Atkinson had been a student at Harvard University, he had attended George Pierce Baker's famous English Workshop 47.

Walter Kerr (1913–1996) was a drama critic for the *New York Herald Tribune* from 1951 till 1966 and then for *The New York Times* from 1966 through 1983. Kerr was eminently qualified to be a drama critic because he had been a professor of theatre at Catholic University in Washington, DC, for more than a decade before becoming a drama critic in New York. During his professional career, he himself wrote or directed half a dozen Broadway shows. Moreover, his wife Jean Kerr (1922–2003) wrote ten Broadway plays, for which we may presume he collaborated with her on the productions. He even wrote a book on playwriting, *How Not to Write a Play* (1955).

Clive Barnes (1927–2008) was a drama critic for *The New York Times* from 1967 through 1978, a time period during which he shared the position with Walter Kerr. There were so many shows opening in New York City in that time that one critic could not cover them all. It was the period of the development of Off-Broadway, Off-Off-Broadway, regional theatre, and many showcase theatre companies. By the time of Walter Kerr and Clive Barnes, there could still be an isolated occasion when a negative review from *The Times* was sufficient to close a show overnight, but because of the increased number of drama critics in and around the New York City area, it was more likely that it took a couple more negative reviews to close a show overnight. Clive Barnes did not stay at *The New York Times* for his entire career, but moved to the *New York Post* from 1978 until his death in 2008.

Frank Rich (1949–) was the drama critic for *The Times* from 1980 through 1993. By Rich's tenure at *The Times*, a single negative review from *The Times* was no longer sufficient to immediately close a Broadway show. It took several negative reviews to close a show overnight. Rich left *The Times* to become the film and TV critic for *Time* Magazine.

Key Names, Venues, and Terms

Aristotle	Goethe's Three Questions
Aside	Walter Kerr
Brooks Atkinson	Reaffirmation of Social Cohesion
Clive Barnes	Frank Rich
George Bernard Shaw	Sense of Community
Robert Brustein	Soliloquy
Direct Address	Stage Whisper
Feedback	Vicarious Experience

Additional Reading

Ball, David. *Backwards & Forwards: A Technical Manual for Reading Plays*. Carbondale, IL: Southern Illinois Press, 1983.

Booth, John E. *The Critic, Power, and the Performing Arts*. New York: Columbia University Press, 1991.

Palmer, Richard H. *The Critic's Canon: Standards of Theatrical Reviewing in America*. Westport, CT: Greenwood Press, 1988.

Wardle, Irving. *Theatre Criticism*. New York: Routledge, 1992.

THE PRODUCER

Chapter III

The theatrical producer is closely associated with financial issues on a production. On **Broadway**, or in the commercial theatre, the objective is to make money from the production. Because the **producer's** function is much more complicated today than it was a century ago, today typically there are multiple producers for a commercial production. Even in those situations when there is no specific producer working on a production, the functions of the producer must be shared by the others who are involved in the production.

In the nonprofit professional theatres, which typically are headed by a Board of Directors, it is the Board of Directors that serves as the producer. In academic theatres, the department of theatre becomes the producer. The theatre department does not work in isolation. Above the department is a dean, sometimes of Fine and Performing Arts. Above the dean are the president and the Board of Trustees. In public academic institutions, there may even be a state Board of Education or a state system Board of Governors, or possibly even the state Governor. Realistically, these other positions generally are not involved in the day-to-day work of an academic theatrical production, but they do have statute responsibility for what happens inside their institutions, and in exceptional situations they may exercise their legal responsibilities for what happens in the theatres.

FINANCIAL CONSIDERATIONS

Some financial considerations will provide some background before we get into the functions of the producer. *Frankenstein*, opening on Broadway in 1981 and closing after a single performance, lost $2,400,000. The scenery in that production cost about $1,000,000, an unusually high amount for the time period. *Big (The Musical)* lost even more money in 1996—$10,300,000. The Broadway production of *Spider-Man: Turn off the Dark* opened 2011 after having spent about $75,000,000 and garnering less than enthusiastic reviews. The show was plagued with a variety of problems: conflict of artistic visions, expensive and sometimes poorly performing technical rigging, and a series of significant injuries to some of the leading actors. The show's

serious problems in previews prompted its producers to temporarily close the production to make improvements. Eventually, it officially opened. The public seemed to buy tickets early on, but it wasn't enough. It closed in January 2014 with an expected loss of $60,000,000. The producers announced that they hoped to reopen the show in Las Vegas, but that never happened.

In contrast, the financial situation for **The Phantom of the Opera** (1986) was much different. In 1994, there were eleven worldwide companies performing *The Phantom of the Opera*, each of which was grossing approximately $1,000,000 per week. That represented an income of over half a **billion** dollars a year. By 2013, the Broadway production had earned $853,122,000. *The Lion King*, another Broadway production, opened in 1997 and had earned $853,846,000 by 2013, with every expectation of running for decades to come. Notice that just two Broadway hits, *The Phantom of the Opera* and *The Lion King* earned over $1.7 billion so far. We all understand that when we go to the casino and win $500 at slots or blackjack, we do so only because other individuals lost $500 to cover our profit; that same concept applies to some extent to shows done on Broadway. However much profit *The Phantom of the Opera* and *The Lion King* made, their profit is balanced by the losses on all the other shows that went into production during that same time period, but did not succeed on or even get to Broadway.

Billy Elliot is a special case. It opened on Broadway in 2008, after performing for three years in London's West End, England's equivalent to America's Broadway, where it performed until 2016. Despite having been running in London for years, the Broadway production still spent approximately $18,000,000 just to get to opening night. Fortunately, *Billy Elliot* was well received. It closed in London after eleven years only because its venue was to be remodeled. For a while there was talk of reopening the show.

The significance of the Performing Arts in the United States is larger than one might suspect. Performing arts in the United States gross more money per year than all the sporting events in the United States combined. In 2013, the New York State Council on the Arts announced that in 2012 entertainment admissions in New York State exceeded the income for all sporting events. In 2012, Broadway theatres alone sold over $1,000,000,000 in theatre admissions. Each Broadway hit show takes in around $1,000,000 per week. With this amount of money involved, it is clear why a theatrical production needs a producer.

Commercial or Broadway theatre productions are produced differently than most other kinds of theatre production in the United States. The corporate structures that are created in order to produce Broadway productions are organized so that the corporate entity will only ever do one script. The organization will try to generate as much income as possible from that one script for as long as the script has any viability. That viability includes film versions, cast albums, and amateur performing rights

that can approach a century in duration. For example, the George Bernard Shaw estate still receives income from amateur, professional, and movie performances of *My Fair Lady* (1956), which was based upon Shaw's play *Pygmalion* (1913). Should the Broadway producers of one show want to do another production of a different script, they will create a new corporation whose sole purpose will be to produce the new script.

PRODUCER'S FUNCTIONS

Let's examine the producer's functions. The producer has four major functions: obtain a "**property**," raise money, hire all staff, and find facilities. Let's look at each of these areas separately.

OBTAIN "PROPERTY"

The "property" means a script or an idea that may be turned into a script. Neither individuals nor organizations have the right to simply mount a theatre production. One must get permission to mount the production from the original creator/s and must provide some form of compensation to the original creator, typically the playwright. Scripts written before the twentieth century are often "copyright" free and may be mounted without compensation if done in the original language. However, translations of plays from any time period must pay compensation to the translator.

The simplest way for a producer to obtain a "property" is for the playwright to submit a script to the producer for production. In other situations, the producer has a "property" in the form of an idea, a novel, a short story, or perhaps a film to be turned into a stage script. Even here, the original creator's permission must be obtained beforehand and appropriate compensation must be paid before a stage script may be produced from such sources. The producer essentially commissions the playwright to create a script that can be mounted. Although a script is obtained from commissioning it or submission by the playwright, the producer and the playwright must execute an "**option**." The "option" is a contract between the producer and the playwright that governs the details of the production. Typically, the producer states the quality of the production that is intended to be mounted, often indicated by noting the quality of the theatre artists that might be hired for the production; the date by which the production must be mounted; and the money to be paid to the playwright, both for the option and the royalties for the playwright after the production opens. Other details typically include how much input and control the playwright will have in the production. Playwrights with significant reputations have significant input—those with a lesser reputation have less input. If the producer cannot mount the production by the deadline, the playwright keeps the option money and is now free to try to find another producer to mount the production.

RAISE MONEY

More than a century ago, producers might use their own money to mount a production, but that was when a relatively simple Broadway production could be done with $35,000 to $50,000. Today, Broadway musicals are capitalized far in excess of $5,000,000, and because of the amount of money needed, it must be found from a variety of sources. There are two groups that might invest money in a Broadway production: **general partners** and **limited partners**.

As a group, the general partners are responsible for making all decisions that relate to the production, and they receive 50 percent of all the profits, regardless of how much or how little money they actually invested. We might well ask, "What might motivate an individual or institution to be involved as a producer for a Broadway production?" Clearly, corporations that are involved in theatre or the performing arts have strong motivations to be involved as Broadway producers. If a musical is being done, a corporation such as **Sony Corporation** might want to be a producer in order to exercise some control over selecting the company that produces the original cast CD or perhaps to make the movie version of the script.

On the other hand, limited partners make NO decisions, and regardless of how much money they invest in the production as a group, they only receive 50 percent of any profits. The rights and responsibilities of the limited partners are spelled out in what is called a **Limited Partnership Agreement**. Limited partners are sometimes referred to as "**angels**" and sometimes are recruited through what are called Angels' or **Backers' Auditions**. A Backers' Audition is essentially a party with abundant food and alcohol at which the producers' vision for the production is presented to the potential limited partners so they might open their checkbooks and invest in the production. Designers often present their sketches and models, which show how the physical production will look. If the leading actors have already been selected by the producer for a musical, they typically will sing songs that have been written for the production. If leading actors have not yet been selected, then the show's composer and lyricist are likely to present the show in a piano or concert version. The purpose of all of this is to schmooze the potential limited partners into investing in the production. Just as we asked what might motivate general partners, we can ask the same of limited partners. The most likely motivation today is that one is interested in theatre and wants to invest in the cultural advancement of theatre. Another likely one is for those who are looking for a tax write-off. The interest in tax write-offs is due to the fact that there are far more commercial productions that fail to earn a profit than those productions that eventually do earn a profit.

HIRE ALL STAFF

The producer hires *all* individuals working on the production: Artistic Collaborators, Actors, Publicity and Promotion, and Contracted Services. Artistic collaborators include designers, directors, choreographers, conductors, and so on.

It is not uncommon in the **commercial theatre** for the producer to hire designers for the production before the director has been hired. Because designers' sketches can help the producer sign up and generate money from the limited partners at backers' auditions, designers are sometimes hired early in the production process. Another major consideration is that the orders and designs for Broadway shows are typically due in the commercial theatre construction shops a week or more before the first day of rehearsal. Designers' contracts typically require at least six weeks of design time before orders are due in the shops. Thus, designers typically are hired months before the first day of rehearsal. In the commercial theatre, the designer is ultimately responsible to the producer, not to the director, even though the director and the designers collaborate on the production. In the academic theatre, this collaboration between director and designers sometimes gives students the erroneous impression that the designer works *for* the director, as opposed to working *with* the director.

The Broadway producer is responsible for hiring all actors, even if the producer doesn't exercise that right with every cast member. Clearly, the producer is centrally involved in the hiring and contract negotiations of leading actors and actresses, because their reputations are major factors in marketing and selling tickets. The producer might not be involved in the details of actually selecting chorus members and may delegate that authority to the director. However, **Actors Equity Association** (AEA, the union for professional theatre actors) prohibits directors, if they are not also producers for the show, from negotiating money or contract conditions with an actor. Thus, the producer effectively selects every cast member by virtue of the fact that the producer alone executes every employment contract with every actor.

Publicity and promotion is very important in theatre, particularly in professional productions. If the public is not motivated by publicity and promotion to buy tickets, there are no bodies in the theatre seats and no income coming into the box office to pay salaries or to buy supplies. Generally, publicity and promotion for the Broadway theatre is handled by hiring a company that specializes in such services. In places like the professional regional theatres, the theatre company typically hires one or more staff members with specialized skills in publicity and promotion to be a member of the company and to provide those specialized services. The approach of contracting for services in the commercial theatre applies to many other functions relevant to a Broadway production. For example, scenery and costumes are built by companies that specialize in building scenery and costumes. A similar approach is applied to all other activities that may be called upon to mount a Broadway production.

FIND FACILITIES

Facilities are needed for four different phases of a Broadway production: auditions, rehearsals, performance venues, and touring considerations. This is because a Broadway production corporation owns no facility and has no need to own a facility.

Once the original production closes, that company will never mount another production—hence, there's no need to have a facility. Thus, a space must be rented for auditions. Sometimes, auditions for a Broadway production might be conducted in a theatre, but more often acting studio space is rented instead.

Rehearsal needs present a different set of circumstances. Broadway productions rarely, if ever, rehearse in a Broadway theatre, primarily because of the rental cost and the fact that most Broadway theatres are busy presenting their own productions. Their stages are already filled with scenery for eight performances a week. If a musical is to be rehearsed, there is a need for at least four separate spaces. One studio is needed for dance rehearsals, a second for acting rehearsals, and a third for singing rehearsals. When the orchestra is hired it will also need a separate rehearsal space. Obviously, space needs include not having dance rehearsals with the associated floor stomping above the space where quieter acting rehearsals are taking place. A sufficiently isolated orchestra rehearsal space is needed so it does not disturb acting and dance rehearsals.

The selection of a space for performance involves a number of considerations. Sometimes, it revolves around whether one of the general partners is a corporation theatre owner, such as the **Shubert Organization**, Nederlander Organization, or Jujamcym Theaters. A corporation such as the Shubert Organization owns a number of theatres in New York City and typically, at least one theatre in a number of major cities around the country. A corporate theatre owner is losing money each day its theatre is unoccupied because it must still pay utilities, taxes, and salaries to its permanent employees. If a theatre-owning company is one of a show's producers, it will make every effort to have the show perform in one of its theatres, particularly if it has an empty one. If there is no such producer for the production, then the show's producers try to negotiate for the most appropriate venue for the production. Considerations include the weekly rental fee for using the facility, box office income conditions that will trigger an eviction notice, and, not the least, whether the facility is available when the production anticipates opening.

If the production becomes a hit, which means it is making a profit, the producers may decide to tour it to other cities across the country. If the show tours to other cities, while still running on Broadway, it will significantly increase the box office take. Considerations for selecting a performance venue in touring cities are very similar to those for selecting a performance venue in New York City. If the Shubert Organization is one of the producers and the Shubert Organization has an available facility in one of the touring cities, then almost certainly the performance will take place in that Shubert facility.

There are several options for touring schedules and venues. For each of these performance venues the producer must arrange for a theatre in which to perform.

Open Run: Initially, touring productions are scheduled for major cities, such as Chicago, Los Angeles, London, Singapore, and so on. In each location, the show performs an open or extended run for as long as there are sufficiently large audiences to buy tickets so the show is earning a profit. This could be months or perhaps even years. Gradually, the show will perform for shorter periods in each new venue. In the United States, the production's scenery, costumes, and lights are generally transported in multiple tractor trailers from venue to venue.

Limited Run: The touring schedule will shorten the time in each new city until the production does limited or fixed periods of a few weeks. Eventually the production will get down to **split-week** runs. For example, the show might perform Tuesday, Wednesday, and Thursday in St. Louis, Missouri and Friday, Saturday, and Sunday in Kansas City, Missouri.

One-Night Stand: Eventually, the show will have absorbed all of the multinight performance market and will tour for **one-night stands**, often referred to as a "bus & truck" tour. They are referred to as bus and truck because the technical crews and the actors travel in their own busses while the scenery is hauled from city to city in trucks or tractor trailers. Though the original show was transported in multiple tractor trailers, by the time the production gets to one-night stands the show typically has been redesigned and simplified so that it will fit into only one or two tractor trailers.

WORLD-CLASS PRODUCERS

Let's examine a few major American world-class producers from the twentieth century. Each of the following producers was responsible for many significant productions on the Broadway stage.

Florenz Ziegfeld (1867–1932) was a major American theatre producer during the first third of the twentieth century. He is best known for his annual productions of **The Ziegfeld Follies**, which started in 1907. Each annual edition of the *Follies* opened in New York City around June for a limited engagement run and then spent the next year touring to various cities around the country. Ziegfeld was also involved in other Broadway productions, most notably *Showboat* (1927). Ziegfeld showed his abilities as a young man in Chicago, where his father owned and operated a music conservatory. For the 1893 Columbian Exposition in Chicago, the elder Ziegfeld sent his son to Europe to hire acts for the Exposition. While the elder Ziegfeld expected his son to hire musical acts, Ziegfeld hired additional attractions, particularly Eugen Sandow, a popular European strong man and body builder. At the Exposition, for an extra fee, proper ladies were permitted to run their gloved hands over Sandow's bulging muscles. When the elder Ziegfeld saw the accumulating profits, he changed his mind about his son's failure to hire only musical acts.

David Merrick (1911–2000) was a flamboyant producer who had great skill in generating publicity for his shows. In an attempt to keep *Hello Dolly* (1964) performing long enough to take the record for the longest running musical in Broadway history, he hired various actresses, including Phyllis Diller (1917–2012), to play the role of Dolly Levi. He even did an all-black production of *Hello Dolly*, starring Pearl Bailey (1918–1990). If the show took the Broadway longevity record, it could demand more money for the show's movie rights. In addition to *Hello Dolly*, Merrick did *The Persecution and Assassination of Jean-Paul Marat as Performed by the Inmates of the Asylum at Charenton, Under the Direction of the Marquis de Sade* (1964, typically abbreviated as *Marat/Sade*) and the musical, *42nd Street* (1980).

Joseph Papp (né Papirofsky) (1921–1991) is probably best recognized for his **New York Shakespeare Festival**, which provided free Shakespearean productions during the summer at the Delacorte Theater in New York City's Central Park. Later he acquired and converted the old Astor mansion in lower Manhattan. That facility became the **Public Theatre**, which contained several performance spaces. There he produced new plays, some of which went on to become major Broadway productions earning significant money. Some of his important productions were *Hair* (1967), *A Chorus Line* (1975), and *Two Gentlemen of Verona* (1971).

Hal Prince (1928–) has won 21 Antoine Perry Awards (Tony Awards), more than anyone else in Broadway history. In addition to being a gifted producer, Hal Prince was also a brilliant stage director, with a reputation for mounting outstanding musical theatre productions. Together with Stephen Sondheim, he developed a new approach to musical theatre, known as the "concept musical." His productions include *Fiddler on the Roof* (1964), *Cabaret* (1966), and *A Little Night Music* (1973).

Shubert Organization is most relevant as a producer because it is a company that owns a large number of theatres in New York City and other major cities around the country. As such, it is often involved as a producer so that its facilities may be the performance venues for commercial theatre productions and their touring productions.

Sony Corporation is a large entertainment conglomerate often involved in commercial theatre productions. As a producer, Sony is able to influence the selection of the producer for CDs and/or films of Broadway shows. From a corporate perspective, the investment of $1,000,000 in a Broadway musical, in exchange for access to the movie rights and additional multiple millions of dollars, is merely pocket change.

Disney Corporation is somewhat different from many other corporate producers. Typically Disney's Broadway activity is focused on Broadway stage productions of its own films; such productions might be expected to run for decades. Disney Corporation was instrumental in cleaning up the pornography venues on 42nd Street by making its first New York City theatre purchase from among those porn theatres on 42nd Street.

Key Names, Venues, and Terms

Actors Equity Association (AEA)
Angels/Backers
Backers' Audition
Big (The Musical)
Billy Elliot
Broadway
Commercial Theatre
Disney Corporation
Frankenstein
General Partners
Limited Partners
Limited Partnership Agreement
David Merrick
New York Shakespeare Festival

One-Night Stand
Option
Joseph Papp
The Phantom of the Opera
Hal Prince
Producer
"Property"
Public Theatre
Shubert Organization
Split-Week
Sony Corporation
Spider-Man: Turn off the Dark
Florenz Ziegfeld
Ziegfeld Follies

Additional Reading

Byrnes, William J. *Management and the Arts*. New York: Focal Press, 2003.

Conte, David M. and Stephen Langley. *Theatre Management: Producing and Managing the Performing Arts*. Hollywood, CA: EntertainmentPro, 2007.

Farber, Donald C. *From Option to Opening*. 3rd ed. New York: Drama Book Publisher, 1977.

THE PLAYWRIGHT

Chapter IV

In Chapter III, we learned that the producer needs a property, or play script, to produce. Generally, the **playwright** produces that script. First, we need to make a distinction about the word "playwright." The term is "playwright" not "playwrite." The term "wright" means "to make." A playwright is one who makes plays—in the same sense that a shipwright makes ships and a cartwright makes carts. However, despite the fact that the individual is a playwright, the actual act of creating a play is called playwriting.

For the most part, most performers in theatre are interpretive artists. However, the playwright is the only noninterpretive artist in theatre. The playwright's script is interpreted by various theatre artists to present to an audience. What the playwright provides is a skeleton, an outline, or a foundation, which the interpretive artists flesh out. As a generalization, what the playwright provides is dialogue. A few playwrights, such as Eugene O'Neill (1888–1953) and George Bernard Shaw (1856–1950), provided extensive commentary, referred to as stage directions, for the interpretive artists and other readers to use. Shaw went even further and wrote very extensive prefaces to his plays, which, in a couple instances, were even longer than their associated plays.

MOTIVATION

Each playwright has some kind of inspiration or inner drive that motivates him or her to write the specific play, or deal with the topic addressed by the play. Many playwrights, particularly during the late nineteenth and much of the twentieth century, addressed a variety of social problems. For example, Arthur Miller's (1915–2005) script *The Crucible* (1953), while seeming to be about the Salem witch trials of 1592, was actually about the McCarthy witch hunts for communists in American society in the 1950s. Henrik Ibsen (1828–1906), back in the nineteenth century, wrote plays such as *A Doll's House* (1879), *Ghosts* (1881), and *Hedda Gabler* (1890) about the status, treatment, and perception of women.

Sometimes, playwrights set challenges for themselves. For example, Harold Pinter (1930–2008) wrote *Betrayal* (1978). When the audience saw the first act, it needed more information to understand how the dramatic action got to that point. The second act provided some answers, but raised more questions. Those last questions were answered only in the last act. Though the audience saw the production in a sequence of Act I, II, and III, the actual story of the play proceeded in the sequence of Act III, II, and I. Thus, Pinter had written the play backward. Stephen Sondheim (1930–) wrote *A Little Night Music* (1973), allegedly to see if he could write a musical in waltz time. Theatre critics' comments and the Antoinette Perry Awards the musical received were ample testament that he succeeded. Last, Suzan-Lori Parks (1963–), who wrote *In the Blood* (2000), wanted to see if she could translate Nathanial Hawthorne's (1808–1864) novel, *The Scarlet Letter* (1850), into a contemporary idiom. In Parks' play, the dramatic action was set among "society's rejects," who were struggling beneath abject poverty.

Some playwrights are concerned about keeping an audience entertained. To a great extent this applies to Neil Simon's (1927–2018) plays, such as *The Odd Couple* (1965), and *The Goodbye Girl* (1993). Some playwrights are motivated by fame and posterity. In the last couple decades of his life, Arthur Miller, aware of his stature as a major twentieth-century American playwright, carefully revised his scripts with an eye toward the future. Some playwrights seem to be motivated primarily by money, though it must be noted that few, if any, playwrights are successful in this regard if their plays do not provide some additional rewards for an audience.

SOURCES

Playwrights may get ideas for their plays from a variety of other literary creations such as a poem, novel, another play, a current societal activity, or a specific incident. For example, Andrew Lloyd Webber's (1948–) *Cats* (1982) was based on a collection of poems written by T. S. Eliot (1888–1965). Another musical, Claude-Michel Schönberg's (1944–) *Les Misérables* (1987), was based upon Victor Hugo's (1802–1885) novel, *Les Misérables* (1862), which was so successful it became the longest running musical in Broadway history. Stephen Sondheim's (1930–) musical, *A Funny Thing Happened on the Way to the Forum* (1962) was based upon several classical Roman plays, including Plautus's (c. 254–c. 184 BCE) *Pseudolus* and *Miles Gloriosus* (both c. 205–184 BCE). Cole Porter's (1891–1964) musical, *Kiss Me Kate* (1948), was based upon Shakespeare's play, *The Taming of the Shrew* (c. 1590–1592). A more interesting lineage is Richard Rodgers' (1902–1979) and Lorenz Hart's (1895–1943) musical, *The Boys from Syracuse* (1938), based upon Shakespeare's play, *The Comedy of Errors* (c. 1594), which in turn was based upon Plautus's *The Menaechmi* (c. 205–184 BCE). Arthur Miller's *The Crucible* (1953), as noted earlier, while seeming to deal with the Salem witch trials of 1592, actually addressed the national hysteria surrounding the

House Committee on Un-American Activities' search for communists in American society in the 1950s. Chikamatsu Monzaemon's (1653–1725) *The Love Suicides at Amijima* (1721) was based on a specific suicide pact that took place in Japan at that time.

A number of productions were based on films. The Disney stage production of *The Lion King* (1997) with music by Elton John (1947–) was based upon the Disney animated film of the same name, which premiered in 1994. That film in turn incorporated ideas and **themes** from Shakespeare's play, *Hamlet* (c. 1602). Jerry Herman's (1931–) musical, *La Cage aux Folles* (1983) was based upon a French film, itself based upon another French play. The Broadway smash hit musical, *The Producers* (2001), by Mel Brooks (1926–), was based upon the same author's film, *The Producers* (1968). This relatively short list of plays based upon other artistic sources hopefully documents the variety of sources that playwrights might consider as springboards for a new play or musical.

One might well ask, "What is the advantage of using other sources for plays?" Using a previously successful script or source is likely to increase the probability for success on the current script. The vagaries of mounting a new production are difficult enough that it warrants borrowing a proven **plot** so there is one less unknown factor in the process.

PLAYWRITING PROCESS

There are generally three major approaches toward producing play scripts: traditional, workshop, and group.

The traditional process entails outlines, drafts, and then edits and revisions, a process not essentially different from most any writing process. Most playwrights, but not all, get to a point that the ideas that inspired them to start writing a play need to be organized. Typically, that organizational pattern is an outline that works out what happens in each act and scene of the play. Then, with or without an outline, the playwright starts producing a draft of the dialogue. Probably, most playwrights at some point in the draft process will speak the dialogue out loud to see if it seems to work in the manner that the playwright imagined. After all, the playwright is attempting to reproduce some level of actual conversation between people, not to produce an essay. As is true of any type of writing, including students' research papers, it is in the revision and editing, where the real creation of the work resides.

Some authors such as Michael Bennett (1943–1987), who did the musicals, *Chorus Line* (1975) and *Dream Girls* (1981), frequently used the workshop approach for generating new scripts. He did workshops that lasted about a year or more, during which time the various exercises and projects that developed were turned into scripted scenes used in the final productions.

Some plays are produced through a group process. A performance group, as might typically be the case for some Off-Off-Broadway theatre groups in New York City, gets together to brainstorm and/or improvise stage actions. At this point, there are two possible approaches: one is to have the group turn the exercises into a scripted scene; the other is to give a playwright the responsibility for turning the scenes into a script. The next day or the next week, the script is rehearsed in the studio, additional improvisation might take place, and the playwright is then tasked with rewriting the revised scene. The process continues until the group considers the script is finished and ready to be presented to an audience.

ARISTOTELIAN ELEMENTS OF DRAMA

Figure 4.1 *Aristotle, author of The Poetics.*

We need to examine and understand the building blocks that a playwright uses for creating a play. For this, we go back to Aristotle (385–322 BCE), who wrote *The Poetics* (c. 335 BCE), in which he discussed the elements from which the playwright constructed a play. Aristotle determined that these elements consisted of **plot**, **character**, **thought**, **diction**, **music**, and **spectacle**, the order in which he discussed them in *The Poetics*. It is a tribute to his thinking that the elements he identified about 2,300 years ago are still the foundation of dramatic construction (Figure 4.1).

- Plot is the most important element and the first one mentioned. For Aristotle, the scenes that are put on stage are imitations of actions. Thus, for him, and for us, the plot is the specific arrangement of the order in which the individual actions are presented to an audience. It is essential to understand that the actions contained in the play—that is the plot—are not the story of what happens. In many plays, the plot is essentially the tail end of a long story. The playwright chooses the content and arrangement of the individual actions that are contained in the play.

- The characters are the fictional beings, typically, but not invariably, human, who "live" the action of each scene. Historical plays generally have characters based upon the historical person, but the playwright typically takes dramatic license in some details in order to create an interesting and dramatic script. The characteristics of characters may be defined by their speech pattern, the way they move, what other characters say about them, what they say about themselves, how they are costumed, and by the patterns and structures of

their dialogue. The playwright may explicitly include these characteristics in the script, or more often leave the specifics to be realized by the collaborative efforts of the director and the actor.

- Thought is the term that Aristotle used for what we equate with **theme** or idea. It is the topic that the play is about. For example, using Arthur Miller's script *The Crucible*, it is obvious that the theme is about the communist witch hunts of the 1950s. At the same time that we discuss theme, or thought, we must recognize that a play is not limited to one theme. A script may contain several themes of differing priorities, any one of which may be emphasized more than another in any given production. It is also important to understand that the themes that are contained in plays are not limited to those that the playwright intentionally included. For example, it was common practice during the latter part of the twentieth century and into the twenty-first century for some directors to accentuate gender issues that were not considered that important when the play was written.

- Diction is equivalent to our word "language," and thus refers to the dialogue that is written for the characters. The structure of dialogue is influenced by the time period being represented, the time period when the play was written, class distinctions of the character, and the rhythm the author wishes to use. In many plays written before the twentieth century, many characters had lines that consisted of one or more complete sentences. In some instances, the character's dialogue goes on for a page or more before another character has a line. In more contemporary scripts, particularly from the late twentieth century, individual lines often are much shorter, sometimes being nothing more than a phrase or a word. The British playwright, Harold Pinter (1930–2008), is particularly known for the brevity of the individual line. In fact, he is well known for his use of pauses in his dialogue structure, typically referred to as "Pinter pauses." After all of this discussion about diction, or dialogue, it is important to understand that the dialogue must be performed, and therefore a fundamental question is, "Can the dialogue be performed?"

- Music was more important in drama when Aristotle wrote. He was describing Greek tragedies that had significant musical components, performed by the chorus. Even though we do not know exactly what the music for those choruses was like, it is presumed that there was some level of music making involved and that the chorus was singing along with this music, or possibly chanting at pitch. Today, we easily apply the issue of music to musicals, but it takes only a little effort to see this application to straight plays as well. In such plays, the "music" is expressed in the form of the variation in the speaking voice. Rhythm may easily be perceived by the pattern of vocal emphasis or possibly the rhyming between different lines of dialogue, as well as the pattern within an individual line. Likewise, we may perceive a melodic line in the rising and falling of the pitch in the speaking voice, as might easily be illustrated in what we refer to as "the Irish lilt."

- Spectacle consisted of all the other aspects of production, and was not considered that important by Aristotle. Spectacle referred to the facade in front of which the plays were presented, the costumes that the actors wore, the movement patterns of the chorus that we might refer to as dance, and the arrangement of actor movement, what we today refer to as blocking.

NON-ARISTOTELIAN ELEMENTS

As impressive as Aristotle's achievement was, he did not address all of the elements that are considered essential to theatre today.

The biggest one concerns **conflict**. An essential point of dramatic action, as presented on stage, is a conflicting situation that creates an obstacle for the main character. Most of the time, the conflict exists between the protagonist, the character the play is about, and the antagonist, the character who obstructs the protagonist from achieving his goals. Sometimes, it's difficult to figure out who is the protagonist, because there are several characters in various kinds of conflict. As a glib generalization, the title character is always the protagonist. Thus, in Henrik Ibsen's *Hedda Gabler*, it is Hedda Gabler who is the protagonist. The protagonist is not necessarily the character the audience likes or for whom it is rooting. Most of the time there is a single protagonist, but in a few plays the protagonist consists of a group, as may be seen in *Fuente Ovejuna* (c. 1613), or *The Sheep Well*, by Lope De Vega (1562–1635).

In terms of conflict, there are three traditional forms of conflict that show up in theatre. The most prevalent one is the conflict between the character of the protagonist and a different character, the antagonist. Sometimes, the conflict is between the two aspects or facets of the same character—that is, the protagonist. In still other situations, the conflict is between the protagonist and some outside force, such as nature or social pressure.

The element of Time is not explicitly addressed by Aristotle, but there is the implication that tragedies take place in about a day. There are two ways of looking at time in a play. One represents the amount of time that is supposed to have elapsed during the course of the play. This can be of any duration, but over the centuries, either because of explicit or implicit rules or the playwright's decision, many plays seem to observe a limitation of approximately 24 hours. The other issue of time pertains to how long the audience in different historical time periods will sit and watch the performance. In earlier time periods, for example, during the seventeenth, eighteenth, and nineteenth centuries, plays ran several hours. During much of those earlier centuries, an evening's theatre entertainment consisted of a curtain-raiser, the main play, and an afterpiece—sometimes providing five hours of theatre. In Shakespeare's (1564–1616) *Romeo and Juliet* (c. 1591–1595) the Chorus refers to the "two hours' traffic of our stage," a reference that most scholars take as a significant understatement.

At the longer extreme during the twentieth century, Eugene O'Neill's *Morning Becomes Electra* (1931) and the production of *The Life and Adventures of Nicholas Nickleby* (1980) ran between seven and nine hours. In the cases of those twentieth-century productions, it was necessary to take a dinner break before seeing the rest of the show. As the twentieth century wore on, most plays gradually decreased their performance time to approximately an hour and a half or two hours. Currently in the twenty-first century, some "full-length" plays are on the order of only seventy-five to ninety minutes long.

As noted earlier, an essential characteristic of drama is that it is an action that takes place in the present tense in front of the audience, as opposed to a narration, or a description of what happened. That characteristic is, and was, still firmly in place as an element of drama, even though Aristotle does not specifically include it in his list of the element of drama. That may be because he initially defines tragedy as an imitation of an action, and perhaps did not feel the need to further discuss it.

PLAYWRIGHT'S LIMITATIONS

As just noted, the presentation of actions is an essential element of theatre, and theatre must therefore show what takes place in an action, rather than merely describe it. This means in order to write a successful play, the playwright is limited to creating actions that may be imitated, instead of describing them. As the canon of world theatre demonstrates, playwrights have created a literally limitless variety of actions to be imitated—and thus put on the stage.

There are many theatre conventions the playwright must observe and use. Some of these such as the aside, the soliloquy, stage whisper, and the direct address have already been mentioned. However, there are some that may not be so apparent. As a generalization, art, and theatre in particular, are constrained by their time periods and their cultures. We can see this readily in films made in the 1940s that purport to imitate historic time periods. Despite that, stars were often seen in hair styles of their own time period. For example, we may see a Cleopatra wearing a pageboy hairstyle, or any number of actresses displaying cleavage that was never a part of the time period being portrayed. Another simple illustration will also make the point about being bound by culture. In the United States for the most part, the color that represents a funeral is black, yet, in some Asian cultures, the appropriate color for a funeral is white.

It is intuitively obvious that the space in which a theatrical presentation may take place is finite. Most of the time, the performance space used is a theatre, and generally a theatre production is limited by the space in the theatre. In the production of *Starlight Express* (1984), the actors, who were impersonating trains, roller-skated around the whole theatre—including up to the balcony—on specially constructed ramps. Most of the time, productions are limited to the space of the stage. For this

reason, outer space cannot be successfully displayed in a theatre. The characteristic of outer space is a limitless void. Regardless of how imaginative the design might be, an audience member merely needs to turn to the side to see another audience member, and thus give away the illusion.

In previous paragraphs, we discussed a play's length in earlier time periods. Now we need to discuss the limitation on how long a twenty-first-century audience will sit in a theatre. If the production is compelling and exciting, an audience willingly sits longer than if the production is slow and plodding. There is a general expectation today that new plays will run about one and a half to two hours. An unknown playwright who writes a seven-hour-long play probably has little to no chance of seeing it produced. On the other hand, the playwright of eminent stature who writes an exciting three-hour-long play has a chance of having it produced today, but inevitably is going to be encouraged to cut its length. However, it is worth pointing out that there is no inherent limitation on the amount of time the playwright may spend writing the play to begin with.

Money is another important limitation. A Broadway mantra is the "five character one set" play. Even though a musical theatre production may be capitalized at $15 to $20 million, the current theatre climate is not going to consider the same amount of money to capitalize a serious topic, nonmusical play. After all, Broadway is a business in which making a profit is the goal of the initial investors. If the perception is that it will take a decade to get to a break-even point, there's not much probability that the show will be mounted in the first place.

Key Names, Venues, and Terms

Aristotelian Elements	Music
Plot	Spectacle
Character	Conflict
Thought	Playwright
Diction	Theme

Additional Reading

Catron, Louis E. *The Elements of Playwriting*. Long Grove, IL: Waveland Press, 2002.

Hatcher, Jeffery. *The Art and Craft of Playwriting*. Cincinnati, OH: Story Press, 1996.

Kerr, Walter. *How Not to Write a Play*. New York: Simon and Schuster, 1955.

Lawson, John Howard. *Theory and Technique of Playwriting*. New York: Hill and Wang, 1960.

DRAMATIC STRUCTURE

Chapter V

Dramas are constructed by using the elements identified in Chapter IV and arranging them to create an action or a scene. The playwright organizes and arranges various actions to create interesting and compelling plays. **Gustav Freytag** (1816–1895) was a German playwright and critic who produced a diagram that explains the structural parts of a well-constructed play. His diagram resembled a pyramid (Figure 5.1) along which various structural parts were arranged to create organized play structures. In Freytag's diagram, the vertical axis represented tension or complication, while the horizontal axis represented time. Freytag's parts, in their production order on the diagram, are **exposition**, **inciting incident**, **complication**, **crisis**, **climax**, and *dénouement*.

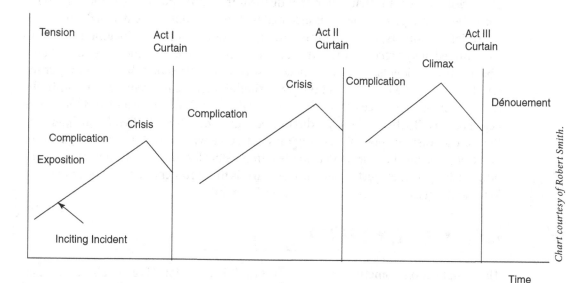

Figure 5.1 *Gustav Freytag's dramatic structure diagram notes the structure of a typical play.*

EXPOSITION

Exposition generally occurs at the beginning of the play and provides information the audience needs to get up to speed with what is happening in the play. In nineteenth- and early twentieth-century dramatic construction, exposition was sometimes arbitrarily provided in what was loosely referred to as the "expository scene." There were two rather trite ways to do this. One was to have the maid and the butler converse about the situation, while they ceremoniously went about their chores of cleaning and tidying the room. The second technique was used after the popularity of the telephone was established. At curtain rise, someone was on the phone or the phone was ringing, waiting for someone to answer it. In the subsequent dialogue, much like the situation with the maid and the butler, the character would have a phone conversation, conveying information to someone on the other end of the line, while the audience caught up by listening to the conversation. Much more sophisticated techniques for handling exposition may be found in the works of master playwrights, who often dispersed the expository material throughout the play. For example, in Sophocles' *Oedipus Rex*, (c. 429 BCE) each new scene seems to provide new background information that helps the audience understand what was going on. A similar technique was used in a much more contemporary example, Arthur Miller's *Death of a Salesman*. Each of that play's flashbacks provided additional information about what happened in the past.

INCITING INCIDENT

The inciting incident is that action that disturbs the *status quo* and gets the play going. For some theatre practitioners it is essential that the inciting incident actually be inside the script. For others, including this author, it is sufficient for the inciting incident to have immediately preceded the start of the play. In *Oedipus Rex*, there are several possible inciting incidents. One is the plague, which both preceded the beginning of the script and continued throughout the play. Another inciting incident, totally within the script, is Creon's entrance and announcement that the Oracle at Delphi said the plague began because Thebes had not yet discovered Laius's murderer. In *Death of a Salesman*, there are at least two possible inciting incidents. One within the script is Willy's return home because mental distractions made it impossible for him to continue his trip. The other inciting incident just before the play starts is the argument that took place between Willy and Biff that morning when Biff got off the train.

COMPLICATION

The complication, sometimes referred to as the "rising action," is generally an increasingly complex tangle of problems, each with its minor crisis. In Freytag's pyramid diagram, the entire left side of the triangle consists of the complication or rising

action. Typically, there is not a single complication, but an escalating accumulation of problems. Just as one complication seems to be on the verge of solution, another problem arises.

CRISES

Generally, each individual complication is accompanied with a crisis, which in turn frequently generates another complication. Part of the sophisticated structuring of the alternation of complication and crises is to build in some sense of relief, only to have it thwarted again by a new complication. Generally, a relentless and continuing building of complications is more than an audience can take for a sustained period of time—thus the need for some relief, as may be noted in Shakespeare's use of comic relief even in his tragedies. As might also be expected, each crisis typically raises the stakes in the play, and consequently each successive crisis heightens the tension in the play.

CLIMAX

The alternating building and releasing of tension continues as the complication rises. Finally, there is one last final crisis, called the climax, that point at which nothing more can happen. From that point onward the play begins to resolve itself.

DÉNOUEMENT

The dénouement, falling action, or resolution, wraps up the play and restores the world of the play to a new *status quo*. As a glib generalization, many of the world's dramatists tied up all the loose ends at the end of the play. However, some playwrights did not do so all the time—Shakespeare's *King Lear* never resolves what happened to the clown. The nineteenth-century playwright Henrik Ibsen used this same technique in *Ghosts* (1881), when it is unclear at the end of the play whether Oswald's mother, Mrs. Alving, will give Oswald the poison or not. Among more contemporary dramatists, particularly those from the middle of the twentieth century onward, there has been a tendency to deliberately leave things unresolved because either the problem had no resolution, as we might find in **theatre of the absurd**, or the resolution is left to the audience. At least two contemporary plays include scenes in which the audience determines the dénouement. In Rupert Holmes' (1947–) *The Mystery of Edwin Drood* (1985), based upon the unfinished novel by Charles Dickens (1812–1870), the audience votes on whom it thinks is the villain. Holmes wrote a variety of endings depending upon the audience's vote. It was the first Broadway musical to have multiple endings, for which the author received a Tony Award. In another script, Paul Pörtner's *Shear*

Madness (1980), a woman was murdered. The audience interrogates the characters at the end of the play about the crime, which means the characters must improvise answers for the audience's questions. Based upon the audience's questions and the characters' answers, the character of the Detective determines from an audience vote how the play ends and who is taken away in handcuffs. The show has proven to be very popular, playing for almost forty years so far.

CLIMACTIC AND EPISODIC DRAMA

Using these techniques for play structure, all of the Western world's playwrights seem to have only ever done two types of plays: episodic or climactic plays. In a climactic play, the plotting takes place at or near the end of the story, that is, at the "climax" of the story. On the other hand, episodic plays are plotted so that various segments of action are presented at intervals that have been selected from throughout the story. In a general kind of way, one may say that climactic plays have significant exposition; episodic plays have little or no exposition. For example, in *Oedipus Rex*, the play takes place in less than one full day, but the story extends all the way back to Oedipus's grandfather. Likewise, in *Death of a Salesman*, the play itself is also less than one day long, but it is the last day of a story that is at least seventeen years long, from when Biff was a high school student. See the chart comparing the major characteristics of Climatic and Episodic Drama on the following page.

EXISTENTIALISM

Existentialism was a philosophy that suggested that humans merely exist and need to provide their own personal moral framework for their lives and the world in which they live. Existentialism was predicated on the concept that there was no intrinsic moral order to the universe. This in turn was based in part on Friedrich Nietzsche's (1844–1900) pronouncement, "God is dead," by which he meant that a God was no longer needed to explain the workings of the universe. The major existentialist dramatist was **Jean-Paul Sartre** (1905–1980). In his play, *No Exit* (1944), three characters are ushered into an oddly decorated room. One is an adulterous socialite, the second a cowardly man, and the third a lesbian. Each wants a relationship with only one of the other two characters, making the third an obstacle to that relationship. Each had died recently and they eventually learn that they are actually in hell. Perhaps the most famous line in the play is "hell is other people."

Climactic Drama	Episodic Drama
1. The plot, the collection and arrangement of actions that are included in the play, is near the end of the story.	1. The plotting of the play consists of actions selected at intervals throughout the story.
2. Typically, there is a cause–effect relationship between the consecutive actions that are included in the play, which means that what happened in one action or scene is the triggering cause for the next action or scene.	2. Typically, there is a noncausal relationship between consecutive scenes. Shakespeare's plays are indicative of this wherein two consecutive scenes might not be part of the same subplot and have little to no connection with each other.
3. The plotting typically is a single thread or line, meaning there are few or no subplots.	3. Often, there are multiple plot threads. For example, in Shakespeare's *A Midsummer Night's Dream*, there are four separate subplots that Shakespeare tied together and resolved in the last scenes.
4. The time span of the play is relatively short. In plays such as *Oedipus Rex* and *Death of a Salesman*, the play is about a day long. However, this does not preclude a climactic play being a week or two long.	4. The time portrayed in the play, whether days, months, or years, is approximately equal to the length of the story.
5. Generally, plays are written with relatively few scenes per act, or perhaps each act consists of only one scene.	5. Scenes are of widely varying length. For example, Shakespeare may have a short scene of half a dozen lines followed by a very extended scene or perhaps even having two very short scenes next to each other.
6. The locale of the play is somewhat restrictive. Often playwrights set such plays in a single room or a single house, but just because a play is set in several locales in a town, province, or state does not disqualify it as climactic.	6. Locales typically are far ranging. In Christopher Marlowe's *Tamburlaine, the Great* (1587), various scenes take place in multiple countries covering much of the known Western world. Henrik Ibsen's *Peer Gynt* (1867) is a more contemporary example that ranges over Europe and North Africa.
7. There are relatively few characters in a climactic drama, many of whom tend to last for the duration of the play.	7. There are lots of characters, possibly with few or no characters repeating from one scene to the others. For example, in Arthur Schnitzler's *La Ronde* (1900), each character in the play appears only in two contiguous scenes, even though there are ten scenes in the play, each in a different locale.

There are a number of characteristics that help categorize a play as being climactic or episodic. No single element is deterministic—it is the combination of all the characteristics that matter.

ABSURDISM

Absurdism was a new structural form for drama that was first defined by **Martin Esslin** (1918–2002) in his book, *The Theatre of the Absurd* (1961). He had noticed that around the 1950s new plays were written that did not conform to the characteristics of either climactic or episodic drama. Absurdism had its roots in existentialism. The social and political conditions that existed in Europe, and particularly in France, following World War II gave rise to the characteristics of absurdist drama. Europe lay in ruins, having just witnessed the most destructive war in human history. The atomic bombs dropped on Hiroshima and Nagasaki made brutally clear to everyone that 100,000 human lives could be snuffed out in a millisecond. For Europeans, there was some small consolation that only the United States had the atomic bomb and then in 1952 it developed the hydrogen bomb. Everyone thought it would take the Soviet Union a decade or more to get its own atomic bomb and decades more to get the hydrogen bomb.

That fantasy evaporated into despair when the Soviet Union acquired the atomic bomb in 1949 and the hydrogen bomb soon after in 1955. Clearly, the world was poised for a nuclear holocaust in which US and Soviet missiles and bombers could achieve mutually assured annihilation—and Europe would be the battleground where it would happen. This engendered a sense of cynicism, hopelessness, and illogical madness that defied reason. The apparent futility of communication and the perception of no clear resolution were sustained by the reality of the cold war. All of this engendered a sense of, "Live for today for tomorrow we may be toast."

The constellation of characteristics that represented Absurdist drama were despair, cynicism, nonsequiturs, hopelessness, futility of communication, a cyclical nature, and no clear sense of resolution.

PLAYWRIGHTS

There were several playwrights who initially represented the new absurdist dramas: **Eugene Ionesco**, **Samuel Beckett**, and **Edward Albee**.

Eugene Ionesco (1912–1994) was a Romanian who lived in Paris. In his play, *The Bald Soprano* (1949), the cyclical and nonsensical elements show up in nonsequiturs in the play. Ionesco used an English-language phrasebook to generate some of the dialog for the play. There is one very extended scene in which two characters assert that they don't seem to remember each other, but at the same time there are so many coincidences that they conclude they must in fact know each other, but they don't remember where or how they met. Following their interaction, the maid comes forward and declares to the audience that while each of them had a child with one brown eye and one blue eye, in one case it was a brown left eye and a blue right eye and in the other case it was a blue left eye and a brown right eye, and consequently the characters did not know each other at

all. At the end of the play, a couple who had come to visit during the play replaces the initial couple and the play starts all over again with the same dialogue, thus exhibiting the cyclical nature of absurdist drama. In Ionesco's *The Chairs* (1952), two elderly characters spend the entire play arranging chairs for a very important speech that is supposed to be the salvation for humankind. When the speaker, the only other character in the play, arrives, he speaks gibberish, thus reinforcing the futility of communication.

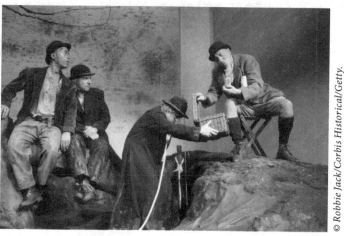

Figure 5.2 *This 1991 production of* Waiting for Godot *was done in London.*

© Robbie Jack/Corbis Historical/Getty.

Samuel Beckett (1906–1989) was an Irishman who moved to Paris where he wrote *Waiting for Godot* (1953; Figure 5.2). The first act of the play consists of Estragon and Vladimir, two tramps, who are killing time waiting for Godot to show up. During the act, two other characters, Lucky and Pozzo, one of them on a rope leash, arrive and leave. At the end of the act, a young man enters and tells the two tramps that Godot sent him with a message that he can't make it today, but surely tomorrow. Act two is essentially a repeat of the previous actions, except that when Lucky and Pozzo arrive they have swapped roles. Again, at the end of the act, a young man enters and again explains that Godot could not make it today, but surely tomorrow. We are to infer that each day will be the same, thus reinforcing the pointlessness of an endlessly repeating cycle.

Edward Albee (1928–) is an American playwright who started his career as an absurdist. His play, *The Zoo Story* (1958), was first produced in Berlin, Germany. Two men, one young and the other middle-aged, meet at a park bench in Central Park in New York City. The young man reveals his inability to have meaningful relationships, even with a dog. They establish a tentative fleeting relationship, after which the younger man provokes the older man into a defensive posture about the park bench. He gives the older man a knife with which to defend himself and then the younger man runs onto the knife, killing himself. The younger man's despair for a meaningful relationship has now been consummated because for the rest of the older man's life he will never be able to forget the younger man.

Thus, we have three major structures to drama, consisting of episodic, climactic, and absurdism. Since that time, we have entered the period of Postmodernism, which is essentially an eclectic mashing together of any of the previous dramatic structural forms.

Additional Reading

Esslin, Martin. *The Theatre of the Absurd.* 3rd ed. New York: Vintage, 2004.

Hatcher, Jeffery. *The Art and Craft of Playwriting.* Cincinnati, OH: Story Press, 1996.

Spencer, Stewart. *The Playwright's Guidebook: An Insightful Primer on the Art of Dramatic Writing.* New York: Macmillan, 2002.

GENRE

Genre is a French word meaning type or kind. In this chapter, we will discuss various types of plays that have been written over the centuries. All theatrical plays may be divided into either **representational** or **presentational** scripts. A representational script is closest to realism. For the student, the easiest way to identify the term is that the first two letters of both "representational" and "real" are "re." In a representational script, the attempt is to represent or recreate an action, whereas in presentational scripting, the action is merely presented. Other terms that are sometimes used as substitutions for presentational are nonrealistic, theatrical, or stylistic.

Dramatic scripts may also be divided by whether they are essentially serious or comic. We will start with the serious plays and then move on to comic scripts.

SERIOUS DRAMA

Serious dramas run the range from **tragedy** at one end to mild **tragicomedy** at the other.

TRAGEDY

Tragic plays always have an unfortunate ending that is calamitous for the protagonist and in many cases leads to the death of the protagonist. Characters in tragic plays are typically of high social standing such as gods, kings, or noblemen. The typical plotting of a tragedy is that the protagonist has a great fall. The circumstances that prompt the fall are sometimes due to external circumstances, but more frequently the protagonist has behavior or personality traits that are instrumental in precipitating the catastrophic situation. In Greek tragedy, this was referred to as *hamartia*, "Tragic flaw," or "fatal flaw." That is because the circumstances of a "good" character who comes to grief is filled with pathos and is often unacceptable to an audience. On the other hand, when a "bad" character comes to "grief," that is acceptable to the audience and is considered "justice." In tragedies, the audience often experiences significant emotional stress of pity and fear—pity for what is happening to the protagonist and fear that similar things might happen

to the observer. Typically, the protagonist, the character the play is about, undergoes a transformation that often includes an increase in empathy and humility. Tragedies are often written in heightened language and until the late seventeenth or eighteenth century they were typically written in verse.

HEROIC DRAMA

In heroic drama, the protagonist typically is no longer a king or a God, but is now a heroic character who may or may not be aristocracy or nobility. As was the case with tragedy, the protagonist is subject to great stress and misfortune and often suffers a great fall at the end. Even if the protagonist suffers a fateful end, often the overall tone of the script is hopeful. The language used in heroic drama, as is the case with tragedy, is typically heightened and/or in verse.

MELODRAMA

Melodrama is a dramatic form that originally developed in France during the late eighteenth and early nineteenth centuries, and was originally characterized by musical accompaniment, which evolved into underscoring for the production, much as we experience today in film and television. As audience interest in this form waned, producers incorporated ever more spectacular effects to lure the public into buying tickets for the productions. The result was a form with gratuitous spectacle and contrived crises regardless of plausibility. This in turn led to less sophisticated motivation until the actions became stereotypical and superficial. Classic examples of this were part and parcel of Saturday morning TV cartoons with the heroine tied to the railroad tracks or the hero tied to a log that was headed for the buzz saw. Today we see melodrama as the typical genre for many cop and detective shows on TV, where plot twists and turns seem more contrived than motivated and where a crisis always occurs before a commercial break or the end of the show. The genre is also frequently used in film, as may be seen in horror films, the Jurassic Park films, and many other adventure films.

BOURGEOIS DRAMA

Bourgeois is another French term that refers to middle class, which we may understand as domestic drama. Domestic drama deals with ordinary everyday people in relatively ordinary situations. Domestic drama has variously been broken down into living room drama, kitchen drama, and bedroom drama, to name but a few.

TRAGICOMEDY

A tragicomedy is a play that deals with the serious and distressing events that initially seem to suggest a cataclysmic ending. However, such plays typically have a happy ending or contain comic elements that seem to soften the generally serious nature of the play.

COMEDY

Comedies run the range from **slapstick**, which is physical, to **satire**, which is typically characterized by a witty skewering of social issues.

SATIRE

Satire is generally considered one of the higher forms of comedy because it typically depends upon a sophisticated and witty treatment of the subject. Its typical approach is to ridicule a situation by exaggerating the circumstances and displaying ironic consequences to the actions taken.

COMEDY OF MANNERS

Comedy of manners plays typically deal with particular social classes, typically the upper class, and the behavior of the individuals who are in that social class. Generally, a significant characteristic of this genre is holding the class up for simple humor or overt derision. A significant characteristic is to expose the social pretensions of the individuals and of the social class. There is a frequent use of witty phrases and barbed retorts. Frequently, but not invariably, the techniques of comedy of manners are combined with satire, particularly in the form of English Restoration period drama.

BURLESQUE

Originally, burlesque was a parody or spoof on some ludicrous development, and for the most part still holds that definition in England and on the European continent. However, in the United States burlesque has changed significantly. As mentioned many times in our study of theatre, when producers get anxious about whether enough tickets will be bought for the production they invariably try to add extraneous embellishments. Such was the case in the United States during the nineteenth century, when burlesques consisted of variety show revues playing on sexual innuendos. As additional embellishments were added, the shows became more sexually explicit. Eventually, this led to productions that contain little more than nude or seminude female bodies—now known as a striptease show.

DOMESTIC COMEDY

Just as domestic drama was about ordinary everyday people in serious situations, domestic comedy is about ordinary everyday people in comedic situations. For the most part, contemporary play scripts are domestic comedy because most plays today are about ordinary everyday people.

SITUATION COMEDY

A situation comedy is actually more likely to be a television series. In each new episode of the series, one or more of the characters get into some more or less silly situation. The humor is in observing how the characters react to the situation. The term is often shortened to "sitcom."

FARCE

A farce usually sets up some silly or preposterous premise and the characters react to that. The form depends upon exaggeration—exaggeration in character, exaggeration in acting, and exaggeration in plot manipulation. Typically, a farce deals with physical comedy of slamming doors, sexual affair escapades, mistaken identities, surprise encounters, and various scenarios of searching and hiding.

SLAPSTICK

Slapstick derived its name from an arrangement of two boards. Back in the seventeenth and eighteenth century when *commedia dell'arte* was popular, some characters used a special prop, a slapstick. It was two long, thin boards separated by a small gap so that when it hit another character it would create a loud slap without actually hurting the character being hit. This type of physical comedy is representative of the physical nature of slapstick. Devices used include slipping on a banana peel, getting the hand or finger stuck in something, scatological humor such as farts and burps, and various types of bodily contortions.

Key Names, Venues, and Terms

Bourgeois Drama (Domestic Drama)	Presentational
Burlesque	Representational
Comedy of Manners	Satire
Domestic Comedy	Situation Comedy (Sitcom)
Farce	Slapstick
Genre	Tragedy
Heroic Drama	Tragicomedy
Melodrama	

Additional Reading

Letwin, David, Joe Stockdale, and Robin Stockdale. *The Architecture of Drama: Plot, Character, Theme, Genre, and Style*. Lanham, MD: Scarecrow Press, 2008.

DEVELOPMENT OF THE DIRECTOR

The emergence of the director as a new separate unifying position in theatre production is a nineteenth-century development. Even though the specific position of the director did not exist in earlier times, the essential directorial functions still had to be done by somebody and were handled by other theatre artists. In the Greek period, the playwright was also the director and the leading actor. In Renaissance England and France, Shakespeare and Molière are known or presumed to have served as the directors for the plays they wrote, as well as being actors in their companies. If there was no playwright because the playwright was dead or otherwise not available, the directorial functions might be handled by a leading actor/manager. By the late eighteenth century and into the early nineteenth century, there were some managers who might not have significant acting experience, but who became the head of their theatre companies because of their management skills, consequently handling some of the directorial functions.

EARLY NINETEENTH-CENTURY BACKGROUND

Before we get too far into the development of the director, we need a general sense of what theatre production was like in the early nineteenth century. From an acting perspective, there was a much greater emphasis on stars. The public's desire to see stars on the stage led many actors to consider themselves the most important element in the production. In productions, actors had a tendency to move downstage to the front of the stage so that they could be more easily seen and heard by the audience. This typically was also the location of the prompter's hood. Though some actors

were more natural, or realistic, compared to other actors of the time, there was little concern for what we today refer to as realistic or psychological acting. Instead, it was normal for actors to use declamatory vocal variety and stereotypical gestures to define their character for the audience.

Today, we are accustomed to the notion that actors are selected for their suitability to the character. In that period, casting followed what were called "**lines**." Some typical lines were leading lady, soubrette, leading man, and utility player. If you were originally hired as a leading lady, then, by right, you always played a leading lady role in each new production, regardless of your appropriateness for the role. Thus, a 50-year-old actress might play the role of Juliet in Shakespeare's *Romeo and Juliet*, unless she realized a younger actress was more appropriate for the role and she surrendered the role to that more appropriate actress. Actors memorized their lines on their own, and for a few days before the show opened, the company would get together to rehearse the details of production. The word "rehearse" gives an inaccurate picture. Major actors might only "mark" their performances. They would start their line, note where they would move, and jump to the end of their line—thus there might never be a complete run-through rehearsal before opening night. As may easily be imagined, this led to a somewhat slapdash quality to the production and led to situations in which the actors might have to improvise their words because they had not sufficiently memorized their lines. This was part of the reason the prompter's hood was located downstage center—when the actor forgot the line, the prompter could easily and discretely prompt the actor and the actor could easily hear the prompt.

Most theatre companies presented productions on a repertory schedule. After the opening night performance, shows would only be presented at an interval that management thought would sustain ticket sales. Thus, performances of the same script might be separated by days, weeks, or even months. Once a show opened, an actor was expected to be performance-ready on only—three to five days' notice. There was no rehearsal for the next performance—actors were expected to do their own line rehearsal preparation. Again, actors could rely upon the prompter should they forget some lines.

Today, we are accustomed to the practice of directors collaborating with other theatre artists to develop a scenic setting and costumes that are appropriate to the production. It was not always so. The scenery used during much of the nineteenth century was "**wing and drop**" scenery, consisting of several flat painted wings on each side of the stage, behind which was placed a backdrop, hence "wing and drop." While flat wings were convenient for shifting scenery from one scene to another by simply raising them up out of the way or pulling them off to the sides of the stage, it did not create a particularly realistic environment as we think of the word "realism" today. Even though scene painters of that time were particularly good and could paint almost

anything quite well, the scenery still had a flat two-dimensional quality to it. Another scenic consideration was that when a company was initially organized, it bought a stock of scenery to fit the productions of its initial season. Only the most important companies, or those with significant financial resources, had scenery created for each new production in subsequent seasons. Most companies at that time reused the scenery from previous productions. For example, if a new production called for a park scene, the manager simply selected one from the theatre's existing stock that seemed best for the new production. A similar process was used for most other scenes in the play. If there were no appropriate setting in the theatre's stock, only then might a new setting be painted for that individual scene. The new production might easily have scenery that was a mixture of scenic styles from several previous shows. Sometimes, furniture and similar decorative elements were merely painted onto the canvas of the wings or the drops. Thus, there was a clear two-dimensional aspect to the production's scenery, and there was very little attempt to have a unifying style or to create a true three-dimensional effect.

In general, costumes were the responsibility of the individual actor. Because part of an actor's fame and income was related to the audience's perception of the actor's stage persona, most actors wanted to look as good on stage as possible. This meant the costume selected by the actor or actress generally was intended to make the actor look "attractive" and was not particularly realistic and generally not historically accurate. The theatrical result was often a collection of varying artistic interpretations for a production: scenery originally intended for other scripts, costumes with a look determined by each individual actor, and a declamatory style of acting with little coherence from one character to another character.

EARLY "DIRECTORS"

Though Georg II, Duke of Saxe Meiningen, is widely recognized for developing the modern position of the director, other theatre artists had been moving toward the new approach for production. One, whom we have discussed before, was the German theatre artist, **Johann Wolfgang von Goethe** (1749–1832). As a theatre director, Goethe had actors rehearse for six to ten days rather than the few days that were more typical. He also used a stick to beat time to get the actors to increase the tempo of their lines. In London, **Mme. Vestris** (née Lucia Elizabetta Bartolozzi) (1797–1856) managed the Olympic Theatre between 1832 and 1838 and then Covent Garden, one of the most important theatres in London, from 1839 until 1842. She is thought to have introduced box sets with ceilings into England in 1832, at a time when most other theatre companies were still using wing and drop sets. In addition, her productions were known for their extensive use of three-dimensional furnishings, such as draperies on the windows. The London productions of **Squire**

Bancroft (1841–1926) and his wife, **Mrs. Bancroft** (née Marie Wilton) (1839–1921), used detailed props of everyday life. By 1867, they made exclusive use of what is referred to as the **"fourth wall" convention**. That means productions were staged as if they were taking place in a real fully furnished room without a fourth wall, the one between the actors and the audience, so the audience could watch the production. Meanwhile, the actors performed as if the fourth wall of the room were still in place, ignoring the presence of the audience.

CONTRIBUTION OF THE DUKE OF SAXE-MEININGEN

The older approach was not appropriate to the new kinds of plays that were being written in the middle and the latter part of the nineteenth century. As has been discussed earlier, these new plays were much more realistic and their aesthetic was to seem to be real life on the stage. The newer scripts called for more realistic acting rather than the overly declamatory acting approach of previous generations. Combined, these called for a more ensemble approach to the production. Some of these approaches were used by the earlier "directors." However, the individual we credit with combining all of these new techniques into a new approach to theatre was **Georg I, Duke of Sake-Meiningen** (1826–1914).

The Duchy of Saxe-Meiningen, as was the case for most other European principalities, had a court theatre. When Georg II ascended the throne, he learned that the Duchy, unlike other principalities in Europe, was relatively poor and did not have enough money to spend on theatre. The Duke needed a more efficient way to manage the **Meiningen Players** and a new way to mount productions. Because Georg had been trained as an architect, he had the artistic training, background, and temperament to be able to contribute artistically to theatre productions. The Duke also admired the theatre productions of the English actor-manager Charles Kean (1811–1868). Kean's Shakespearean productions were more realistically and historically mounted than others of the time and contained more historically accurate scenery, though the production's effects were still focused to feature Kean as the production's star.

The Meiningen Players hired an actor, **Ludwig Chronegk** (1836–1891), upon whom the Duke relied for advice and whom he subsequently promoted to the position of company manager. In addition, the Duke's third wife, **Ellen Franz** (1839–1923), a professional actress, served as a dramaturg along with other responsibilities. Together the three changed the way theatre productions were done by the Meiningen Players.

In many of the principalities in Europe, stars were hired for the court theatres. Due to the Meiningen Players' financial problems, the Duke used a new approach. He imposed a number of practices that were different than what anyone had done before.

- Actors were no longer assigned roles based upon traditional acting lines. Instead, they were assigned roles based upon the actor's appropriateness for the character. An actor who played the lead in one production could find that he or she was playing a supporting role or even a minor role in the next production. Some actors objected to this new approach to production and were terminated if they refused to comply.

- Actors were required to perform as an ensemble, meaning that the actors' movements about the stage were designed for the aesthetic effect on the production, rather than simply bringing the speaking actor down to the footlights as had been the practice before.

- During the rehearsal process, actors were no longer permitted to simply "mark" their roles, or to simply walk through their parts. They were required to act full out all the time at each rehearsal.

- Actors, including those in crowd scenes, had individualized "business," or movements and gestures, prescribed for them.

- The Duke instituted a much longer rehearsal period. Rather than rehearsing for only ten days as had been done by Goethe, the Duke had his company rehearse for weeks or months—whatever was required—until the production was sufficiently prepared to present to the public.

- All scenery was custom-designed. Stock settings were no longer used as had been the case for most other theatre companies. Because of the Duke's training as an architect, he designed historically accurate scenery and he drew the sketches for the scenery.

- The Duke typically included characters in his sketches that gave a sense of the intended composition and arrangement of the actors for a particular moment in the play.

- The same sense of historical accuracy was also applied to costumes, which were now carefully designed by the Duke and were no longer chosen by the individual actor.

INFLUENCE OF THE MEININGEN PLAYERS

Had the Meiningen Players stayed in their own locale it's possible that few people would have been aware of the Duke's accomplishments. However, the Meiningen Players toured thirty-eight major European cities between 1874 and 1890, and the new approach to theatre production was seen and appreciated by other audiences and consequently influenced other theatre artists across Europe. They included **André Antoine** in France, **Otto Brahm** in Germany, **Constantin Stanislavsky** in Russia, and **J. T. Grein** in England.

FRANCE

In France, the Meiningen Players influenced **André Antoine** (1858–1943). Antoine was a clerk for the Paris gas company during the day and an amateur actor who had seen the Meiningen Players performing in Brussels. Antoine was particularly interested in the works of Émile Zola (1840–1902), a French naturalist playwright, and he subsequently started the **Théâtre Libre** in 1887 in order to produce those scripts. Antoine used true "fourth wall" conventions, which included having the actors and/or the furniture facing upstage, or away from the audience, on occasion. He was also known for using naturalistic props in productions. For example, if the script called for a side of beef, the centuries-old approach had been to make a papier-mâché prop for the production. However, Antoine was reputed to use a real side of beef. In one production, *La Terre* (1901), a live chicken scratched around in the litter. Eventually in 1906 Antoine was named director of the Odéon theatre, where he stayed until 1914. The significance of this last appointment was that it was one of the more important theatres in France at that time and through that theatre Antoine influenced other developing theatre artists in France during the early part of the twentieth century.

GERMANY

In Germany, the Meiningen Players' legacy is seen in the work of Otto Brahm (1856–1912) and the **Freie Bühne**. Otto Brahm was a drama critic who was made head of the Berlin Theatre Committee and consequently was called upon by the committee to create a German theatre company called *Die Freie Bühne*, which opened in 1889. Its translation, "The Free Stage," is a clear reference to André Antoine's Théâtre Libre, which also meant "Free Theatre." The theatre's goal was to reflect the ideas of the Meiningen Players. Unlike Théâtre Libre, which used amateur actors, Freie Bühne used professional theatre artists. Because of that, performances were held in the afternoon since the actors had other acting jobs at night in the traditional theatres. Eventually a journal, also called *Die Freie Bühne*, was published. In 1894, Freie Bühne merged with the **Deutsches Theatre**, and Otto Brahm became the director of the new theatre company. The Deutsches Theatre was, and remained, one of the most important theatres in Germany during the first half of the twentieth century. In his capacity as director, Brahm influenced many other German theatre directors, including Max Reinhardt (1873–1943), one of the most influential German directors of the twentieth century.

ENGLAND

In England, the Meiningen Players' legacy is represented in the work of the **Independent Theatre**, founded in 1891 and headed by J[acob] T[homas] Grein (1862–1935). The Independent Theatre was similar to the Freie Bühne in that it used professional

actors. However, unlike the Freie Bühne, which hired actors and rehearsed its own productions, the Independent Theatre subcontracted its productions. An outside producer was hired to select the cast and rehearse the company and then present the productions as an Independent Theatre production. The productions mounted by the Independent Theatre created much controversy in England because the social issues the plays addressed were contrary to the traditional social norms of the time. By the time the company closed in 1897, it had mounted twenty-six plays, including such realistic and naturalistic plays as Henrik Ibsen's *Ghosts* and Émile Zola's *Therese Raquin*.

RUSSIA

The Meiningen Players performed in Moscow in 1885 and 1890 when **Constantin Sergeyevich Stanislavsky** (1863–1938) saw them and was given the opportunity to rehearse with the Meiningen Players. Years earlier he had also seen productions at Théâtre Libre while he was in Paris studying at the Comédie-Française. What he experienced with the Meiningen Players prompted him and his friend **Vladimir Nemirovich—Danchenko** to spend an entire evening in the late 1890s at a bistro talking about their ideas for a new way of mounting theatre productions and a new type of theatre company. This led to their founding of the **Moscow Art Theatre** in 1898. For the final production of their first season, Danchenko suggested to Stanislavsky that they do a production of **Anton Pavlovich Chekhov's** play, *The Seagull*, a script that Stanislavsky was not particularly interested in mounting. The script had received an earlier mounting in St. Petersburg, where, due to insufficient rehearsal time, poor understanding of the script, and the new realistic theatre writing style of Chekhov, the production had been a failure. Chekhov was so disappointed by that production that he left the theatre, vowing never to write for the theatre again. However, when *The Seagull* was mounted at the Moscow Art Theatre under Stanislavsky's direction, the production was a hit. It was so successful that the income from its performances helped to cover much of the debt of the first season. The company's survival, due to a generous contribution, allowed the Moscow Art Theatre to construct a new facility a few years later. In addition, the logo that was created for the production of *The Seagull* became the logo for the Moscow Art Theatre.

There were several important consequences of the Moscow Art Theatre's first year. Chekhov decided to write more plays and, consequently, he became one of the most important Russian playwrights of the century. Stanislavsky was motivated to develop an approach to acting training that dealt with the new type of realistic scripts. That acting training, with its subsequent augmentations, is still the foundation for acting training in most of the Western world. Beyond that, the Moscow Art Theatre became one of the most important theatres in Russia and served as an incubator for

other theatre practitioners and theatre companies in Russia. The new and improved theatre production techniques that had started with the Meiningen Players were promulgated throughout Russia, through most of Europe, and eventually the Americas.

UNITED STATES

In the United States, the situation was quite different. The Meiningen Players never toured the United States, though it is conceivable that some American directors may have seen the Meiningen Players in performances when the directors made their trips to Europe. However, it is certain that some directors saw productions that demonstrated the influence of the Meiningen Players' approach. During the late nineteenth and early twentieth centuries, it was common practice for major American directors to make a summer trip to Europe in order to see what productions were being done there and to acquire new scripts that could be picked up, brought back to United States, and adapted for presentations here.

One such director was **David Belasco** (1859–1931), who was particularly known for the details in his productions and for their realistic and/or naturalistic look. Like André Antoine, Belasco was known for using realistic props. Belasco used real blood for props rather than fake stage blood. Belasco was notorious for the details in his productions. In his production of *Madame Butterfly* (1900), when Butterfly is waiting for Lieut. Pinkerton to come to visit her, there was a fourteen-minute lighting fade, without dialogue, as the sun set, the moon and stars came out, and the sun came up again the next morning.

Belasco had a reputation as a "**star maker**," meaning he had a talent for selecting relatively unknown actors and actresses who then achieved spectacular acting results on the stage under his tutelage. Some eventually decided they no longer needed Belasco's guidance and attempted to start an independent career path. In many cases, they never again achieved their former success.

IMPACT OF THE DUKE OF SAXE-MEININGEN

Thus, we can see that the innovation of a unifying directorial approach to productions, initiated by the Duke of Saxe-Meiningen, was promulgated throughout Europe and, eventually, the Americas to become the standard of theatrical production with which we are familiar today.

Key Names, Venues, and Terms

Acting "lines"
André Antoine
Squire and Mrs. Bancroft
David Belasco
Otto Brahm
Anton Pavlovich Chekhov
Ludwig Chronegk
Deutsches Theatre
"Fourth wall" convention
Ellen Franz
Freie Bühne
J. T. Grein
Johann Wolfgang von Goethe

Independent Theatre
Madame Butterfly
Meiningen Players
Vladimir Nemirovich-Danchenko
Moscow Art Theatre
Odéon Theatre
Georg II, Duke of Saxe-Meiningen
The Seagull
Constantin Sergeyevich Stanislavsky
"Star maker"
Théâtre Libre
Mme. Vestris
Wing and drop

Additional Reading

Carlson, Marvin. *The French Stage in the 19th Century*. Metuchen, NJ: Scarecrow, 1972.

Koller, Ann Marie. *The Theatre Duke: Georg II of Saxe-Meiningen and the German Stage*. Palo Alto, CA: Stanford University Press, 1984.

Miller, Anna Irene. *The Independent Theatre in Europe: 1887 to the Present*. New York: Long and Smith, 1931.

Worrall, Nick. *The Moscow Art Theatre*. London: Routledge, 1996.

DIRECTING

As we learned in Chapter VII, the position of the director did not exist before the nineteenth century. The functions we now ascribe to the director were originally handled by the playwright. If the playwright was not available, a leading actor often functioned as the surrogate director. By the late eighteenth century, the function of the director might be handled by an actor-manager. As discussed in Chapter VII, the changes in playwriting and in production practices that started taking place around the middle of the nineteenth century resulted in a new theatrical position called the director. In this chapter, we will deal with the functions and responsibilities of the director, desirable qualities for the director, and the types of directors.

FUNCTIONS AND RESPONSIBILITIES OF THE DIRECTOR

The six major functions of the director are selecting the script; analyzing and interpreting the actions and characters of the script; casting the actors; collaborating with the other artists, particularly the designers; rehearsing the actors, and coordinating the work of all the other artists to create a unified production.

SELECTING THE SCRIPT

In the commercial theatre, it is the producer's responsibility to obtain a script to be mounted, often before a director has been selected. In such cases, it becomes the director's task to "buy into" the selected script, and accept the selection as his or her own. In other professional theatres, typically the theatre company's artistic director and staff select a season for the theatre company, either of specific scripts to be produced or of particular genres or particular playwrights. The artistic director then often contacts prospective professional directors who might have the opportunity to influence final script selection.

In the academic theatre—and to some extent in the community theatre—the director more often is the one who initiates selection of the script. In the academic theatre, the training of students is the primary goal in script selection, so the director may propose scripts from a range of time periods, genres, production styles, acting challenges, and so on, that will broaden the students' training. Final script selection is done in collaboration with other members of the artistic production team, subject to considerations such as technical difficulties, cost for production, the availability of acting talent, physical resources, and the availability of production rights. (The availability of the rights to mount a previously produced script is always subject to nearby professional productions of the same script.)

Whether the script selection is by the producer, the artistic director, or the director, topics of consideration are relatively the same. One consideration is the purpose for doing the production. In the commercial theatre, the intent is to make money; hence the script selection is based upon the need for maximizing income. In other professional theatres, income potential is never far from the center of the consideration process, but that selection process may include considerations such as the cultural enrichment of the theatre company's audience. If the theatre company has a specific goal (e.g., only doing Asian-American topic plays), then that clearly has a significant impact on the selection process. In the academic theatre, even though the central consideration is invariably the education of the participants and the audience, box office income is still an important consideration.

Another consideration is catering to audience's wants and needs. In order for the public to be motivated to buy tickets, the audience must be provided with what it wants—or can be made to believe it wants. As a glib generalization, this often means providing entertainment. Depending upon the audience's sophistication, a well-acted and well-mounted Shakespearean production can be as entertaining as a lighthearted musical romp. In the selection process, the traditional audience demographics, as discussed in Chapter II on the Audience, must be borne in mind.

The availability of resources is another consideration. In addition to money, resources include technical facilities such as shops, level of staff skills, available acting pool, and facilities. The cost and scale of the physical production is directly related to the size of the theatre stage. The larger the stage the more scenery will be needed and the more money that will be needed. In addition, the skills of the production crews and the production shops are important considerations. In the academic theatre, the available acting pool typically is confined to student actors. In professional theatre companies, the choice always revolves around the balance between salary and acting skill. In a small regional theatre, the average weekly actor salary ranges between $600 and about $1,000. If one script has a cast of ten and another has a cast of twenty, generally the smaller cast show will be selected.

ANALYZING THE SCRIPT AND SELECTING AN INTERPRETATION

The director must analyze the script in order to arrive at the directorial concept for the production. The first step is to analyze the script for its meaning. Often this involves research on the playwright and his or her other scripts, since playwrights typically develop similar themes and approaches through multiple different scripts. The director then analyzes the script for structure and characters. The director needs to understand the characters' motivations and relationships with other characters in the play. In order to do this, the director needs to do a psychological, physiological, and sociological analysis of each character in the script. In terms of the psychological aspects, in transactional analysis, there are three states: adult, parent, and child. It is helpful for the director to understand which state is manifested at any given moment and to understand what the motivations are for that state, thus making for complex psychoanalysis of characters and their motivation. Physiological analysis involves considerations of necessary movement patterns, business, and sometimes physical appearance. The sociological considerations for character analysis relate to things such as socioeconomic class, religion, profession, family structure, education, sexual orientation, and politics.

All good plays have several themes rather than a single theme. The director must determine which theme or which aspect of the theme is to be accentuated in the specific production—selecting an interpretation. The title character in Shakespeare's *Macbeth*, for example, may be seen as simply manipulated by the Three Fates and having no personal role in what happens to him. In such a production, the scenic design might show the character of Macbeth as a small pawn in a larger world he does not control. A contrasting thematic interpretation in a different production might be that Macbeth is self-directed and through his own drive and desire he assassinates Duncan to become king. Here, the designer might have a scenic design that depicts Macbeth as clearly being able to dominate his environment. Alternately, Macbeth may be seen as a reticent man, insufficiently motivated to seek the throne of Scotland on his own, without the drive of his overly ambitious wife. The scenic expression of this might be a softer, more feminine environment in the castle settings, reflecting Lady Macbeth's dominance. The significant point of this discussion is that any of the three appropriate interpretations may be amply supported by the script. Ultimately, the director must make a decision on the matter to arrive at the interpretation to be incorporated into the current production.

The other members of the artistic team must also analyze the script for production needs: the number, type, and quality of production elements. For example, in an arena theatre production, all other things being equal, the costumes and props must be executed in greater detail because the audience is relatively close to them.

On a proscenium stage, by contrast, those same elements may be less expensively executed because the closest audience member is often a dozen or more feet away. Scenery is determined by the needs of the script—a unit set, a simultaneous set, or three different sets to be moved on and off stage, and so on—and whether the particular venue might handle them. In terms of costumes, are the characters to remain in one costume throughout the play or are there to be two or three costumes for each character? Similar kinds of considerations apply to lighting, sound, and special effects.

CASTING THE ACTORS

The most important consideration in casting a show in the professional theatre is finding the needed talent at a price the company can afford. The casting process is a quest to determine if the actor is potentially able to realize the character the director has envisioned while also "fitting" into the look and feel of the rest of the cast. Directors tend to select actors whose work they already know and actors who already have experience in the type of show being cast. (An exception is the academic theatre, where actors are acquiring new skills and experiences as part of their education.) For the most part, actor salary is not a concern of the director. Salary is the pervue of the company's Business Manager and/or Artistic Director. If the director works for a theatre company where the average salary for an actor is $800 per week, there may be significant problems if the actor insists on $1,500 per week. If the extra salary cannot be accommodated in the budget by reducing other line items, the director will need to find another actor.

Traditional techniques employed in the auditioning process include interviews, monologues, cold readings, and improvisations, among others. Major established professional actors typically do not go through an audition, but rather, interview with major artistic personnel such as the playwright, producer, and director in order to confirm the actor's interest in the production and an agreement on a unified artistic viewpoint.

The traditional auditioning process usually follows auditioning guidelines laid down by **Actors Equity Association (AEA)**, sometimes derogatorily referred to as "cattle calls." Each actor is allocated approximately a two-minute time slot in which to demonstrate his or her talent and appropriateness for the role and the production. Sometimes, to evaluate the actor's flexibility, the director may ask the actor to redo the audition with a different motivation. Actors who are unable to do so are too inflexible and typically will not be cast.

In order to evaluate an actor's versatility and creativity, the director might use cold readings and/or improvisations. "Cold reading" means doing scenes the actor presumably has never seen before. In an improvisation, the director gives the actor a

setup and asks the actor to invent the words, movements, and emotions on the spot. The difficulty of these two techniques is that they are relatively time intensive and thus typically are not employed in the initial audition process.

COLLABORATING WITH OTHER ARTISTS

The other major collaborating artists in a theatrical production are the designers of scenery, costumes, lights, and sound. In some circumstances, the artistic team may also include a choreographer, choral director, publicity director, and so on. Through a number of meetings, the team needs to develop a shared concept for how the production will be mounted in view of the director's original concept. In the best of all possible worlds, true collaboration takes place between the director and the designers, with a robust give-and-take involving all members of the team. In the professional and commercial theatre, the members of the artistic team are experienced professionals who are experts in their specific areas of endeavor, capable of executing their jobs without direct daily supervision from the director after the production's concept has been agreed upon.

An illustration of the collaborative process among the members of the artistic team might involve a production of Shakespeare's *The Taming of the Shrew*. The director might mention that he wants to set the play in a different time period in order to make the script more accessible or to give it a new perspective. The scenic designer suggests setting the play on a southwest American hacienda in the early nineteenth century. The costume designer chimes in that the costumes could be done using traditional attire complete with sombreros. The lighting designer suggests that the lighting could have scenes of intense sunlight alternating with scenes of cool romantic evening lighting. In this interpretation, the social construct of the original Italian location and the southwest American location are similar, but might provide a more accessible perspective for an American audience. After additional discussion and refinement, the new time period interpretation is accepted by all. After having agreed upon a production concept, the designers focus on the details of their area while the director rehearses the actors.

REHEARSING THE ACTORS

There are three general divisions to the rehearsal process: script study, **blocking**, and **run-throughs**. In script study, or "**table work**," the director and the cast read through the script and discuss issues such as concept, characterization, theme, and interpretation. Following this, the director begins to stage, or "block," the show. Blocking refers to the major movement patterns of the characters about the set. Some directors meticulously preblock the entire show and relay that blocking pattern to the cast. Other directors, particularly when working with professional actors, and/or smaller casts, may rely more upon the actors' instincts for appropriate movement and give feedback to shape the movement of the play on the whole. The director breaks

the show down into more manageable units such as acts and scenes in order to focus on the individual actions of the rehearsal process. As the smaller units develop their intended dramatic structure, they are combined into ever larger units for rehearsal with run-throughs. Eventually, individual acts or the entire production are rehearsed by run-throughs.

COORDINATING THE PRODUCTION ELEMENTS

In most professional theatres, and in many academic theatres, rehearsals take place in a rehearsal hall rather than on stage. This allows the scenery, lights, and props to be installed on the stage and rigged for production. At some point, the production elements, which have been prepared in disparate locations, must be efficiently brought together in the theatre. The **technical rehearsals** integrate the physical production with the actors. Typically, the lighting focus, cues, and timing have been prepared before the actors' arrival at the technical rehearsal. During the rehearsals with the actors adjustments are made and rehearsed until those involved are satisfied with the result. The next phase is the integration of costumes in the **dress rehearsal**. Though each actor's costume was previously seen and adjusted for fit, the dress rehearsal is the first time complete costumes are viewed in relation to other characters' costumes under stage lighting conditions. Again, minor adjustments in cues and business may be necessary once costumes are added to the production. Following one or two dress rehearsals, the production may move directly to opening night, or in the commercial theatre, may go through a number of previews or a preopening tour before the official opening night.

QUALITIES FOR DIRECTORS

One might almost say there is an endless list of desirable qualities for a professional director, but despite that it is useful to address a number of them.

- Observation: Observation is possibly the most important skill a director can have. An essential function of the director–actor relationship is for the director to assist in the creation of believable characters. In order to do this, the director needs an extensive repertoire of observations from which to draw and to possibly suggest changes to the actor.
- Curiosity for Human Condition/Activities: Considering that one essential function of theatre is to explore human relationships, the director must understand the psychology and sociology of human activities in different cultures and different time periods. For example, to successfully stage a production of the medieval play *Everyman* (c. 1500), the director and cast must understand the centrality of religion in everyday life in the time period.

- Intelligence/Education: At its simplest, the director needs an education in the process and effect of directing. This may be formal training such as through a Master of Fine Arts (MFA) theatre training program, but skills may also be picked up by experienced actors over years of observing good directors in action. Directors also need a broad knowledge base, intellectual curiosity about all forms of human activities, and an awareness of the full range of human endeavors in many fields.

- Empathy/Psychology: In a theatrical production, one typically wants the audience to have some degree of empathetic feeling for, and understanding of, the characters and their situations on stage. Even if the production is a Bertolt Brecht play, for which the playwright wished to eliminate the audience's unthinking empathetic feelings for the characters, the director needs an understanding of how empathy works. Associated with this is an understanding of the psychology of behavior: why people do what they do.

- Leadership: The director is expected to provide essential leadership for the artistic team, from initial meetings with designers through final rehearsals with actors.

- Organization: The detailed minutia of preparing a theatrical production requires strong skills in organization and time management. The scheduling of rehearsals (though sometimes left to the **stage manager**) is essential in order to be sure that each actor and scene is efficiently developed without actors sitting around waiting for their scene.

- Training/Skills: In the professional theatre, specialized skills on productions are simply hired as needed. These might be positions such as a Dialect Coach or a Fight Director. In the academic theatre, where the director is often also a faculty member, having specialized training and skills to teach student actors is almost essential.

- Patience: The high stress environment of preparing a production in the professional theatre often leads to frayed nerves on the part of many involved. Few people do their best work when operating under high stress. If the director is able to patiently encourage his fellow artists to do their best work everyone gains.

- Research Skills: While most professional artists in the theatre carry in memory vast amounts of knowledge about theatre and other human endeavors, nobody carries in memory all the information that will be needed for a single production, let alone a career. Each production presents its own array of potential research questions: What in the playwright's life impacts this play's theme?; What social conditions of the original script are comparable to today's society?; In what way do the different aristocratic classes of the seventeenth century delineate the status of the characters in this play?; How were hand weapons worn and used in eighteenth-century Spain?; and so on. The director needs to know how to find answers to such questions.

DIRECTOR TYPES

There are three types of directors: **interpretive**, *auteur*, and *laissez-faire*. The interpretive director is one who sees the essential directorial purpose of the production as interpreting the script as the playwright would have done if the playwright were directing the production under the given circumstances. This is the approach generally preferred by professional directors today and is taught in most graduate theatre programs in this country. *Auteur* is a French word meaning "author." An *auteur* director is one who sees the script as merely input to his or her own artistic expression, and may cut, rearrange, or perhaps even write new scenes to fit the director's artistic vision. This may be more likely with plays written by playwrights who have died. As a number of recent court cases have shown, living playwrights do not take kindly to productions that change their scripts, including changes in the setting of the plays. *Laissez-faire* is another French word meaning "hands off" or "leave it alone." In this approach the director tries not to intrude too much into the "natural" development of a script in the hands of professional actors—it is likely to be a disaster as a technique for dealing with untrained amateurs.

STAGE MANAGER

Reflecting the responsibilities expected of stage managers, AEA has determined that stage managers should receive the highest minimum-weekly-salary of all the "non-artistic" staff members working regularly on a theatrical production. In many ways, the stage manager may be perceived as a surrogate director, that is, as a substitute for the director when the director cannot be present for rehearsals or performances. The director is not expected to be at performances; hence, the stage manager's most important job is to run performances and preserve the director's work in each performance.

FUNCTIONS

The stage manager's most important function is to run performances and present the show as the director prepared it. In order to do that, the stage manager needs an accurate record of the production's preparation. Thus, during the preparation process, the stage manager meticulously records the results of the rehearsal process. That recording is typically done in a copy of the script, referred to as the "**prompt book**." When the prompt book is completed at the end of the rehearsal process, it contains a recording of all movement patterns, that is, blocking; any notations about goals, subtext, objectives, beats, and so on, that will put the line or action into context; and notations of the location, duration, and effect of all the technical processes involved in the production such as light cues, sound cues, scene shifts, and even cues for the

actors' entrances. During the rehearsal process, the prompt book is the reference for checking line readings, blocking, and cue placement. After the show opens, the prompt book becomes the "script" for calling the show and each of its cues for lights, sound, and so on. The prompt book needs to be complete enough and clear enough so that a different stage manager may successfully call the show during performances if the original stage manager is unavailable for some reason. In some situations, the prompt book notes go to the playwright so that he or she may incorporate them into the script that is printed for distribution by companies such as Dramatists Play Service or Samuel French.

The stage manager also assists the director as needed for the production. These include things such as running lines with actors if the actors have difficulty memorizing lines, keeping track of the rehearsal schedule, being sure that the actors needed for a particular scene are available when needed by the director, and scheduling and accommodating costume fittings for the actors. In some professional situations, the director might give small scenes to a trusted stage manager to stage and/or block.

Probably the next most important function the stage manager has in the rehearsal process is to coordinate the integration of production elements. While aesthetic unity of design choices with acting and directing is the director's responsibility, typically the stage manager deals with the technical details of integrating those elements smoothly into the production. As noted elsewhere, this integration process takes place during the technical and dress rehearsals.

After the show has opened, the essential function of the stage manager is to call the show. In the professional theatre, the director has completed his or her assignment on opening night and typically leaves the production. From that point on, it is the stage manager who starts each performance and calls each of the various cues in the production. In the commercial theatre, and some larger professional theatres, the stage manager is responsible for maintaining the director's interpretive choices and also "directs" replacement actors in their performances. In the commercial theatre, only in unusual situations, is the show's original director brought back to direct cast replacements—perhaps for the leading roles.

QUALIFICATIONS

Aside from creative/artistic functions, the qualifications for stage managers are similar to those for directors, though in different proportions. For the stage manager, the most important skill is probably attention to detail.

- Attention to Detail: Because the stage manager is the one who is expected, by job description, to arrange for the integration of all the technical elements during the technical and dress rehearsals, attention to the details of theatre production is essential. A typical ten- to fifteen-second transition from one

scene in a musical to the next scene will illustrate this: "Lights out, Follow spots out, Fly drop out, Strike table and chairs, Porch unit on, Fly drop in, Lawn chair on, Orchestra go, Actors go, Lights go, Follow spot A go, Follow spot B go." Moreover, in many productions the different elements have time durations, in the middle of which another cue is started.

- Organization: The stage manager is expected to be even more organized than the stage director, if that is possible. Even before the rehearsal process begins, the stage manager must do a production analysis of the scripts. It is an indication of possible needs for every other production department in the show, to make sure nothing is overlooked in preliminary discussions. The AEA rules for rehearsal and performance times and procedures, depending upon the individual contract, can run in the neighborhood of a hundred pages. The stage manager, as the director's surrogate, is required to ensure observance of all the applicable rules. The rehearsal process for a Broadway musical might typically include three or four different rehearsal studios. It is clear that scheduling actors efficiently between the separate rehearsal studios for acting, singing, and dancing requires superior organizational skills.

- Training/Skill: As is the case with other professional theatre specializations, extensive training and skill is essential. If a stage manager comes out of an academic theatre program a certain degree of expertise is expected. Despite that, AEA rules require that a stage manager must serve as an assistant stage manager for a minimum number of years and a minimum number of productions in order to be advanced to the position of stage manager.

- Leadership: During the rehearsal process, the stage manager must manage the staff of assistant stage managers and crew members who might be involved in the rehearsal process. Starting with the technical rehearsals or perhaps a little earlier, the stage manager officially is responsible for the technical crew members working on the last phase of production preparation. Once the show opens, the stage manager is the single authority on stage for the actors and all of the crew members. Accordingly, the stage manager needs to be skilled in managing people and resources.

- Calmness: Despite the chaos that may or may not be taking place on stage at any given moment, the stage manager must remain in control and calmly deal with whatever unexpected situation may arise.

- Efficiency: In many ways, this applies specifically to the scheduling of rehearsals among the various rehearsal studios during the preparation process and particularly to being efficient during the technical rehearsal and dress rehearsal phase. During technical rehearsals, the stress is very high and those who are present sometimes get impatient at the multiple repeats of scenes and cues and the constant waiting.

- Patience: Just as was the case for the director, the stage manager must have seemingly endless patience, particularly when dealing with actors who typically are under stress about prospects of presenting a new production to another audience.
- Research Skills: In essence, the research skills the stage manager needs are not at all different from those skills that other members of the production's artistic team must be able to call upon.

Key Names, Venues, and Terms

Auteur Director
Actors Equity Association (AEA)
Blocking
Dress Rehearsal
Interpretive Director
Laissez-Faire Director

Prompt Book
Run-Through
Stage Manager
Table Work
Technical Rehearsal

Additional Reading

Cole, Toby and Helen K. Chinoy. *Directors on Directing*. New York: Bobbs Merrill, 1980.

Dean, Alexander and Lawrence Carra. *Fundamentals of Play Directing*. 5th ed. New York: Holt, Rinehart and Winston, 1989.

Kelly, Thomas A. *The Back Stage Guide to Stage Management*. 3rd ed. New York: Back Stage Books, 2009.

ACTING

In addition to being the central activity of theatre, acting is also something that all humans do. We all play roles in our everyday lives, though most of us don't think of what we do as acting.

ROLE-PLAYING

The roles one plays in everyday life may consist of father, mother, son, student, grand-child, and so on. We are also well aware that young children are quite proficient at acting. Anyone who has observed young children playing may have had to be careful not to sit or step on a child's invisible friend. At the same time children are acting and pretending to be another character, they are also well aware they are only pretending, and when asked, readily distinguish between real life and play.

The **role-playing** in everyday life is significantly different from the profession of act-ing. Unless we are dealing with psychologically aberrant behavior, the roles we play in life are merely different facets of our individual life. We learn early in life that there are implied limitations to what may and may not be appropriate in different situations. The vulgarities of language used regularly with a dorm-mate are widely understood to be unacceptable at home with our parents. The nuances of both the language and the behavior that we use with relatives we generally do not use with strangers. Thus, we have compartmentalized our lives, and only show specific facets of the self to their appropriate audiences. On the other hand, professional acting consists of creating characters that are different from the self—even though elements of the self may be consciously or subconsciously incorporated into the creation of the fictional character.

CHARACTER TYPES

Theatre people make distinctions between different types of characters: **archetypal**, **stereotypical**, and **three-dimensional**.

- The archetypal character involves a universal characteristic that is often considered "truthful" about such characters.

- The stereotypic character is generally perceived as being relatively two-dimensional and lacking significant distinguishing characteristics.

- Three-dimensional characters are based upon the concept that the character has unique and distinguishing characteristics evocative of real human beings in real recognized situations—we think of them as three-dimensional or "fully rounded."

INTERNAL/EXTERNAL ACTING

Theatre professionals also distinguish between internal and external acting. **External acting** refers to a set of behaviors and techniques that are sort of layered on top of a character. This was typically the acting technique through the sixteenth, seventeenth, and eighteenth centuries. During that time, much of the acting had an elocutionary quality to it, and actors often made grandiloquent gestures. Despite the fact that external acting was not in favor during most of the twentieth century, there were some actors, such as Lawrence Olivier (1907–1989), who were extraordinarily proficient at the external approach. When external acting is done by consummate professionals such as Laurence Olivier, it is typically indistinguishable from the work of consummate internal acting, even by theatre professionals. In **internal acting**, the actors put themselves in a state of imagining how the character would behave in a given situation and then behaved in that manner. In this way the actor is generating the behavior from inside, almost like an improvisation.

Today we are relatively accustomed to the notion that acting training is one of the courses of study in a university. However, before the twentieth century, such schools and training programs did not exist. To become an actor, one joined a theatre company as an apprentice. Over a period of time, one took on increasingly more complex and more responsible positions in the theatre company. There might be some individual instruction provided on a one-on-one basis. For the most part, however, the aspiring actor learned acting by observing the professionals in the company and by taking on increasingly more difficult acting assignments. Acting during the nineteenth century and earlier was organized into "lines" such as leading lady, leading man, soubrette, or utility player. Generally, the actor was hired by a theatre company in a particular line and would only play characters in that line. There were ways to change your "line" but that is beyond the scope of this book.

There is a special relationship between the actor—including most other performing arts professionals—and his "**instrument**" that is not relevant for other fine artists. The actor uses his body and voice to depict the character in the script. There are techniques for modifying the actor's physical and vocal characteristics, but for the most

part the actor must learn how to modify the voice and the body's movements in order to appropriately depict the character. In Tennessee William's play, *Cat on a Hot Tin Roof* (1955), for example, the female lead is addressed as "Maggie, the cat." Clearly, to appropriately play this role as envisioned by the playwright, the actress must modify her movement patterns to be catlike to emulate those associated with cat behavior. Presumably she would modify her vocal characteristics so she'd almost seem to purr at times.

DELSARTE SYSTEM

The external acting technique used by a significant number of nineteenth-century actors was the Delsarte acting system. François Delsarte (1811–1871) was an actor who codified the predominant acting system of the time, even though he did not invent it. The acting technique illustrated in Delsarte handbooks was stereotypic, typically both in its approach and its aesthetics. Even though this approach may seem preposterous to us today, the system broke down every emotional context into a specific bodily position. Holding your arm straight out in front of you elicited a specific emotional quality. If the arm was straight and at a 30-degree elevation, a 45-degree elevation, a 60-degree elevation, or straight overhead, then each angle had a different emotional expression. All an actor needed to do was work through the script and determine the character's emotional state for each moment in the play. Then in a kind of acting-by-the-numbers routine, the actor selected the various body positions that corresponded to each emotional state and simply assumed that posture at that moment in the script. Examples of this approach may readily be seen in some early silent films.

The development of new Modern Drama plays made clear how inadequate the Delsarte acting system was. At the same time, there were actors, in this and earlier time periods, who were much more realistic, much more internal, and were seen as having better acting skills. The realistic and naturalistic scripts being produced by the newer playwrights called for more three-dimensional and realistic depiction of characters and action. That transition to a more psychologically nuanced approach to acting left the Delsarte acting system behind in the dust.

STANISLAVSKY SYSTEM

The developments of the newer types of plays that were being written and **Constantin Sergeyevich Stanislavsky's** opportunity to rehearse with the Meiningen Players on their tour to Russia prompted him to depart from casting plays by using **acting lines** when the Moscow Art Theatre opened. It also prompted him to consider new ways to train actors at the Moscow Art Theatre's school. Stanislavsky initially referred to his approach as "a method," but many of his "disciples," when they came to the United States in particular, referred to the system as "the method." Stanislavsky's system, as it is now called, was laid out in a number of books including, *An Actor Prepares* (1936). Because Stanislavsky's last book was not translated into English until about 1961,

some of the modifications Stanislavsky himself made to his system were not available to many acting teachers in the United States until well past the middle of the twentieth century.

Stanislavsky identified a number of components in his acting system. Even though a few of the elements have been modified and augmented over the intervening century, the Stanislavsky system is still the basis for acting training in the United States and many other Western countries.

- Relaxation: Relaxation and relaxation exercises are intended to eliminate unintended stress and muscle tension. Based upon the concept that the actor needs to figuratively turn his body over to the character's impulses, the actor's body must be relaxed so that it may respond without injury or fatigue to the needs of the character.

- Observation: Because the actor is creating a character different from the self, the actor needs a repertoire of human characteristics that may be applied to the construction of the character. Obviously, the only way to create a reservoir of human behavior that is different from the self is to observe other people. However, observations must not be confined exclusively to observing humans—it must also include observing animals. In some situations actors are expected to play animals—we need look no further than *Strider* (1979) or *Cats* (1981), the first about horses, the second about cats (Figure 9.1). In other situations, the actor is playing a human being who has behavior patterns that are characteristic of animals. The earlier example about "Maggie, the cat" is one specific example.

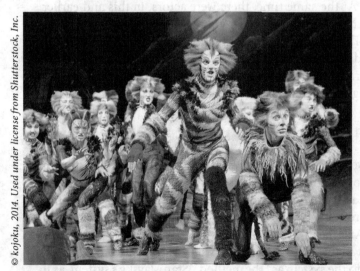

© kojoku, 2014. Used under license from Shutterstock, Inc.

Figure 9.1 *Cats, the musical, requires actors to observe cats in order to move in a catlike manner.*

- Concentration: When the actor is on stage performing, the actor must not allow himself or herself to be easily distracted by what is happening offstage or in the audience. To deal with this, actors-in-training have exercises to reinforce concentration skills. One exercise consists of the actor sitting in a chair with the objective of reading a book. The other members of

the class have the task of distracting the actor in any way they can, short of touching him.

- Concreteness: Specificity is essential to good acting. One cannot successfully act "love." One must select a specific kind of love—such as love of money, love of self, love of food, love of pleasure, love of another specific person, and so on. After making that decision, then the actor must chose specific actions that will allow the character to express that.

- Inner truth: It is not enough to be able to concentrate or to have concreteness, the character the actor creates must be perceived by the audience as having truthfulness to it, which is the same thing as being perceived as real.

- Emotional recall: This was sometimes referred to as emotional memory and was one that Stanislavsky ultimately did not consider that important. Initially, the idea was to recall the emotion from a past event and to play that emotion. The actor would recall the casket viewing for a father or grandmother and play that emotion for the stage funeral scene. If you had to portray real fear during a stage fight, the actor would recall a mugging and play that emotion. Stanislavsky observed that some actors experienced hysteria after using the technique and thus he eventually eliminated it. The author recalls from his own undergraduate and graduate theatre training that some acting teachers instructed students to recall the emotional feeling of killing a pestering fly. Then use that emotional recall to give a sense of reality to the feeling of wishing to kill someone. Today the process is closer to remembering the emotions of similar past actions and finding the actions that will express that for the character in the given present action.

- The "**Magic if**": In some ways this characteristic supplanted emotional recall. It is based upon the premise that one does not have to actually have experienced something in real life in order to act it. The actor need only imagine how the character would behave or feel, based on memory of similar behavior or feelings, "if" the character were in the specific situation called for in the script.

- Believability: Somewhat related to inner truth, believability's characteristic is that regardless of the process the actor uses to create the character, the audience must still believe that it is real and honest within the context of the world of the play.

ACTING PROCESS

As might be expected, there is significant overlap between the acting process and the directing process. This is understandable considering the actor and the director work together so closely in conjunction with the process of creating theatre.

- Read the play: It is axiomatic that the starting point in any theatrical production is to carefully read the script. In contemporary theatrical practice,

the operating principle is to mount the production as the playwright might do it were he or she doing so under the given production circumstances.

- Play Analysis: The analysis that the actor does in many ways is similar to that which the director does. However, it may be necessary for the actor to go into even greater detail than the director about the actor's specific character.

- "Given Circumstances": The expression "given circumstances" refers to the "data" that are provided by the script about the situation both preceding and surrounding the actions of the play and behavior of characters. These include what time of day does the action take place, what situation sets the action of the play into its forward trajectory—the who, what, when, where, and why of the play?

- Character Analysis: The character analysis that the actor does parallels what the director does, but clearly the actor does it in much greater detail. Actors often construct an elaborate "back story," sometimes called an "autobiography" that provides motivation for the character's behavior in the script. The director might have considered elements of a back story, but the director rarely fleshes one out as much as the actor must do.

- Research: Among professional actors doing period plays, extensive research is essential. It is common practice for actors who are to perform characters in historical situations to read the available works for that background. Many actors also do equally extensive research for contemporary plays. In one not atypical situation, the actor Jack Nicholson (1937–) spent a number of weeks as a patient in a mental hospital as research preparation for his role in the film *One Flew Over the Cuckoo's Nest* (1975).

- Motivation: In order for actors to play believable characters in the contemporary theatre, the actor must carefully determine the various levels of motivational considerations that go through the character's mind for each moment in the script. There are several specific levels used by professional actors.

 ○ **Super-Objective**: Various theatre professionals and theatre authors use other terms interchangeably for the concept of **super-objective: spine** or through line. The terms spine or through line are often terms that a director might use to represent the overall arc of the script. The term super-objective is more typically used by actors and refers to the single unchanging goal that each character has in the script and which lasts without change throughout the play. Other objectives for the various scenes flow from the super-objective. For example, the super-objective of Jean in August Strindberg's *Miss Julie* (1889) is to achieve nobility. Everything he does in the script can be traced back to that single overarching objective.

 ○ Objective: An objective is a goal or desire that the character has for any given scene or moment. In either real life or in stage acting, one has an

objective and keeps pursuing that one objective until either the objective has been satisfied or the situation changes and the character or person readjusts the objective to deal with the new given. An example from *Miss Julie* is that Jean wants to start a Hotel in Switzerland. In order to do that he needs capitol or money from Miss Julie—hence his instruction to her to steal money from her father's desk.

- **Beats**: There are at least three interpretations for the term beat. One is an indication of rhythm, such as when the director says "Pick up the beat," by which the director means increase the rhythm or pace. A second definition means to take a pause, as when the director says "Take a beat there." The third meaning for beat, as it relates to this subsection on motivation, means the point at which the character's objective changes to a new one. Typically, the actor marks the script, often with a slash, at every place in the script where the objective changes.

- Text versus **subtext**: The text consists of the lines as written by the playwright in the script. The subtext is the specific underlying meaning or context that is given to the words of the text. As noted elsewhere, the playwright typically provides the text for the play and in some instances might even provide stage directions to give a clearer context for the meaning of the lines in the script. If the stage directions are not supplied by the playwright, it is up to the director and the actor to analyze the script and the action to determine the intended subtext.

- Scoring the Script: "Scoring the script" is an expression used by actors to indicate the notation process that actors do on a script. At a minimum, scoring would include the notation of beat placements throughout the script. In more elaborate scoring, that could include notation of the active verbs that are used in each beat and perhaps even notations of vocal quality, volume, and pitch changes.

- Movement: There are three major divisions of movement. **Blocking** is the determination of major movements about the stage and is often determined by the director and the actor working in concert with each other. **Business** refers to smaller pieces of movement. For example, the character may cross to the grandfather clock and wind it. In this example, crossing to the clock is blocking and winding the clock is business. The third division of movement typically happens in a musical and is choreography. On top of this, the actor may add finer idiosyncratic movement characteristics in order to make the character unique. Some of these could be a limp, a constant jiggling of coins in the pocket, or an atypical bodily attitude. This idiosyncratic characteristic is applied not just to movement, but also to vocal characteristics and psychology. All actors do this to some extent. Great actors do this more—it is part of the admiration that both audiences and theatre professionals have for Meryl Streep's (1949–) ability to create such unique characters for stage and

film (Figure 9.2). It is also a feature of a number of characters showing up in hit television series. Over the last few decades, they include Carroll O'Connor (1924–2001) playing Archie Bunker in *All in the Family*, Peter Falk (1927–2011) playing Lt. Colombo, Tony Shalhoub (1953–) playing Adrian Monk, Hugh Laurie (1959–) playing Dr. Gregory House, Jim Parsons (1973–) playing Sheldon Cooper in *The Big Bang Theory* (Figure 9.3), and Jonny Lee Miller (1972–) playing Sherlock Holmes in *Elementary*.

© Helga Esteb, 2014. Used under license from Shutterstock, Inc.

Figure 9.2 *Meryl Streep is admired by audiences and theatre professionals for her ability to create such completely different characters that seem to exhibit so little of her own personal mannerisms.*

© Jaguar PS, 2014. Used under license from Shutterstock, Inc.

Figure 9.3 *Jim Parsons plays Sheldon Cooper in The Big Bang Theory, just one of a number of actors playing memorable idiosyncratic characters on TV series.*

- Vocal: There are several techniques available to the professional actor for changing the vocal aspects of the character.
 - Vocal Quality: Vocal quality refers to several characteristics such as timbre, pitch, nasality, and resonance placement. For example, an actress playing a temptress might choose to play the character as being breathy.
 - Volume: Changes in volume are probably the easiest to understand, it means simply making the voice louder or quieter.
 - Accent/Dialect: In the professional theatre, film, and television, we are accustomed to hearing characters who display foreign accents or regional

dialects. Professional actors are expected to have a range of accents readily available and to have the skills to easily acquire whatever new accent or dialect may be called for in the script by its given circumstances.

○ Individualizing: As was the case for movement, so too in the area of vocal characterization there is a need for the actor to be able to individualize the vocal quality of the character to fit the given circumstances of the script.

ACTOR'S REHEARSAL PROCESS

Again as was the case for the acting process, the rehearsal process for the actor almost exactly parallels that for the director.

- **Table Work**: Table work for the actor is identical to that for the director. Everyone typically sits around a table, reads the script aloud, discusses its given circumstances, does some initial determination of motivation, and typically considers what the arc of the show and of the characters will be.

- Get Script On Its Feet: As mentioned earlier, both the director and the actors want the actors to get on their feet and move about the rehearsal space so they may incorporate movement in the creation and presentation of the characters. Among professional actors, with their years or decades of experience, the words of the script impel actors to move in response to the lines.

- Blocking: Probably the most important feature of getting the script on its feet is blocking. As has been noted repeatedly, blocking is the determination of the major movement patterns about the stage, determined either by the director alone or by the director in concert with the actor.

- **Stage Geography**: In order to have a convenient system for recording movement patterns about the stage, the stage traditionally has been divided into a number of locations. At its simplest, the several acting locations consist of two bands: one band is **upstage** and the second is **downstage**. The terms "upstage" and "downstage" are derived from the seventeenth century when the stage floor was sloped, or raked, to accommodate the forced perspective that was used for scenery. Thus, when an actor moved away from the audience, he was actually moving to a higher elevation or "up stage," and when approaching the audience, was moving to a lower elevation or "down stage." Each upstage or downstage band is further subdivided into three areas: one at the left, one in the center, and one on the right. Note in this situation that the reference of "**stage left**" and "**stage right**" on a proscenium stage is *always* from the actor's perspective as the actor faces the audience. The notation of left, center, and right in each band gives a total of six different acting areas: down left, down center, down right, up left, up center, and up right. Those six designations are often sufficient for intermediate sized stages. There are of course more complicated stage geography systems

containing three or more bands, each band with four or more divisions. A variety of other techniques are typically used for thrust stages or arena stages, but their discussion is beyond the scope of this book.

- Get Off Book: Until the actors learn their lines, they are moving around the rehearsal studio holding a script in their hands. This gets in the way of spontaneous acting and both the director and the actors know significant acting on stage cannot happen with a script in hand. Getting "off book" means the actors have memorized their lines. In some situations, such as for one-week musical stock, some directors require the actor to be "off book" from the very first rehearsal. During the first few rehearsals after "off book," one might hear the actors call for "line" as they continue committing the rest of the show to memory.

- Recording As You Go: The stage manager records the development of the script during the rehearsal process in the master script, the prompt book. Actors must also record as they go, but the actor is only concerned with recording his own character's movements and motivations. Both actors and stage managers use only pencil in the recording process so that old notations may be easily and cleanly removed from the script.

- Run Scenes: There are two considerations for running scenes for theatrical rehearsals. One is repeatedly running scenes so that the repeating reinforces the stage actions so that acting seems spontaneous during performance. Moreover, running scenes are often where the real creativity of theatre is developed. Each time through a scene gives the actor an opportunity to make different choices and to try smaller or greater differences in the character. A phrase that is frequently used in theatre is "making choices." This refers to different goals and behaviors the actor might try during the rehearsal process to find one that is satisfactory to the actor and to the director. A variety of techniques might be used during the rehearsal process to elicit new approaches to incorporate into the character's performance. Improvising a situation related to, or perhaps not related to, the script might elicit ideas to be incorporated into subsequent scene run-throughs. Another technique that arose late in the twentieth century was the incorporation of theatre games into the rehearsal process, again with the objective of trying to find new ways of interpreting the character. Another consideration is the generation of business as a process for finding individual ticks and behaviors to incorporate into the character.

- **Run-Through**: A run-through is a longer version of running scenes. A run-through is an opportunity to continue to repeat and ingrain acting behavior. It also provides the actor and the director the opportunity to see each smaller unit of acting, such as a scene, in a larger context.

- **Technical Rehearsals**: Technical rehearsals are when the technical aspects of production, such as scenery, costumes, lighting, and sound, are integrated

with the acting. Technical rehearsals often are long, boring, and stressful situations as scenes must be run over and over again until the result coincides with the conception of the various artistic team members.

- **Dress Rehearsals**: Dress rehearsals add costumes and makeup to the production, and, for the most part, provide the last opportunity to make adjustments to the production before it opens to the public. In the commercial and professional theatre, there may be several previews during which improvements might still be made. In the case of original scripts, new lines, or in extreme cases, perhaps even new scenes and new scenery might be added.

- Performances: Performances are the culmination of a rehearsal process that has gone on for six to eight weeks in the commercial theatre and a design and construction process that has gone on for several months. Elsewhere in professional theatre, rehearsal periods may be as short as one week in some summer stock operations. At the opposite extreme, Michael Bennett (1943–1987) sometimes had his musical productions in "workshop" for close to a year. While professional theatre people through their training and experience have generated expectations of how a performance will work out following the rehearsal process, nothing is an absolute given—only an audience and the critics will be able to determine if all of the rehearsal process has paid off.

PROFESSIONAL ACTING

TRAINING

Training in preparation for a career in theatre is a long and arduous process. For most young actors today that process includes a four-year undergraduate college degree program, typically in theatre. No subject is totally irrelevant to the preparation of a professional actor. A well-trained professional actor will need an exposure to and a familiarity with the full range of liberal studies. On top of that foundation will be added general skills in theatre production, theatre history, and script analysis, in addition to specific skills in acting, movement, and voice. If the student is in a Bachelor of Arts (BA) Theatre program, the student might take several courses in acting, movement, and voice. If the student is in a Bachelor of Fine Arts (BFA) Theatre program, where the objective typically is a professional career in theatre, the student is likely to take acting classes each semester of the four-year program and a rather extensive sequence of coursework in voice and movement. Of course, throughout any collegiate theatre program it is essential that actors perform in plays because the mounting and presentation of plays to a public audience is the living laboratory of the theatre discipline.

Figure 9.4 *Dustin Hoffman is famous as an actor who continued to "take classes" even after becoming a famous actor.*

Upon completing a bachelor's degree in theatre, it is relatively common for professional actors to enter a three-year Master of Fine Arts (MFA) program in acting. In such a program, the student typically takes even more advanced courses in acting, movement, and voice. It generally is presumed that the student is also working in summer stock for additional experience—in fact even some undergraduate programs presume their students spend some time in summer stock to acquire additional professional acting experience.

The competition for employment in acting is so intense that would-be actors need to do everything within the actors' control to have a little extra edge. Thus, some actors train to be a "triple threat," meaning being an actor, singer, and dancer. Other students take specialized courses such as combat and circus techniques. Professional actors such as Dustin Hoffman (1937–) are continually "taking classes," in order to refine existing skills or create new ones (Figure 9.4). Following graduate school or internships, the beginning actor is ready to start working as a journeyman actor and accumulating experience and credits. Beginning professional actors often find early employment in regional theatres, summer theatres, and dinner theatres. The catch phrase in theatre is, "It takes 15 years to become an overnight success."

FINANCIAL CONSIDERATIONS

Financial considerations for either beginning or experienced actors are dismal at best. Actors Equity Association (AEA) has more than 20,000 members—that is, members who are already recognized as being professional actors. According to recent data from AEA, approximately one-third of its members work less than one week a year. Many, perhaps most, work for a weekly salary that is at, or only slightly above, the AEA weekly minimum for their theatre category. For example, in a LORT D theatre, the smallest LORT category, the minimum 2018 weekly salary was $600. On Broadway, the minimum was $2,034 per week in 2018. Though that suggests a salary above $100,000 per year on Broadway, it must be remembered that relatively few actors work fulltime for a year, and the cost of living in New York City is very high. At the other end of the spectrum are the salaries paid to stars on Broadway. Matthew Broderick (1962–) and Nathan Lane (1956–), who opened on Broadway in *The Producers* (2001), were each reported to have made $50,000 per week. Having fulfilled their original contract, they left the show, but were subsequently rehired by the producers. Depending upon the source, each of the two actors was reputedly paid $75,000 or $100,000 per week when they reprised their roles (Figure 9.5).

Figure 9.5 *Nathan Lane (left) and Matthew Broderick were reputed to have earned between $50,000 and $100,000 per week for their performances in The Producers.*

As extravagant as this may or may not appear, the real money in acting is available for stars in TV and movies. It is common for major actors in TV series to make over $100,000 per episode. Ashton Kutcher (1978–) and Jon Cryer (1965–), both in the comedy series *Two and a Half Men*, each made $600,000 or more per episode in 2013. It has been reported that Jim Parsons, Johnny Galecki (1975–), and Kaley Cuoco (1985–), all from *The Big Bang Theory*, asked for and received $1,000,000 each per episode for the 2014 season. They subsequently took a salary cut so that other supporting actors in the series could get a pay raise. The highest paid TV actress in a comedy series is Sofia Vergara (1972–) of *Modern Family*. Among the dramatic series, Mark Harmon (1951–), the star of *NCIS*, earned $525,000 per episode in 2013, while Mariska Hargitay (1964–) of *Law and Order: SVU*, earned $500,000 per episode (Figure 9.6). On an annual basis for 2018, Sofia Vergara reputedly made $42.5 million; Jim Parsons, $26.5 million; Johnny Galecki, $25 million; Kaley Cuoco, $24.5 million; Mark Harmon, $19 million; and Mariska Hargitay, 13 million.

Figure 9.6 *Mark Harmon is reputed to be the highest paid actor in a television drama series.*

In the film industry, it is common for stars to demand and receive multiple millions per film. Top male film stars are able to demand a salary above $30 million per film. When coupled with deferred options and other benefits, the combination can sometimes amount to about $100,000,000 per film. On an annual basis for 2018, the highest paid film actors were George Clooney (1961–), $239 million; Dwayne "The Rock" Johnson (1972–), $124 million; Jackie Chan (1954–), $45.5 million; Scarlet Johansson (1984–), $40.5 million; and Angeline Jolie (1975–), $28 million.

The lure of these fantastic salaries are partly responsible for the aspirations to be professional actors among young people. While a few individuals do earn these top incomes, the typical live theatre actor's salary often does not exceed $100,000 per year.

Key Names, Venues, and Terms

Acting Lines	Role-Playing
The Actor Is His "Instrument"	Run-Through
Archetype	Stage Geography (Upstage, Downstage, Stage Right, Stage Left)
Beat	
Blocking	Constantin Stanislavsky
Business	Stereotype
François Delsarte	Subtext
Dress Rehearsal	Super-Objective (Spine)
Internal/External Acting	Table Work
Magic If	Technical Rehearsal
Objective	

Additional Reading

Adler, Stella. *The Art of Acting.* New York: Applause Books, 2000.

Benedetti, Robert. *The Actor at Work.* 10th ed. Boston: Allyn & Bacon, 2008.

Cole, Toby, and Helen K. Chinoy (eds.) *Actors on Acting.* 4th ed. New York: Crown Publishing Group, 1995.

Hagen, Uta. *A Challenge for the Actor.* New York: Charles Scribner's Sons, 1991.

Stanislavsky, Constantin. *An Actor Prepares.* New York: Theatre Arts Books, 1965.

PHYSICAL THEATRES AND DESIGN

Chapter X

In our previous discussion, we identified the major components of theatre as Audience, Performer, and Space. Designers, particularly **scenic designers** and **lighting designers**, define the space on a stage. The **costume designer** and the **sound designer** add other components that suggest what, where, and when the space may be. However, before we may discuss how the designers alter space to fit the different needs of different productions, we need to discuss the major types of contemporary theatre spaces that are used as the venues for theatrical productions.

TYPES OF THEATRE SPACES

The three major types of theatre spaces are **proscenium**, **thrust**, and **arena**.

- The **proscenium theatre** is the most prevalent theatre performance space currently used in the western world and the one most likely to be known to most people because it is so frequently found in high schools and middle schools. The contemporary proscenium theatre may be traced back to its development in the Italian Renaissance and from there back to the *proskenion* of the Greek theatre. The proscenium theatre's defining characteristic is an arch or opening that separates the audience space from the stage space and through which the audience watches the performance. The proscenium opening may range from perhaps as little as 15 feet wide up to 60 or more feet wide. Because of this arrangement, all members of the audience in a proscenium theatre have a generally similar viewpoint for the production. If the scenery is a box set—that is, it looks like a room—it is typically arranged so that one wall is missing, in what is referred to as the

Figure 10.1 *This proscenium theatre with boxes on either side of the proscenium opening is typical of the late nineteenth and early twentieth century.*

"fourth wall convention." In this configuration, it is possible for the characters in a proscenium production to be totally enclosed within an environment—that is, totally inside the room consisting of a back wall, two sidewalls, a floor, and a ceiling. It is the only theatre form in which the characters may be totally contained in a visibly believable environment. In many proscenium theatres, there is an orchestra pit between the audience and the proscenium arch, which increases the distance between the audience and the actors. Thus, because the first row of the audience may be 15 or more feet from the proscenium, fine details in costumes, scenery, or props do not register easily. In addition, this distance reduces the rapport between actors and audience (Figure 10.1).

- In a **thrust theatre**, the audience sits on three sides of the performing space, and the production often has a scenic background on the fourth side. The interest in thrust theatres was primarily due to the fact that that was the type of theatre used by Shakespeare and his company during the Elizabethan period. In the thrust theatre configuration, those audience members sitting directly in front of the stage view the performance against a scenic background. On the other hand, the audience members sitting on the two sides view the performance against a background of other audience members on the other side of the stage. Typically, the actor–audience relationship in a thrust theatre is much closer, in some theatres being only a few feet. Because of this closeness, greater finesse is needed in executing scenery, costumes, and props. This closeness also generates a more intense relationship between the audience and the performance. Because of the two parts of the audience on the sides, a totally enclosed physical environment is not possible on the thrust stage. However, in good productions, the audience's willing suspension of disbelief permits it to imagine there is a complete physical environment, even though a physically enclosing environment does not exist.

- The **arena theatre** has audience sitting on all sides of the performance. Thus, every member of an arena theatre audience watches the performance against a background of other audience members. Just as the thrust theatre could not

have a scenic wall between the audience and the performance, similarly, there can be no scenic walls in an arena production. As was also the case with thrust productions, greater detail is needed in the execution of costumes and props because the audience is so close. Not having scenery for the arena theatre or limited scenery for the thrust theatre has a financial advantage because of the savings achieved by not having to build extensive amounts of scenery (Figure 10.2).

© View Pictures/Getty Images.

Figure 10.2 *The Fichandler Theatre at Arena Stage in Washington, DC, has the audience completely surrounding the stage.*

There are a few other types of stages that might be used in specific situations.

- Conceptually, the **flexible theatre**, sometimes called a black box, experimental theatre, or studio theatre, is a large relatively empty room. It is an outgrowth of using "found spaces" in which to do theatre. Around the middle of the twentieth century, particularly in America's largest cities, many large spaces were pressed into service by some theatre groups. The flexible theatres built today are a refinement and consolidation of the practices used in "found space" productions. Flexible theatres are designed to facilitate varying the actor–audience configuration on a show-by-show basis. Flexible theatres are incorporated into building construction plans today primarily to provide an alternative to the main stage facility, often a proscenium or thrust theatre.

- **Environmental theatre** also developed after the middle of the twentieth century. The philosophic concept of environmental theatre is that the audience and the characters inhabit the same space. In the other theatre types, the audience and the performance are conceptually thought of as being in separate, if contiguous, spaces. Eugene Lee's (1939–) design for *Slave Ship* (1970) is an iconic example of environmental design. *Slave Ship* depicted the transportation of slaves from Africa to America and had a central scenic unit upon which the slaves were chained. The audience surrounded the central unit, which was on rockers so the unit could be rocked to simulate the effect of rolling waves. The walls of the theatre were covered with wood so the audience could feel that it was on board the ship and down in the hold with the slaves. To add to the ambience, pots were arranged around the theatre and were reputed to contain putrefying excrement and flesh to augment the sensation of actually being on board a slave ship.

- The **extended apron** theatre also developed around the middle of the twentieth century. A number of thrust theatres had been built that demonstrated the improved actor–audience rapport that could be achieved for productions done on a thrust stage. Many academic and theatre institutions only had proscenium theatres, but wanted to do productions in a thrust configuration. Consequently, a number of those operations extended the apron, that floor space that is downstage of the proscenium arch, in order to achieve a more thrust-like configuration. Later in the century, this led to the construction of proscenium theatres in which the orchestra pit could be raised and lowered, and, if desired, raised to the level of the apron to create an extended apron configuration that approached thrust configuration. Such configurations did reduce the distance between the audience and the performers, but typically there were only a few token audience members who sat on the sides.

DESIGN AREAS

The major design areas for theatre are scenery, costumes, lights, and sound. All designers for Broadway and the larger regional theatres must be members of United Scenic Artists (USA). Membership in that guild or union is achieved only after passing a rigorous multiday exam during which one must demonstrate the technical skills essential for work as a professional designer.

SCENERY

Scenery design covers the decor and props. Decor is the first part of the stage setting that most people refer to when they talk of "scenery." It consists of the walls of the setting, the special floor that may be constructed for the show, and any platforms or elevations that may be used, such as stairs. The second part consists of props and deals with **set props** and **hand props**. Set props are the properties that give specific characteristics to a setting and include such things as pictures on the walls, drapery and curtains, furniture, rugs, and items that make a room look real and lived in. Hand props are the properties that actors actually handle. Nonprofessionals are often amazed by how much of scenic settings are actually props (Figure 10.3 and 10.4).

If more than a single setting is needed for a production, the scene designer is responsible for determining how to shift, or move, from one scene to another. The scenic designer is not responsible for the actual construction of scenery—that is the responsibility of the technical director or the professional scenery construction company if it is a commercial theatre production. However, it is the designer's responsibility to produce a complete set of drawings from which the technical director and his crew may build the production. In the commercial theatre, the designer is not permitted

to help build or paint on his or her own production, but in many regional and academic theatre operations the designer typically assists in painting. The scenery must be built in large scenic construction shops. In regional, academic, and community theatres, there are typically one or more shops to build, paint, and rig the scenery. In the commercial theatre, separate scenic construction companies bid on and subsequently construct the shows (Figure 10.5).

Figure 10.3 *This design for a production of* You Can't Take it with You *consists of the setting, the properties, and the compositional lighting.*

Figure 10.4 *The set when stripped of its properties and the compositional lighting gives a significantly different effect.*

Figure 10.5 *In the professional and commercial theatre and the largest academic theatres, significant space is needed to build scenery for productions. At this commercial scene shop equal spaces are needed to assemble and to paint scenery. For a sense of size, note the people in the far background.*

COSTUMES

Costume designers are responsible for the design of clothes, makeup, and hair. Clothes are what people normally think of when they think of costumes, but there is more to it than what is usually seen. In order for period costumes to look correct on stage they need to have the proper foundation garments. For example in a Civil War era show, females must wear properly designed and constructed crinolines in order for the dress to have the proper silhouette, or outline. The costume designer is also responsible for designing and arranging for makeup and hair. Only if the makeup for a production has some unique characteristic will a makeup expert be retained to design that aspect of the show. After the makeup has been designed, theatre actors are expected to put on their own makeup. However, in film and television, actors rarely are permitted to do their own makeup primarily because of the subtlety that is needed for film and TV work. A similar kind of process applies to hair. In general, theatre actors are expected to also do their own hair after it has been designed by the designer. In some shows, the characters might not be humans or even animals. *Starlight Express* (1984) characters were railroad trains (Figure 10.6).

© Robbie Jack—Corbis/Getty Images.

Figure 10.6 *The costumes for* Starlight Express *are unusual because they are for train characters, and the costumes have a mechanical feel to them.*

Photo courtesy of Robert Smith.

Figure 10.7 *This regional Theatre costume shop has a range of specialized sewing and costume construction equipment in addition to significant work surfaces.*

As was the case for scenery, the costume designer is not expected to build the costumes, though in many institutions the costume designer might be expected to assist on the construction. Just as scenery for professional productions is constructed in professional scenery construction shops, so too are professional costumes built in professional costume construction shops. The individual who has the responsibility for the actual construction of costumes is the costumer or the professional costume construction shop (Figure 10.7).

LIGHTS

The lighting designer is responsible for designing the lighting rig that will be used to light the production. Lighting design is much more than simply illuminating the stage. Through the various elements of light, the designer directs the attention of the audience and creates an ambience that reinforces the theme and mood of the show.

SOUND

Sound design is a relatively new field in the theatre. Until about the middle of the twentieth century, sound was a subdivision of props because most of the sound production techniques employed mechanical objects, such as half coconut shells to create the sound of a horse's hooves. The development of electrical and electronic equipment since then has made sound design so much more different. In the beginning, even though electronic sound equipment existed, sound reinforcement was not a common practice. Today however, virtually all musicals use microphones for sound reinforcement, and it is a rare show that does not have some sound effects in it.

FUNCTIONS OF DESIGN

There are a number of general functions of design, some focusing more on the scenic environment and others focusing more on costumes.

- Define Space: It is necessary to give some sense of the space in which the production takes place, even if that is a space with no definable location, called "limbo." Some authors refer to this aspect of the **design function** as staging the story, by which is meant providing those areas on the stage so that the actions of the script may be presented. Most of the time, this involves a specific kind of place such as a living room or other space. Generally, it is the scene designer who is primarily responsible for defining the space. If the setting is a generalized location, the space might be defined by which parts of the stage are lighted. In other situations, sound may contribute to defining the space. For example, if frogs are chirping we would generally presume that the setting is outside near water or a swamp. On occasion it is possible for costumes to define the space, if the decor itself does not provide that information. For example, characters in full firefighter-gear on a limbo stage would be indicative of a fire location.
- Express Character: Costumes are the primary design method for expressing character. The economic status, social class, relation to other characters in the cast, and psychological state can all be expressed to varying degrees by the costumes. Lighting may also play an important part in giving a sense of the psychological state of the character at any given moment. Scenery may also be used to express

character. The prop dressings that are used in a living room setting may express character, based upon the presumption that the character has selected the props that are used in the room, and hence are indicative of the character.

- Define Relationships: Costumes are probably most indicative of relationships between characters. For example, in Shakespeare's *Romeo and Juliet* more than a couple designers costumed the Capulets in shades of red, orange, and yellow, while the Montagues were often costumed in blues, greens, and similar cool colors. Thus, whenever a new character enters the stage, the audience immediately is aware of the family relationship. Many costume designers also use quality of fabric as an indication of economic and social status, with brighter colors and richer surface treatments indicating higher status.

- Enhance Theme: Ordinarily, all areas of design are involved in enhancing the theme of the play. As mentioned earlier in Chapter VIII, scripts have multiple themes and it is important that all designers are enhancing the same theme. A classic 1921 production of Shakespeare's *Macbeth*, with scenery and lighting by Robert Edmond Jones (1887–1954), illustrates what may happen when themes are different. In that production, the actors used a very realistic acting approach while the scenery was very stylized. The critics found that in that production the conflict didn't work. However, the success of Arthur Miller's production of *Death of a Salesman*, designed by Jo Mielziner (1901–1976) in 1949, demonstrated that there is no inherent conflict between realistic acting and stylized scenery.

- Reinforce Style and Mood: A simple indication of this would be using straight lines, sharp contrasts, stark images, and somber tones as indications of tragedy. Conversely, curved lines, subtle shading, attractive images, and colorful pastel tones are often indicative of comedies.

- Enhance Actors' Work: For the most part this applies to costumes. In contemporary theatre productions, particularly in musicals, characters are often called upon to execute movements in period garments that ordinarily would not be possible in real period garment. A classic example is sewing a gusset of spandex, or similar fabric, into the crotch of pants so that the actor may execute a split without ripping open the seam. Similar kinds of examples exist for scenery. For example, Actors Equity Association (AEA) does not permit professional theatres to have a rake of greater than 1″ rise per foot of run on inclines without explicit permission from AEA. In fact, AEA has a number of rules about how technical theatre techniques may be applied in productions to ensure the actors' safety.

- Focus Attention: To a great extent this is primarily a function for the lighting designer. Lights typically direct the audience's attention to the brightest lighting or to a moving light such as in changing light level in a light cue. This works because through evolution the human eye is automatically attracted to the brightest area or anything that moves. In addition, other design areas are also used to direct attention. For example, scenery is often painted darker at

the top so that the audience's attention is drawn to the more brightly painted lower portions of scenery where the characters and the action are. Scenic designers are also able to focus attention to specific areas of the stage by means of internal design lines. For costumes, design principles are typically used to focus the audience's attention on the actor's face.

- Fit into Theatre: Regardless of what other functions may be addressed by the design for the production, the overriding consideration is that when all is said and done, the production must fit into the theatre. There are a number of ingenious techniques, beyond the scope of this book, that designers may use to make the physical production seem larger than it actually is. The first-class national tour of *The Phantom of the Opera* is a rare instance of a production literally renovating theatres to make the stage large enough for the production to fit into the theatre.

- Operate Efficiently: Essentially this boils down to an issue of money. Efficiency in theatre generally means not having to redo something because it wasn't done correctly the first time, or because someone has changed his or her mind.

DESIGN PROCESS

The total design process for each of the design areas is different, but there are a significant number of shared steps, particularly in the beginning of the design process, including the following:

- Read the Script: The first step for designers, as is true for all other theatre practitioners, is to read the script. The preferred interpretive approach for theatre today is to mount the production as the playwright might do if the playwright were available. In order to figure out how the playwright might have done the production, it is necessary to read the script and analyze it in the same kind of detail that was referred to for the director and the actors.

- Serve the Needs of the Script: This is an area that is often confusing to people who do not work in theatre. We are accustomed to the situation in our homes, where furniture and space arrangements are made to handle the full range of possibilities that might occur in our lives. However, on stage it is only necessary to provide for those specific actions that are called for in the script, and therefore designers typically do not provide for other actions. One example will make this sufficiently clear. In our homes, the dining room typically contains sufficient chairs for everyone in the family. In a stage dining room, we only provide seating for those characters who are actually in the scene. If the action is for four people to sit at a dining room table for a family with eight members, the requirement is to provide seating for four people—not eight. However, this may provide some sense of incongruity for discriminating audience members. Consequently, some designers will provide more than the minimum number of seats. The problem is that providing eight seats when

only four will be used may eat up more real estate than the production can spare. In such a situation, a designer may use a table that looks like it can seat more than four, even though there may not actually be space for eight. Some designers might be sure that there are eight chairs in the dining room, perhaps against the walls, even if all eight chairs could not fit at the table.

- Research: All professional theatre designers carry in memory a general awareness of the architecture, furniture, clothing, paintings, sculpture, and so on, for all time periods, nationalities, and styles. Despite that, it is rare for a designer to have sufficient detail in memory to completely design a production. Consequently, designers need to do extensive research on the details of the production's period, unless the designer has quite recently designed in that period. There are a number of ways to do research. The designer may go to historic period locations or museums, or examine historic costumes. Often designers go to books on specialized topics for research information. Decades ago, many designers accumulated files of pictures and other images for research. New York City's Public Library also had a very extensive picture collection for this purpose. Of course in the time of computers and Google searches, a seemingly infinite collection of images is available online.

- Conference with the Director: The purpose of the conference with the director, and other members of the design team, is to collaborate and come up with an approach for how the specific production is going to be mounted. In real life, the exact timing of the conference with the director is quite flexible, as is the number of conferences. In some situations, a conference may take place immediately after reading the script. This might be done in those situations where the director and the designers have a long-established relationship and have developed a kind of shorthand for determining where to take a script. In other situations, the members of the team do not want to blithely pursue one interpretation for the script only to subsequently learn after the conference with the director that the director wants to go in a different direction.

- **Thumbnail Roughs**: Thumbnail roughs are small pencil drawings that designers use to work out solutions to the design problems in the show. Thumbnail roughs may vary in size from about 2″ × 3″ up to about 5″ × 8″. Fundamentally, thumbnail roughs are a method of communicating between the designer and himself or herself. Despite that they are often shared with other members of the production team. It is not enough to imagine in the mind what the design will look like. It is essential to do drawings because the human brain is too compliant and will automatically morph the image in the mind's eye to make it fit whatever parameters the mind thinks apply. Only by actually drawing is the image fixed for critical observation. Also, the mere act of drawing stimulates reactions that lead to a modification of the drawing impulse in the act of drawing. As might be expected, scenic and costume designers' thumbnail roughs are predictive images of what the

finished product might look like. The lighting designer doesn't literally do thumbnail roughs, but typically the lighting designer does light sketches, often with pastels, that give a sense of the lighting look that is intended for various moments in the play. Regardless of the designer's area, the designer keeps producing various thumbnail roughs until he or she is satisfied that an appropriate solution to the production's needs have been sketched. In some cases, designers consolidate the various rough ideas into a final thumbnail rough (Figure 10.8 and 10.9).

- **Color Roughs**: A color rough typically is the final and best thumbnail rough with general indications of color tonalities added. Color schemes are organized at this stage rather than waiting to discover problems in the final **presentation sketch** phase (Figure 10.10).

Photo courtesy of Robert Smith.

Figure 10.8 *Sometimes the design solution comes quickly, needing only one or two thumbnail drawings before finding the final solution.*

Photo courtesy of Robert Smith.

Figure 10.9 *The design solution for* Ring Round the Moon *was much more complicated, and there were more than a dozen thumbnail rough drawings before a final solution was found.*

Photo courtesy of Robert Smith.

Figure 10.10 *This color rough for* Rhinoceros *shows basic color tonalities applied to the best thumbnail solution.*

Figure 10.11 *The presentation sketch shows the stage set as it is expected to look under stage lighting. Because* Dracula *is a mystery, its colors and lighting are much darker as reflected in the sketch.*

Figure 10.12 *Because this show is a comedy, its colors and lighting are much lighter and brighter. Compare this presentation sketch for* Crimes of the Heart *with its thumbnail rough in Figure 10.8. Note that the proportions in the presentation sketch are a more accurate indication of scale than was shown in the thumbnail.*

Design Variations: At this point, the process for the various designers diverges, with each following a slightly different process.

SCENIC DESIGN

- Presentation Sketch: The scenic designer does one or more final presentation sketches. The sketch is typically done in scale and perspective. The most frequent scale for sketches is half inch to the foot, meaning that half an inch in the drawing represents one foot on the stage. Most professional designers are able to do freehand perspective drawings; others use a mechanical drafting perspective process. There is a very elaborate drawing and drafting process for this, which is beyond the scope of this book. The presentation sketch is a predictive pictorialization of a specific moment in the play, including the effects of stage lighting (Figure 10.11 and 10.12).

- Draftings: Even though draftings are placed at this point in the design process sequence, often a portion of the needed draftings for the production are done before the presentation sketch is finished. The purpose of draftings is to detail exactly what the scenery looks like so that it may be built by the scene shop people. There are a number of specific draftings that are needed for a scene design. All draftings are done at a specific scale, often half inch to the foot.

 ○ **Ground Plan**: The ground plan is a bird's-eye view, often drawn to the scale of half inch to the foot, showing the exact placement and dimensions of the completed scenic design, including furniture. In addition to the scenery, the ground plan shows any special masking or draperies that are used to hide the offstage spaces.

 ○ Deck Plan: Some people use the terms "ground plan" and "deck plan" interchangeably; however, a deck plan is actually a drawing of the special flooring that is constructed for a play. For a Broadway or similarly elaborate musical, a special floor containing the scenery shifting machinery is generally designed and needs to be drafted so that the shop may build it.

○ Centerline Section: A scenic centerline section can be visualized if one imagines cutting the theatre and scenery in half along a line running through the center of the auditorium, moving one half of the scenery and theatre out of the way, and looking at the remaining half from the side.

○ **Design Elevations**: Design elevations are drawings which show a front elevation of every scenic element in the production. They are done to an accurate scale, typically half inch to the foot. In the commercial theatre and to a lesser extent in the professional theatre, the design elevations are the contract with the scene shop for what the scenery should look like. Some people use the term "front elevations" as equivalent to design elevations. Those terms are not to be confused with rear elevations. Rear elevations are done by the technical director, not the scenic designer, and are detailed drawings of what the scenery looks like from the back and show how the scenery is to be built, an issue that generally does not directly concern the designer.

Photo courtesy of Robert Smith.

Figure 10.13 *The paint elevation is a scaled drawing that shows exactly how the scenery is to be painted. Here the paint elevation is of a drop for a production of* The Servant of Two Masters.

• **Paint Elevations**: Essentially paint elevations are documentation of what the painted scenery will look like. In the commercial theatre, the designer is not permitted to paint his or her own scenery, hence the need to provide instructions to the professional paint crews who are members of USA (Figure 10.14). There is a specific distinction between the presentation sketch and the paint elevation. The presentation sketch is a perspective image of the stage scenery showing the effects of a specific lighting moment in the play. By contrast, paint elevations are flat colored drawings of every piece of scenery, painted as if illuminated by white-light work lights (Figure 10.13).

Photo courtesy of Robert Smith.

Figure 10.14 *Because Broadway scenic designers are not permitted to paint on their own productions, professional scenic artists must do the painting on Broadway shows. Here, scenic artists, all of whom are members of USA, paint a "drop" during a national conference of United States Institute for Theatre Technology (USITT) in St. Louis.*

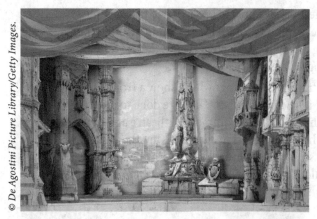

Figure 10.15 *Charles Campon's model for Giuseppe Verdi's opera,* Don Carlos, *gives a scaled three-dimensional representation of the setting even though the model is essentially a wing and drop setting.*

Figure 10.16 *A white model for* Tartuffe, *here with some color added, uses photo reductions of design elevation draftings to construct a simple model for a set that gives a better sense of three-dimensional space.*

- Models: In some situations, and for a variety of reasons, a model is preferred to a presentation sketch or is wanted in addition to the presentation sketch. Complete detailed models are labor intensive, often requiring one or two full-time design assistants working a week or more to produce one. The primary advantage of a model is its scaled detail and the three-dimensional aspect of the model (Figure 10.15). Sometimes simpler models, called white models, are made from draftings for the production, either with or without some indication of color (Figure 10.16).

COSTUME DESIGN

- Presentation Sketch: As was the case with the scenic designer, the costume designer also does presentation sketches that are predictive pictorializations of what the costumes will look like. Unlike the scenic designer, the costume designer's sketches are the contract for how to build the costumes and what they are to look like. This is because the costume designer does not supply draftings; instead well-done

costume drawings often contain indications of seam placement, which serve as construction guides for the costume shop. Another important distinguishing characteristic is that the costume design sketches have **fabric swatches**, or small samples of fabric attached to them. The costume designer or costume design assistant shops for the fabric samples so the costume construction shop will know where to obtain the specific fabric that is to be used to build the costumes. If something is not sufficiently clear in the drawing, detailed or alternate view sketches are drawn as an aid to the final construction (Figure 10.17).

Photo courtesy of Robert Smith.

Figure 10.17 *Costume sketches for three lead characters in* Carousel, *which guide the costume shop in constructing the costumes. Note the inclusion of auxiliary detail views that show items that need a larger drawing or show an item that cannot be seen otherwise. Note particularly the inclusion of swatches of the fabric that are to be used by the costume shop to buy the fabric that is to be used to build the costumes.*

LIGHT DESIGN: The lighting designer's approach is very different from what the scenic designer or the costume designer does.

- **Light Plot**: The light designer does a *schematic* rather than a pictorialization. The schematic is called a light plot. It is a bird's-eye view of the theatre with indications of all the scenery, architecture, and lighting equipment that is going to be used to light the production. In the light plot, typically done to a scale of half inch to the foot, the type and location of every lighting instrument to be used in the show is drawn in its accurate location (Figure 10.18).

- Spot Lights: The light designer uses a variety of spotlight instruments. The ellipsoidal reflector spotlight (ERS) is used because it has a bright relatively even field of light with a relatively hard edge that may be shaped by internal shutters so the light beam will only light

Photo courtesy of Robert Smith.

Figure 10.18 *A light plot is a schematic drafting of all the lighting equipment that will be used to light a production.*

the desired areas (Figure 10.19). The Fresnel has a relatively soft-edged beam and relatively little internal control of the light beam (Figure 10.20). So called "Intelligent Instruments" are very complicated and have remote control over the focus, movement, color, patterns, and other characteristics of their light beam (Figure 10.21).

- Paper Work: There are a number of various listings that the lighting designer does for each show. A dimmer schedule or instrument schedule, similar to but not identical to each other, contains a listing of the various instruments, their focus, location, the color medium used, and the dimmer to which the lights are assigned (Figure 10.22). The designer typically makes what is called a cheat sheet, simply a notation of the various dimmers, the focus direction, and lighting color. This sheet is used frequently during the actual setting of the light cues during the cue setting process.

Figure 10.19 *An ellipsoidal reflector spotlight (ERS) is the most frequently used lighting instrument because its internal shutters allow shaping of the relatively hard-edged beam of light the instrument produces.*

Figure 10.20 *The Fresnel spot is named for its use of the type of lens developed by the French physicist Augustin-Jean Fresnel. Its soft-edged beam is shaped by the barndoors on the front of the instrument.*

Photo courtesy of Robert Smith.

Figure 10.21 *The electronic innards of an "Intelligent Lighting Instrument." The ellipsoidal reflector spotlight and the Fresnel spotlight contain little more than a lamp and a reflector, together with minor mechanical methods for adjustments. The "intelligent" instrument contains multiple motors and electronic control of the lenses, color filters, and movement, all controlled remotely from a lighting console. Such instruments cost multiple thousands of dollars each.*

Show: Crimes of the Heart			Kutztown University		
Hook Up Sheet			Robert Lewis Smith		
Dimmer	Location & Number/s	Type & Watts	Color	Focus	Notes
1	#2 House 5, 8, 9	36 × 9 Ellip @ 750	Rx 54	1, 2, 3	Frame to Portal
2	#2 House 1, 3, 6	36 × 9 Ellip @ 750	Rx 35A	1, 2, 3	Frame to Portal
3	#2 House 2. 4. 7	36 × 9 Ellip @ 750	Rx 9	1, 2, 3	Frame to Portal
4	#1 House 8, 12, 16	36 × 9 Ellip @ 750	Rx 54	4, 5, 6	Frame to Portal
5	#1 House 2, 6, 10	36 × 9 Ellip @ 750	Rx 35A	4, 5, 6	Frame to Portal
6	#1 House 3, 7, 11	36 × 9 Ellip @ 750	Rx 09	4, 5, 6	Frame to Portal
7	#1 Elec. 3, 6	26″ Fres @ 500	Rx 54	7, 8	
8	#1 Elec. 1, 4	26″ Fres @ 500	Rx 35A	7, 8	
9	#1 Elec. 2, 5	26″ Fres @ 500	Rx 09	7, 8	
10	#2 Elec 1, 3, 7.	34 1/2 × 6 Ellip @ 750	Rx 02	Back 1, 2, 3	Frame to Apron
11	#4 Elec. 1, 3, 4	36′ Fres @ 500 w 4BD	Rx 02	Back 4, 5, 6, 7, 8	
12	#3 Elec. 3; #3 Rt Side 1	26 × 9 Ellip @ 750	Rx 02; 54	Stairs Side Day	Frame to Stairs

(Continued)

	Show: Crimes of the Heart			Kutztown University	
13	#4 Elec. 2; #3 Rt Side 2	26 × 9 Ellip @ 750	Rx 60; 55	Stairs Side Night	Frame to Stairs
14	#1 Elec. 7	16 × 9 Ellip @ 750	Rx 02	Stairs Front Day	Frame to Stairs
15	#1 Elec. 8	16 × 9 Ellip @ 750	Rx 60	Stairs Front Night	Frame to Stairs
16	SR Boom 1, 2, 3	14 1/2 × 6 Ellip,; 16 × 9 Ellip.; 1 6 × 12 Ellip. All @ 750	Rx 68	Night Fill 1, 2, 3	Frame to Portal
17	#1 Elec. 9, 10, 11	36' Fres @ 500	Rx 68	Night Fill 4 - 8	
18	SR Boom 4	14 1/2 × 6 Ellip @ 750	Rx 54	Bed Front	Frame to Apron
19	Ante-Pro. 2	13 1/2 × 5 Ellip @ 500	Rx 02	Bed Down	Frame to Apron
20	#2 Elec. 4	13 1/2 × 5 Ellip @ 500	Rx 08	Front Door	Frame to Door
21	Hang from #2 Elec.?	Table Light Fixture	–	Table Light	See Scenic Design
22	Ante-Pro 1; #2 Elec. 5; #2 SL Side 1; #3 Elec 1	14 1/2 × 6 E.@ 750 TH; 36" Fres.@500 w 4BD	Rx 08	Table Illumination	
23	#2 Elec. 2	16" Fres @ 500	Rx 08	Table Down	
24	#1 House 15	16 × 9 Ellip @ 750	Rx 08	Table Front	
25	On Set 3		–	Stove Fixture	See Scenic Design
26	#2 SL Side 2	13 1/2 × 5 Ellip @ 500	Rx 08	Stove Down	
27	#2 Elec. 6	16 × 12 Ellip @ 750	Rx 02	Dining Rm Door	Frame to door
28	On Set 1	16" Fres @ 500	Rx 54	Dining Rm Back	Mount on Prosc
29	#1 House 4, 13	26 × 9 Ellip @ 750; gobo	Rx 07	Front Window Day	Window Pattern
30	#1 House 5, 14	26 × 9 Ellip @ 750; gobo	Rx 63	Front Wind. Night	Window Pattern
31	#7 Elec 3, 8, 9	36 × 12 Ellip @ 750	–	Stain Wind. Back	Frame to window
32	#7 Elec 4	13 1/2 × 5 Ellip @ 500	Rx 08	Kitch. Wind. Back	Frame to window
33	#6 Elec. 5, 7	214" Scoops @ 1000		Cyc Top Night SR	
34	#6 Elec. 1, 3	214" Scoops @ 1000		Cyc Top Night SL	
35	Cyc Floor	3 M–16 Strip		Cyc Foot	
36	Cyc Floor	3 M–16 Strip		Cyc Foot	
37	Cyc Floor	3 M–16 Strip		Cyc Foot	
38	#2 SL Side 3; #5 Elec 2	16 × 12 Ellip @ 750; 16" Fres @ 500 w 4BD	Rx 02 / Rx 54	Porch Day	
39	#3 SL Side 1; #5 Elec. 3	16 × 12 Ellip @ 750; 16" Fres @ 500 w 4BD	Rx 60 / Rx 55	Porch Night	
40	#5 Elec. 1	16" Fres @ 500	Rx 08	Porch Down	
41	#1 SR Side 1; #7 Elec 2, 6	16" Fres @ 500 w 4BD; 14 1/2 × 6 Ellip @ 750; 16 × 9 Ellip @ 750	Rx 54 / Rx 08 / Rx 08	Yard Day	

Show: Crimes of the Heart				Kutztown University	
42	#3 SR Side 3, #7 Elec 1, 5	16" Fres @ 500 w 4BD;	Rx 68	Yard Night	
		14 1/2 × 6 Ellip @ 750;	Rx 65		
		16 × 9 Ellip @ 750	Rx 65		
43	#7 Ellip. 7	16" Fres @ 500 w TH	Rx 54	Steps Down	
44	#8 Elec. 1, 2, 3,	34 1/2 × 6 Ellip @ 750	Rx 06	Porch Leaf gobo	Leaf gobo
45	#1 House 1, 17	26 × 9 Ellip @ 750	Rx 15	Halo Front	
46	#3 Elec. 2	16" Fres @ 500	Rx 09	Halo Down	
47					
48	#6 Elec. 3, 4, 6	314" Scoop @ 500		Cyc Top Day	
HP	Refrigerator on set	Refrigerator light	–	Refrigerator Light	

Figure 10.22 *The Dimmer Schedule is a tabulation of which types of instruments will be connected to which dimmers, where the instruments will be mounted, and with notation of the color and focus.*

Chart courtesy of Robert Smith.

Key Names, Venues, and Terms

Arena Theatre

Color Roughs

Costume Designer

Design Elevations

Design Functions

Design Process

Environmental Theatre

Extended Apron Theatre

Fabric Swatches

Flexible Theatre

Ground Plan

Hand Props

Light Designer

Light Plot

Paint Elevations

Presentation Sketch

Proscenium Theatre

Scenic Designer

Set Props

Thrust Theatre

Thumbnail Roughs

Additional Reading

Cunningham, Rebecca. *The Magic Garment: Principles of Costume Design.* 2nd ed. Long Grove, IL: Waveland Press, 2009.

Dunham, Richard. *Stage Lighting: Fundamentals and Applications.* Boston: Allyn & Bacon, 2010.

Pecktal, Lynn. *Designing and Drawing for the Theatre.* New York: McGraw-Hill, 1995.

Wolf, R. Craig and Dick Block. *Scene Design and Stage Lighting.* 10th ed. Belmont: Wadsworth Publishing, 2013.

PART II.

THE VARIETY OF THEATRE

In this section of the book, we will examine the variety and range of Theatre that is available today. In Chapter XI, Contemporary Theatre, the styles, genres, and general characteristics of the various mainstream components for spoken word theatre that were previously discussed are laid out in a chronological line from the middle of the nineteenth century into the twenty-first century. However, before doing that, a general understanding of the early nineteenth-century theatre practices that preceded the Modern Drama period will be sketched out. In Chapter XII, we will discuss the various types of venues for theatre during the contemporary period from commercial theatre, or Broadway, to community theatre.

The remaining chapters of this section will layer on top of the contemporary theatre chronology other specialized and interesting theatre topics such as Musical Theatre, African and African-American Theatre, Asian Theatre, and Diversity Theatre. These other varieties of theatre may be seen across our country at least weekly, even if only in specific locales, and Asian theatre may be seen around the world on a literally daily basis.

CONTEMPORARY THEATRE

Chapter XI

The Contemporary Theatre period consists of two other major periods: the Modern Drama period, which started approximately 1870, and the Postmodern Drama period, which began to appear near the middle of the twentieth century. However, in order to fully appreciate Modern Drama we need to examine those earlier practices to which Modern Drama reacted. A fuller discussion of the antecedents to Modern Drama may be found in the Development of Theatre section consisting of Chapters XVII through XXI.

BEFORE MODERN DRAMA

There were two predominant dramatic styles around the beginning of the nineteenth century: **melodrama** and the **"well-made play."**

THEATRE BACKGROUND

As noted before, acting was defined by "lines" such as leading lady, leading man, soubrette, utility player, and so on. When actors or actresses first entered a theatre company, they entered in a particular line. When parts for a new script were assigned, the leading-lady-line-actress, as a matter of right, was entitled to the most important female role. For example, a 50-year-old actress might play the role of Juliet rather than an actress of a more appropriate age. If the individual actress recognized that the role of Juliet was not appropriate to her age, she could surrender it to a younger leading lady actress—but lacking that surrender, the role was hers by right.

Costuming was often neither historically accurate nor appropriate to the character. It was the actor's responsibility to provide his or her own costume, unless the costume had some unique characteristics, in which case the company might cover part of the cost. Actors chose costumes that made them look "good" on stage and which

supported the perception that the individual actor had status among other actors. In some ridiculous situations, a beggarly character might have a costume made with "rags" of silk and satin.

Most theatre companies in the early to middle nineteenth century used **wing and drop settings**. These consisted of two to five sets of wings, flat-painted units on each side of the stage, with a backdrop behind all of them. The overhead space was masked by borders, often painted to look like foliage or sky, in order to hide the technical equipment at the top of the stage. Because of this, the scenery had a relatively flat look. In some cases, furniture and other properties might be painted onto the flat surfaces of the scenery. The relatively low light level made it somewhat easier to blend the flat elements together. While wing and drop settings were quite common, first-rate theatre companies in Europe had begun using **box settings** for new productions early in the nineteenth century.

Ordinarily, new companies bought a complete set of wing and drop scenery for their initial season. First-rate theatre companies in the major cities, such as London, Paris, and Philadelphia, might have new settings created for each new production. However, for most ordinary theatre companies of the time, any new productions the company did after the first season typically reused scenery built for that first season. If the new play needed a park scene, the managers lowered the park sets they already had and simply chose the one they thought would best fit the new script. The same process would apply if a salon, or room, was needed. Only in specialized situations would scenery be custom painted for a scene in the new production if there weren't an appropriate one already in stock.

Stage lighting in the beginning of the nineteenth century was predominantly gaslight with perhaps a supplement of limelight. The gas lighting consisted of metal pipes with holes drilled in them that were hung overhead behind the scenic borders. Gas was pumped into the pipes and lighted just as we do for gas stoves today. The lighting level could be dimmed by reducing the amount of gas flowing to the pipe behind each border. Obviously, the use of live flame on stage sometimes led to significant fires that also resulted in the loss of scenery, buildings, and lives. Rural and shoestring theatre operations might still use candles or oil lamps for lighting. Even though really bright light could be generated by using limelight, the fact that each instrument required its own individual operator made it expensive to use. The limelight was generated by using the flame of an acetylene torch on a piece of limestone, but it needed constant adjustment. Its intense greenish-cast light gave rise to the expression of "being in the limelight," suggesting that the actor was important enough to have a limelight. Of course electric lighting for the stage was not available until a couple years after Joseph Swan in England invented the electric light bulb in 1878, and Thomas Edison invented it in the United States in 1879.

Production practices were relatively slapdash by our standards. If a new play was being prepared, it might rehearse for up to a week and might not have a complete run-through

before opening night. Even though Johann Wolfgang von Goethe inaugurated the idea of rehearsing shows for up to ten days in the late eighteenth century, relatively few theatre companies adopted the practice. By comparison, professional theatres today often rehearse full time for eight hours per day, six days a week for perhaps four to six weeks. In the nineteenth century, little time or effort was spent on individualized blocking or movement patterns for most shows. It was common practice for the star to move downstage center to act and to use elocutionary vocal techniques to present the character to the audience. Down center was closest to the audience and also where the best lighting was because that's where the footlights were. It's also where the prompter was in case the actors forgot their lines. Shows were done in rotating repertory, which meant the play would only be performed at an interval that management thought would generate a reasonable amount of money at the box office. Thus, there could be days, weeks, or perhaps months, between performances of a given script. Once a production had been performed, actors were expected to be performance-ready after receiving a three- to five-day notice of the next performance date, depending upon the individual theatre company. Typically there would be no additional rehearsals before the next performance—actors were expected to prepare on their own.

MELODRAMA

The composition of the theatre audience started to change in the late seventeenth century and on through the eighteenth century. The late seventeenth-century English audience was heavily aristocratic and upper middle class. The inclusion of lower middle class and even lower-class populations increased during the eighteenth century. By the early nineteenth century, the audiences had significant numbers of lower-class people, who preferred simplified human experiences to which they could easily relate. The result was an audience with a more sentimental attitude toward both life and the types of plays they wanted to see.

Melodrama was originally developed in France as a play with songs and evolved to become a play with musical underscoring. Over a period of time, melodrama producers used a variety of approaches to get the public to continue buying tickets for new productions. One such approach was the inclusion of simplified and idealized presentations of human experiences that reflected the audiences' concerns. Another characteristic was that the nature of the dramatic conflict in melodrama became more external. This put conflict beyond the control of the protagonist; hence the character's responsibility for what happened to him was reduced or eliminated. If father got robbed on his way to deliver the mortgage money, he was not responsible. Likewise, if he was sidetracked by the allure of alcohol, it was the alcohol that did him in, not his own personal shortcomings. With less personal responsibility, melodrama characters tended to become more two-dimensional stock characters who could be divided into "good" or "evil" characters. The hero and heroine were typically idealized into paragons of human virtue, though in some cases they were none too bright.

Still another approach led to the inclusion of more spectacular effects, and acts or scenes frequently ended with a cliffhanger. To entice the public to buy more and more theatre tickets for new shows, spectacular effects were incorporated for their gratuitous affect. Thus, we get the stereotypic image of the heroine tied to the railroad tracks or the hero tied to a log about to run through the buzz saw in the sawmill. Yet invariably, despite all the conflicts that might arise during a melodramatic play, there was always a happy ending in which the hero and heroine were reunited. This preference for happy endings had started in the sentimentalism of the eighteenth century and continued into the nineteenth century. It even saw Shakespeare's tragedies rewritten to provide happy endings—with Romeo and Juliet celebrating their marriage at the end of the play, for example.

WELL-MADE PLAY

A major characteristic of the well-made play was its well-crafted "formulaic" approach to scripting. This formula approach was codified by Gustav Freytag (1816–1895), whom we discussed in Chapter V with regard to his diagram of the traditional structure of a play. Such plays were often more realistically structured and motivated than melodramas, and might even address social issues. Two authors of this genre were Eugène Scribe (1791–1861) and Victorien Sardou (1831–1908), who prompted the English playwright, **George Bernard Shaw**, to refer, in mockery, to such plays as "Sardoodledoms." The concept of a well-crafted formula script led to the development, particularly in France, of playwriting workshops where individual playwrights in the playwriting studio were masters of particular techniques. If a romantic scene between two young lovers was needed, then the playwright who was best at writing romantic scenes wrote that scene in the script. If another scene involved a fight between two men, then the playwright who was most proficient at writing conflicts between men would write the scene. Thus, plays were sometimes the result of a committee approach rather than the work of an individual artist.

MODERN DRAMA

In opposition to the prevailing theatrical environment of melodramas, well-made plays, and various musical revues, some playwrights wanted to present more realistic situations on stage. In part, they were responding to the scientific discoveries that suggested a different way of looking at the world and society.

SCIENTIFIC BACKGROUND

There were a number of physical, social, and political scientific issues that impacted and were reflected in Modern Drama. We need a brief understanding of the scientific

thinking that prompted those playwrights to deal with new topics in new ways from the middle to the end of the nineteenth century.

Karl Marx (1818–1883), best known for his book *The Communist Manifesto* (1848), advanced the idea that the proletariat, or working class, possessed the most important component of industrial production, specifically its labor. He argued that the proletariat needed to control its labor for its own advantage rather than for the advantage of the industrialists. This led to conflicts between the working class and the owners, a class conflict that was regularly represented on stage and in literature, such as in the novels of Charles Dickens.

Charles Darwin (1809–1882) is best known for his book *On the Origin of Species* (1859). Charles Darwin advanced his theory of the evolution of species, based on the concept that individual species struggle or conflict with their environment and other members of their species for survival and the subsequent opportunity to reproduce. Each individual member of a species struggles for survival and only that individual most and/or best fitted for the environment will be able to survive and produce the next generation. The impact of **heredity and environment**, which are central considerations in Darwin's original theory, likewise become central issues in the development of the new Modern Drama.

Sigmund Freud (1856–1939) is widely recognized as the father of modern psychoanalysis. He labeled different facets of an individual's mind as the superego, the ego, and the id. These terms are not used that much today. The terms used for contemporary transactional analysis are parent, adult, and child, clearer notations of the mind's components. The superego, or the judgmental parent, is that component which imposes the moral imperative of "should" and "ought." The ego, or the adult, is concerned with everyday actions of getting through life and is the component that decides whether there is time to cross the street without being hit by an automobile. The id, or child, is concerned with satisfying uninhibited childlike impulses of self-indulgence. The significance of Freud's contribution was that it provided a way to understand the complexity of the human thinking process and the motivation for people in real life. When such complex people were put on stage as characters in plays, Freud's ideas served as a basis for presenting such complexity. **Henrik Ibsen**'s play, *Hedda Gabler*, illustrates such a character switching from one psychological state to another, which can only be adequately understood in terms of the multiple components of the human mind, as identified by Freud.

THEATRICAL BACKGROUND

Rarely does a new style or practice immediately supersede that which preceded it. Changes generally take place gradually. While many theatre people collectively refer to Henrik Ibsen, George Bernard Shaw, August Strindberg, and Anton Chekhov as

"fathers" of Modern Drama, they were preceded by other playwrights in both Europe and America who were attempting to present more realistic characters and dramatic situations on the stage. In England, there was Thomas Williams Robertson's (1829–1871) *Caste* (1867). In continental Europe, there were Alexandre Dumas *fils'* (1824–1895) *The Lady of the Camellias* (1852) and Émile Augier's (1820–1889) *M. Poirer's Son-in-Law* (1854). In the United States, Modern Drama didn't arrive until decades after its emergence in Europe. Here, its precursors were William Gillette's (1855–1937) *Secret Service* (1895) and William Vaughn Moody's (1869–1910) *The Great Divide* (1906).

REALISM

The philosophic goal of realism was to show the effect of heredity and environment. Modern Drama also had a significant social concern. Some playwrights wanted to address specific social theses, and the script was how they did it. For example, in George Bernard Shaw's play *Pygmalion*, Shaw's view was that language defined social class. The play thus became a discussion of how Liza, a guttersnipe with no socially acceptable speech or behavior patterns, is educated through lessons in voice and social etiquette to emulate the behavior of aristocracy. Several dramatists dealt with these types of plays.

© Nicku, 2014. Used under license from Shutterstock, Inc.

Henrik Ibsen.

Figure 11.1 *Henrik Ibsen, who wrote in several styles and genres, is today best known outside Norway as one of the fathers of Modern Drama.*

Henrik Ibsen (1828–1906; Figure 11.1) was a Norwegian playwright who wrote many historical and romantic plays early in his career. In the 1870s, he became more interested in realistic dramas and today is recognized primarily for the realistic plays he wrote. *A Doll's House* (1879) (Some critics and scholars refer to the play as *A Doll House*, feeling that is a more accurate representation of the play's theme.), addressed the status of women in the typical nineteenth century household. Years ago in the play, Nora forged a signature in order to obtain a loan to take her husband on a curative trip. Nora feels that it was appropriate for her to do so because it saved her husband's life, but her lawyer husband does not see it that way. Torvald, her husband, instead chastises her, pointing out that she is just like her father, who also forged documents, thus invoking the issue of hereditary as an influencing characteristic of Modern Drama. Nora also fears the bad influence she might have on her children by just being in their presence—another reference to the

issue of heredity and environment. Because the audiences of that time were scandalized by the notion that a woman would walk out on her husband and children, they rioted repeatedly when the production was mounted in various locations in Europe.

Later in *Ghosts* (1881 but not presented till 1882), Ibsen addressed the issue of what happens when a woman, who should have left her husband, does not. If that weren't bad enough, he incorporated the topic of syphilis. In the play, Oswald is infected with syphilis, a disease Ibsen thought was hereditary, hence a reference back to the characteristic of Modern Drama. Oswald asks his mother to give him poison when he reaches the point that he goes insane and is not able to take care of himself. Again, audiences across Europe were incensed that such topics were presented on stage and repeatedly referred to such plays as "filth."

George Bernard Shaw (1856–1950), who was awarded the Noble Prize in Literature in 1925, wrote *Mrs. Warren's Profession* (1894), in which a well-to-do woman faces a social dilemma. Mrs. Warren's daughter, who was educated at the university, introduces her fiancé to her mother. Everyone learns that Mrs. Warren is a professional prostitute who owns several "houses" in Europe. In his preface to the play, Shaw defends Mrs. Warren's right to earn an acceptable standard of living for herself and her family through the means at her disposal, regardless of society's constraints on prostitution.

Anton Chekhov (1860–1904), a Russian playwright, wrote *The Seagull* (1896), which dealt with the life surrounding Arkadina, a Russian stage actress, her lover Trigorin, and her son Treplev. *The Seagull* is important because it was produced by the Moscow Art Theatre in its first season. The play was originally mounted unsuccessfully in St. Petersburg using traditional nineteenth-century production techniques. However, when mounted in Moscow with Constantin Stanislavski's direction and the production practices of the new Modern Drama, it was a critical and financial success (Figure 11.2). But even at that, there was still some negative reaction to the script. The production was temporarily censored by the government because the relationship between Trigorin and Arkadina was deemed too sexually explicit for the stage (Figures 11.3).

Figure 11.2 *Anton Chekhov reading his play,* The Seagull, *to the cast. Stanislavsky sits at the extreme right.*

© Nicku, 2014. Used under license from Shutterstock, Inc.

CONTEMPORARY THEATRE **129**

Figure 11.3 *Chekhov's plays are still a significant part of contemporary theatre seasons. This production of* The Seagull *featured variously draped fabric curtains to create the environment of the play.*

NATURALISM

Naturalism is a specialized category of realism, in which the realistic elements become superrealistic. The philosophic intent of naturalism was perceived as the "scientific" study of people. Scientists put animals in mazes or similar experimental situations to observe how the animals responded. Other scientists of the day took thin slices of their specimens to examine under the microscope. Following the example of the scientists, naturalistic playwrights put characters on stage in difficult situations to observe how they reacted to the "experiment." Some considered this the same as taking a "slice of life" to put on stage so it could be examined. The idea was to set up an "experiment" on stage and give the audience the opportunity to observe the experiment taking place in front of it. Because naturalism is thought of as a "slice of life" it often has a darker nitty-gritty underbelly of society aspect to it.

"FOURTH WALL" CONVENTION

The naturalistic theatre's movement toward more "scientific" plays reinforced the movement toward more realistic looking scenery and consolidated theatre's dependence on the proscenium theatre structure. The environment for plays, whether realistic or naturalistic, tended to look more and more like real rooms, which gave more emphasis to the box set. The box set looked like a room with two sidewalls, a back wall, a floor, and a ceiling. In realism, the box set and fourth wall convention provided more believable environments for the plays. However, in naturalism, where the intent was to put an "experiment" on stage, it was necessary for the room's fourth wall to seem

to be transparent so that the audience could watch the experiment taking place on the stage. At the same time, the characters, the "test animals," were "oblivious" to the transparent fourth wall and the observing audience. In some productions, the characters sometimes faced upstage as "real" people might do in a real room or chairs might be placed with their backs to the audience. This real depiction of action only increased the use of box sets during the nineteenth and the twentieth centuries (Figure 11.4).

In addition to the transition from wing and drop sets at the beginning of the nineteenth century to box sets by the middle to the end of the century, there were other changes in production practices relating to directing and acting. The more realistic scripts being written impelled more realistic approaches in both acting and directing as illustrated in the

Image courtesy of Robert Smith.

Figure 11.4 Moon Over Buffalo *is a contemporary manifestation of a box set. It has a floor, side walls, and a back wall that look like a real room, complete with a collection of set decoration properties. The set was mounted on a wagon to allow for shifting scenes, the reasons for the dark horizontal line or crack on the downstage portion of the floor.*

productions done by the **Duke of Saxe-Meiningen**. The subsequent European tours of the Meiningen Players influenced other future directors, such as André Antoine in France at his Théâtre Libre, Otto Brahm in Berlin at the Freie Bühne, and Constantin Stanislavski in Moscow at the Moscow Art Theatre. Stanislavski also started developing his system of acting training, which could be used for the new Modern Drama rather than the stilted approach of the Delsarte system.

POPULAR ENTERTAINMENT

Modern Drama plays were not the only form of entertainment that were done in the theatres of America and Europe for most of the nineteenth and some of the twentieth century. Other popular entertainments were frequently done in theatres including **vaudeville, burlesque, circuses**, and *Tableaux Vivants*.

Vaudeville developed from the middle of the nineteenth century till the Great Depression in the twentieth century. Essentially it consisted of a program of unrelated variety

acts that had little more purpose than to entertain the public, often the lower classes. A typical program might consist of singers, animal acts, dancers, jugglers, acrobats, and comic skits or short plays, each of which might be about fifteen to thirty minutes long. In the beginning, some vaudeville acts were not considered suitable for family entertainment. Starting in the 1880s, Tony Pastor (1837–1908) improved the quality of vaudeville offerings by removing the suggestive components until vaudeville was considered appropriate for families. Vaudeville continued in this vein into the twentieth century. Today it shows up as variety shows or revues, particularly on TV.

Burlesque originally meant a parody or a satiric interpretation of some other art form and maintained that original form in Europe, particularly in England. As mentioned before, when producers get anxious about selling enough tickets to fill the theatre, producers resort to the inclusion of other diversions, such as implicit or explicit sexuality. Such was the case in the United States where burlesque eventually degenerated into little more than a strip-tease show.

Circuses became quite popular in the late eighteenth century and continued into much of the nineteenth century. Today circuses typically perform under canvas tents that tour with the circuses, or perform in large arenas. However, from the eighteenth century through the beginning of the twentieth century, circuses sometimes took place in a theatre. Larger traditional theatres were renovated to accommodate circuses, often with horses and riders. When the circus was done, the venue was renovated back into a theatre.

Tableaux Vivants, which means "living pictures," were popular during various parts of the nineteenth century, but there is relatively little interest in them today. A *Tableaux Vivant* presented a work of art, typically a sculpture or a painting, as a three-dimensional representation with living performers, often in a theatricalized presentation. Classical Greek and Roman sculptures were always popular because they seemed to present "naked" figures under scanty fabric drapes, even though the women were invariably wearing tights. Modern audiences may get a sense of *Tableaux Vivants* from Stephen Sondheim's musical *Sunday in the Park with George* (1984) in which the last image in Act I is a recreation of Seurat's painting *A Sunday Afternoon on the Island of La Grand Jatte* (1884).

ANTIREALISTS

As the nineteenth century turned into the twentieth century, there was a significant negative reaction to realistic and naturalistic dramas. Many people were not sympathetic to the theatre's depiction of events and actions that resembled everyday life and which dealt with topics that many people felt should not be discussed in polite society. This resulting reaction against realism, referred to as antirealism, lasted for

the first ten to thirty years of the twentieth century. Many of the young people who were interested in the antirealist movement were disaffected young men, some of whom had moved to Switzerland, in part because Switzerland was a nonaligned neutral nation during World War I. Many of those young people were dismayed by the stories of the horrors taking place on the battlefields. There were a series of movements including **Symbolism, Futurism, Dadaism, Surrealism,** and **Expressionism**.

- In Symbolism, the plays evoked a sense of mystery and mysticism rather than realism and characters often had symbolic meaning. Maurice Maeterlinck (1862–1949), a symbolic playwright, who was awarded the Nobel Prize in Literature in 1911, wrote *The Blue Bird* (1908). In it, a brother and sister, seeking the blue bird of happiness, travel the world searching for it, only to ultimately discover upon their return that it had been in their own backyard all the time.

- The Futurists idolized the technological equipment and machinery of war—not so much because it was for war, but because of its use of ingenious mechanical equipment. Locomotion was highly valued and there was often a compression of time and space in futurist plays. Though there were no futurist plays of any significance, futurist concepts and its admiration for technology does show up later in the twentieth century in such plays as **Eugene O'Neill**'s (1888–1953) *The Hairy Ape* (1921).

- Dadaism, a nonsense term, was a reaction against rules and regulations. While many of the "isms" had manifestoes dealing with the philosophy of the individual movements, Dadaism by contrast had no rules, no standards, no guidelines, no meaning, nothing—it was life without rules.

- Surrealism focused upon the unconscious and the dream world—hence there was a rejection of logic. Some contemporary playwrights included Jean Cocteau (1892–1963) and Federico Garcia Lorca (1898–1936). In Lorca's *Blood Wedding* (1933), the Moon comments on the action taking place on stage.

- Expressionism's objective was to present the play from the perspective of the main character. This often gave a harsh distorted unreal quality to the protagonist's perception of what was happening in the play. Of the various "isms" that were developed during this time period, Expressionism is the only one that was significant enough to continue on toward the middle of the twentieth century.

The Italian, **Luigi Pirandello** (1867–1936), who wrote *Six Characters in Search of an Author* (1921), is probably the most important author of nonrealistic plays. He was awarded the Nobel Prize in Literature in 1934. For him truth was not fixed in reality. Just as each individual's reality could change, so too could his "truth." In the play, the six characters who were discarded by their original author show up at a stage seeking to have their story told. They try to entice the director into helping them complete their story by having him become their new author. The work is an archetypal

discussion of illusion versus reality and art versus life. In one of his lines, the Father strongly suggests to the director that their lives as characters are more awe-inspiring than the lives of the real people because the characters' lives are fixed and immutable for all time, whereas the lives of the actors change from day to day.

EPIC THEATRE

Bertolt Brecht (1891–1956) started as an antirealist, but by the late 1920s he developed what he called epic theatre, which was also a reaction against realism and naturalism. Brecht did not want his audiences to become emotionally attached to the characters nor to emotionally lose themselves in the action of the play. He wanted the audience to distance itself from the production, thus creating the "alienation effect" (*Verfremdungseffekt*), which was intended to jar his audience out of its emotional stupor and to make it think about the events being depicted on stage. In *The Three-penny Opera* (1928), Brecht set his play among the pickpockets and petty thieves of the Victorian-era London, incorporated discordant music, and used signs to label the scenes. By revealing in advance what was going to happen in the scenes, he sought to keep the audience from being caught up in the action so it could focus on the content being presented. Brecht was an ardent communist for whom, though rarely stated overtly in his plays, communism was the answer to the problems depicted in his plays. Brecht came to the United States to escape the Nazis, and he worked in Hollywood for a number of years writing film scripts. In 1947, he was called before the **House Committee on Un-American Activities**, under the leadership of Joseph McCarthy (1908–1957), who was conducting a witch hunt for members of the Communist Party in American society. When Brecht was called before the committee, he was asked—as were all people appearing before the committee—"Are you now, or have you ever been, a member of the Communist Party?" He denied membership and soon booked ship-passage back to Germany where the communist East Germany government welcomed him and gave him the Berliner Ensemble theatre in which to work for the rest of his professional life.

AMERICAN MODERN DRAMATISTS

Having laid out a basic chronology for the late nineteenth and twentieth century Modern Drama in Europe, we need to look more closely at the work of American playwrights. Though they may not have made significant contributions toward the development of Modern Drama during the first half of the twentieth century, nevertheless they were important in terms of being world-class artists. In our discussion, there is only room to comment on one or two of their most important or representative plays.

The first of these was Eugene O'Neill (1888–1953) whose two most important plays are *A Long Day's Journey into Night* (1939–1941) and *The Iceman Cometh* (1939, but not performed on Broadway till 1946). The semiautobiographical *A Long Day's Journey into Night*, depicts a single long night in the dysfunctional Tyrone family, which is weighed down by alcohol and drug abuse. *The Iceman Cometh* is set in Harry Hope's bar, filled with down-and-out alcoholics who still have hopeless dreams of changing.

Their friend, Hickey, arrives with a new message for them to face their delusions. In the end, most return to their previous delusions as Hickey is hauled away by the police for murdering his wife (Figure 11.5). Eugene O'Neill won several Pulitzer prizes for his plays and was the first American playwright to have a significant presence on the world stage, due in no small part to being awarded the Nobel Prize in Literature in 1936.

Tennessee Williams (1911–1983), (né Thomas Lanier Williams), wrote *A Streetcar Named Desire* (1947). Blanche Dubois, the leading female character in the play, was brought up in a privileged life on a Southern plantation. Desperate to escape the death which surrounded her on the plantation where family members were dying, she soon steps beyond the pale of proper behavior, for which she is terminated as a high school English teacher. When she visits her sister, she runs into Stanley, her sister's husband, whom Blanche perceives as a brutish ignorant man. Their conflict, and her eventual destruction, becomes a metaphor for changing class structure in the United States following World War II.

Figure 11.5 *Four cast members from the original Broadway production of The Iceman Cometh.*

Arthur Miller (1915–2005) wrote *Death of a Salesman* (1949). Willy Loman, the protagonist in the play, has been bothered for decades by his own perception of his role in the failure of his son, Biff. This stems from Biff's discovery of his father's infidelity in a hotel room in Boston seventeen years before the play starts. Willy's dream was to be a successful well-liked businessman. In a last desperate reach for the American

dream, Willy commits suicide with the expectation that a $20,000 life insurance policy payout will get Biff started in a business career. However, Biff has accepted that he is just an ordinary guy who will never achieve greatness.

NEW THEATRE SPACES

In addition to the new approaches in directing, acting, and playwriting styles, there were new developments in theatre spaces. For most of the nineteenth century, theatre was presented in proscenium theatres, a configuration on the European continent that had been passed down without major changes from the seventeenth century. In those theatres during the latter part of the nineteenth century, box sets were often used. However, some theatre companies experimented with different actor–audience relationships. For example, the thrust stage, which was resurrected from the Elizabethan theatre configuration, permitted the audience to sit on three sides of the performance, with a more or less detailed scenic background. The rapport between the actors and the audience was improved on the thrust stage, prompting others to see whether a similar improvement in rapport would exist in arena productions. The success of those practices soon led to the building of arena theatres, where the audience totally surrounded the performance.

During the middle and latter part of the twentieth century, any large-volume space could be pressed into use as a theatrical performance space. This led to the development of adjustable or flexible theatre spaces—that is, spaces where the actor–audience relationship could be adjusted on a show-by-show basis. In America's largest cities such as New York City, those "found spaces" greatly reduced the costs of doing theatre because of the reduced need for extensive scenery. A particular outgrowth of this was the development of **environmental theatre**. The distinguishing characteristic of environmental theatre was that both the audience and the characters of the play were conceived as occupying the same environment. A classic example was Amiri Baraka's (1934–2014) production of *Slave Ship* (1967) in which the audience was made to feel it also was in the cargo hold of a ship transporting slaves from Africa to America.

POSTMODERNISM

Though many playwrights continued to write realistic and naturalistic plays well into the late twentieth century, around the middle of the twentieth century some playwrights started writing different kinds of plays. For the rest of the century, playwrights continued trying new approaches. Some plays started to pose questions without offering clear answers. Plays fragmented the characters or had subplots. Some playwrights took plots and situations from other works and cast them in new situations or examined them from a new perspective, such as the feminist perspective.

Often there was an illogical arrangement of the actions. **Postmodernism** is the style most prevalent in Europe and the United States at the present time. In it, playwrights draw from and mix together any of the previous theatrical styles, a very eclectic process that makes it virtually impossible to label any given play as belonging to a single particular style. Generally, this process began in France in the early 1940s with existentialism.

EXISTENTIALISM

The philosophic base to existentialism is that there is no moral order to the universe and hence no guiding rules. Individuals merely exist and it is incumbent upon individuals to formulate their own rules and standards for existing. In **Jean-Paul Sartre's** (1905–1980) *No Exit* (1944), three characters are shown into an oddly furnished room. During the course of the play, we learn that they are in fact in hell and that their punishment is to pay retribution for the pain they caused others in life. The relationship that each seeks with the other two will not be possible, and they are meant to torment each other for eternity. Perhaps the most famous line in the play is "Hell is other people." Sartre was awarded the Nobel Prize in Literature in 1964.

THEATRE OF THE ABSURD

Theatre of the absurd was influenced by existentialism and was an aftermath of the philosophical chaos that ensued at the end of World War II. Europe was devastated by the war that had raged across Europe through country after country for the better part of a decade. In addition, the dropping of the atomic bomb on the Japanese cities of Hiroshima and Nagasaki made the world painfully aware of how fleeting life really could be—100,000 human lives were easily obliterated in a microsecond. For a short time Europe felt reassured, secure in the knowledge that only the United States had the atomic bomb. When Russia got the atomic bomb in less than five years, any sense of security quickly evaporated. Europe was well aware that it would be the battleground in a nuclear conflict between the Union of Soviet Socialist Republics and the United States. That knowledge nurtured the social angst of the futility of life, particularly a life that seemed to be without moral order or even the benign attention of a caring god. In addition, the bellicose language of the Cold War instilled the concept of the futility of communication. Martin Esslin, as noted earlier, recognized these characteristics in the works of several playwrights and wrote about it in his book, *Theatre of the Absurd* (1961).

Several playwrights of the time period, particularly in France, started to present this nihilistic view of life in plays such as *The Bald Soprano* (1950) by **Eugene Ionesco** (1912–1994) and *Waiting for Godot* (1953) by **Samuel Beckett** (1906–1989), who was awarded the Nobel Prize in Literature in 1969. Both playwrights, though not born in France, are considered to be French in outlook after each emigrated to France early

in his life. In both plays there is the clear sense that the situation is going to repeat itself in an endless cycle after the curtain falls, thus indicating the problem has no solution. Ionesco addressed the futility of communication in *The Chairs* (1952), and examined Shakespeare's play in *Macbett* (1972). Beckett's *End Game* (1957) addresses the nuclear holocaust directly by being set at the end of the world. Then in *Breath* (1969), the entire action is a thirty-second cry/sigh, starting with a baby's cry and ending with a death gasp.

Other European playwrights pursued the agenda started by Ionesco and Beckett. Heiner Müller (1929–1995) sometimes reworked other famous plays for a more contemporary socialist agenda, in such works as *Hamletmachine* (1977). English playwrights included Edward Bond (1935–), Harold Pinter (1930–2008), and Caryl Churchill (1938–). Bond dealt with inarticulate characters, particularly in *Saved* (1965), in which a baby is stoned to death in its perambulator. In *Lear* (1971), he rewrote Shakespeare's play to make it more contemporary. He revisited the Shakespearean theme again in *Bingo* (1974), this time faulting Shakespeare for not having a political commitment. Pinter, who was awarded the Nobel Prize in Literature in 2005, wrote of enigmatic situations and fragmented families and relationships in *The Birthday Party* (1957), *The Homecoming* (1964), and *Betrayal* (1978). Churchill often fragmented her characters. *Top Girls* (1982) opens with a drunken party scene in which Marlene is celebrating her promotion with other "top girls" from history. The actresses playing those other characters at the party subsequently acted different characters in the play. In *Cloud Nine* (1979), Churchill fragments characters even more by using numerous instances of cross-gender casting, and also addresses issues of sexuality.

AMERICAN PLAYWRIGHTS

Edward Albee (1928–2016) started writing absurdist plays, but later became a post-modern eclectic playwright whose masterpiece is considered to be *Who's Afraid of Virginia Woolf?* (1962). In it, Martha and George, a college history professor, go after each other tooth and nail because neither totally lives up to the aspiration that the other has for a spouse. Because they were unable to have children, they fabricated a fictional child, whose achievements and failures become the ammunition with which they pummel each other. Into this toxic environment enter a young ambitious biology faculty member and his mousey wife, resulting in a night that none of them will ever forget. In *Seascape* (1975), two lizard-like creatures come out of the sea onto the land to see whether they want to continue their evolution. Following an afternoon discussion with a human couple, they decide to return to the sea. In *Three Tall Women* (1991), Albee has fragmented one character into three parts, each played by a different actress.

Lanford Wilson (1937–2011) wrote a number of realistic-seeming plays, perhaps the best remembered one was *The Fifth of July* (1980), which opened in 1978 at the Circle

Repertory Theatre that he helped found. Wilson, homosexual himself, often wrote of gay identity and gay social issues. In *The Fifth of July*, a gay wounded Vietnam veteran faces anxiety about starting a new job as a high school teacher, while a cloud of self-absorbed stoners swarms around him.

August Wilson (1945–2005) was a self-educated black playwright. A high school teacher accused him of plagiarism, so Wilson walked out of the school and educated himself at the Pittsburgh Public Library. Wilson set himself the task of writing a ten-play series, called *The Pittsburgh Cycle*, which chronicled the black experience in America during the twentieth century, one play for each decade of the century. Shortly after completing the last play in the series Wilson died of cancer. Probably his best remembered play in the series is *Fences* (1985), which opened on Broadway (1987) starring James Earl Jones (1931–). The major character, Troy Maxson, was a significant baseball talent, who could not play Major League Baseball, in part because of his color. His personal disappointment motivates him to prohibit his son from pursuing a college athletic scholarship so that his son will not likewise be disappointed by the failure of white men's promises. Though the play started in 1957 and Troy himself broke a color barrier, becoming the first black garbage truck driver in Pittsburgh's sanitation department, he is unable to see that for his son the times are changing.

Sam Shepard (1943–2017) is relatively unique because he is both a world-class actor (perhaps best remembered for the film, *Apollo 13*) and a world-class playwright. In the beginning of his acting career, Shepard was dissatisfied with the roles that were available for young men of his age and decided to solve the problem by writing those roles himself. One of those was *True West* (1980), a play that gave new meaning to the expression "sibling rivalry." One brother is a reasonably successful Hollywood screenwriter, the other not much more than a hustler. The play ends without resolution, but it seems relatively clear that one is going to kill the other shortly after the curtain falls.

Beth Henley (1952–) is sometimes referred to as the "southern Chekhov." In *Crimes of the Heart* (1977), she seems to have used Chekhov's *The Three Sisters* as a springboard. The play deals with the three McGrath sisters, who are trying to reconcile the disappointments and unhappy consequences of their dysfunctional lives, as they are caught up in a dizzying array of comic interventions.

Suzan-Lori Parks (1963–) is arguably the best living black female playwright in the United States today, having won a Tony and a Pulitzer. In her play *In the Blood* (1999), she recasts Nathaniel Hawthorne's (1804–1864) *The Scarlet Letter* (1850) into contemporary idioms. Her play, *Topdog/Underdog* (2002), goes even further than Sam Shepard's *True West* in its depiction of sibling rivalry. Here, the rivalry is much rawer and is constantly simmering just beneath the surface as the two brothers, Lincoln and Booth, try to accommodate to their situation in life. The characters' names foreshadow what is going to happen at the end of the play.

The move away from Broadway, to a great extent, paralleled postmodernism. Just as fragmentation was part of postmodernism, so too was there a fragmentation of where theatre was presented. The first move, labeled "**Off-Broadway**," referred to productions performed in theatres with fewer than five hundred seats. This allowed a reduction in the cost for theatre productions and permitted a greater degree of experimentation and the presentation of more avant-garde works than were possible on Broadway. The major Off-Broadway movement started in the 1950s and may be represented by the founding of the New York Shakespeare Festival in 1954. Approximately a decade later in the 1960s, a movement to "**Off-Off-Broadway**" got underway. The seating was limited to 199 seats, and the theatres typically were in found spaces that had been converted to performance venues. About the same time in the 1960s, the Ford Foundation started making grants available for funding theatre productions and for the construction of theatre buildings. With Ford Foundation money, performance spaces could be constructed across the country—construction that eventually led to the creation of more than two hundred regional theatre companies.

TWENTY-FIRST-CENTURY THEATRE

In many ways there was no clear distinction between twentieth-century theatre and twenty-first-century theatre. For the most part, the production processes and styles of the twentieth century just slid into the twenty-first century. The eclecticism of the end of the twentieth century continued to be the predominant style of the twenty-first century. Many of the newer scripts have unrealistic plotting, including angels and ghosts as characters in the shows. Some of the elder playwrights of the twentieth century essentially retired and were no longer active in the twenty-first century. However, many other active playwrights of the late twentieth century continued to write into the twenty-first century. Those include Edward Albee (1928–2016): *The Goat, or Who is Sylvia?* (2002); Tom Stoppard (1937–): *Coast of Utopia* (2002), *Rock 'n' Roll* (2006), *The Hard Problem* (2015); Caryl Churchill (1938–): *A Number* (2002), *Seven Jewish Children* (2009), *Love and Information* (2012); Christopher Durang (1949–): *Vanya and Sonia and Masha and Spike* (2012), *Why Torture is Wrong, and the People Who Love Them* (2011); Patrick Shanley (1950–): *Doubt, A Parable* (2004), *Storefront Church* (2013); Paula Vogel (1951–): *Indecent* (2015); and Suzan-Lori Parks (1963–): *Top Dog/Under Dog* (2001), *Father Comes Home from the War* (2018).

A couple relatively new voices in the twenty-first-century theatre include Sarah Ruhl (1974–) and William Cain (1947–). Ruhl has already been a finalist for two Pulitzer prizes, was nominated for a Tony Award for Best Play, given a McArthur "genius" Award, and teaches at the Yale School of Drama. Her major works are

Eurydice (2004), *In the Next Room (or The Vibrator Play)* (2009), and *For Peter Pan on Her 70th Birthday* (2017). Her plays include mysticism and ghosts and juxtapose ordinary aspects of life with mythic issues of love and war. William Cain, a Jesuit priest, worked as an actor and director, founded a Shakespeare company in Boston, Massachusetts, and wrote for the ABC TV series "Nothing Sacred" back in the 1990s. His major plays include *Equivocation* (2009), which deals with Shakespeare as a character in the Gunpowder-plot attempted assassination of James I of England in 1605, and *How to Write a New Book for the Bible* (2012), which deals with Cain caring for his dying mother. Interestingly enough, both *For Peter Pan on Her 70th Birthday* and *How to Write a New Book for the Bible* contain autobiographical material about the two authors' mothers.

Key Names, Venues, and Terms

Absurdism (Theatre of the Absurd)

Edward Albee

Alienation Affect *(Verfremdungseffekt)*

Antirealism

Dadaism

Expressionism

Futurism

Surrealism

Symbolism

Samuel Beckett

Box Set

Burlesque

Anton Chekhov

Circus

Charles Darwin

Environmental Theatre

Epic Theatre

Existentialism

Fourth Wall Convention

Sigmund Freud

Beth Henley

Heredity and Environment

House Committee on Un-American Activities

Henrik Ibsen

Eugene Ionesco

Karl Marx

Melodrama

Arthur Miller

Naturalism

Off-Broadway

Off-Off-Broadway

Eugene O'Neill

Suzan-Lori Parks

Luigi Pirandello

Postmodernism

Realism

Duke of Saxe-Meiningen

Jean-Paul Sartre

George Bernard Shaw

Sam Shepard

Tableaux Vivants

Vaudeville

Well-made Play

Tennessee Williams

August Wilson

Lanford Wilson

Wing and Drop Set

Additional Reading

Brocket, Oscar and Robert Findlay. *Century of Innovation: A History of the European and American Theatre and Drama since the Late Nineteenth Century.* 2nd ed. Boston: Allyn & Bacon, 1991.

Eyre, Richard and Nicholas Wright. *Changing Stages: A View of British and American Theatre in the Twentieth Century.* London: Bloomsbury, 2000.

Innes, Christopher. *Avant-Garde Theatre, 1892–1992.* New York: Routledge, 1993.

Roose-Evans, James. *Experimental Theatre: From Stanislavsky to Peter Brook.* 2nd ed. New York: Routledge, 1996.

VARIETY OF THEATRE VENUES

Chapter XII

There are several types of theatre operations or venues in the United States. Let's examine the purpose and operation of a number of them.

COMMERCIAL THEATRE

Actually, there are two types of **commercial theatre** operations. The first, with which we are most familiar, are the productions that appear on **Broadway**; the second consists of industrial theatre operations. The primary purpose for commercial theatre is to make money. In the United States, that primarily means "Broadway" in New York City, or more specifically, those theatres located approximately between Sixtieth Street and Thirty-Fifth Street and

Figure 12.1 *The lights of Times Square in New York City, which is in the heart of the theatre district, blaze with advertisements for theatre and other commercial products.*

Photo courtesy of Robert smith.

between Sixth Avenue and Eighth Avenue (Figure 12.1). In England, the primary location for commercial productions is London's West End.

143

BROADWAY AND TOURS

Everything about a Broadway production is handled to maximize the amount of money that may be charged for tickets to the production. Thus, producers will take great pains to hire artists, both actors and designers, whose work will justify the highest ticket price. It is common today for good tickets to a top Broadway musical to cost at least $150 per seat. If one wants seats in the middle of the orchestra for a hit Broadway musical on a few days' notice, then you are talking about more than $450 or $500 per ticket. The intent of most Broadway productions is to run the show for as long as possible in order to bring in the greatest amount of money. When the show in New York City is a success and the producers can reasonably project a weekly profit, the producers invariably consider alternate performance venues in other cities—known as touring companies. The touring process starts by doing an extended run production in major cities in the United States, such as Chicago, Los Angeles, Miami, Dallas, Washington, DC, and so on. In these venues, as was the case in New York City, the production will perform for as long as possible while still making a profit—typically for weeks or months (Figure 12.2).

Photo Courtesy of Robert Smith.

Figure 12.2 *The Shubert Theatre, which is just off Times Square in New York City, is one of the iconic theatres in the Broadway theatre district.*

After the market for large cities has been exhausted, the producers turn to limited engagements of weeks run, **split-week runs,** and **one-night stands**. In many ways, runs of only a couple weeks are similar to open runs except that they start as limited engagements. In a split-week run, the production is often divided between two reasonably close locations such as Cincinnati and Cleveland, Ohio. The production might play Tuesday, Wednesday, and Thursday in Cleveland and then perform Friday, Saturday, and Sunday in Cincinnati. After the market for split-week performances has been exhausted, the producers typically decide to tour one-night stands, sometimes referred to as "**bus and truck**" tours, because the cast and crew travel in busses while the scenery travels in trucks. By this point, the scenery and lights have typically been redesigned so they will fit into only one or two tractor trailer trucks.

The process for presenting a bus and truck tour is so different from the way theatre performances are ordinarily prepared for an audience that it warrants special attention. In virtually all other venues a production takes days or weeks to get into a theatre. A bus and truck tour performance must get in and then out of the venue in about eighteen hours at each location. The trucks arrive at the tour venue's stage door about 8:00 in the morning. The professional touring crew heads supervise the local professional stagehands, who are members of International Alliance of Theatrical Stage Employees (IATSE) in unloading the truck and installing the show into the theatre.

First, the lighting equipment is hung and flown into the flies, the space above the stage. Then the scenery is installed beneath the lighting equipment. After the scenery has been installed, the heads of the scenery department often check into their hotel to sleep until mid-afternoon. Meanwhile, the lighting people focus the lights while the props people install the properties on the sets. Sometime toward the end of the afternoon, the cast arrives in its bus. Occasionally there might be a need to make relatively minor adjustments to fit the particular performance venue, but generally there is little need for a full rehearsal. Preparations for the performance begin and the curtain typically goes up about 7:30 or 8:00 at night. Following the performance, all of the scenery, lights, and costumes are "struck"—or removed from the stage—and packed back onto the tractor trailers and hauled to the next location. The cast members check into their hotel to spend the night before they board their bus the next day to head to the next day's performance venue. Immediately following the strike, the production's technical crew members get on their bus to sleep as the bus travels to the next morning's venue, where the process starts all over again. For everyone involved in touring productions, it is a grueling routine, but the monetary compensation often makes up for that.

INDUSTRIAL SHOWS

Whereas the Broadway production and its touring versions are all about selling tickets for a specific production—the show is the product being sold—in industrial shows, the theatrical process is used as the method to sell some other product. A classic example is the Milliken Fabric shows that appeared regularly in New York City. Fundamentally, the theatrical production was used as the gimmick for exhibiting the extensive variety of fabrics Milliken manufactured. Clearly, it was the fabrics that were being exhibited for sale by the gimmick of a theatre production. Typically, industrial shows are musicals targeted for potential buyers. Industrial shows were quite popular in the late twentieth century, and though they have declined, they have not totally disappeared.

Back in the late 1960s, the author was a stagehand for an industrial show mounted by General Electric's Personal Products Division. Much of the show was representative of Industrial shows. The production's original script had songs, dances, and dialogue intended to market the Division's line of radios, TVs, and phonographs to an audience of buyers. There were many inside jokes that related to the behavior of various

management personnel or the specialized field of personal products advertising and sales. It was the year Sammy Davis Jr. was announced as the Division's spokesperson—the audience erupted in jubilation at the announcement because a whole new market segment was now opened up due to the new spokesperson. The audience consisted of buyers for various stores and chains. The performance started at approximately 9:00 in the morning and seemed to last interminably until lunch. A few managers had dialogue in the production, and some even attempted to sing. One production technique, which kept the audience attentive and awake, was to use attractive scantily clad young ladies holding samples of the Division's product line, while the products were described using sexually provocative innuendos.

PRESENTATION HOUSE

Presentation houses are found on many college campuses and in many intermediate-sized cities in the United States, into which a variety of performance events are scheduled for the public. Presentation houses present a wide range of theatre, opera, music, dance, and other special attractions such as guest speakers (Figure 12.3). They are also the location where the largest percent of Americans are exposed to professional theatrical events. Because of this range of presentations, the facility's primary purpose is **enculturation**—or exposure to the range of cultural heritage—for the surrounding communities. Presentation houses generally are not found in the dozen or so largest cities in the country, because those cities generally have a facility devoted to each type of presentation, including at least one separate facility for touring commercial productions. Those cities frequently have a separate facility for each of the city's various professional artistic companies, such as the opera company, the symphony, the ballet, or the **regional theatre**. In foreign countries, there is also a tendency to have separate stand-alone facilities in the largest cities for each of the types of theatrical presentation: opera, ballet, theatre, and symphony. Sydney, Australia, is somewhat unusual in that its iconic opera house accommodates the full range of theatrical presentations (Figure 12.4).

© Sean Pavone, 2014. Used under license from Shutterstock, Inc.

Figure 12.3 *Radio City Music Hall is an unusual presentation house in a major city. It does a mixed fare of presentations, including its famous Rockettes dancers.*

Because of the range of events scheduled and the difference in audience sizes, presentation houses often have a large space that will seat 1,000 to 2,000 or more and also a smaller performance space. A municipal presentation house, that is, a presentation house supported by the local municipal government, typically is the home for the season of the local professional symphony, the local professional opera company, and the local professional dance company, each typically performing for a couple days to a couple weeks. In addition, such houses typically bring in a

Photo courtesy of Robert Smith.

Figure 12.4 *The Sydney Opera House in Australia is actually a large presentation house. It contains at least six different venues that annually host the opera, ballet, theatre, and symphony along with a range of other attractions. As such, it was built without any production shops other than the incidental repair work that its various tenants might need during their residency.*

season of other events, such as music presentations, touring theatre productions, and a slate of public speakers. If there is a smaller performance space in addition to a large space, the smaller space might be used for the season for a regional theatre company and **community theatre** productions. In part, the variety of offerings is a function of the enculturation objective. Despite that, presentation houses typically must cover much or all of their financial expenses. In some few situations, the municipality may underwrite a small part of the expenses of the presentation house through taxes or donations. Because of the need to cover significant portions of its expenses, presentation houses may host between one hundred and three hundred performances a year.

Presentation houses on a college or university campus are slightly different. Typically, there are no local professional theatre, opera, or dance companies to occupy the facility for significant portions of the year, but there are exceptions. Depending upon the size of the university, the performance spaces may be shared with campus groups and professional touring groups. For large universities, it is common for the largest space to be almost totally dedicated to professional touring presentations. As is the case for municipal presentation houses, collegiate presentation houses have a primary function of enculturation, though that function often is incorporated into the educational mission of the institution. With that in mind, collegiate presentation houses typically offer a large assortment of events.

PROFESSIONAL THEATRE

The professional theatre in the United States, sometimes referred to as **"League of Resident Theatres" (LORT)**, regional theatres, and/or "**nonprofit theatres**," has a primary purpose of enculturation. The idea is that a range of plays from various genres and periods will be presented to an audience for the purpose of widening the audience's cultural experience, while at the same time providing a significant degree of entertainment, and perhaps even some enlightenment. This group of theatres is often referred to as "nonprofit theatres" because Internal Revenue Service (IRS) statutes prohibited such companies from making and disbursing any profits. Virtually all professional theatres in the United States in this category are supported by significant fund-raising activities in addition to selling tickets. These theatre organizations are underwritten, at least in part, by foundation grants; governmental appropriations, such as federal, state, or local Art Council groups; businesses; and donations from individuals. In the extremely rare eventuality that an individual theatre operation actually makes a profit on its season, that profit cannot be dispersed to the executives, but must instead be plowed back into the theatre operations.

In many ways, this "nonprofit" approach reflects the reality of theatre production for the last two and a half millennia. In ancient classical Greece, theatre was underwritten by the Athenian city-state and by an assigned wealthy patron for each production. During the beginning of the reemergence of theatre during the medieval period in Europe, theatre funding was from the Catholic Church, professional guilds, such as leather workers or water bearers, and municipal governments. In Renaissance England's Elizabethan period, theatre companies were sponsored by members of the nobility. From the Renaissance to the twentieth century, there were many court theatres across Europe that presented various types of theatrical productions. Thus, the courts were the sponsors for opera, symphonies, dance, and theatre. In most of the modern twenty-first-century world, theatre is significantly supported by the national government entities, typically at national theatres. In Asia, the traditional Asian theatre forms, and even some contemporary Asian forms, are supported by government appropriations. Only in the United States is there relatively little national government underwriting of theatre and the arts.

The range of professional theatre organizations in the United States is extremely diverse. For example, there are significant numbers of black theatre companies, Hispanic theatre companies, and feminist theatre companies—those that have only female personnel or those that present exclusively feminist issues. New York City has the Pan Asian Repertory Theatre that deals with Asian issues. Last, there are a number of children's theatre companies around the country—those in which children are the actors and those in which adults perform for children. Some theatre companies

only mount original scripts—for example, AMAS in New York City only does original musicals. Other theatre companies only do musicals, still others only do American plays. Despite the fact that there is some specialized focus for some of the theatre companies, probably the majority of professional regional theatre companies in the United States do a variety of productions each season, typically including musicals, dramas, comedies, and a selection of classical pieces, perhaps with an original script thrown in now and then.

DINNER THEATRE

A dinner theatre is one in which a meal and a theatrical production are combined into a single package. For the most part, the purpose of dinner theatres is to provide entertainment to an audience, while ideally making a profit for the theatre owners. Dinner theatres are particularly attractive to people who like to have their entertainment provided in a one-stop-shopping kind of arrangement. Many dinner theatres have their own bar because the profit margin on alcoholic drinks is much higher than that on the food or the theatre performance.

Dinner theatres come in a variety of venues. Probably most deal with some kind of buffet arrangement, though there are some for which a sit-down dinner with waiter service is provided. Sometimes the food is served in one room and the production is presented in another. In still other situations, the space that was initially used for serving the buffet is cleared and subsequently used as the performance space. In still other situations, the table setting is also the point from which the audience watches the production. Because the primary function of dinner theatre is entertainment of the audience, it is typical for dinner theatres to do light comedies and musicals—one doesn't expect to find a production of *Oedipus Rex* at a dinner theatre (Figure 12.5).

© *Courtesy of Robert Smith.*

Figure 12.5 *Dinner Theatres provide entertainment and food as a package operation. Typically the audience watches the production from its dining location. Shown here is the Moulin Rouge in Paris.*

A variation of the dinner theatre concept is what happens at many gambling casinos around the country. There, a show is performed in the "show room" and the "dinner" is reduced to buying several rounds of drinks. For example, one Las Vegas, Nevada, show the author attended had tables so tightly packed together that once the audience was seated at the tables, it was impossible to leave without forcing half a dozen other people to get out of their chairs first.

COMMUNITY THEATRE

The primary function of community theatre is to provide for a nonvocational interest in theatre. For the participants, theatre is the "play activity" by which they relax and have fun entertaining themselves, while hoping and/or presuming that the audience will be entertained as well. Community theatres range from those in which all participants in the production are amateurs to those in which all staff positions are held by trained professionals. In virtually all cases, the actors and the running crew members are volunteers who generally do not get paid. In some specialized cases, actors playing leading roles in community theatre productions might get paid something ranging from $100 per run to perhaps $100 per performance. Those community theatres that operate with professional staffs may do so for decades or they may be growing and aspiring to attain regional theatre status. In terms of facilities, some theatre organizations have state-of-the-art facilities, while others rent or beg the use of a performance space that may be modified for performance functions. As was the case with dinner theatres, where entertainment is a significant component, community theatres often have a tendency to do comedies and musicals, but equally as often might take on serious dramas.

ACADEMIC THEATRE

Regardless of the great variety of academic theatres that exist, virtually all of them have as their core function enlightenment, or education. Sometimes this is primarily for the participants, yet in other situations it is for the audience as well. There is a variety of divisions within academic theatre: the **humanist tradition**/liberal arts, student activity, fund-raising, enculturation, theatre discipline, and professional training.

HUMANIST TRADITION

Probably most collegiate academic theatre programs in the United States are focused on the humanist tradition, wherein the exposure to and the understanding of dramatic works results in well-rounded and liberally educated individuals. Another consideration is the idea that theatre also has a significant social function—in many

periods dealing with the social issues of its time. In almost any academic situation, in addition to the educational component, enculturation is a significant concern, both for the student participants and for the audience, whether the audience is exclusively students or a combination of what is called "town and gown." For this reason, most academic theatre programs are concerned with providing a diverse range of plays from the canon of world drama.

THEATRE AS ACTIVITY

In some situations, theatre is sometimes seen by the institution's administration as providing a student activity, something for the students to do so they don't get bored and get into trouble. This was a characteristic of theatrical activity at both Harvard University and Princeton University more than seventy-five years ago. Interestingly enough, each university today has a regional theatre located on its campus, a feature that also exists at dozens of other American universities.

THEATRE TRAINING

In those situations where theatre training is the primary function of the academic program there are two major approaches. One, typically at the undergraduate level, involves training students in the discipline of theatre, commonly manifested as an academic major in theatre. Other undergraduate institutions go beyond that, with the objective of training for a professional career in theatre. While some undergraduate programs may have a professional career objective, virtually all graduate theatre programs have a professional career objective, whether offering a Master of Fine Arts (MFA), so one may work in the professional theatre, or possibly even teaching, or a PhD for which the objective typically is teaching at the college or university level.

FUND-RAISING

A last consideration of academic theatre is fund-raising. The mere fact of selling tickets in a collegiate situation can be considered fund-raising to cover production costs. Many operations, such as high schools, often do theatre expressly for the purpose of raising money, perhaps for the senior class trip or something similar. This specific fund-raising activity of theatre is more likely to be found in middle school and high school, where sometimes double-casting is used as a method for inducing family and friends to buy tickets for multiple performances.

SUMMER THEATRE

Back in the early to mid-twentieth century, summer stock theatre was a format for presenting shows for one-week or two-week runs, often in summer vacation venues.

Frequently, summer theatre productions were done in "quaint" venues, such as a barn or a tent, each of which presented its own set of problems. In most cases, the theatre company did its own productions. However, around the middle of the twentieth century something called a "**star package**" was developed. It was a production that was structured to play at half a dozen or more different theatres with an actor of "star" quality, often from the movies or television. It was perceived as a win-win for the theatre managers and for the stars. The drawing power of the star generally promised a significant boost in ticket sales that in turn could support a significant salary for the star for an extended period of time. The author recalls one summer in the mid-1960s, when Ray Bolger appeared at our theatre and reputedly was making $3,000 a week.

The idea for a "star package" was that any variations for the cast were kept to a minimum. The show traveled with its own costumes and specialized props. Similarity in the scenery was achieved because every theatre had to use an identical ground plan, resulting in blocking that was essentially identical from theatre to theatre. Even the color of the settings and choice of props was subject to the scrutiny of the Advance Director, who traveled from theatre to theatre one week ahead of the cast. Thus, the Advance Director was able to ensure that the cast experienced few significant differences from theatre to theatre.

More recently, summer theatre simply refers to any of the other kinds of theatre that are done during the summer months. Starting after the 1950s, a lot of this new summer theatre activity was being done by academic theatre institutions. In some cases that theatre activity took place on the main campus; in other situations the institution had a separate theatre in a different location that catered to the people in the vacation environment.

COMMEMORATIVE FESTIVALS

There are many festivals that occur in the United States and other countries as well, many of them sometimes taking place during the summer months. Festivals generally are commemorative—either commemorating the work of an individual playwright or commemorating some historical event. A **Shakespeare festival** is the most popular festival in the English-speaking world that commemorates an author. Perhaps the most famous one in North America is the Shakespeare Festival at Stratford-on-Avon in Ontario, Canada. In New York City, free Shakespeare in the Park, an operation originally founded by Joseph Papp, takes place every summer in Central Park at the Delacorte Theatre. The Oregon Shakespeare Festival in Ashland, Oregon, takes place in a reconstruction of a Shakespearean era theatre. Its theatre burned down in 1940 and was rebuilt in 1947. That theatre was subsequently torn down and several others have been built since then (Figure 12.6). Not all author-commemorating festivals are devoted to Shakespeare—the Shaw Festival, also in Ontario, Canada, was

founded to present the works of George Bernard Shaw. Another festival is the Inge Festival in Independence, Kansas, devoted to the works of William Inge. Most of these festivals eventually evolve to include scripts by other playwrights who were active during the same time period.

The last type of festival commemorates some historic event. Only a few of the various commemorative festivals may be covered in the space available. The world's longest running commemorative festival is the *Oberammergau Passion Play*, which has been performing every ten years in Oberammergau, Germany, since 1634, missing only in 1770 and once during World War II. The community was ravaged by an outbreak of the black plague, but its inhabitants prayed to God to stop the plague, in exchange for which they promised to do a passion play for eternity.

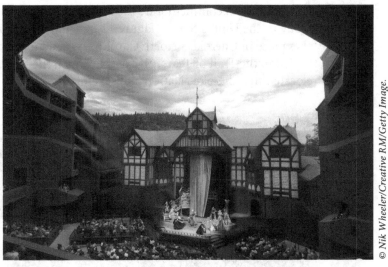

Figure 12.6 *Oregon Shakespeare Festival's production of Henry VIII is presented in its outdoor reconstruction based on the Fortune Theatre measurements.*

Figure 12.7 *The Hill Cumorah Pageant takes place annually to commemorate Joseph Smith receiving tablets that he translated into The Book of Mormon.*

In the United States, there are many outdoor commemorative festivals such as the *Hill Cumorah Pageant,* which takes place during the summer in Palmyra, New York. It commemorates Joseph Smith receiving the copper tablets from the Angel so that he could translate them into what became *The Book of Mormon* for the Church of Jesus Christ of Latter Day Saints (Figure 12.7). In Virginia, *The Lost Colony* takes place

each summer to commemorate the founding and disappearance of the first English colony in the United States (Figure 12.8). *Unto These Hills* is an outdoor drama that takes place in Cherokee, North Carolina, every summer to commemorate the events that led to the Trail of Tears, an event in which the US military forcibly marched and relocated the Cherokee Nation and several other Indian tribes to Oklahoma.

© George F. Mobley/Getty Images.

Figure 12.8 *The Lost Colony commemorates the establishment and loss of the first English colony in Virginia.*

Key Names, Venues, and Terms

Academic Theatre	Nonprofit Theatres
Bus and Truck	One-Night Stand
Commercial Theatre/Broadway	Presentation House
Community Theatre	Professional Theatre
Dinner Theatre	Regional Theatre
Enculturation	Shakespeare Festivals
Humanist Tradition	Split-Week Run
Industrial Shows	Star Package
LORT (League of Resident Theatres)	

Additional Reading

Conte, David M. and Stephen Langley. *Theatre Management: Producing and Managing the Performing Arts.* Hollywood, CA: EntertainmentPro, 2007.

Novick, Julius. *Beyond Broadway: The Quest for Permanent Theatres.* New York: Hill and Wang, 1968.

Ziegler, Joseph. *Regional Theatre: The Revolutionary Stage.* New York: DeCapo Press, 1973.

MUSICAL THEATRE

Chapter XIII

When we refer to plays we typically refer to the playwright as the originator or creator of the individual script. In the case of musicals, there may be three different components, each of which may be done by a different author. The primary creation of a musical is typically credited to the composer. The lyricist is the one who writes the words for the songs. The third component is the book or script. There are variations in how the three component parts are generated. In some cases, one author writes all three components—in other situations there is a different author for each component.

Musical theatre is the only American form of theatre on the world stage. Musical theatre is commonly described as starting in the middle of the nineteenth century. However, music and theatre had been combined in opera and **operettas** for centuries, and even showed up in much of spoken-word theatre. We know classical Greek tragedies from the sixth century BCE had a chorus that sang and danced between the dramatic episodes. In the Roman period, we know that perhaps a third of each comedy was accompanied by music, as Terence carefully noted in some of his plays. We know that Shakespeare included one or more songs in his productions—even in the tragedies—in order to provide some relief from the dramatic tension. During parts of the seventeenth and eighteenth century, ballad operas were quite popular—for example, John Gay's *The Beggar's Opera* (1728). Toward the end of the eighteenth century and the beginning of the nineteenth century, melodramas originally had melodies and then had background music, much like movies and TV today. Thus, music and dance were frequently incorporated into theatre productions. Despite all of this prior incorporation of music into theatrical productions, it is still generally accepted that the beginning of American musical theatre as we know it today started in the middle of the nineteenth century.

THE BLACK CROOK

Despite a long prior theatrical legacy, the 1866 production of *The Black Crook* is traditionally cited as the start of musical theatre. That script included elements from Goethe's *Faust* with music composed and/or arranged by Thomas Baker, mostly from adaptations of other songs. The producers of *The Black Crook* were anxious about whether they could sell enough tickets to their production and about the amount of money that had already been invested in the show. Luckily for the producers, a French ballet troop was stranded in New York City because its performance venue had burned. The producers of *The Black Crook* decided to incorporate the dance company into its production. Dance frequently had been used in theatrical productions. However, it typically was an inserted element or might be part of what was called an "afterpiece"—entertainment added after the main show. Dance typically had not been incorporated into theatrical production before, except in the case of ballet. *The Black Crook* performed over 450 times at Niblo's Garden, which seated about 3,000, and the show ran for 18 months. In a period when women's skirt hems were near the ground, seeing women on stage in tights was an exotic and potentially erotic treat. That run grossed over $1,000,000.00, an unheard of amount of money at that time. The show's success prompted imitators to incorporate into future productions that show's new features of a dance company and most importantly scantily clad females.

EARLY MUSICAL INFLUENCES

Two forms that influenced the development of the early musicals were **Revues** and **Operettas**.

REVUES

An idea that contributed to the development of musicals was the revue, a collection of unrelated variety acts packaged together as a production. Variety acts were also a feature of the minstrel shows that were popular during much of the nineteenth century. Variety acts also were a mainstay of vaudeville from its beginning on into the twentieth century. Thus, there was ample exposure to revues and the variety acts contain therein.

The popularity of revues lead some producers to create a series of productions that appeared every year or so. Ludwig Engländer's (1853–1914) *The Passing Show* series started in 1894. However, the more famous revue series, **The Ziegfeld Follies**, started in 1907 and generally appeared every year thereafter till the early 1930s. The annual *Follies* show opened in the summer in New York City and then toured the nation while preparations for the next year's production took place in New York City. Because *The*

Ziegfeld Follies was a revue, there were various composers for each of the different musical numbers in it. **Florenz Ziegfeld** (1867–1932) was the producer of the *Follies*. The *Follies* had been just another series of theatrical revues until Ziegfeld hired Joseph Urban (1872–1933) as his designer, and thus provided a new level of sophistication for the productions. Joseph Urban came to the United States to be the production director of the Boston Opera Company. When the opera company folded, the outbreak of World War I stranded Urban and his studio crew in the United States, and Urban needed to find work for himself and his studio staff members, hence he was available for hiring by Ziegfeld.

It was somewhat common for American theatre producers to hire European actors for their productions as that was who Americans audiences were accustomed to seeing as stars. Opposing the general trend of imported actresses, the *Follies* took on a new elegance as Ziegfeld endeavored to "glorify the American girl" (Figure 13.1). Ziegfeld philosophically thought theatrical producers did not need to hire European actresses for theatrical productions—there were plenty of beautiful American women available. The revue remained popular into the late twentieth century as seen in *Bubbling Brown Sugar* (1976), *Ain't Misbehavin'* (1978), and Stephen Sondheim's (1930–) *Putting It Together* (1999) (Figure 13.2).

Figure 13.1 Ziegfeld Follies *"glorified the American girl" in this scene from about 1907.*

Figure 13.2 Ain't Misbehavin' *is a contemporary revue seen here in a rehearsal shot for the New York City revival in 2011.*

MUSICAL THEATRE **159**

OPERETTAS

© Everett Historical/Shutterstock.com

Figure 13.3 *Poster for the American production of Gilbert and Sullivan's* H.M.S. Pinafore *done in New York City in 1879.*

© Quim Llenas/Getty Images.

Figure 13.4 *This 2016 revival of* The Merry Widow *is seen in a dress rehearsal.*

Operettas also had impact on the development of musical theatre. One group of operettas was written by **William Gilbert** (1836–1911) and **Arthur Sullivan** (1842–1900). The two men had a somewhat strained relationship because Arthur Sullivan wanted to be known and appreciated as a classical music composer. Despite their relationship, they were quite successful. Part of the Gilbert and Sullivan operetta's attraction for the audience was their exotic settings and plots dealing with foreign or oriental countries, sailor life, and pirates. The production of *The Mikado* (1885) for example, catered to orientalism. A prominent feature of Gilbert and Sullivan operettas was the inclusion of a patter song, a kind of tongue-twister song sung at a very fast pace, which demanded extraordinary articulation and diction. One example from *H.M.S Pinafore* (1878) was "I Am the Very Model of a Modern Major General." Another characteristic of the Gilbert and Sullivan productions was their lighthearted upbeat comedic nature (Figure 13.3).

While many other operettas were written, another major operetta composer was **Franz Lehar** (1870–1948), probably best known for *The Merry Widow* (1905). In it, the German government fears a young widow might marry a foreigner, thus taking her

vast fortune out of the country. It arranges for a young military officer to woo her. Despite problems, everything turns out well, they get married, and the fortune stays in Germany. The musical contains beautiful and luscious music and lyrics, almost approaching the quality of opera (Figure 13.4).

MATURING OF THE MUSICAL

Much of what had passed as musical theatre was little more than musical revues. The first significant development of the musical was called a "**clothesline revue**." The "clothesline revue" was an improvement over the simple revue because it had an arbitrary plot device to tie together the individual variety acts. There were two relatively typical plot devices, both involving some form of talent show. In one, the characters were aboard a transatlantic ship and needed some activity to pass the time. Thus, any kind of entertainment act could be fitted into the revue. The other approach was to set the locale at a country club, where again a talent show was done. Obviously, doing a clothesline revue seemed to suggest a more cohesive production than just doing a simple musical revue. The general approach for musicals of that time period was that the plot—what little plot there might be—simply stopped so that a song could be done.

PRINCESS THEATRE SHOWS

An innovative approach was taken by the shows done at the small Princess Theatre in New York City during the latter years of the 1910s. There, **Jerome Kern** (1885–1945), P.[elham] G.[renville] Wodehouse (1881–1975), and Guy Bolton (1884–1979) produced musical shows that were recognized at the time as more sophisticated than earlier "clothesline" musicals because they were more integrated and included jazz music. Consequently, the shows became the model for the subsequent development of the musical form.

SHOW BOAT

What Jerome Kern learned at the Princess Theatre bore fruit in *Show Boat* (1927). Kern and his new librettist, **Oscar Hammerstein II** (1895–1960), approached Edna Ferber (1885–1968), seeking permission to use her novel, *Show Boat* (1926), as the basis for a musical theatre production. Ferber expressed significant reservations about the project, but agreed to let the young authors try. The result was a major milestone of the American musical theatre. Interestingly enough, Florenz Ziegfeld was the show's producer and Joseph Urban was its scenic designer. Significant points about *Show*

Boat were its inclusion of adult themes—the very issues that had given Ferber pause about turning it into a musical in the first place. Previous musical theatre productions had been light and frivolous. *Show Boat* featured an unhappy marriage and depicted the demeaning treatment of blacks, particularly in the South. Among the actors who lived and worked on the showboat, the Cotton Blossom, as it navigated the Mississippi River, was one mixed-race married couple. In one southern town, the sheriff came aboard on reports of a mixed marriage and insisted the couple could not stay with the company. The couple left the showboat company so the boat could continue its trip south. In the show, songs were used to advance the themes and action of the plot. One of the featured songs of the show was "Ol' Man River," which resonated with the lives of black people who had no choice but to simply go along with the flow.

OKLAHOMA!

Oscar Hammerstein II teamed up with a new composer **Richard Rodgers** (1902–1979) for what both initially expected to be a single collaboration. The resulting show, *Oklahoma!* (1943), was such a hit that it played over two thousand performances, and the two men remained musical theatre collaborators for decades. The major contribution of *Oklahoma!* to the development of the musical was its integration of action, singing, and dancing—what is today called a "book musical" (Figure 13.5). *Showboat* had only integrated songs—now both songs and dances were integrated. Agnes DeMille (1905–1993) choreographed the first act "Dream Ballet," which was the clearest example of this new approach. Laurey's dance depicts the nightmare of a bride who fears something might happen to Curly because of Jud's hatred toward Curly. She fears she might be forced to marry Jud if something happens to Curly. In their next production, *Carousel* (1945), Rodgers and Hammerstein II wrote musical scenes. For the song "If I Loved You," rather than breaking into song in the traditional manner, the authors wrote a musical scene, with part of it in dialogue, part underscored with music, and part

Figure 13.5 *The chorus line from the 1943 Broadway production of* Oklahoma!

in full song. Another characteristic of virtually every Rodgers and Hammerstein II musical was some form of critique of racism. In *Oklahoma!*, racism existed between the cowboys and the farmers. In *The Sound of Music* (1959) it was Nazism. In *South Pacific* (1949), their treatment of racism was even more pointedly presented in the song, "You've Got to be Carefully Taught [to Hate]." The innovative show was awarded the Pulitzer Prize in Drama, only the second musical to have been so honored. The first musical to receive the Pulitzer Prize in Drama was *Of Thee I Sing* in 1932 with music by Ira Gershwin (1896–1983).

WEST SIDE STORY

The next significant musical was *West Side Story* (1959). The show's composer was **Leonard Bernstein** (1918–1990), its lyricist was **Stephen Sondheim** (1930–), the director and choreographer was Jerome Robbins (1918–1998), and the scenic designer was Oliver Smith (1918–1994). The plot was an adaptation from Shakespeare's *Romeo and Juliet*, but set in modern New York City with the two rival gangs, the Sharks and the Jets. Up until that show, all of musical theatre was referred to as "musical comedy" because despite any serious components all had relatively happy endings. Obviously, *West Side Story* was an anomaly—it clearly was a musical tragedy. It took a couple decades for theatre people to solve the problem by calling the form "musical theatre," the phrase used today. Actually the first musical tragedy was Kurt Weill's (1900–1950) *Lost in the Stars* (1949). Because *West Side Story* had much greater success it has been credited with being the first musical tragedy.

THE GOLDEN AGE

The Golden Age of the American musical theatre is somewhat arbitrarily defined as lasting from about 1950 till about 1970. There were many productions and many composers, including **Cole Porter, Irving Berlin, Frank Loesser**, and the team of **Alan Jay Lerner** and **Frederick Lowe**.

Cole Porter (1891–1964) wrote musicals for many years before scoring a big hit with **Kiss Me Kate** (1948), based upon Shakespeare's play, *The Taming of the Shrew*. The production features a theatre company's performances of *The Taming of the Shrew*, alternating with backstage scenes that parallel the plot of Shakespeare's script. Fred Grahm, an arrogant actor, director, and manager, plays the role of Petruchio opposite his ex-wife, who plays Katherine. Their private squabbles spill over into their onstage performances of the Shakespearean play. The subplot involves Bianca and Bill, a gambler trying to evade some gangster muscle looking to collect on his debt. The gangsters are particularly erudite, as they demonstrate when they sing "Brush Up Your Shakespeare."

Irving Berlin (né Israel Isidore Beilin) (1888–1989) is famous for having written iconic American songs such as "God Bless America," "White Christmas," and "The Easter Parade." Early in Berlin's career he composed some songs that were included in *The Ziegfeld Follies* (1919) and in four of the editions of the *Music Box Revue* (1921–1924), but he had not yet been responsible for the composition of a complete musical. He was the composer and lyricist for *Annie Get Your Gun* (1946), the story of Annie Oakley's pursuit of Frank Butler. Oakley is a rustic, rough-edged sharpshooter young woman who joins *Buffalo Bill's Wild West* show to pursue her love interest, Frank Butler. Their oversized egos keep getting in the way of their love for each other, until Oakley learns "You Can't Get a Man with a Gun."

Frank Loesser (1910–1969) wrote **Guys and Dolls** (1950) based upon stories by Damon Runyon (1880–1946). In it, an unlikely attraction between a Salvation Army woman, Sarah Brown, and a roving gambler, Sky Masterson, provided interesting plot developments. The love story is set in motion when Masterson bets he can take any woman to lunch. The woman selected in the bet is Sarah. In one scene, Masterson gambles in a sewer, because a more convenient gambling location cannot be found due to police surveillance. He bets his money against his buddies' IOUs (I owe you) to attend a Salvation Army revival meeting, hence, his need for luck in "Luck be a Lady Tonight." Later, at the mission, there is a rousing religious revival in "Sit Down You're Rocking the Boat," as the gangsters "receive" religion.

Alan Jay Lerner (1918–1986) and Frederick Lowe's (1901–1988) production of **My Fair Lady** (1956) was based upon George Bernard Shaw's (1856–1950) play *Pygmalion* (1912). In the musical, Professor Henry Higgins, a misogynistic and arrogant vocal coach, teaches Eliza Doolittle, a Cockney guttersnipe flower girl, proper speech and proper behavior, but in the process he finds he has "Grown Accustomed to her Face" and fallen in love with her. Other pop hit songs from the musical included "I Could Have Danced All Night," "On the Street Where You Live," and "Get Me to the Church on Time." The show garnered Tony Awards, including Best Musical, and became the longest running Broadway show at that time.

THE CONCEPT MUSICAL

Even though the idea of a concept musical appeared earlier in the twentieth century, today the term generally is applied to the musicals first created by Stephen Sondheim, the composer, and **Hal Prince**, the producer and director for many of Sondheim's shows. In a concept musical, the plot is not the major feature of the production. Instead, some production concept holds the show together—often interweaving the various elements of the show into a fabric that is the show's metaphor. For example, in the production of *Follies* (1971) the plot revolves around a reunion of former

Ziegfeld Follies girls at the demolition of the theatre in which the *Follies* productions had taken place decades earlier. One of the points was the irony contained in the contrast between the word "*Follies*" and the audience's learning about the "follies" the characters committed in their past. A later musical done by the same team was **Sweeney Todd or the Demon Barber of Fleet Street** (1979), which adapted Victorian melodrama to contemporary sensibilities. The plot was based in part upon a historical incident that took place in England, when human flesh was baked into meat pies that were sold and consumed by the public.

CONTEMPORARY MUSICALS

Some major musicals from the latter part of the twentieth into the twenty-first century include **La Cage aux Folles, The Phantom of the Opera, The Lion King, The Producers, Wicked, The Book of Mormon**, and **Spider-Man: Turn Off the Dark**.

La Cage aux Folles (1983), based upon a French film that in turn was based upon a French play, had music and lyrics by **Jerry Herman** (1931–) and book by Harvey Fierstein (1954–). The plot revolves around a gay couple whose son, Jean-Michel, invites his fiancée's ultraconservative and homophobic parents to come for a visit. The problem is that Jean-Michel's "parents" run a nightclub that features cross-dressing drag queens, where his "mother" is the star. In Fierstein's hands, the show unabashedly confronts the issues of homosexuality in a musical theatre format.

The Phantom of the Opera opened on Broadway in 1988. It had music by **Andrew Lloyd Webber** (1948–), lyrics by Charles Hart (1961–), and was based on the French novel, *Le Fantôme de l'Opéra* (1909). The Broadway production was directed by Hal Prince. The show is the longest running production in Broadway history, having exceeded 10,000 Broadway performances. It also made the most money worldwide of all Broadway productions, topping $5.6 billion, and still counting. Webber had a long history of musical theatre productions before *The Phantom of the Opera* including *Joseph and the Amazing Technicolor Dreamcoat* (1968), *Jesus Christ Superstar* (1970), *Evita* (1976), *Cats* (1981), and *Starlight Express* (1984). The plot of *The Phantom of the Opera* revolves around a gifted opera singer, Christine, who is the object of an obsessive, terribly scar-faced, musical genius, called the Phantom of the Opera. Various mishaps befall the opera company whenever the Phantom does not get his way, which is to see Christine star in his new opera.

The Lion King (1997), based upon the Disney animated film of the same name, had music by **Elton John** (né Reginald Kenneth Dwight) (1947–) and lyrics by Tim Rice (1944–). For the Broadway production they were joined by additional composers and

Figure 13.6 *The Lion King is the largest grossing show in Broadway history. Julie Taymor's design and direction for the show featured oversized puppets that were manipulated by the actors.*

lyricists. The plot is a coming-of-age story about a lion cub named Simba that was based in part on Shakespeare's *Hamlet*. Julie Taymor (1952–), the director and designer, was responsible for creating sumptuous visual looks for the production, including a number of oversized puppets manipulated by the actors. The show has become the largest grossing show in Broadway history. Even more important, the show paved the way for additional productions based upon Disney films and Disney animated cartoon movies (Figure 13.6).

The Producers (2001) was written by **Mel Brooks** (1926–), based upon his own 1968 film of the same name. It featured two theatrical producers who conceive of a scam to sell more than 100 percent of the shares in a show. If the show is a flop, none of the shares need to be paid back so they may keep the excess and realize a huge profit. Unfortunately, despite their intention to create a flop, the show becomes a hit. They get caught and go to prison.

Wicked: The Untold Story of the Witches of Oz (2003), conceived as a prequel to the novel, *The Wonderful Wizard of Oz* (1900) was based upon another novel *Wicked: The Life and Times of the Wicked Witch of the West* (1995). It had music and lyrics by **Stephen Schwartz** (1948–), who had previously written *Godspell* (1971) and *Pippin* (1972). Schwartz is one of only two American composers to have three different shows performed over 1,500 times on Broadway; the other is Jerry Herman.

The Book of Mormon (2011), by Trey Parker (1969–), Robert Lopez (1975–), and Matt Stone (1971–), is a satire on organized religion, and in particular on the two-year missionary requirement for young Mormon adults. The plot concerns two young men who are sent to Africa as missionaries. Neither is religiously nor practically equipped to address the issues faced by the people they are supposed to help. The African people are more concerned about life and death issues such as food, poverty, health, and AIDS rather than learning about a new religion (Figure 13.7).

Figure 13.7 The Book of Mormon *is a recent Broadway hit musical.*

Spider-Man: Turn Off the Dark (2011) had music and lyrics by Bono (1960–) and The Edge (1961–). The show was the most complex technical production in Broadway history and was plagued with problems from the beginning, including injuries to the flying actors. Julie Taymor of *The Lion King* fame, was the original director, but conflicts with artistic interpretation led to her departure from the production. Poor ticket sales and insurance problems prompted the producers to close the show in January of 2014, with a loss of about $60,000,000. The producers stated they anticipate reopening the show in Las Vegas, but that hasn't happened yet.

Hamilton opened Off-Broadway in February of 2015 at the Public Theatre and then on Broadway in August of 2015. The show has music, lyrics, and book by Lin-Manuel Miranda (1980–), who also starred as Alexander Hamilton. The show features minority actors in "white" roles, a process known as "color-blind casting" and incorporates hip-hop music. The show was considered a critical success, having earned eleven Tony Awards and the Pulitzer Prize for Drama. It set a financial record as the first Broadway show to gross over $3,000,000 for an eight-performance week. The musical is essentially a biography of Hamilton's life and the role he played as one of the nation's founding fathers.

Theatre has always reflected its society. Musical theatre is no different. In a number of ways contemporary musicals are different from earlier ones. In earlier musicals, social issues were often subliminal. In Rogers and Hammerstein shows, the racism theme as in *Oklahoma!* and *South Pacific* was subtle and missed by some audience members. Contemporary musicals are more confrontational in addressing social issues. Homosexuality

and cross-gender are central in *La Cage aux Folles*. The specter of AIDS is addressed in Jonathan Larson's (1960–1996) *Rent* (1994). The breaking of the barrier between audience and performance may be seen in Galt MacDermot's (1928–) *Dude* (1972), Leonard Bernstein's *Candide* (1956), with its environmental staging by Hal Prince in 1973, Webber's *Starlight Express*, and *Spider-Man*. Today there is a greater frequency of musicals based on films, such as *La Cage aux Folles*, *The Producers*, and a host of Disney productions, including *The Lion King*. There has been a heavier dependence on technical equipment from *The Phantom of the Opera*, which often rebuilt its touring theatres so they could handle the excessive scenic loads and the show's need for additional dressing room space, to the elaborate technical demands of *Spider-Man*.

JUKEBOX MUSICAL

A newer form of musical theatre, called a jukebox musical, is based upon a compilation of songs from a single artist, genre, or time period. The jukebox musical features a collection of pop songs that typically have already been released. The compilation is generally from one artist or artistic group, but sometimes it is a genre. An example of the single artist or group is *Jersey Boys* (2005), featuring Frankie Valli (1934–) and The Four Seasons. *Ain't Misbehavin'* is a genre jukebox musical featuring music of the Harlem Renaissance and Fats Waller (1904–1943).

There are several formats that are often used for a jukebox musical. One format presents the songs as a biographical sketch of the artist as in *Buddy—The Buddy Holly Story* (1989). Another format is structured around a genre as in *Forever Plaid* (1990) featuring 1950s Male Vocal Harmony. A last format is the fabricated plot as in *Mamma Mia!* (1999), which is based on the songs of ABBA. Catherine Johnson (1957–) fabricated a plot that would allow her to simply drop various ABBA songs into it in a logical manner. *Mamma Mia!* was also made into a very successful film starring Meryl Streep. Relatively current jukebox musicals include *Sunny Afternoon* (2014) featuring songs by The Kinks and *Lazarus (Musical)* (2016) featuring the songs of David Bowie (1947–2016). The most recent jukebox musical film is *Rocketman* (2019), featuring the life and songs of Elton John.

Key Names, Venues, and Terms

Irving Berlin	*La Cage aux Folles*
Leonard Bernstein	*Carousel*
The Black Crook	Clothesline Revue
The Book of Mormon	Concept Musical
Mel Brooks	William Gilbert and Arthur Sullivan

Guys and Dolls

Oscar Hammerstein II

Jerry Herman

Jerome Kern

Kiss Me Kate

Elton John

Jukebox Musical

Franz Lehar

Alan Jay Lerner and Frederick Lowe

The Lion King

Frank Loesser

The Merry Widow

My Fair Lady

Oklahoma!

Operettas

The Phantom of the Opera

Princess Theatre Shows

The Producers

Cole Porter

Hal Prince

Revue

Richard Rodgers

Stephen Schwartz

Showboat

Stephen Sondheim

Spider-Man: Turn Off the Dark

Sweeney Todd or the Demon Barber of Fleet Street

Andrew Lloyd Webber

West Side Story

Wicked

Florenz Ziegfeld

The Ziegfeld Follies

Additional Reading

Bordman, Gerald. *The American Musical Theatre: A Chronicle.* 3rd ed. Oxford: Oxford University Press, 2001.

Jones, John Bush. *Our Musicals, Ourselves: A Social History of the American Musical Theatre.* Medford, MA: Brandeis University Press, 2003.

Lerner, Alan Jay. *The Musical Theatre: A Celebration.* New York: McGraw-Hill, 1986.

AFRICAN AND AFRICAN-AMERICAN THEATRE

For this chapter, African Theatre refers to theatre, written by both black playwrights and white playwrights in Africa that deals with the black perspective. The African-American label refers both to theatre by black American playwrights and to theatrical activities that depict and relate to the African-American experience and situation in the United States, particularly during the twentieth and twenty-first centuries.

AFRICAN THEATRE

Theatricalized activity in Africa existed long before the colonization of Africa began millennia ago. Indigenous theatrical activity was and is associated with rituals and festivals that were central to the cultural lives of the indigenous African people. Many of these rituals are associated with rites of passages for a culture's individuals. Indigenous theatrical activities include dance, music, and the use of masks. It is probably impossible to separate the development of dance from the development of music, as both presumably developed together. Costumes, masks, and other artifacts have long been associated with the indigenous rituals and festivals of Africa.

Animism, or the belief in spirits, is not significantly different in Africa than from animism in other indigenous cultures around the world. Thus in Africa, there is a spirit for the rock, a spirit for the tree, a spirit for the leopard, a spirit for the elephant, and so on. The spirit that the leopard had would likewise inhabit the skin of the leopard even if the leopard were dead. When that leopard skin was worn by a person,

171

the spirit of the leopard would likewise inhabit the person and that spirit would guide the movement and behavior of the person in ritualized performances. It should be no surprise to imagine that this indigenous relationship with spirits should also apply to theatrical activity.

When colonial European nationalities arrived in Africa, they brought their own cultural activities with them, including their own approaches to theatrical performances. Over time, the indigenous people were exposed to the new culture's activities. Some indigenous people modeled and imitated the behavior of the colonizing culture perhaps as a way of ingratiating themselves to the colonists. Some indigenous people culturally ignored the imported cultural ideas. Still others found that some aspects of the colonizing culture could be integrated into the African culture.

NIGERIA

In the twentieth century in northern Africa, in Nigeria in particular, this inclusion of some aspects of the colonizing culture may be found in the work of **Wole Soyinka** (né Akinwandel Oluwole Soyinka) (1934–). The indigenous Nigerian Yoruba culture did *Egungen* festivals, which incorporated the indigenous activities. Soyinka, at various times a university professor, was awarded the Nobel Prize in Literature in 1986. Many of his plays are a blending of indigenous traditions with the techniques and structures of Western theatre. One such play is **Death and the King's Horseman** (1975), based upon a historical event that took place in 1946, when a King died and his counselor followed him into death as required by his culture's expectations. As depicted in the play, Elesin, the former King's counselor and horseman, is preparing to die and follow his King into the afterlife. The colonial magistrate, Simon Pilkings, overreacts and intervenes. Unbeknownst to anyone, Elesin's son interrupted his medical school studies in England and as expected by his culture's guidelines, returned to assume his father's position, should his father be unable to perform his duties. The son's subsequent death strongly suggests a clash of cultures. However, in a note included in the script, Wole Soyinka strongly denied that there was any culture clash.

SOUTH AFRICA

In South Africa, at the opposite end of the continent, a different situation developed. Racial tensions were very high as apartheid, the brutal repression of blacks by white South Africans, was in full swing in the middle of the twentieth century. Over a period of a few years, foreign institutions attempted to pressure the apartheid South African government to ease its repression. In 1963, a number of foreign authors refused to grant permission for the performances of their plays in South Africa. By 1966, British Equity, the union for professional actors, prohibited its members from acting in productions presented in segregated venues. In that supercharged environment, theatre and theatre organizations became very political, including both black

theatre groups in the black homelands and some white theatre groups. One such white playwright was **Athol Fugard** (1932–). The apartheid laws in South Africa were so restrictive that on occasion Fugard was not able to hire black actors for the theatre company—he had to hire them as household servants instead. Two of Athol Fugard's plays are indicative of the problems that existed under apartheid. In *Sizwe Banzi Is Dead* (1973), one of the two major characters in the play, Sizwe Banzi, is unable to find employment and needs to obtain forged papers that will give him a new name and will allow him to travel and find work. In order to do this, the real Sizwe Banzi must cease to exist. Thus, during significant parts of the play Banzi laments his own impending figurative death.

The somewhat autobiographical *Master Harold . . . And the Boys* (1982)—which at one time was banned in South Africa—was more about individual interpersonal relationships between blacks and whites in South Africa. In the play, Halley has a difficult relationship with his father, an alcoholic who has not been particularly involved or effective as a father. Halley's mother runs a tea room and employs two black men. One of them, Sam, has been a surrogate father for Halley. Halley's disappointment and frustration upon learning that his father is being checked out of the hospital and is coming back home causes him to lash out viciously at Sam, thereby destroying the relationship that had existed between the two.

AFRICAN-AMERICAN THEATRE

AFRICAN GROVE THEATRE

Black theatre in the United States started in the beginning of the nineteenth century at the African Grove Theatre in New York City. It started in 1820/1821 and continued on and off until 1827. The African Grove Theatre was in the African Grove pleasure garden, a nineteenth-century feature that allowed ordinary people to stroll in park-like settings and gardens that also provided the opportunity for drinking beer and being entertained. There were separate gardens for blacks and whites, each trying to provide similar kinds of activities and attractions for its patrons. At the African Grove Garden, the entertainment often was condensed versions of Shakespearean plays, produced by the director/manager, William Henry Brown. One of the original plays produced there was *The Drama of King Shotaway* (1823), the first black-authored and black-acted script in North America.

There were two actors of note in the company. One was James Hewlett, who played many Shakespearean roles. The second and historically more important one was **Ira Aldridge** (1806–1867), a young black actor who received his training and first acting experiences at the African Grove Theatre. Reading the proverbial handwriting on the wall and because his father, a deeply religious man, wanted to send

Figure 14.1 *Ira Aldridge was the first black man to play the lead role in Shakespeare's* Othello.

him to a seminary in Schenectady, New York, Aldridge left for London at the age 17. He worked for a number of years in the provincial theatres of England. By the 1850s, he was recognized for the psychological realism that he brought to his acting, and he eventually became a world-class Shakespearean actor, even appearing before royalty (Figure 14.1).

NINETEENTH-CENTURY THEATRICAL DEPICTION OF BLACKS

Much of what passed for entertainment in nineteenth-century America and much of the twentieth century was essentially making fun of a succession of various nationalities and ethnic groups such as Native Americans, Dutch, Germans, Swedes, Scots, Irish, Italians, Poles, Hispanics, Asians, and blacks. There were a number of nineteenth-century activities that impacted the stereotypic depiction of black people.

One of those was developed by **Thomas Dartmouth (Daddy) Rice** (1806–1860) in the 1830s. Rice was a white performer who happened to observe a crippled stable-man, named Jim Crow, who was dancing and singing a song. Though Rice was not the first to imitate blacks in blackface, he saw an opportunity for himself and decided to recreate the character on the stage as entertainment. Rice wore **blackface** to do so, and called the character **"Jim Crow."** Though blackface had been used in the theatre for centuries, and others were doing similar blackface performances, Rice's popularity ignited the nineteenth-century craze for the depiction of blacks that eventually led to the development of **Minstrel Shows**. Rice himself had no personal involvement in minstrel shows, but his depiction of a black character on stage clearly initiated the desire to see similar denigrating depictions of black people on stage. Minstrel shows filled that need.

The minstrel show was developed in 1843 when Dan Emmett (1815–1903) created the Virginia Minstrels. E. P. Christie (1815–1862) modified the earlier minstrel structure to give it its traditional tripartite characteristic that remained until its demise in the twentieth century. The first part of a minstrel show consisted of white men in blackface, sitting in a semicircle on the stage. On one end was Mr. Tambo, who played the tambourine, and on the other end was Mr. Bones, who played the

bones. The character in the middle was Mr. Interlocutor, who often was in whiteface. This first part of the minstrel show structure consisted of a walk-around, songs, and comic patter among Mr. Bones, Mr. Tambo, and Mr. Interlocutor, who essentially played the straight man. The second part of the minstrel show consisted of olio acts, essentially a revue that took place in front of a curtain hung approximately halfway upstage. The third part of the min-

strel show consisted of either a par-
ody or sometimes a romanticized
sketch of "darkies" and plantation
life. Minstrel shows were very pop-
ular and could still be seen till the
middle of the twentieth century.
The author remembers his gram-
mar school mounting a minstrel
show in the early 1950s. The pop-
ularity of minstrel shows lead to
the development of black minstrel
companies that were advertised as
"authentic," "Ethiopian," "coon,"
or "colored" companies—but such
companies were still obliged to
perform in blackface (Figure 14.2).

Figure 14.2 *An advertisement for a minstrel show during the 1850s.*

Blackface performances continued to be a feature of American entertainment through much of the twentieth century, including the New Year's Day Mummers Parade in Philadelphia. The Civil Rights Laws of the early 1960s and President Kennedy's assassination in November of 1963, prompted the Mummers Day Parade officials to ban the use of blackface in December, 1963. Despite protests and a court injunction, the January 1964 parade was done without blackface. That marked the beginning of the end for blackface in the United States. Today it is inconceivable that anyone would do blackface in a public theatre venue, except possibly in an historic context.

Harriet Beecher Stowe's (1811–1896) novel, *Uncle Tom's Cabin,* was first adopted for the stage in 1852. It had been published earlier that year as a complete novel after initially appearing as a magazine serial. After it was turned into a stage play, it became the most popular theatre script during the rest of the century, with around four hundred companies eventually performing it at various venues. It was most influential in the abolition movement, with its depiction of slavery. Some theatrical productions embellished the novel and many productions were known for the elaborate spectacles that were created for the production. As was the case for productions previously discussed in this section, black characters were typically played by white actors in blackface.

Another famous nineteenth-century theatre production that addressed black issues was Dion Boucicault's (1820–1890) *The Octoroon* (1859). In it, Zoe, who had been raised as a "free" slave, was forced into a slave auction because of a legal technicality. A young white man had fallen in love with her because of her charm and very light skin color. That script was one of the very few melodramas that did not end happily—Zoe dies in the very last scene. Even though the script depicts a few plantation owners as treating their slaves well, it also made the point that despite that, slaves were property and when the owner's finances changed, the slaves could be sold "down river." Again, many if not all black characters were played by white actors in blackface.

TWENTITH-CENTURY AFRICAN-AMERICAN THEATRE

There were a number of significant African-American productions in New York City. One production, *In Dahomey* (1902), featured Bert Williams (1874–1922), a black man who performed in blackface. A few years later, Florenz Ziegfeld hired Bert Williams to appear in various editions of *The Ziegfeld Follies,* making Williams one of the few black performers to tour the country in major white productions. There were also other black actors who appeared in mostly white productions. Bill "Bojangles" Robinson (1878–1949) was a talented dancer who appeared in films with Shirley Temple. Another intriguing black performer was "Moms" Mabley (1894–1975), who had a long career as a comedian in film and the theatre, often doing raunchy sketches of an older housewife-type woman with a penchant for young men.

Figure 14.3 *Noble Sissle and Eubie Blake (right) in 1927.*

In Harlem, the northern borough of New York City, black arts and entertainments developed and flourished during the early decades of the twentieth century in a movement referred to as the **Harlem Renaissance**. There were significant nightclubs, small black drama clubs, and other venues featuring poetry, singing, and a wide range of entertainments. Though initially intended for and patronized by blacks, it soon became fashionable for white people to make the trip to Harlem for the creative activities that were available there.

Despite continuing segregation, there were black theatres in various locations in the nation. In 1921, the Theatre Owners Booking Association was created to provide booking opportunities for the black theatres, just as the Syndicate and the Shubert's had done earlier for white theatres.

In that same year, 1921, a new musical production, *Shuffle Along*, with music and lyrics by **Ubie Blake** (né James Hubert Blake) (1887–1983) and **Noble Sissle** (1889–1975), opened on Broadway (Figure 14.3). It was the first black musical to play a major Broadway theatre and performed for more than a year. It was followed by other shows and black performers. In 1927, Dorothy and Dubose Heyward (both white) wrote *Porgy*, which George (1898–1937) and Ira (1896–1983) Gershwin (also both white) turned into the musical ***Porgy and Bess*** in 1935. In that same year, **Langston Hughes** (1902–1967) opened ***Mulatto,*** which dealt with lynching. It ran over four hundred performances on Broadway, an unusually long run for a straight play at that time.

AFRICAN-AMERICAN PLAYWRIGHTS

Starting near the middle of the twentieth century, important African-American playwrights were having their productions done on Broadway, Off-Broadway, and in the black regional theatres of America. One such major regional theatre was the **Negro Ensemble Company**, founded by Douglas Turner Ward (1930–) in New York City (Figure 14.4). Another was the Free Southern Theatre founded by Tom Dent, Gilbert Moss, and John O'Neill in New Orleans, Louisiana, the first integrated theatre company in the South. Today, African-American plays are done by many regional theatre companies in the United States. Theatre Communication Group (TCG) is an organization of over 350 regional theatres in America. Of its current member theatres, over sixty-five note a special production interest in presenting African-American theatre including True Colors Theatre Co. in Atlanta, Georgia; Crossroads Theatre in New Brunswick, New Jersey; Actors Co-op Hollywood, in Hollywood, California; New Stage in Jackson, Mississippi; and Penumbra Theatre Company in St. Paul, Minnesota.

© Bettmann/Bettmann/Getty Image.

Figure 14.4 *Douglas Ward Turner (right) performs in a Negro Ensemble Company production,* Ceremonies in Dark Old Men.

Alice Childress (1920–1994), a black actress, playwright, and novelist who wrote her first play in 1949, became the first African-American woman to author an Off-Broadway production. In 1966, she wrote **Wedding Band: A Love/Hate Story in Black and White** that deals with an illegal romance between a white man and a black woman. Later she wrote *Moms: A Praise Play for a Black Comedienne* (1987), dealing with the life of "Moms" Mabley.

Lorraine Hansberry (1930–1965) is best known for her play *A Raisin in the Sun* (1959), the first play by an African-American female to open on Broadway (Figure 14.5). The plot revolves around a woman whose husband died, for which she is expecting an insurance settlement check for $10,000. She wishes to buy a nice home in a suburban neighborhood with the money. Her son wants to use the money to invest in a liquor store, but she objects because of her belief that alcohol harms other people. Meanwhile, her daughter thinks the money should be put aside to pay for her medical school education. A representative from the white neighborhood committee visits and offers a bribe if the black family will not move into the white neighborhood. Despite a number of difficulties, the family decides to move to the new home anyway. One of the features of the play was that it depicted an African-American family as being essentially no different in its concerns and family relationships than those of white families.

Figure 14.5 *The cast from the original Broadway production of* A Raisin in the Sun, *(from the left) Ruby Dee, Sidney Poitier, and Diana Sands, reprised their roles for the film.*

Amiri Baraka's (né LeRoi Jones) (1934–2014) plays arduously attacked white oppression of African-Americans. *Slave Ship* (1970) is a theatrical montage of images relating to the African-American experience, but most particularly with the horrors of the transatlantic crossings that were part of the slave trade. The production was done as an environmental theatre production, in which the audience and the characters of the play are perceived as inhabiting the same environment. The idea was for the audience to imagine itself inside the hold of a transatlantic slave ship. The theatre had containers reputedly filled with putrefying meat and excrement to enhance the ambiance of being on board a human cargo transport ship.

Charles Fuller (1939–) is perhaps best remembered for **A Soldier's Play** (1981). He was awarded the Pulitzer Prize in drama, and subsequently turned his play into a successful film.

The plot deals with the death of a black man at a military base that everyone suspects is a racism issue. The play's irony is that the murder was done by the African-American sergeant who did not want the accomplishments of African-Americans to be tarnished by the unsophisticated and ignorant behavior of the murdered black soldier.

Ntozake Shange (1948–2018) is best known for her evocative play, *For Colored Girls Who have Considered Suicide When the Rainbow Is Enuf* (1976), a collage of poems and short scenes evoking the African-American woman's experience.

August Wilson (1949–2005) set himself the task of writing a ten-play cycle dealing with the African-American experience in America during each decade of the twentieth century. Two plays in that cycle are *Fences* (1985) and *The Piano Lesson* (1990), both awarded the Pulitzer Prize in drama. *Fences* also received an Antoinette Perry Award (Tony). Within a few months of writing the last play in the cycle Wilson died from cancer. As a young man, Wilson had to surmount significant difficulties. He was accused of plagiarism by a high school teacher in his hometown of Pittsburgh, Pennsylvania. He walked out of the school never to return and by the strength of his own character proceeded to self-educate himself at the public library. Wilson was the first African-American to have a Broadway theatre named for him in 2005.

George C. Wolfe (1955–) wrote *The Colored Museum* in 1986. The script is quite humorous, but a number of African-Americans were offended by the apparently disrespectful representation of African-Americans' behavior as seen in the play. One segment of the script, *The Last Mama on the Couch Play*, is a spoof of Lorraine Hansberry's play *A Raisin in the Sun*. The stage directions note that Mama should wear a dress matching the fabric of the sofa and drapes. At the point in the play when her son is shot and killed, she moans that no one ever dies in an all-black musical. To negate his death and turn the performance into an all-black musical, she breaks out in song and dance, whereupon her son returns to life. Later George C. Wolfe became the director of the Public Theatre in New York City for a period of about ten years at the turn-of-the-century.

Suzan-Lori Parks (1963–) is arguably the best living African-American female playwright in America. In 2001, she wrote *Topdog/Underdog*, which was awarded the Pulitzer Prize. The play dealt with two black brothers, Lincoln and Booth, both of whom had been abandoned by their parents when they were young teenagers. Now, both are down on their luck. Lincoln works in a New York City arcade wearing whiteface as a Lincoln impersonator so that people will pay money to "assassinate" Abraham Lincoln. Booth is unemployed and trying to master the three-card monte, a hustle at which Lincoln had been a master. By the end of the play it is obvious that each had been hustling the other, with the outcome that's expected given characters named Booth and Lincoln. Later in 2011, Suzan-Lori Parks revised George and Ira Gershwin's *Porgy and Bess* for a very successful Broadway revival.

Key Names, Venues, and Terms

African Grove Theatre

Ira Aldridge

Animism

Amiri Baraka

Blackface

Egungen Festivals

Eubie Blake

Alice Childress

For Colored Girls Who have Considered Suicide When the Rainbow Is Enuf

"Jim Crow"

Death and the King's Horseman

The Drama of King Shotaway

Fences

Athol Fugard

Charles Fuller

Lorraine Hansberry

Harlem Renaissance

Langston Hughes

Master Harold . . . And the Boys

Minstrel Show

"Moms" Mabley

Mulatto

Negro Ensemble Company

The Octoroon

Suzan-Lori Parks

Porgy and Bess

Thomas Dartmouth (Daddy) Rice

Ntozake Shange

Shuffle Along

Noble Sissle

A Soldier's Play

Wole Soyinka

Harriet Beecher Stowe

Topdog/Underdog

Uncle Tom's Cabin

Wedding Band: A Love/Hate Story in Black and White

August Wilson

George C. Wolfe

Additional Reading

Banham, Martin. *A History of Theatre in Africa.* Cambridge: Cambridge University Press, 2004.

Elam, Harry J. and David Krasner. *African-American Performance and Theatre History.* New York: Oxford University Press, 2001.

Kerr, David. *African Popular Theatre: From Pre-Colonial Days to the Present Day.* London: Heinemann Drama, 1995.

ASIAN THEATRE

Chapter XV

Asian theatre is discussed in this section rather than the Developmental History section because all of the traditional Asian theatre forms are still regularly performed somewhere in the world today, much as they were when they were first developed centuries ago. Part of the reason that we know how traditional Asian theatre was done is that instruction in the techniques of traditional theatre is still offered in their Asian countries of origin. In many cases, the legacy of theatrical practices has been handed down from father to son for many generations. In other cases, primary literary sources still exist from the time period when the art was invented, developed, or refined. The writings of those original artists still inform many Asian theatrical traditions. The traditional Asian theatre forms may still be seen any week of the year in their native homelands. Even in the United States, it is possible to see authentic traditional Asian theatrical performances any year, with the highest concentration in Asian sections of our largest cities. Many presentation houses across the country, including college campus presentation houses, also present authentic Asian theatrical performances every several years. The major forms of traditional Asian theatre are found in India, China, and Japan, which we will examine separately.

INDIAN THEATRE

For millions of years, the Indian subcontinent tectonic plate has been slamming up against the Asian tectonic plate, with the result that the Himalaya Mountains were raised, essentially making India impenetrable by land from any other location in Asia. Only in the area of the Khyber Pass, in northwest India, is it possible to gain access to the Indian interior by land. Consequently, Indian culture and theatre were able to develop in relative isolation, with only incidental and infrequent invasions coming in through the northwest. The Himalaya Mountains also prevented moist ocean air currents from carrying water to other parts of Asia. The rain and snow that fell as the air currents rose ever higher in the Himalaya Mountains fed the many rivers flowing through India and made possible the abundant vegetative growth that

made India almost a Garden of Eden. This led to the early development of cities, which in turn led to a city-culture dating as far back as 2,300 BCE. There were some hints of dance, and by 1,000 BCE, some short dialogues for up to three characters appeared as part of the Rig Veda. King Asoka (272–232 BCE) condemned public meetings that included performances, making it obvious that performances were being done by that time period.

The predominant Indian religion was Hinduism, coupled with animism. Hinduism was modified by Buddha (between c. 580 and c. 400 BCE) creating a second religion called Buddhism. The basic tenet of those religions is that life is suffering. Another shared principle of Hinduism and Buddhism is that you are reborn, based upon the karma that you earned in your previous life. If you accumulated good karma, you will be reborn in a higher station. If you accumulated bad karma, you will be reborn in a lower station, such as an animal or perhaps even a plant. Thus, the world is filled with gods and demons, and virtually all objects have spirits that conceivably could be your ancestors. The only way out of the repeating cycle of rebirth is by achieving **nirvana**—meaning union with Atman and the achievement of nothingness—which coincides with an end to suffering. The philosophic concept of karma implies a cosmic justice, in which only the karma you generated in your previous existence has any impact on your current situations. Thus, there can be no tragedy in Indian drama—if you have a bad situation now, you must have done something really bad in your previous existence.

EPICS

Just as there are two major epic poems in Greece, so too are there two major epic poems in India: the **Ramayana** and the **Mahabharata**. These epics are quite important to Indian culture as many of the plays, and even a few of the contemporary "**Bollywood**" movie scripts, are derived from the epics. The Hindus see their gods in man's image. Consequently, the gods in the epics are depicted with particularly human passions and weaknesses.

The *Ramayana* dealt with events that supposedly took place approximately 2,000 BCE. Rama, to honor a pledge he made, abandoned his throne and wandered in a self-imposed exile for fourteen years, accompanied only by his beautiful wife, Sita, and his younger brother, Lakshmana. During the course of his wanderings, he fought many demons in various jungles. On one occasion, he was distracted by a golden stag that was actually a demon in disguise. While Rama was thus distracted by the golden stag, Ravana, Lanka's demon king, kidnapped Sita and took her to Lanka, or modern-day Ceylon. Rama enlisted the aid of Hanuman, the monkey general, who had the ability to fly. Hanuman flew to Lanka, set his tail on fire, used it to burn down the demon's palace, and rescued Sita (Figure 15.1).

Figure 15.1 *Many plays and dance dramas revolve around the life of Rama, depicted at center.*

The *Mahabharata* dealt with the battle of two rival factions of a family: the Kauravas and the Pandavas. Duryodhana, the eldest Kaurava, gambled with the eldest Pandava. The latter lost everything, including the common wife he shared with his brothers, in a single roll of the dice. The Kauravas demanded the Pandavas go into exile for twelve years before the Pandavas could request restoration to their former positions. Even though the exile turned into thirteen years, Duryodhana refused to discuss the Pandavas' return. The god Krishna tried to intervene to settle the disagreement, at first trying to be fair to both factions. After observing the refusal of the Kauravas to bargain in good faith, Krishna sided completely with the Pandavas. A huge war was started that also involved many of the gods and ultimately led to the total destruction of both family factions.

NATYASASTRA

The *Natyasastra* is a theatre production book written sometime between 200 BCE and 200 CE. It presents the background both on how drama was "created" in India and how to do drama. According to the book, the god Indra asked the god Brahma to create a new diversion for the gods. Brahma created a fifth Veda called drama (Natya) by combining recitation from the Rig Veda, song from the Sama Veda, acting from the Yajur Veda, and aesthetics from the Atharva Veda. Vedas are ancient Indian religious hymns, incantations, and verses created by Brahma to be sung, chanted, or recited. For the new Veda, Brahma asked Indra to compose plays and asked the gods to act. Because Indra thought it was improper for the gods to act in plays, Brahma taught the dramatic arts to humans—Bharata and his sons. Other gods were involved

in designing and protecting the theatre. The book itself is attributed to Bharata Muni (who may actually have been multiple authors) who allegedly wrote down the instructions he received from Brahma. The *Natyasastra* is the world's earliest and most comprehensive text on producing plays. (Aristotle's *The Poetics*, though written up to several hundred years earlier, is a work of dramatic criticism and not a handbook on the total production techniques of drama.)

The *Natyasastra* is exceedingly detailed. It categorizes more than thirty types of dramas, has five long chapters on body movements, five chapters on voice, and also deals with other production processes, including properties, costumes, makeup, and theatre construction. One particular feature of the Indian drama aesthetics is *rasa*, or "flavor," which is the emotion or sentiment of the play. Each play may contain several different rasas, or flavors, but each script must have only a single dominant *rasa*, a characteristic which is still part of Indian drama today. The elaborate detail contained in the *Natyasastra* ensured a significant degree of consistency in early Indian theatre production. Consequently, that permits the traditional Indian theatre production techniques to persist until today in some isolated locales.

PLAYWRIGHTS

In general, early traditional Indian theatre scripts were written in Sanskrit. There were many Sanskrit playwrights, all of whom seem to have been either kings or friends of kings. Of the many plays written, the two recognized masterpieces are **The Little Clay Cart** (c. 350 CE) and **Shakuntala** (conjectured c. 500 CE). *The Little Clay Cart*, a ten-act play, was written by Sudraka, possibly a legendary individual. The play concerns Charudatta, who was in love with a courtesan, and the trials and tribulations they faced. Interestingly enough, both that play and its source script are the only two known serious Sanskrit plays dealing with a courtesan. *Shakuntala* is a seven-act play written by Kalidasa, who is recognized as the very best Sanskrit writer. In the play, Shakuntala and the King self-betroth in a private ceremony before he must return to the palace. Unfortunately, a curse causes him to forget who she is when she comes to the palace as his heavily pregnant wife. Because of the curse he refuses to accept her as his wife. Shakuntala's mother, herself a deity, flies Shakuntala away to a secret abode in heaven to shield her from further humiliation. At the end of the play, after his memory is restored, he is reunited with Shakuntala and their son, the future king. In begging for her forgiveness, he falls prostrate at her feet, an unprecedented action for any king or any Indian male to take.

DANCE DRAMA

There are various types of dance dramas in India. Two major types of Indian dance drama are **Kathakali** and **Chhau**. Kathakali was developed in seventeenth-century Kerala, a region on the southwest coast of India. Thampuran requested the use of

some dancers from his neighbor. When the neighbor refused, Thampuran decided to create his own troop and new dance form, based on a dream he had. A special feature of the new form was the very elaborate makeup and the large and elaborate headdresses that were worn. The dance uses hand gestures somewhat typical of other traditional Indian dance theatre forms (Figure 15.2).

Another type of dance drama is Chhau, with the distinguishing characteristics that the performers wear masks and that there is no dialogue between the characters. The dance form developed out of martial arts skills and incorporated acrobatic movements. Typically the dance dramas are composed of two or three dancers, but sometimes a larger group is used.

Figure 15.2 *Kathakali performance. Note the elaborate makeup, headdress, and costumes. The movements seem monotonous, repetitive, and slow by Western standards.*

CONTEMPORARY INDIAN THEATRE

Contemporary Indian theatre includes modern productions of Western scripts as well as productions by contemporary Indian playwrights. Probably the best-known contemporary Indian playwright was **Rabindranath Tagore** (1861–1940), who was awarded the Nobel Prize in Literature in 1913. He wrote a number of plays that incorporated aspects of traditional Indian theatre with Western theatre structure. His best-known play outside India is ***The Post Office*** (1913), dealing with the poignant situation of a young dying child. In his own naïve way, the young boy is able to inspire other characters to find the little pleasures in the drudgery of their everyday lives.

Figure 15.3 *Bollywood productions feature gratuitous spectacle and a contemporary carefree attitude toward life.*

It would not be appropriate to leave the discussion of contemporary Indian theatre without at least a passing reference to "Bollywood." Bollywood initially referred to a genre of Indian musical film, characterized by singing, dancing, and gratuitous spectacle that was developed after the middle of the twentieth century (Figure 15.3).

Figure 15.4 *Bollywood TV soap opera studio setting.*

Many Bollywood actors are major cultural icons in the Indian culture. Many of the films suggest a contemporary carefree attitude toward life, at least in life as it is presented in the Bollywood films, which for many people becomes an escape from their own lives. Today Bollywood has a wider perspective and there are now Bollywood TV shows, including Bollywood soap operas (Figures 15.4).

CHINESE THEATRE

Today, China is a vast country in Southeast Asia, but during the time period of the development of Chinese drama much of the population lived in a band near its eastern Pacific seaboard, even though the seat of government was further inland. The predominant religion was Confucianism, which was compatible with and merged with ancestor worship, a major tenet of Chinese life. Records of Shamans in early dances date back to the third millennium BCE. The arts and music, in particular, were associated with court institutions. Emperor Ming Huang (685–755 CE) created the "**Pear Garden**" in 714, as a school that trained thousands of singers and dancers, both male and female. At one time the Pear Garden orchestra had seven hundred members. Though there was a long period of dramatic development in China during the early dynasties, the most important dynasty for the development of literary Chinese drama was the Yuan dynasty, the period on which we will concentrate.

TRADITIONAL CHINESE THEATRE

The Mongols, who came out of the western steppes to conquer China, began the Yuan Dynasty in 1234. Before that time period, advancement for scholars was primarily through a very elaborate examination process. One took regional exams, and if

successful, went to the capital to take the final exam. Successful individuals typically would be appointed to various positions in the government. Thus, the government was filled with intellectuals, who often were also accomplished practitioners in many fields of art, including playwriting. It was not uncommon for some government officials to have their own theatre companies. When the Mongols conquered China, they initially eliminated the entire examination process, dismissed many officials, and tried to suppress the Confucian way of life. Because the Mongols liked drama and patronized it, they did not try to suppress the drama. The consequence of both actions was that the former government officials, who now found themselves unemployed, either had more time to devote to playwriting or they did it to maintain their livelihood. Thus, we get the start of the most literary period in Chinese drama. By the middle of the sixteenth century approximately 1,750 plays existed. Even though the literary quality was high, each play inevitably was also "operatic" and contained many songs because all traditional Chinese dramas contained songs.

The traditional Chinese theatre form was both a symbolic and a minimalist endeavor. Traditionally, the "scenery" consisted of little more than a table and two chairs, which were arranged to represent a wide range of locales. On the other hand, costumes and facial makeup were very elaborate. The makeup was very stylized, with color symbolism playing an important role. For example, red colored makeup indicated generals of outstanding loyalty, blue represented mischievous or arrogant individuals, and purple represented distinguished officials. Likewise, costumes were symbolic—that of a general often consisted of flags on his back, each flag representing a military division. On other occasions, a flag with a wagon wheel on it, and held at the waist, denoted being in a chariot (Figure 15.5). Up until about the middle of the twentieth century, all actors were males. One famous female impersonator actor, Mei Lanfang, surprisingly was hired as a spokesperson to help sell women's girdles in the United States in the early part of the twentieth century.

In each act of a Chinese drama the character enters, announces who he is, and what he is doing. This was done because often only the "best" scenes from selected scripts in the Chinese repertoire, rather than the complete play,

Figure 15.5 *Traditional Chinese opera is done with relatively few scenic elements. This modern production has more scenery than traditional productions. Costumes on the other hand are very elaborate, colorful, and symbolic. Likewise the painted facial patterns are very symbolic.*

were performed for an evening's entertainment. The music that was used in the plays was relatively traditional and the playwright's job was to write new lyrics for the traditional music rather than to compose new music for the play. Over the centuries, greater or lesser improvements in music and production techniques brought *Xiqu*, or Chinese Opera, as the form is called, to where it is today. While the label **Beijing Opera** is often used as if it were representative of all of Chinese Opera, Beijing Opera is technically only a regional style.

There were many Chinese playwrights and many excellent Chinese scripts. Major scripts include Hsing-Tao Li's *The Chalk Circle* (1300), which served as the source for Bertolt Brecht's *The Caucasian Chalk Circle*; Gao Ming's (1302–1370) *Lute Song* (1358?), consisting of forty-two acts and adapted as a Broadway musical in 1946; Ma Chih-yuan's *Autumn in Han Palace*, a May/December romance between an Emperor and one of his courtesans, based on a true story; Tang Xianzu's (Hsien-tsu) (1550–1610) *The Peony Pavilion* (1598), consisting of fifty-five acts that presents life as an illusion; Hong Sheng's (1645–1704) *The Palace of Eternal Youth* (1688), considered by many to be one of China's finest plays; and Kong Shangren's (1648–1718) *The Peach Blossom Fan* (1699), unusual for its tragic ending.

CONTEMPORARY CHINESE THEATRE

A kind of revolution took place in Chinese theatre around the beginning of the twentieth century. Nearly all previous Chinese theatre had been a form of Chinese Opera, which of course meant that virtually all of Chinese theatre had songs. The change from sung drama to only spoken drama began with the importation of Shakespeare's and Molière's scripts from the West. Original spoken drama in twentieth-century China started in 1907 with the Spring Willow Society's production of *The Black Slave's Cry to Heaven*, which was an adaptation of *Uncle Tom's Cabin*. **Cao Yu** (Ts'ao Yu) (1910–1997), who wrote **Thunderstorm** (1934), is widely recognized outside China as the most important Chinese author of twentieth-century spoken drama. The play's title refers to the approaching storm, which was a metaphor for the disturbances that would overwhelm the family of the Chinese mine owner. A young man leads the revolting miners against the mine owner. In the end, both learn that the young man is the mine owner's long lost son by his presumably dead first wife, who also turns out to still be alive.

On a different front and decades later, a new kind of revolution, the Cultural Revolution, took place in China. Mao Zedong (1893–1976), a communist, led a "people's" revolt and became the Chinese leader. He wanted to eliminate anti-working-class depictions and to substitute an anti-elite sentiment in the Chinese culture and the arts. His wife, Jaing Qing (1914–1991), a third-rate Chinese Opera performer herself, became instrumental in restructuring Chinese Opera. Old works were revised and new works were commissioned, many under her personal supervision.

Three of the new scripts thus created were *Taking Tiger Mountain by Strategy* (1958), which was set in 1946 Manchuria and dealt with Communist forces and the rallying of the masses; *The White-Haired Girl* (1958), commemorated the expulsion of the Japanese from China; and *The Red Detachment of Women* (1964), which commemorated an all-female Chinese military unit.

JAPANESE THEATRE

Japan is an archipelago of islands stretching more than 1,000 miles about 100 miles offshore of the eastern coast of China, Korea, and Russia. This relative isolation from the rest of Asia ensured that the Japanese culture and Japanese theatre would develop on its own. There were two predominant traditional religions in Japan. One was Shintoism, a coupling of nature and ancestor worship, complete with beliefs in shamanism and evil spirits. In general, this created a cultural fear of revenge from restless spirits, and some of the early Japanese theatrical forms were intended to calm those spirits. Part of this cultural fear may be conveyed by noting the Japanese people's reaction to the introduction of the telephone to Japan in the twentieth century. When Japanese people answer the phone today, they often say, "mushi mushi," and the person on the other end of the line is expected to respond in similar fashion. This is based upon the "knowledge" that the Fox, a trickster spirit, cannot say, "mushi mushi." Hearing, "mushi mushi," from the other end of the line is an assurance that the person is not a masquerading Fox, who is about to try to trick you. The other predominant religion in Japan was Zen Buddhism, a philosophy in which one comes to understand the universe through self-contemplation.

TRADITIONAL JAPANESE THEATRE

As was the case in India, there were two major epics in Japanese culture. One was the *Tale of Genji* (c. 1,000) with eight hundred verses. The other was *The Tale of the Heike* (twelfth century), consisting of forty-eight volumes, recounting the rise and fall of the Taira and Minamoto clans. Both were sources for a number of **Noh** and **Kabuki** scripts. There were three major types of traditional theatre in Japan, Noh, Kabuki, and **Bunraku**, each initially identified with a different social class.

Noh: Though there were dance drama antecedents for Noh drama, Kan'ami (1333–1385) is credited with having created Noh almost from nothing. However, it was Kan'ami's son, **Zeami Motokiyo** (1363–1443), who became the acknowledged master of Noh and who raised it to the high stature it has achieved. In addition to being a master performer, Zeami wrote four books on the art of Noh that are major sources for the aesthetics and techniques of Noh to this day. Noh drama was particularly appreciated by the aristocratic class of the samurai, who were expected to lay

down their lives on a moment's notice in service to the Shogun or to the Emperor. As in China, the ruling Japanese samurai were expected to be cultured individuals who could compose credible poetry in poetry-writing contests, for example. The samurais' perception of the transitory nature of their lives was particularly compatible with Zen Buddhism. This was likewise reflected in Noh drama, which typically included lines from, or references to, poems and other writings that were intended to generate a contemplative attitude about the particular Noh script.

Structurally, Noh drama begins with the entrance of the **Waki**, the second actor, who does a self-introduction and an announcement of where he has been and where he is going. The **Shite**, the protagonist and lead actor, who typically wears a mask, enters and does a dance or scene. Often, the Shite exits and reenters, appearing in his true form, which might have been hidden in the previous scene (Figure 15.6). Noh drama is a minimalist style, one in which only those essentials needed to portray the characters and convey the dramatic action are on stage. The stage is a simple platform with four pillars holding up a roof. If the play involves spirits, the back wall often has a pine tree painted on it (Figure 15.7). Musicians sit in front of that wall. Because of the archaic nature of the language used and the elongated vocalization patterns employed, even native Japanese today sometimes need a libretto to completely understand what is being said.

© MANAN VATSYAYANA/Getty Images.

Figure 15.6 *The shite, or protagonist, in Noh theatre often wears a mask that is slightly smaller than life size. Costumes are often elaborate, but the rest of the staging is rather minimal. The musicians may be seen playing in front of the stage's back wall. The pine tree on the back wall indicates that the play is one of the spirit world.*

Photo courtesy of Robert Smith.

Figure 15.7 *Originally Noh stages were outside. When they were brought indoors the previous roof was retained. To the left is the entrance passage with several pine trees along it. The audience is seated on two sides and in the Noh National Theatre there are monitors in the backs of the seats that display the translation of the dialogue.*

Kabuki: Kabuki was favored by the middle class in Osaka and in Edo, the medieval name for Tokyo. The form originated in the early 1600s, when **Okuni** performed a shamanistic ritual to appease the vengeful spirit of her dead lover on the ground of a dry riverbed. She incorporated both outlandish clothing and anticonformist behavior, or *kabuki mono*, the term that gave the form its name. Okuni was followed by imitators, and the form degenerated into prostitution. By 1629, female performances of Kabuki were banned because of the prostitution. This was followed by young boys' Kabuki, which was likewise banned in 1652 again because of prostitution. That left Kabuki to be performed only by men up until the very late twentieth century when some females performed with smaller Kabuki companies or separate female Kabuki companies were created.

Kabuki is an elaborate and spectacular theatrical form featuring colorful costumes, colorful scenery, fantastically colorful facial makeup, and lots of action (Figure 15.8). The Kabuki stage resembles a proscenium stage, but has a **hanamichi**, or walkway, about 5 feet wide on the stage right side of the auditorium, on which spectacular entrances and exits are often staged (Figure 15.9).

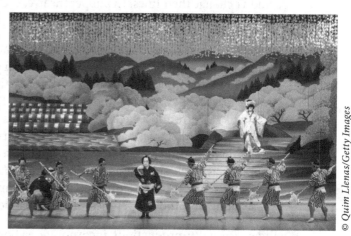

Figure 15.8 *Traditional Kabuki productions are grand, spectacular, and colorful. The character on the upper steps is an onnagata or female impersonator, played by a male actor.*

Traditional Kabuki uses special effects including elevator stages and revolving stages. Kabuki has a number of special features.

- **Mie**: A *Mie* is a specialized stance used to make a dramatic statement, typically accompanied by crossed eyes.

- **Roppo**: A *Roppo* is used for a spectacular exit and is a Japanese term that means "going in six directions."

- **Hikinuki**: A *Hikinuki* is a fast costume change, typically done on stage in front of the audience in mere seconds, by pulling threads from the garment.

Figure 15.9 *Curtain for a production at the Kabuki National Theatre. The actor on the left is on the hanamichi making a final exit and doing a Mie.*

- *Onnagata*: An *Onnagata* is a male actor who impersonates a female character. Because of the restrictions about female actors that had been in place since the seventeenth century, male actors had to learn to convincingly portray female characters. Only in the late twentieth century did a few companies with female actors appear.

The single most important Japanese playwright of this time period was **Chikamatsu** Monzaemon (1653–1724), who was called the "Japanese Shakespeare." For ten years, Chikamatsu wrote for the Kabuki stage, but his irritation with actors altering his scripts prompted him to leave Kabuki and write for Bunraku because the puppets couldn't change their lines. In puppet theatre, every line in the script is spoken by the one chanter, who works from a script.

Bunraku: Simplified puppets were used by peasants in rituals from about the eighth century. However, early in the sixteenth century, or about the time of the invention of Kabuki, puppetry became associated with the *Joruri*, or chanter. In the late seventeenth century, Takemoto Gridayu (1651–1714) hired Chikamatsu away from the Kabuki theatre and asked him to write for his puppet theatre. Chikamatsu stayed with the puppet theatre for about twenty years writing new plays and adapting others for the puppet theatre. Some of his scripts were based upon current events of the time, such as a love suicide, as presented in *The Love Suicides at Amijima* (1721). The puppet form was further refined by Uemura Bunraku—Ken (1737–1810), a puppeteer whose name gave the puppet theatre its current identifying label.

Today, Bunraku productions incorporate elaborate construction of both sets and puppets and elaborate manipulation of the puppets, which range from one-half to one-third human size. Three handlers are needed today to handle each of the major puppets, while secondary puppets might be handled by one or two puppeteers. For the large puppets, the third, and least experienced puppet handler, manipulates the puppet's feet, which in the case of female characters might be nothing more than moving the skirt to look like there are feet under it. The second handler is assigned the left hand of the puppet, and typically needed ten years of experience on the feet before advancing to manipulating the left hand. The first handler manipulates the head and right hand and likewise needed approximately ten years of experience on the left hand before being able to advance to manipulating the head and right hand. All puppeteers are enclosed in black costumes, the Japanese theatrical convention for invisibility, except for the first handler whose head is exposed today, because the first handler is often a national living treasure. In addition, the first handler typically wears high clogs, to put him at an elevation that allows the other handlers to more efficiently coordinate their puppet manipulation process (Figure 15.10).

Another artist in Bunraku is the *Joruri*, who is the chanter/narrator of the play and an equal artist with the puppeteers. The *Joruri* speaks all the lines of all the characters, including any vocal characterizations that might be used to identify

the different characters. In addition, the *Joruri* narrates the production. Vocal clarity is more important than a beautiful voice. The vocal demands and strains on the *Joruri*'s voice are so high that he can only perform for an hour at a time, the point at which another *Joruri* continues the show.

CONTEMPORARY JAPANESE THEATRE

The beginning of contemporary Japanese drama started in the very late nineteenth century and was advanced by the work done at Waseda University and at Keio University, where Western scripts were first mounted. There were two major Japanese dramatists of the twentieth century. Mishima Yukio (1925–1970) tried to write modern forms of Noh plays, in which he advocated for ultratraditional samurai values. He ultimately killed himself via the traditional ritual of hara-kiri. Abe Kobo (1924–1993) wrote absurdist plays that baffled the Japanese critics. One of his shorter plays was *The Man Who Turned into a Stick* (1976), a glimpse of a society in which everyone is so rigid they turn into sticks.

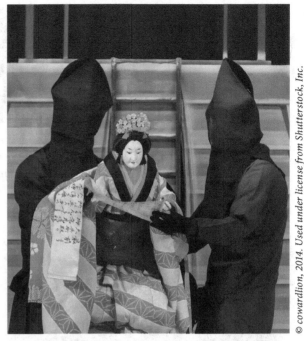

Figure 15.10 *Japanese Bunraku puppet theatre. Major puppet characters have three puppeteers. Others may have only one or two. The black outfits of the puppeteers are the Japanese theatre convention for invisibility.*

SOUTHEAST ASIAN THEATRE

Much of the traditional theatre that is in Bali, Burma, Indonesia, Java, Thailand, and other Southeast Asian countries is derivative of Indian forms and techniques, with some influence from China. Thailand has *Khon*, which is a masked mime dance, based on the stories from the *Ramayana*. In Java, there is *Topeng*, a masked form based on the *Ramayana* and the *Mahabharata*. In Bali there is *Wayang wong*, another masked form that shows influence from the Chinese, particularly in the masks, and again is typically based upon the *Ramayana*.

Various forms of puppetry may also be found across Asia, but probably the most interesting and certainly the most iconic, are the **shadow puppets** (Figure 15.11).

Figure 15.11 *Various forms of shadow puppets performances may be seen across Asia. This performance is from India and is representative of the level of production that may typically be seen in Indian villages.*

Figure 15.12 *Backstage view of shadow puppets used in an Indian production showing the open work and the bamboo splints that are used for manipulating the puppets.*

Various types of leather are used because each has a different translucency and/or transparency. In production, a light shines through the puppet to project its shadow on a screen, such as a sheet. In addition, elaborate forms of coloring were sometimes added to enhance the effect (Figure 15.12).

Some of these shadow puppets are elegant and exotic works of art that were originally created from leather (Figure 15.13).

Figure 15.13 *Detail of a Wayang shadow puppet showing intricate construction and coloring.*

Key Names, Venues, and Terms

Beijing Opera
Bollywood
Bunraku
Chhau
Chikamatsu
Hanamichi
Hikinuki
Joruri
Kabuki
Kathakali
The Little Clay Cart
Mahabharata
Mie
Natyasastra
Nirvana
Noh
Okuni

Onnagata
Pear Garden
The Post Office
Ramayana
Rasa
Roppo
Shadow Puppets
Shakuntala
Shite
Rabindranath Tagore
The Tale of Genji
The Tale of the Heike
Thunderstorm
Waki
Cao Yu
Zeami

Additional Reading

Mackerras, Colin. *Chinese Theatre: From Its Origins to the Present Day.* Honolulu, HI: University of Hawaii Press, 1983.

Miettinen, Jukka O. *Classical Dance and Theatre in South-East Asia.* Oxford: Oxford University Press, 1992.

Ortolani, Benito. *The Japanese Theatre: From Shamanistic Ritual to Contemporary Pluralism*, rev. Princeton: Princeton University Press, 1995.

Richmond, Farley P., Darius L. Swann, and Phillip B. Zarrilli. *Indian Theatre: Traditions of Performance.* Honolulu, HI: University of Hawaii Press, 1990.

DIVERSITY

In addition to the African-American theatre discussed in Chapter XIV, there is a range of other diverse theatres, particularly in the United States, to be discussed: Women, Gay/Lesbian, Asian-American, Hispanic, and Native-American.

WOMEN/FEMINIST THEATRE

These two distinct movements are focused more on activities in the United States, but their objectives can also be seen in Europe. Feminist Theatre started as a political and agitprop reaction, starting around the 1960s, to the oppression and control of women by the dominant male culture. Among other things, it sought political and economic equality for women. Women's Theatre on the other hand, though similar to Feminist Theatre, is more specific and seeks more financial and employment opportunities in Theatre for women, addressed in some spheres by the development of Women's Theatre groups that confronted specific women's issues.

EUROPE

Though clearly not a female playwright, Euripides was sensitive to the treatment of women and was far more realistic in portraying that treatment than other Greek dramatists. From our perspective, Euripides wrote more sensitively about women in *Medea* and *The Trojan Women*. However, it is not until the medieval period that we find the first female playwright—**Hrotsvitha of Gandersheim** (ca. 935–973). She was the canoness of a priory and wrote six plays dealing with the perspective of nuns in a convent. In that period, becoming a nun was generally the only socially acceptable option a woman had other than becoming a wife. In addition to being the first female playwright, Hrotsvitha was the first playwright since the classical period of Greece and Rome whose name is known. Hrotsvitha's best-known plays are *Dulcitius* and *Paphnutius*.

The next significant female European playwright, **Aphra Behn** (1640–1689), didn't appear until the English Restoration period. She was widowed at a young age and began writing to support herself. She also worked as an English spy, something she had in common with Christopher Marlowe. She was widely recognized at the time as being a rather salacious writer, frequently surpassing men in her use of suggestive and erotic material. She is best known for her play *The Rover* (1677), the story of a young woman whose male family members had decided she will either marry the Viceroy or enter a convent. She is equally determined to seek her own liaisons if possible, and, at the very least, to experience "life" before she must wear the habit. Importantly, Behn was not the only female playwright of that period, but she is now the best known.

In the nineteenth century, a number of playwrights, even though they were males, began to address issues specifically related to women. Henrik Ibsen addressed women's issues most directly in *A Doll's House* (1879), in which Nora walks out of her house and marriage at the end of the play. For that depiction Ibsen and the play were vilified. In 1886, he continued his examination of the new woman in *Rosmersholm*. **August Strindberg** dealt with unique female characters in some of his plays including *The Father* (1887) and *Miss Julie* (1888). Strindberg's plays are often characterized by some critics as "battles of the sexes." George Bernard Shaw was much more sympathetic in his treatment of the modern woman, as may be seen in his plays *Candida* (written in 1894, but not produced till 1898), and *Pygmalion* (1912).

There were a number of female playwrights in Europe during the twentieth century. Among them was Gertrude Stein (1874–1946). She was born in the United States, but moved to Paris around age 30 where she lived and worked for the rest of her life. She wrote the libretto for *The Mother of Us All* (1947), and Virgil Thomson (1896–1989) wrote the music. The opera is about Susan B. Anthony and her role in the fight for women's suffrage. A variety of other historical figures are also included in the opera. In England, **Caryl Churchill** (1938–) dealt with sexual/gender issues in addition to feminist issues. Two of her plays are *Cloud Nine* (1979), which makes extensive use of cross-gender casting, and *Top Girls* (1982), about Marlene, a driven business woman and what it cost her to achieve the status of a top woman.

AMERICA

In America, the first significant female playwright was **Anna Cora Mowatt** [Ritchie] (1819–1870), who wrote *Fashion: Or, Life in New York* (1845). The play is a satiric treatment of affluent people modeling ridiculous foreign behavior or "fashion." Mowatt was well read and wrote plays early in her life, but did not take up playwriting again, until, like Aphra Behn, she was widowed young and turned to writing to have an income.

In the twentieth century, there was **Sophie Treadwell** (1885–1970), who wrote *Machinal* (1928), an expressionistic treatment of a woman who was on trial for murdering her husband. The major mid-twentieth-century American female playwright was **Lillian Hellman** (1905–1984), perhaps best known for *The Little Foxes* (1939), a portrait of the callousness of a Southern family intent on becoming well-to-do, and *The Children's Hour* (1934). **Lorraine Hansberry**, another significant playwright of the mid-twentieth century, died at age 35 and is more closely identified with African-American theatre. Her most famous work is *A Raisin in the Sun* (1959).

By the three-quarter point of the twentieth century, there were many more female playwrights: **Maria Irene Fornes'** (1930–2018) *Fefu and Her Friends* (1977) and *Mud* (1983), which depicts the female character's dehumanizing treatment at the hands of two men; **Beth Henley's** (1952–) *Crimes of the Heart* (1978), a Chekhovian take on three Southern sisters facing their tribulations, including one who shot her husband because she realized she just didn't like him, and *The Wake of Jamey Foster* (1982) (Figure 16.1); Tina Howe's (1937–) *Painting Churches* (1983), dealing with the onset of Alzheimer's in the painter's father, and *Pride's Crossing* (1997); **Marsha Norman's** (1947–) *'Night, Mother* (1983), in which Jessie carefully lays out for her mother and the audience why committing suicide is the only rational thing to do; **Suzan-Lori Parks'** (1963–) *Topdog/Underdog* (2001), dealing with the sibling rivalry between two black brothers who had been abandoned by their parents as young teenagers; **Sarah Ruhl's** (1974–) *In the Next Room* (or the *Vibrator Play*) (2009), addressing late nineteenth-century techniques for treating "hysterical" women; **Paula Vogel's** (1951–) *How I learned to Drive* (1997), dealing with child sexual abuse; and **Wendy Wasserstein's** (1950–2006) *The Heidi Chronicles* (1988), chronicling Heidi's journey during the changing perspective on feminism during the late twentieth century. Some of these women playwrights also addressed concerns about other issues such as sexuality or African-American issues.

Image courtesy of Robert Smith.

Figure 16.1 *Beth Henley's comedies are still popular. This design was for* The Wake of Jamey Foster. *See additional drawings for* Crimes of the Heart *in Figures 10.8 and 10.12 in Chapter X.*

The Feminist Theatre movement has made significant progress in changing society, but there is still much to be achieved before political and economic equality is a reality. The imperative of the late twentieth-century Women's Theatre movement has abated some, because today it is common for plays by and about women to be part of a typical regional theatre's season. More recently, the Women's Theatre issues today

have been targeting the film industry. Of Theatre Communication Group's (TCG) 350-member theatres, 35 note that plays by and about women are of special interest in their production schedule. The Tennessee Women's Theatre Project in Nashville, Tennessee, The VORTEX in Austin, Texas, and The Wooster Group in New York City are some examples.

GAY/LESBIAN THEATRE

Perhaps the first treatment of homosexuality in European theatre may be found in Christopher Marlowe's (1564–1593) *Edward II* (1593). It was not a particularly sympathetic treatment, despite Marlowe's own homosexuality, as *Edward II* ultimately was executed by the English nobility, in part because of his homosexual activity. However, the play does present a gay theme of being oppressed by the dominant "straight" culture of the nobles. Centuries later, Oscar Wilde (1854–1900) made veiled allusions to the gay society in his play, *The Importance of Being Earnest* (1895). Despite the fact that some gay allusions may be found in the play, the play itself is not part of a gay theme in theatre and certainly the majority of the audience in its time period had no awareness of the gay allusions. Oscar Wilde, who was married with two sons, was the central figure in the notorious trials for "indecency" in 1895 and for which he was sentenced to prison. In *The Importance of Being Earnest*, the character named "Cecily" has a name that was gay code for a "boy toy" and the preferred gift given to such boy toys was a silver cigarette case—the object Jack lost the last time Jack visited Algernon. Oscar Wilde was subliminally thumbing his nose at and showing his contempt for the polite society of his time by including these gay code terms.

Other oblique references to homosexuality may be found in other plays that likewise were not part of the gay theme theatre. Near the end of Lillian Hellman's (1905–1984) *The Children's Hour*, one of the female characters confesses to the other that she thought she had latent feelings for the other. Robert Anderson's (1917–2009) *Tea and Sympathy* (1953) also obliquely addressed homosexuality, because the leading male character was perceived as not being "manly" enough.

The first Off-Broadway treatment of homosexual men as ordinary people may be found in the American playwright **Mart Crowley's** (1935–) *Boys in the Band* (1968). Despite its inclusion of gay stereotypes, it was widely recognized in its time as being the first play to present gay men as central rather than peripheral characters. The play ran for over one thousand performances.

The biggest issue to galvanize the gay community and prompt the profusion of gay theme theatre activity was the appearance of AIDS in the 1960s and the inaction of President Ronald Reagan and mainstream society to address the epidemic. A number of playwrights addressed those issues. **Harvey Fierstein** (1954–) dealt with gay

issues in *Torch Song Trilogy* (1981) and *Safe Sex* (1987), and made his biggest impact with the book of *La Cage aux Folles* (1983). *Torch Song Trilogy* deals with Arnold, a torch-song-singing drag queen, and his search for love. In *La Cage aux Folles*, an ultraconservative homophobic man confronts his daughter's fiancé, whose "parents" are gay. *Safe Sex* is a direct and explicit discussion of gay sexual practices in the time of the AIDS epidemic. **Larry Kramer's** (1935–) *The Normal Heart* (1985) is a semiautobiographical play dealing with recognizing AIDS as an epidemic and finding the political will and financial support to confront it. **William M. Hoffman's** (1939–2017) *As Is* (1985), among other things, deals with the agony that AIDS imposed on relationships. At the end of the play, one character decides to take his friend "as is" even though he has AIDS.

Probably the most important play at the end of the twentieth century dealing with gay issues was **Tony Kushner's** (1956–) ***Angels in America: A Gay Fantasia on National Themes*** (1992), a two-part play that was nearly seven hours long and for which he received the Pulitzer Prize in drama. Among other things, the play is an indictment of the Reagan-era policies toward and about gay culture and the epidemic of AIDS.

Today the subject matter of gay and lesbian plays no longer has to be related to AIDS. Plays on gay/lesbian issues are done by a range of regional theatres, both mainstream theatres and special focus theatres. One notable lesbian theatre company was **Split Britches**, started in 1980 by Peggy Shaw (1944–), Lois Weaver (1949–), and Deborah Margolin (1953–). An example of its work was a satiric take on Tennessee William's *A Streetcar Named Desire*, entitled *Belle Reprieve* (1991). Another gay theatre company, the **Ridiculous Theatrical Company**, was headed by **Charles Ludlam** (1943–1987). Ludlam wrote many scripts, often playing leading roles in drag, including *The Mystery of Irma Vep* (1984) and *The Artificial Jungle* (1986). The scripts typically were parodies of other works or styles and the production style was over the top. Today, gay/lesbian regional theatres are widespread. Of TCG's member theatres, forty note special interest in Gay/Lesbian theatre, including About Face Theatre in Chicago, Illinois; Actor's Express in Atlanta, Georgia; and Actors Theatre of Phoenix in Phoenix, Arizona.

ASIAN-AMERICAN THEATRE

The Asian-American theatrical scene in the United States is much smaller than that for the previous groups. During most of the nineteenth and twentieth centuries, Asians and Asian-Americans were typically presented in stereotypical roles. Probably the most important Asian-American playwright is **David Henry Hwang** (1957–), who wrote *FOB* (1980)—meaning "fresh off the boat." Hwang is best known for ***M. Butterfly*** (1988), based upon a true story. In the play, a French

diplomat was in love with a Chinese opera performer. For a decade the diplomat believed his partner in the affair was a woman, but learned only after his arrest for espionage that she was actually a cross-dressing spy. Hwang addressed the sexuality of Asian males in *Kung Fu* (2014), the story of Bruce Lee, but also a metaphor for the rise of the Asian cultures. There are relatively few Asian-American theatre companies. Only fifteen of TCG's member theatres have a special interest in Asian/Asian-American theatre, but they include East West Players in Los Angeles, California; Mu Performing Arts in St. Paul, Minnesota; and the Pan Asian Repertory Theatre in New York City.

HISPANIC THEATRE

Various theatrical activities existed before the arrival of Europeans in the New World, but a Mayan dance drama, *Rabinal Warrior,* is possibly the oldest that we know of, dating from the thirteenth century. Following the arrival of the Spanish, Corpus Christi plays were done in Mexico as early as 1521. A particularly interesting early Hispanic playwright was **Sor Juana Inés de la Cruz** (1651–1695). She wanted to attend university dressed as a man but her mother refused to allow her to do so. Consequently, she had to self-educate herself and, like Hrotsvitha, became the prioress of a convent. She wrote *Divine Narcissus* (1690) and other works and today is considered one of the greatest Spanish-language poets.

As happened in other cultures in the Western world, in the late nineteenth century in Latin America, social problem plays began to appear that addressed issues of racism and women's treatment. This continued into the twentieth century. Because each Latin American country has its own unique theatrical genres and history, we can only do a brief overview. **Augusto Boal** (1931–2009), born in Brazil, was a Marxist playwright and theorist, whose book, *Theatre of the Oppressed* (1975), became a rallying point for other authors with a socialist agenda. In Chile, **Egon Wolff** (1926–2016) wrote *Paper Flowers* (1970). In the play, a professional woman brings home a homeless man, identified in the script as The Hake, a fish with a voracious appetite. Over the course of the play, their relationship changes and The Hake becomes domineering, eventually psychologically destroying the woman. In Mexico, **Elena Garro** (1920–1990) wrote *A Solid Home* (1957), about a woman whose aspiration for a solid home is finally realized in her marble crypt. Garro is considered one of the two best female Mexican writers since Sor Juana Inés de la Cruz. In Trinidad, **Derek Walcott** (1930–2017), who won the Nobel Prize in Literature in 1992, blended African heritage issues into the Hispanic world in his work with the Trinidad Theatre Workshop. His play, *Ti-Jean and His Brothers* (1958), is a parable about brains over brawn when dealing with the devil, portrayed as a white man.

The two most important Hispanic American playwrights are Maria Irene Fornes, noted earlier, and **Luis Valdez** (1940–). Fornes' play, *Fefu and Her Friends*, is set in and around Fefu's New England home. The play is divided into three parts. In the middle part, the audience is divided into four different groups and in rotation watches the different scenes taking place around the house. In an unexplained bizarre action in the third part, Fefu shoots a rabbit in the backyard and one of the human characters immediately dies of a bullet wound to the head. One of her other plays, *Mud* (1983), deals with a woman who aspires to better herself. Unfortunately, the two men in her life see her as little more than an object to be possessed, and one of them shoots her at the end of the play rather than let her leave. Luis Valdez is intimately associated with the theatre company called **El Teatro Campesino**, which was originally associated with the United Farm Workers strikes in California during the 1960s. Initially, those plays were short agitprop productions frequently presented on a flatbed truck. "Agitprop" is short for "agitation propaganda." Later, Valdez wrote his best known play, *Zoot Suit* (1981), based in part on a real murder and the events surrounding it.

There are around one hundred different Hispanic American theatre groups in the United States. TCG membership includes more than thirty theatres with a special interest in Latino/Hispanic theatre, including GALA Hispanic Theatre in Washington, DC; The Western Stage in Salinas, California; Repertorio Espanol in New York City; Teatro del Pueblo in St. Paul, Minnesota; and Teatro Vista Theatre with a View in Chicago, Illinois.

NATIVE-AMERICAN THEATRE

Just as there were indigenous theatres in the Hispanic world, so too there were theatrical activities among Native-Americans long before contact with Europeans. In Pueblo villages of the American Southwest, there often were two Kivas, or clubhouses, one of them was used for the rehearsal of dance dramas. Among the Zuni, there were festivals at which a clown, sometimes referred to as a trickster, would parody the festivities' activities and comment upon topical situations, such as a shaky marriage. Many of the indigenous peoples had a variety of rituals and festivals that might appeal to the gods for special favor or mark rites of passage in their culture. Many of those rituals are frequently presented today as a means of attracting tourist dollars. For example, the Hopi Indians, also from America's southwest, continue to do their rain dances today for that purpose.

Native-American theatre had to fight the stereotypes generated during the nineteenth century and perpetuated through most of the twentieth century. During that time,

American theatre depicted Native-Americans as either vengeful killers or noble savages. The famous nineteenth-century actor, Edwin Forrest (1806–1872) frequently sponsored national playwriting contests. A script that was produced by one such contest was *Metamora; or the Last of the Wampanogs* (1828), written by John Augustus Stone (1801–1834). Though neither Forrest nor Stone were Native-Americans, the play was one of the few to feature Native-American characters.

In the twentieth century, **Lynn Riggs** (1899–1954) became the first Native-American playwright to have his plays produced on Broadway, including *Green Grow the Lilacs* (1931), the basis for the musical, *Oklahoma!*. Later in the century, **Hanay Geiogamah** (1945–) founded the American Indian Theatre Ensemble in New York City in 1972. In that same year, he wrote the first of several Native-American plays, *Body Indian*. **Bruce King** (1950–), who wrote his first play in 1969, wrote *THREADS: Ethel Nickle's Little Acre*. Today, he is more widely recognized as a very accomplished postimpressionist painter of evocative and nostalgic recollections of Native-American scenes. Tompson Highway (1951–), literally born in a snow bank beside a highway, is a professional pianist and playwright, who at one time headed Canada's most prominent Native-American theatre company—Native Earth Performing Arts in Toronto. He dealt with Native-American issues in *The Rez Sisters* (1986), part of a seven-play cycle featuring the same characters, and *Ernestine Shuswap Gets her Trout* (2004). In *The Rez Sisters*, the women exhibit an appreciation for the positive aspects of life despite living on the reservation. **William S. Yellow Robe Jr.** (1950–) also headed a couple of Native-American theatre companies. He wrote *Grandchildren of the Buffalo Soldiers*, which deals in part with cultural conflicts between African-Americans and Native-Americans. The play was started about 1996, had a staged reading in 2001, and was eventually mounted in 2005. His most recent play, *Wood Bones* (2013) appeared in New York City at the Abington Theatre. Marie Clements' (1962–) works are often a blend of theatre and storytelling. Her most recent play is *Tombs of the Vanishing Indian* (2012).

Spiderwoman Theatre is the oldest continually performing Native-American and women's theatre company in America. It was started in 1975 by Gloria Miguel, Muriel Miguel, and Lisa Mayo, who blended theatrical techniques and storytelling in order to deal with contemporary Indian issues. There are fewer than a dozen theatre companies—only six from TCG—with a special interest in Native-American theatre including Native Voices at the Autry in Los Angeles, California and Cyrano's Theatre Company in Anchorage, Alaska. Other theatre companies include the American Indian Theatre Company of Oklahoma in Tulsa, Oklahoma and the American Indian Repertory Theatre in Lawrence, Kansas.

Key Names, Venues, and Terms

Angels in America
As Is
Aphra Behn
Augusto Boal
Boys in the Band
Caryl Churchill
Crimes of the Heart
Mart Crowley
A Doll's House
El Teatro Campesino
Harvey Fierstein
Maria Irene Fornes
Elena Garro
Hanay Geiogamah
Grandchildren of the Buffalo Soldiers
Green Grow the Lilacs
Lorraine Hansberry
The Heidi Chronicles
Lillian Hellman
Beth Henley
William M. Hoffman
Tina Howe
How I Learned to Drive
Hrotsvitha of Gandersheim
Henry David Hwang
In the Next Room
Bruce King
Larry Kramer

Tony Kushner
Charles Ludlam
M. Butterfly
Machinal
David Mamet
Metamora
Anna Cora Mowatt
'Night Mother
Marsha Norman
Suzan-Lori Parks
Ridiculous Theatrical Company
Lynn Riggs
William S. Yellow Robe Jr.
The Rover
Sarah Ruhl
Sor Juana Inés de la Cruz
Split Britches
August Strindberg
Sophie Treadwell
Spiderwoman Theatre
Topdog/Underdog
Top Girls
Luis Valdez
Paula Vogel
Derek Walcott
Wendy Wasserstein
Egon Wolff

Additional Reading

Canning, Charlotte. *Feminist Theatres in the U. S. A. Staging Women's Experience*. New York: Routledge, 1996.

MacDougall, Pauleena. *Native-American Drama: A Critical Perspective*. New York: Cambridge University Press, 2009.

Maufort, Marc (ed.). *Staging Differences: Cultural Pluralism in American Theatre and Drama*. New York: Lang, 1995.

Pottlitzer, Joanne. *Hispanic Theatre in the United States and Puerto Rico*. New York: Ford Foundation, 1988.

PART III.
THE DEVELOPMENT OF THEATRE

In Part III, we will examine the historical development of Theatre, starting with Greek Theatre in Chapter XVII. From the Greeks, we proceed to the Romans and, following the fall of the Roman Empire, to the Medieval Theatre. The explosion of Theatre in the Renaissance continues through the seventeenth and eighteenth centuries. Finally we start into the nineteenth century. In order to bring the historical development full circle, one would return to the Contemporary Theatre at the beginning of Part II.

GREEK THEATRE

Greece is a peninsula with a very convoluted coastline and associated islands all located near the eastern end of the Mediterranean Sea. The mountainous terrain made land communication between the various valleys quite difficult. Consequently, isolated individual city-states developed, such as Athens, Thebes, Corinth, and Sparta. The sea was an important wayfare for the early Greeks and they soon became proficient seafarers and merchants. Consequently, Greek colonies eventually developed on the shores of Asia Minor, various islands in the Mediterranean, and as far west as the coasts of Italy and Sicily. Initially, Greece was a remote backwater, culturally quite distant from the then recognized centers of civilization in Persia and Egypt. Greece didn't even have a written language of its own until it added elements to the Phoenician alphabet and created its own written language around 700 BCE. A remarkable achievement of the Greek people and their culture is that in less than two centuries they moved from no written language to the literary pinnacle that we recognize today in the Greek drama.

The Greeks were a religious and fearful people. They created gods in their own image and gave them human foibles, recognized in the phrase "The gods have feet of clay." It was common practice for Greeks to have one or more religious shrines in their homes. Some Greeks even had a shrine to the "unknown gods," to which they made offerings because they feared offending any gods even if they didn't know who they were. The Greeks also had a fatalistic life view. In their mythology, the Three Fates were constantly weaving a tapestry composed of yarns, each representing a human life. When the weavers finished using a particular yarn, the yarn was simply clipped off, thus ending a human life.

BEGINNING OF THEATRE

No one is absolutely certain about how Greek theatre developed. Aristotle (384–322 BCE), the Greek theatre critic, in his book *The Poetics (c. 335 BCE)*, wrote that tragedy developed from the Greek **dithyramb,** a sung and danced ode, or hymn, to the god Dionysus, but Aristotle was writing approximately two hundred years after the

invention of Greek drama. Some of our more contemporary scholars have argued that funeral elegies, recounting the exploits of important individuals, were a contributor to the development process. Other scholars found that reproductive and fertility rites were a more important contributor. Others have put forth the theory that drama was imported from Egypt where the *Abydos Passion Play* had been performing for over 1,500 years before the Greek drama appeared. The problem with advancing the *Abydos Passion Play* is that it was part of a religious ritual and there is no evidence that it ever moved beyond being ritualistic. Still other scholars postulated that the tradition of the oral story teller, as represented by Homer with his *Iliad* and *Odyssey*, were primal generators. A reasonable conjecture, and the one held by the author, is that all of these might have had some part in the development of theatre in Greece, but that the dithyrambs, with their singing and dancing that most closely paralleled those similar activities in the drama, were probably a more important influence than any one of the others. Part of this may also be supported by the fact that Thespis, a known dithyramb chorus leader, was also the winner of the first theatre festival in 534 BCE in Athens.

Dithyramb presentations honored the god Dionysus, the Greek god of wine, fertility, and partying, whose worship was imported from Asia Minor (Figure 17.1).

Figure 17.1 *The slightly tipsy god Dionysus has grapes in his left hand and holds a cup of wine in his right hand. The nakedness of the body alludes to the fertility aspect of the worship of Dionysus.*

Dithyrambs were choral odes or hymns presented by males as part of religious rituals and eventually became a festival with contests. The dithyrambs often were stories about heroes and myths. There was a choral leader who may have recited, sung, or improvised the story and a group of fifty **chorus** members, who typically were satyrs. Satyrs were woodland deities who were half goat and half man, typically associated with the worship of Dionysus. They had the ears, horns, tail, and hind legs of the goat, while the rest of the body was male. It is possible that the function of the chorus may only have been to provide a choral refrain to the choral leader (Figure 17.2).

There is still much conjecture about what the early dithyrambs were really like. Dithyrambs may date from about 700 BCE, the same time period when Greece was developing its own written language. By 600 BCE, the dithyramb had become a literary form. **Thespis** was a dithyramb chorus leader who separated

Figure 17.2 *Satyrs were half goat half male beings typically depicted in dithyrambs and in the satyr plays of the Greek tragedians. On this piece of Greek pottery the satyrs are making wine.*

himself from the narrative approach of the traditional dithyramb and became the first to impersonate the dithyramb's characters—thus becoming dramatic and inventing drama in Greece.

DRAMA FESTIVALS

Initially Greek dramas were presented only at festivals in the city-state of Athens. The first festival was held in 534 BCE when Thespis, the person reputed to be the first actor, participated and is reputed to have taken first prize. It took decades or perhaps centuries for drama to be performed in other city-states in Greece. The Athenian festivals were part of religious celebrations in honor of the god Dionysus. There were four festivals associated with the worship of Dionysus. They were the Lenaea, held in late January; the Anthesteria, in late February, though there is no record of dramas having been done at it; **City Dionysia**, in late March; and the Rural Dionysia, held in late December. The City Dionysia was the most important festival and was the only one with plays until 442 BCE.

The structure of the City Dionysia changed over time, but we will discuss the typical structure from the fifth century BCE, the classical period of the major Greek tragedians. The festival lasted six or seven days depending upon the time period, with a specific activity for each day of the festival. The first day was devoted to one or more processionals that focused on the religious nature of the festival. The second day was devoted to dithyrambic competitions, with each of the ten tribes of Athens entering its own group for the two divisions of boys and men. Depending upon the time period, the dithyrambs were performed for one or two days. The next day, five comedies by five different playwrights were presented, though there were periods when the comedies followed the tragedies. On each of the fourth, fifth, and sixth

days, a single tragic playwright's plays were presented, with a different playwright for each day. Each playwright was required to write three tragic plays, and after 501 BCE a **satyr play** was added to the requirements. The three tragedies could either be three separate plays, each of which dealt with the same or similar themes, or the three plays could be part of the same story, much as we might think of acts of a full-length play today. The satyr play, featuring half-goat half-human beings, often was a parody of the themes or characters presented in the tragedies. The last day of the festival was devoted to awarding prizes and things such as fines. For example, an audience member might be fined for excessive drunkenness, an actor could be fined for not learning his lines, and in very unusual circumstances the playwright could be fined for writing about a topic that was too painful for the audience, as happened for the production of *The Fall of Miletus* by Phrynichus in 493 BCE. There were awards for the playwright and the *choregus* or producer. Acting awards were not added until 449 BCE. In part, that was because the playwright was always the leading actor up until around the time of Sophocles.

PHYSICAL THEATRE

Because theatre productions were essentially a religious festival for the god Dionysus and a civic function for the city-state of Athens, it was necessary to hold the festival on or near sacred ground and near the Acropolis, the center for civic activities (Figure 17.3).

Photo courtesy of Robert Smith.

Figure 17.3 *The Acropolis is a rock outcropping in the center of Athens that rises a couple hundred feet above the surrounding land. It was the central location for religious and civic activity in Ancient Athens. The most prominent structure on the Acropolis was the Parthenon, the temple to the goddess Athena. The Theatre Dionysus is located at the foot of the Acropolis, almost directly under the Parthenon.*

The theatre productions were originally presented on sloping land at the foot of the Acropolis. Unfortunately, an early audience scaffold collapse and its associated fatalities resulted in building a more permanent facility with stone seating cut into the hillside. The traditional image of the classical Greek theatre is of a circular orchestra surrounded on three sides by the ***theatron,*** or audience seating, variously translated as "the seeing place" or "the hearing place." In the very early periods, much of the acting took place in the orchestra. A wooden façade had been constructed to serve as an acting background on the edge of the orchestra opposite the audience. Eventually, a stone ***skene,*** which served as an acting façade and a storage building was constructed to replace the wooden structure. The *skene* contained three to five doors or openings called ***thyromata,*** with the center one typically larger than the others. In front of the doors was a platform level, whose height varied over time, and upon which much of the acting took place in later time periods. At the sides of the *skene*, between it and the *theatron*, were the *parodoi* or passageways through which the chorus entered and exited at the beginning and end of the play. The *parodoi* were also used by the audience as one of the ways to enter and leave the theatre. By convention, one side was from the city and the other was from the country. In the center of the orchestra was an altar, or ***thymele,*** which was used both for religious festival offerings and also in the plays, such as when Jocasta makes an offering to the gods in **Sophocles' *Oedipus Rex*** (Figures 17.4 and 17.5).

Photo courtesy of Robert Smith.

Figure 17.4 *The present-day ruins of the Theatre Dionysus at the foot of the Acropolis are from the Hellenistic period, several centuries after the golden age of the Greek drama. By the Hellenistic period, as shown here, the theatre had been renovated to replace the original circular orchestra and to have an* **orchestra** *that was closer to a semicircle. The entrance from the "country" is to the left and the one from the "city" is to the right. It is reputed that the fifth-century BCE theatre seated 17,000 people.*

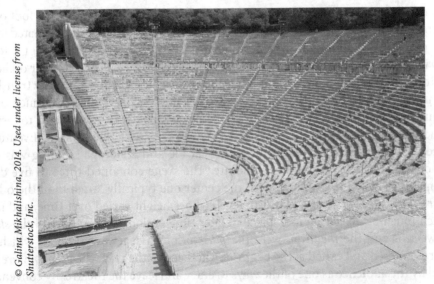

Figure 17.5 *The Theatre at Epidaurus, in southern Greece, is the best-preserved theatre from the Greek period. Note the parodoi on the left. The theatre is still used today for productions.*

PRODUCTION

The *Archon*, an Athenian city-state official, selected the playwrights to be presented in the next year's festival and by so doing selected the plays to be presented in the next year. Established playwrights could submit an outline; newcomers had to submit complete scripts. Each playwright was assigned a *choregus*, or producer, who was responsible for paying for the chorus, costumes, rehearsals, and similar items. The *choregus* was a wealthy individual for whom it was considered an honor to be selected. Because there was an award for the work of the *choregus*, sometimes a lot of money was spent on productions, occasionally resulting in bankruptcy for the *choregus*. The city-state of Athens provided the playwrights' fees, actors, and of course the theatre itself. From the beginning, theatre was considered important enough to the Athenian city-state that part of it was underwritten by the government, a practice that continued through time up to the present day in most of the world.

In general, there were only three male actors who shared playing all the speaking characters in the show, whether male or female, thus making it necessary for doubling. Originally, as devised at the time of Thespis, there was only one speaking actor, who was limited to having dialogue with the chorus and the chorus leader. **Aeschylus** is reputed to have added the second actor and Sophocles added the third actor, which was the maximum number of speaking actors that could normally appear in a script,

though there were a few exceptions in the tragedies and certainly exceptions in the comedies. Initially, the playwright was also the leading actor. However, Sophocles' weak voice prompted him to give up being an actor, a practice soon followed by other playwrights. In addition to the three actors who had all the speaking roles, there were other mute, or silent, actors, who appeared on stage. During the fourth century BCE, after dramas were performed at other locations and in other city-states, acting developed into a profession. One impressive record is of Polos, who at age 70 performed in eight plays over a period of 4 days.

In addition to the actors, there was a chorus, initially consisting of fifty people. Aeschylus reduced the number of chorus members to twelve for each of his plays and Sophocles increased the chorus members to fifteen for each play. More chorus members were used in comedies. Artistic creativity was sometimes used for the choruses. The chorus of furies for Aeschylus' *Furies* was so scary that at least one woman is reputed to have suffered a miscarriage at the chorus' entrance in that production. The chorus members were responsible for singing and dancing, though we have no real idea what either the music or the dancing was like. We do know that the flute and the lyre were used in dithyrambs, so it is reasonable to presume that they were also used in theatre productions. In the beginning, as represented in some of Aeschylus' plays, in particular in the **Oresteia,** the script for the part for the chorus was quite extensive. The part of the chorus generally got shorter during the course of each play. Moreover, the chorus became much less important over a period of time and eventually became irrelevant to the play.

There were a number of production conventions that were part of Greek dramas. Because the Greek dramas were part of a religious festival, violence could not be shown on stage, though an exception does exist in the play *Ajax*. Even though the violence itself could not be shown on stage, the results of violence could be freely displayed. This was achieved by using a low rolling wagon called an **ekkyklema** that rolled out through the central doorway, as was done a couple times in Aeschylus' *Oresteia*. Another convention was the **machane**, essentially a crane that could drop actors from the roof of the *skene* onto the stage. Some playwrights wrote themselves into a dramatic corner and needed a god to come down from heaven and solve the problem in the play. Today, we refer to this imposition of an improbable solution by the Latin phrase, **deus ex machina**, or "god from the machine." In Aristophanes' comedy, *The Clouds* (423 BCE), the character of Socrates was suspended from the *machane* because Socrates always had his head in the clouds. In that production, Socrates is reputed to have stood up in the audience so the audience could compare him to his likeness on the stage.

Because only three actors were available for all speaking roles, it was necessary to be able to disguise the actor from one character to the next. The use of masks helped with that doubling, and the mask's fixed expression was easily projected to the back

of a theatre that might contain 5,000 to 20,000 people. Many scholars also consider it likely that the actors wore *kothurnori*, or thick-soled boots, to appear taller on stage. More than a century ago, scholarly publications included book illustrations showing actors standing on clogs, but that was a mistake. Those clogs were in fact merely tenons that fitted the statues in holes to hold the statues in their proper places. A particularly surprising Greek costume appendage, particularly in the comedies and the satyr plays, was a phallus that sometimes hung down to the knees. They were realistic looking, as may be seen in scenes from Greek vase paintings. They were often made of leather and had veins accentuated by painting.

TRAGIC STRUCTURE

Greek tragedies had a relatively common structure. Most started with a prologue or a scene, followed by the **parodos**, which was the entrance of the chorus and its first song. Following that there was an alternation of episodes, or scenes, and choral parts. Many plays seem to have five episodes, but there was no hard rule on the total number of episodes. At the end of the play the chorus exited in the **exodos**. The central esthetic of Greek tragedy was for the audience to have a **catharsis**, a purging of pity and fear. The audience was expected to have pity for what happened to the protagonist and fear that something similar might happen to the audience member. In this aesthetic, the leading character had a tragic flaw that made him or her partly responsible for what happened. This flaw was referred to as **hamartia**, or "missing the mark." **Hubris**, or overweening pride, which often manifested itself in plays as arrogance, was the most typical *hamartia*.

PLAYWRIGHTS

There were many playwrights in the classical Greek period. Complete texts for only five Greek playwrights have come down to us, even though we have fragments from many others. Because each tragedian wrote four plays and the comedy contest was for five playwrights, each annual City Dionysia Festival produced seventeen new plays. Over the centuries of the Greek dramatic period, literally thousands of plays were written. Unfortunately, only forty-two complete plays are extant, or still existing: five by Aeschylus, including the *Oresteia*, consisting of three separate plays; seven by Sophocles, plus a large fragment from *The Trackers*, a satyr play; eighteen by **Euripides**, including *Cyclops*, the only extant complete satyr play; eleven by **Aristophanes**; and one by **Menander**. The *Oresteia*, with its three composite scripts, is particularly important because it is the only extant trilogy—that is, its three component plays were written for performance on the same day.

TRAGIC PLAYWRIGHTS

The earliest playwright, for whom we have complete extant texts, is Aeschylus (525–456 BCE) who, among other accomplishments, fought in the battle at Marathon. His most important work, the **Oresteia**, written in 458 BCE, consists of three separate plays: **Agamemnon, The Libation Bearers**, and **The Furies** (Figure 17.6).

The first play, *Agamemnon*, dealt with Agamemnon's return from the Trojan wars, when he is greeted by Clytemnestra, pretending to be a loving wife. She still bears a long-simmering hatred for Agamemnon because he sacrificed their child, Iphegina, some ten year earlier in order to obtain favorable winds to carry the Greek ships to Troy. In retribution, Clytemnestra murders Agamemnon. In *The Libation Bearers*, Elektra, the last remaining daughter of Clytemnestra and Agamemnon, prays for the return of her brother, Orestes, so that he might avenge the murder of their father. Orestes, under orders from the god Apollo, returns and kills his mother, Clytemnestra. In *The Furies*, Orestes is hounded by the Furies who seek vengeance because he killed a blood relative. He flees from Delphi to Athens where a trial is held to determine his role in the charge of blood-guilt. Athena sets up a jury system to determine whether Orestes, because he was under orders from Apollo to kill Clytemnestra, is responsible for the murder of Clytemnestra. Athena casts the final vote to create a tie, thus acquitting Orestes.

Sophocles (c. 496–406 BCE) introduced the second actor into Greek drama, and was often described as "showing men as they ought to be" (Figure 17.7). His most important play is *Oedipus, the King* (c. 429 BCE), in which Oedipus learned about his origins and the horrific acts he committed unwittingly. In *Oedipus, the King*, Oedipus, who grew up in Corinth, fled Corinth because he received a prophecy from the Oracle at Delphi that he would kill his father and wed his mother. In his travels away from Corinth in order to escape his fate, he killed a man at a place where three roads met, the world's first documented case of road rage. He met and answered the riddle of the Sphinx that was terrorizing Thebes (Figure 17.8).

Photo courtesy of Robert Smith.

Figure 17.6 *Bust of Aeschylus, author of* The Orestia, *the only extant trilogy.*

Photo courtesy of Robert Smith

Figure 17.7 *Bust of Sophocles, who is best known for* Oedipus, the King.

Figure 17.8 *Greek painting of Oedipus answering the riddle of the sphinx.*

For that he was rewarded with a marriage to Thebes' queen, Jocasta. Many years later, Oedipus is ordered, again by the Oracle at Delphi, to determine what happened to Laius, Thebes' previous king. That one-day journey of discovery changes Oedipus' life forever. *Oedipus, the King* clearly was the model Aristotle, the Greek theatre critic, used in *The Poetics* to describe the preferred form and techniques for a tragedy. Sophocles wrote two other plays dealing with Oedipus, ***Antigone*** (c. 442 BCE) and *Oedipus at Colonus* (406 BCE), but not produced till 401 BCE by his grandson. Students sometimes mistake those three plays as being a trilogy. Though Sophocles' three plays deal with the same story or theme, they were written over a period of thirty-five years and thus cannot be a trilogy. In *Oedipus*, Oedipus, just as Orestes had done in *The Orestia*, came to realize that the gods preordained his acts. Thus, he was not personally responsible for the results. Consequently, he achieved a level of deification in *Oedipus at Colonus*.

Euripides (480–406 BCE), who was born of well-to-do parents at Salami, was described as "showing men as they are." Euripides wrote far more realistic plays than his fellow playwrights, and his plays are more popular today than those of the other tragic playwrights (Figure 17.9).

In addition, a number of Euripides' plays dealt with women and feminist issues, millennia before feminism was popular or had even been defined. Two of Euripides's most important plays are ***Medea*** (431 BCE) and ***The Bacchae***, the latter produced by Euripides' son in 405 BCE, after his father's death. The role of Medea is highly coveted by actresses to this day. In it, Medea murders her two young sons in order to punish their father, Jason, of the Argonauts fame,

Figure 17.9 *Bust of Euripides, whose female characters are still considered highly desirable by actresses today.*

for setting her aside so he can marry a much younger princess. In *The Bacchae*, the god punishes King Pentheus for trying to prevent the people from worshiping the god. The vengeful god has Pentheus ripped apart by his mother and other worshipers in their bacchanalian frenzy.

COMIC PLAYWRIGHTS

The most important Greek comic playwright was Aristophanes (448–380 BCE), who is best known for **Lysistrata** (411 BCE), in which Lysistrata, frustrated with the duration of the Peloponnesian War, decides that the women of Athens and Greece should go on a sex strike. The concept in Greek comedies by Aristophanes was that a **"happy idea"** would be discussed. A "happy idea" was considered a preposterous proposal, but Aristophanes was able to play the sex strike for all the sexual innuendos one might imagine. Another playwright, Menander (c. 342–291 BCE), from whom we have only a single complete extant script, *The Grouch* (c. 317 BCE), is important because his plays were the models for many Roman comedies. Beyond the formal comedies of the Greek classical theatre there were other theatrical comedic presentations called *phlyaques*. They presented less sophisticated and relatively crude domestic situations, and under similar or different labels continued to show up in most time periods.

IMPACT OF GREEK THEATRE

Greek drama was a supreme achievement in its own right. In addition, the Greek drama and Greek theatre production techniques were adopted as the model for both the Roman drama and the Roman physical theatre. Beyond that, the rediscovery of Greek drama during the Italian Renaissance centuries later, served as the impetus for the blossoming of drama across Europe during the Renaissance.

Key Names, Venues, and Terms

Aeschylus	Dithyramb
Antigone	*Ekkyklema*
Archon	Euripides
Aristophanes	*Hamartia*
The Bacchae	"Happy idea"
Catharsis	*Hubris*
Choregus	*Lysistrata*
Chorus	*Machane/Deus ex machine*
City Dionysia	*Medea*
Dionysus	Menander

Oedipus, the King

Orchestra

Oresteia: Agamemnon, The Libation
 Bearers, and The Furies

Parodos and Exodos

Satyr play

Skene

Sophocles

Theatron

Thespis

Thymele

Thyromata

Additional Reading

Arnott, Peter D. *The Ancient Greek and Roman Theatre.* New York: Random House, 1971.

Pickard-Cambridge, A. W. *The Dramatic Festivals of Athens,* reissued ed. New York: Oxford University Press, 1988.

Taplin, Oliver. *Greek Tragedy in Action.* London: Routledge, 1993.

ROMAN THEATRE

The Roman civilization starting as the **Etruscans** living north of present-day Rome expanded to fill all of present-day Italy, a large boot-shaped peninsula to the west of Greece that sticks out into the Mediterranean Sea. While the Etruscans were developing in northern Italy, much of southern Italy and parts of Sicily were actually Greek colonies. Thus, the two cultures were in a position to exchange ideas. The Romans were particularly fond of Greek developments in the arts. One may almost think of the Romans as being like the Borg, in that they assimilated anything and everything that could be of use.

The Roman drama had its roots in Etruscan dancing, which was imported to Rome about 464 BCE. A type of drama called *Fabula Attellana* was popular in southern Italy and consisted of short 300- to 400-line quasi–improvised comic interludes dealing with country life, cunning and cheating, and farcical situations. Those plays featured stereotypic stock characters that reflected folk activities and coexisted with the formalized Roman theatre.

Just as the Greeks had festivals to their gods, the Romans had festivals to their gods. While Greek theatre was invariably associated with the worship of Dionysus, Roman festivals were typically devoted to multiple gods, but never included Bacchus, the Roman equivalent to Dionysus. The Roman festivals began with music and dance, and eventually added dialogue. Interestingly enough, during these festivals the proper procedure was essential—even a slight error in the festival's procedure required redoing the entire festival.

The Romans had up to six festivals that varied in length from as few as eleven days around 200 BCE to as many as forty-three days in 14 CE, but the most important one for us is the *Ludi Romani* that took place in September. The original *Ludi Romani* festival was established around 600 BCE and was dedicated to the god Jupiter. Initially, this festival consisted of boxing, chariot racing, and similar events until around 364 BCE when performances were incorporated, but the first drama wasn't added till

240 BCE. Because the Romans valued and appreciated Greek art and Greek artisans, Roman comedy was modeled on Greek comedy, in particular the plays of Menander. However, the conservative nobles in Rome objected to the plays that were presented, because they "diluted Roman values" and corrupted the youth. Many comedy plots depicted young lovers disobeying their parents' plans for arranged marriages or, even worse, showed crafty slaves outwitting their dimwitted masters. Thus, Roman comedies evolved to depict Greek characters in Greek locales—after all it was perfectly fine to have Greek masters outfoxed by crafty slaves. "Modeling" of Roman dramas on Greek dramas is a polite term. The Roman dramas were little more than translations of the Greek originals. Terrence, in particular, notes in some of his scripts the extent to which he faithfully followed the scripts of Menander.

PLAYWRIGHTS

The two most important comic Roman dramatists were **Titus Maccius Plautus** (c. 254–184 BCE) and **Publius Terenius Afer** (c. 190–159 BCE), typically referred to as "**Terence**." Plautus was a very popular playwright and many other Roman playwrights attributed their own plays to him in order to enhance the status of their own plays—hence, the reason that some Roman sources attributed over one hundred plays to him. Today, Plautus is credited with twenty-one or so plays—twenty of which are extant. His best-known plays are *The Braggart Warrior* (204 BCE), *Pseudolus* (191 BCE), and *The Menaechmi*. Parts of the first two were the basis for Stephen Sondheim's musical, *A Funny Thing Happened on the Way to the Forum* (1962). The last one was used by William Shakespeare as the basis for his *The Comedy of Errors* (1594?).

The "Afer" in Terence's name is a reference to his birth in or near Carthage, on the northern coast of Africa, a fact that prompted some individuals to infer he was black, something that cannot be absolutely documented. Terence was a stoic, a philosophy also exhibited in his plays. Stoicism is accepting things as they are, sort of accepting life with a "what will be, will be" attitude. In general, Terence's comedies are more sophisticated and more complex than those of Plautus. Terence sometimes used double plots by incorporating two different Greek sources into one of his play, as he did in *The Brothers*. Terence wrote six plays—all of which are extant. Both playwrights typically used much music in their scripts, with Plautus using more music than Terence.

Lucius Annaeus Seneca (4 BCE–65 CE) is the most important Roman tragedian. Seneca started tutoring the future Emperor, Nero, in 49 CE; became advisor to him when Nero became Emperor; and ran the Empire for five years. Unfortunately for Seneca, Nero subsequently ordered Seneca to commit suicide. Seneca, who wrote nine plays, modeled his works on the Greek tragic playwrights (Figure 18.1).

The influence from Euripides perhaps accounts for the psychological motivations found in Seneca's plays. In addition, Seneca used ghosts, soothsayers,

violent spectacle, and ghoulish situations. Seneca wrote in the five-act structure, presumably a reflection of Horace's influence. Theatre scholars have long debated whether Seneca's plays were intended solely for reading. There is no definitive answer, but it is clear that his plays were not done for public performance—however that does not rule out private performances at banquets in the great homes of the well-to-do. Two of his major works are *Phaedra* and *Thyestes*, based upon an unknown Greek playwright.

Figure 18.1 *Seneca is the Roman tragic playwright, who was also tutor to the Roman Emperor Nero and ran the Roman Empire for a number of years.*

Just as there was a Greek theatre critic, there was a Roman theatre critic, **Quintus Horatius Flaccus** (68–8 BCE), referred to as **"Horace,"** whose book of theatrical criticism was ***Ars Poetica (The Art of Poetry)*** (24–20 BCE). In it, Horace implies an establishment of the unities—of time, place, and action. The unity of time implies a twenty-four-hour period for the drama. Unity of place implies a single locale, though there might be several settings in the one locale. The unity of action implies a single plot, typically with no subplot. It is presumed that Horace derived these unities from the Greek drama because many Greek dramas seem to adhere to such limitations. However, there were no such explicit limitations in the Greek drama. Other guidelines suggested by Horace favored a five-act structure and disparaged the use of *deus ex machina*, or "god from the machine," by which was meant an improbable last-minute solution. It was also expected that there would be no more than three speaking characters on stage at the same time, a clear reference to the practice from Greek tragedy. Another consideration was decorum, meaning the behavior of the characters must fit and be appropriate to their status.

PHYSICAL THEATRE

The Roman physical theatre developed from the Greek physical theatre, in particular from the theatres of the Greek Hellenistic period. The Greek Hellenistic period theatres, several centuries after the classical Greek period theatres, generally featured a semicircular orchestra and a *theatron* that butted up to the architectural *parodoi*, that were now stone archways attached to the *skene*.

In the beginning, Roman theatres were built into hillsides, as the Greeks had done, but the Romans soon learned to build theatres as freestanding structures that did not need a hillside to support the auditorium. The Roman theatre stage, or *pulpitum*, was larger than the classical Greek theatre stage, sometimes being as much as 300 feet wide. In the Roman theatre, the most prominent feature of the *pulpitum* was the **scaena frons**. The *scaena frons* was an elaborate architectural backing to the stage that was typically three stories high, elaborately decorated with statuary in niches, and had colonnades. There were several doorways in the *scaena frons*. The *scaena frons* was considered to be a representation of a street. Above the stage was a wooden coffered ceiling. The audience space, or **cavea**, was also protected from the blazing sun by the awning, or **velium**, over the auditorium. In the semicircular façade at the back of the *cavea*, there were temple—niches with religious statues that gave some religious stature to the theatre building. There were passageways, called **vomitoria**, under the *cavea* that were also used by the audience (*Figure 18.2*).

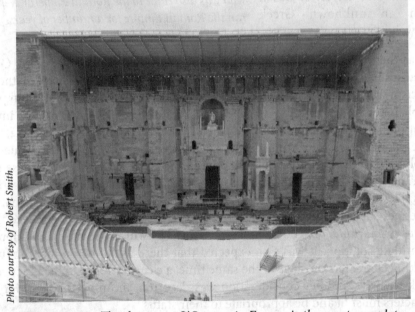

Figure 18.2 *The theatre at L'Orange in France is the most complete and best preserved Roman theatre in the world. The roof is of modern construction and is used to support the rigging from which modern lighting equipment is hung—here preparation is taking place for a concert. The three-story scaena frons was originally covered with marble and the niches were filled with statuary, all of which have since been scavenged. Note the semicircular orchestra. The cavea butts up against the pulpitum, and the parodoi archways may be seen left and right.*

PRODUCTION

Theatre productions were associated with particular festivals, ceremonies, or commemorations—thus most early Roman theatre structures were temporary wooden constructions. The first permanent theatre in Rome, the Theatre of Pompey, was not built until 55 BCE.

Most locales depicted in the extant Roman dramas are street scenes, though scenery could have been used in the productions. A *siparium*, a curtain covering part of the *scaena frons*, could have been painted like a backdrop. In addition, **Marcus Vitruvius Pollio** (c. 80–70 BCE–c. 15 BCE), a Roman architect referred to as "**Vitruvius**," wrote the ten-volume *De Architectura* (15 BCE?). In that work he referred to *periaktoi* and noted a difference between comic, tragic, and satiric faces, presumably one on each side of the three-sided *periaktori*. The costumes used in Roman drama were similar to those used in Greek drama, except that the Roman dramas used shorter chitons, or tunics (Figure 18.3). The Roman masks were also slightly different than the Greek masks—some of which gave rise to the notion that the masks had megaphones in them. For **pantomime**, which was a kind of interpretive dance with a script, the masks had closed mouths. **Mimes**, to be distinguished from pantomimes, could be extremely erotic—depicting both live and simulated sex acts—and typically did not use masks.

Roman actors, called *histeriones*, were held in low regard, despite the fact that one of them, Theodora, married Emperor Justinian. Generally, public Theatre actors were males, but females often performed in the mimes. One famous actor was **Quintus**

Figure 18.3 *Mosaic of Roman actors with masks.*

Roscius (131–63 BCE), who rose to nobility and appeared in Plautus' *Pseudulus*. He was such a successful actor that he became very wealthy and founded a school for actors and orators, thus creating the Western world's first school of theatre.

ROMAN SPECTACLE

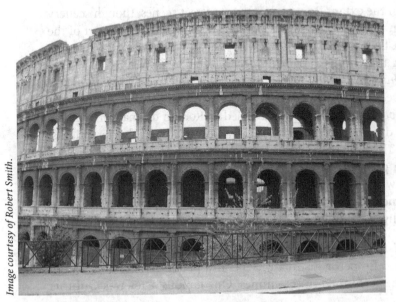

Image courtesy of Robert Smith.

Figure 18.4 *The Coliseum was the venue for many of the spectacles staged during the Roman period. It seated about 50,000 people and it could be flooded in order to stage naval battles.*

The most iconic feature of Roman theatrical activity was the **circus**. Initially the circuses were oval race tracks featuring chariot racing, but they were also used for cavalry battles, wrestling, and battles with animals and people. Spectacular activities included gladiatorial combats, started in 264 BCE at private funerals. They became part of state festivals in 105 BCE, and 5,000 pairs fought two centuries later in 109 CE. Eventually, being a **gladiator** became a career choice—top gladiators had high standards of living and some were actually able to retire. The **Coliseum**, seating 50,000 people, was the most famous circus and was built between 70 and 80 CE. The Coliseum was an elaborate multifunctional facility that could even be flooded to present ship battles. At the Coliseum's inaugural, 9,000 animals were killed in 100 days (Figure 18.4).

DECLINE

Formal Roman theatre went into decline with the rise of Christianity. Christians objected to theatrical performances after Christianity became the official religion of the Roman Empire. The Christians objected to theatre because they had been martyred at the Coliseum and had been the subject of scorn at theatrical venues. The capital of the Roman Empire was moved from Rome to Constantinople in 330 CE when

the Roman Empire was divided into two parts: the Eastern Roman Empire centered on Constantinople and the Western Roman Empire centered on Rome. After 398 CE, a Christian could be excommunicated if he attended the theatre on holy days rather than attending church. The Western Roman Empire continued its decline due in part to the pressure from the Vandals, the Goths, and so on. Rome itself felt this pressure and was sacked for the second time in 476, a date often taken as the end of the Western Roman Empire. This combination of circumstances spelled the end of institutional theatre in the Western world. However, even though institutional theatre no longer existed, theatrical activity did not totally die out. Strolling players and entertainers managed to make a subsistence living traveling from village to village and performing wherever they could find a paying audience, sometimes in the homes of the well-to-do, at country inns, and at local festivities such as country fairs.

IMPACT OF ROMAN DRAMA

The Roman drama is important in its own right, but beyond that, Roman plays had significant impact in the late medieval and early Renaissance periods. Because the Catholic mass in the west was universally conducted in Latin, the performances of Roman dramas were essential in developing Latin fluency for the training of young priests and lawyers. The Roman drama also became a major catalyst in the development of Renaissance drama. Renaissance practitioners were intent on reviving the classical culture that was represented in the plays of the Roman and Greek playwrights and tried very hard to imitate them.

Key Names, Venues, and Terms

Ars Poetica (The Art of Poetry)	*Periaktoi*
Cavea	Titus Maccius Plautus (Plautus)
Circuses	*Pulpitum*
Coliseum	Quintus Roscius
Etruscan	*Scaena frons*
Fabula Attellana	Lucius Annaeus Seneca (Seneca)
Gladiator	*Siparium*
Histeriones	Publius Terenius Afer (Terence)
Quintus Horatius Flaccus (Horace)	*Velium*
Ludi Romani	Marcus Vitrivius Pollio (Vitruvius)
Mimes	*Vomitoria*
Pantomine	

Additional Reading

Arnott, Peter D. *The Ancient Greek and Roman Theatre*. New York: Random House, 1971.

Beacham, Richard C. *The Roman Theatre and its Audience*. Cambridge: Harvard University Press, 1992.

Duckworth, George E. *The Nature of Roman Comedy*, 2nd ed. Norman, OK: University of Oklahoma Press, 1994.

MEDIEVAL THEATRE

Chapter XIX

The fall of the Western Roman Empire continued its decline into the Dark Ages. In most of Western Europe, the monolithic structure of the Roman Empire was gone, and in its place were small regional enclaves typically surrounding religious, mercantile, court, or educational centers. Both the structural and philosophic center of life during the medieval period revolved around Christ and the church. The fact that the Roman Catholic mass throughout Europe was conducted in Latin made Latin the one unifying element in European society, but of course only the educated were able to share in and appreciate that unification.

There were very few centers of learning and those that did exist were typically at monasteries or courts. Europe as a whole reverted to a feudal agrarian society consisting of manors on which each person was protected by an ever-increasing circle of overlords. This protection came at a price—allegiance to the overlord and the necessity of performing service or work for the Lord of the Manor. A characteristic of medieval culture was the perception that the world had always been as it was, and, at least among the uneducated, there was no sense of historical development. It was a time period in which few people could read the few books that did exist. In general, books were copied by hand and consequently were expensive and rare. Even the Bibles that were used in churches had to be hand copied and their decorations, called illuminated manuscripts, could take about a decade to execute when copying a new Bible. Consequently, the copying of a new Bible had to be underwritten by significant donations from the very well-to-do. At that, the complete Bible was only available in Latin—death was a possible sentence for those who were caught reading the Bible in the vernacular, meaning the local language of the country or region. It was not until after the 1450s when Gutenberg invented movable type that printing was a relatively convenient undertaking.

Even though theatre as a formalized organized activity ceased to exist in Western Europe following the fall of the Roman Empire, entertainment did not cease.

Many of the pagan rituals of Europe were subsumed into the liturgical calendar of the Catholic Church. Thus, the winter solstice was converted by the Catholic Church into Christmas and spring fertility rites were likewise converted to Maypole festivals and Easter. Other festivities included sword dances and Morris dances. Some sword dances included intricate dancing steps among sharpened swords to demonstrate the dancer's dexterity. Morris dances arose from European or African sources and involved darkening the face with ashes. Typically, the dance group, sometimes associated with May Day, consisted of six dancers dressed in white, a clown, and a hobby horse. In addition, strolling players would often eke out a meager standard of living by performing anywhere a paying crowd could be found. This could include venues such as country fairs, festival days, country inns, or performing in the house of the Lord of the Manor. Juggling, playing musical instruments, storytelling, and performing acrobatics were some of their additional talents.

The Catholic mass was a source of confusion for many ordinary people. It was universally performed in Latin, a language ordinary people could not understand. The mass was relatively fixed and, though not theatre, it certainly was theatrical. Some of the clergy were aware of this noncomprehension issue on the part of the congregation and sought ways to increase its comprehension. In some locations, as a lead up to Easter Sunday, the corpus, or body of Christ, was removed from the church's cross and "buried" in the church's crypt to commemorate Christ's crucifixion and subsequent "burial" in the sepulcher. On Easter morning, the congregation and clergy would find the church doors "locked" and also find that "devils" had taken over the church and had locked out the congregation. The congregation and the priests would go from door to door and plead with the devils to leave and let them in. Eventually, the congregation prevailed and entered the church. There they found that the corpus had "risen" and had been restored to the cross.

QUEM QUAERTIS

Presumably *Quem Quaertis* was the first **trope** and was added to the Easter mass at the Benedictine Abbey of St. Gall in Switzerland. The oldest extant text is from 925, so clearly the earliest inclusion was some time before that date, possibly as early as the very late 800s. The text of *Quem Quaertis* is very short and dealt with the three Marys' visit to the sepulcher to anoint the body of Christ for burial. The first three of its seven lines follow:

> **Angel:** *Quem quaertis in sepulchro, Christicolae? (Whom seek ye in the sepulcher, O Christians?)*

> **Marys:** *Ihesum Nazarenum crucifixum, O caelicola! (Jesus of Nazareth who was crucified, O heavenly one.)*

Angel: *Non est hic, surrexit sicut praedixerat, ite, nuntiate quia surrexit, dicentes: (He is not here, he is risen as he fore-told.)*

Translated by Edd Winfield Parks

The *Quem Quaertis* text closely parallels that in the Bible and was sung or chanted by members of the clergy who were in costume. Eventually, other parts of the Bible were adapted and included in specific masses, such as those for the nativity and the ascension. Possibly by the twelfth century most of the Bible had been dramatized into short playlets.

HROTSVITHA OF GANDERSHEIM

Tropes were not the only dramas done in Latin. Hrotsvitha of Gandersheim (c. 935–973) was one of several playwrights who wrote in Latin; however, she was the only female playwright at that time. Thus, she became the world's first female playwright, the first named playwright since the classical age of Greece and Rome, and the first playwright to deal with the feminist perspective, albeit from the perspective of a nun. Hrotsvitha was the canoness of a priory, and her plays focused on the religious life and the salvation of the soul, as may be seen in two of her plays, *Dulcitius* and *Paphnutius*. Her plays were probably never performed outside their religious context, and it is possible that they were only read.

CYCLE PLAYS

After a sufficient number of plays were created that were based on the stories in the Bible, they were collected together into cycle plays and presented together in the church. Several stations were arranged around the church or possibly in the chapels on the periphery of the church. The audience would move from station to station for each play. Because churches had no seating at that time, it was relatively easy for scenery to be set up and for the audience to move from location to location. At its simplest, each location or station could consist only of a **mansion.** A mansion was like a little house from which an actor would enter. By convention the locale for the action was the same as the locale of the mansion. The mansion might be as simple as a doorway with a sign on it indicating its locale, for example, "Bethlehem." The *platea* or common playing area in front of and around the mansions would take on new locales depending upon the mansion from which the actors entered. Eventually, the cycle plays, so-called because they represented the cycle of human experience from the creation to the last judgment, or Genesis to Revelation, were associated with **Corpus Christi Days**. Doing the cycle plays in the church eventually became a

distraction for the celebration of the mass that each priest or brother was required to do on a daily basis. Consequently, the cycle plays were moved outside the church to the steps at the front of the church. By this point, the festive nature of play going and the economic impact of visitors coming to see the cycle plays prompted civic institutions and **guilds** to take over the presentation of the plays.

Guilds were professional groups associated with specialized skills, much like unions today. An individual Guild was responsible for one or more cycle plays. For example, the Crucifixion play was often done by the leather workers' Guild because that Guild had the skills to fabricate the leather bodysuit that the actor playing Christ needed to wear for the Crucifixion scene.

Cycle plays were done all over Europe. In England alone, 127 towns did cycle plays at various times and places, such as the York, Coventry, Wakefield, Chester, and Cornish cycles. Cycle plays could be performed on a two-year to ten-year rotation, or in some cases performed only once. Plays were typically presented on Monday, Tuesday, and Wednesday of Whitson Week, the seventh week after Easter. The number of plays in each locale's cycle was also variable. At York, England it took fifteen hours to perform all of them in 1475. In France, there were even more plays and more of its cycle plays are extant.

There were two major ways to mount cycle plays. One was to arrange them around a city square, much like their previous arrangement inside the churches. This was more common on the continent, as depicted in the illustration for the 1547 staging at **Valenciennes** that lasted for twenty-seven days. The second way was to mount each play on a wagon. Wagons were used in Spain, the Netherlands, and England, where they were called **pageant wagons**. Typically, pageant wagons would have four or six wheels and might be perhaps 10 feet wide by perhaps as much as 30 feet long. Generally, the wagons were two-stories tall, though for special scripts a wagon might have a third story, where the character of God could appear. The bottom story of the wagon generally was enclosed, probably with fabric, and served as a tiring room, or changing room, and also as the storage room for the props used in the play. The second story, which was clearly above head height for the crowd, was where most acting took place. In those cases when the acting was not confined to the wagon, the actors came down to the ground to perform. In other cases, the pageant wagon might be parked next to a platform or a second empty wagon that provided an expanded acting area. The pageant wagons would be driven in rotation to various performance sites on a circuit about town over a period of three or so days (Figure 19.1).

Eventually production techniques for the cycle plays became quite extravagant. When arranged around a town square, heaven was on one side and the **hell mouth** was on the opposite side of the square. To indicate the lavishness of heaven, sometimes the scenic elements were gilded with gold leaf. On other occasions, heaven could be mechanized so that it would open to reveal the spectacle within. At the hell mouth, the

portal to hell was typically the gaping mouth of some dragon, complete with fireworks, cannons, smoke bombs, and devils. It was traditional for the devils to harangue the audience and, presumably by prearrangement, to drag some misbehaving younger children into the hell mouth. Special effects included flying, blood and guts, and the use of a trebuchet. The last ordinarily was used as a catapult, but in the plays it was used to perform fast substitutions for bodies and dummies. In

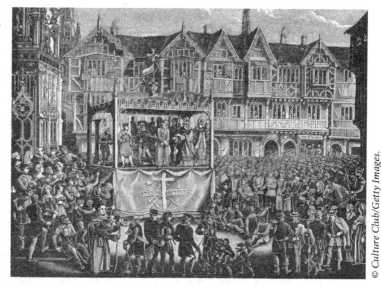

Figure 19.1 *This nineteenth-century drawing shows a conjectured reconstruction of a pageant wagon used for medieval cycle plays.*

one special effect, a severed head bounced three times and at each bounce produced a different well with flowing wine, milk, and water.

For the most part, acting was done by amateurs, but "professional" strolling players were also used. Typically, a cycle play used five to ten characters. Often the actors were males, but females were sometimes used. The costumes in the plays were typical of everyday medieval life; however, the character of God was often dressed as the Pope or the Emperor. Ecclesiastical garments were frequently available for such special uses.

MEDIEVAL GENRES AND VENUES

Cycle plays were not the only kind of theatre done in the late medieval period. Other types of plays included **morality plays, mystery plays, miracle plays, Atellan farces, folk plays, interludes, vernacular plays**, and academic plays.

- Morality Play: The purpose of a morality play was to teach a moral lesson. Morality plays started in the twelfth century, but the best known was *Everyman* (c. 1500). Its basic premise was that Everyman was summoned by Death to make an accounting of his life. Everyman asks all of his friends and acquaintances whether they will accompany him on the trip. At first each agrees to accompany him, but when the true nature of the trip is revealed

each declines to make the trip—only Good Deeds is willing to go. Initially, she is too weak to travel, but finally does accompany him. As Everyman steps into his grave, he learns that Good Deeds are the only thing that matter for salvation. To drive home the moral lesson, a Doctor of Theology enters and admonishes the audience members to attend to their good deeds and then encourages them to tithe.

- Mystery Plays: Essentially, mystery plays were about the life of Christ. A subdivision of mystery plays was passion plays that dealt with the final days of Christ's life and his resurrection.

- Miracle Plays: In addition to the miracles performed by Christ, other miracle plays included the miracles performed by saints.

- Atellan-Type Farces: Atellan-type farces were the relatively short, sometimes quasi-improvised, often scatological, rustic entertainment that dealt with domestic situations. They had existed in various forms from the time of the Greeks.

- Folk Plays: Folk plays were also relatively short. In England, *Robin Hood and the Friar*, only 118 lines long, was a dramatization of the fight on the bridge between Robin Hood and Friar Tuck. Another one, *Oxfordshire St. George Play*, had only sixty-two lines. In it, various dances are performed, the dancers "die," they are revived by a pill from the Doctor, another pill kills the Dragon, and then Father Christmas enters and they collect money (Figure 19.2).

- Interludes: Interludes were a special entertainment for the aristocracy, the very well-to-do, or the educated. They originally started as "debates" on moral issues, but eventually evolved to become more secular. For the most part, they were entertainment to wile away the hours between dinner and bedtime. *The Foure P.P.* (c. 1520) by John Heywood (1497–1580) is such an example and concerns four quacks, a Pardner, a 'Potecary, a Palmer, and a Peddler, who meet on a road by chance and have a contest to see who can tell the biggest lie.

Figure 19.2 *Folk plays and vernacular plays would be mounted anywhere a paying audience could be found. This detail from Peter Brueghel's* Flemish Fair *painting shows a stage setup at a country fair.*

- Vernacular Plays: There was a range of vernacular plays, which are plays written in the native language of the region or the country. Vernacular language plays existed by the

twelfth century. A late French play, *Pierre Pathelin* (c. 1470), is a farce about a lawyer who helps a shepherd avoid a charge of sheep stealing by having him respond only "baa" to any question. At the end of the play when the lawyer attempts to collect his fee, the shepherd merely keeps responding "baa." In Germany, Hans Sach (1494–1576) who was widely known as a master singer also wrote about two hundred vernacular plays.

- Academic Theatre: As surprising as it may seem, theatre was often a standard part of education in the universities of Europe, particularly at Oxford University and Cambridge University in England. In part, Oxford and Cambridge were founded to train priests. From the fourteenth century, the faculty members in Greek and Latin were required to periodically present Greek and Roman plays in their original languages. It was necessary because Latin was the language of both the Catholic mass and the Bible. Thus, students were being trained to speak, hear, and read Latin. At that time, the source documents for the Bible were in Greek, hence the need to learn that language too. Even at the **Inns of Court**, or law schools, in England, Latin plays were also done so lawyers could master Latin, the official language of the law and diplomacy.

OBERAMMERGAU PASSION PLAY

We cannot leave the topic of medieval drama without making reference to the production of the *Oberammergau Passion Play* at Oberammergau in Germany that started in 1634. That date is clearly within the Renaissance time period, but the rural and remote location of the village of Oberammergau in the Bavarian Alps meant it was still very medieval in its sentiment and culture. In 1633, the village of Oberammergau was beset by the bubonic plague and many people died. The villagers prayed to God asking him to stop the plague. They promised to do a passion play for eternity if he would stop the plague. Miraculously, the plague in the village did stop even though it continued to sweep through the surrounding areas. The first *Passion Play* was performed in the church yard in 1634. So far, the villagers have kept their promise and have performed their world-famous passion play every ten years, having missed only in 1770 and once during World War II. The *Oberammergau Passion Play* is thus the world's longest running production, but the script has been modified and updated over the centuries (Figure 19.3).

In the middle of the sixteenth century, the Feast of Corpus Christi was removed from the liturgical calendar of the Church of England. In addition, Elizabeth I banned the production of religious drama in England, and religious drama was also banned in Paris. With the exception of the *Oberammergau Passion Play*, cycle plays and most related religious dramatic productions have faded into posterity. Their interest today is due primarily to historical and scholarly interest.

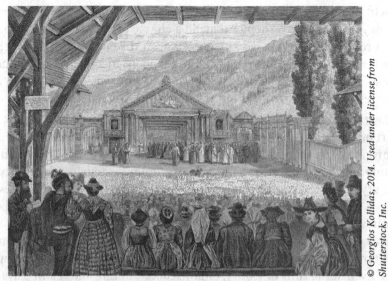

Figure 19.3 *This nineteenth-century drawing shows an earlier edition of the Oberammergau Passion Play that has been performed at a regular interval since 1634.*

IMPACT OF MEDIEVAL THEATRE

The major contribution of the medieval period to the development of theatre was the reintroduction of institutionalized theatre into Europe. The fact that cycle plays were originally supported by and performed in the Roman Catholic churches gave some sense of respectability to acting that was, at least for the cycle plays, greater than that derived through strolling players. Another point to note is that both times theatre was "invented" in Europe it was done in association with religious observations.

Key Names, Venues, and Terms

Atellan Farce	Hell Mouth
Corpus Christi Days	Hrotsvitha of Gandersheim
Cycle Play	Inns of Court
Everyman	Interlude
Folk Play	Mansion
Guilds	Miracle Play

Morality Play

Mystery Play

Oberammergau Passion Play

Pageant Wagon

Platea

Quem Quaertis

Trope

Valenciennes

Vernacular Play

Additional Reading

Muir, Lynette R. *The Biblical Drama of Medieval Europe*. New York: Cambridge University Press, 1995.

Tyedeman, William, Michael J. Anderson, and Nick Davis (eds.). *The Medieval European Stage, 500–1550*. Cambridge: Cambridge University Press, 2001.

Wickham, Glynne. *The Medieval Theatre*. London: Weidenfeld and Nicolson, 1974.

RENAISSANCE AND SEVENTEENTH-CENTURY THEATRE

The Renaissance saw a cultural and societal shift from a focus on godliness and concern for the next life—the dominant concern in the medieval period—to a fuller study of man, or humanism, and a greater concern for the present life. Discoveries in art and science provided a greater sense of reality. While the Dark Ages had been dominating the medieval period in Western Europe, Constantinople had become a center of learning and culture. However, in 1453 the Ottoman Empire conquered Constantinople, forcing its scholars and educated people to flee west to Italy, taking their learning and libraries with them. This influx of new information and new research sources engendered a renewed interest in classical Roman and Greek cultures and, for our discussion, theatre in particular. This inaugurated a renewed interest, or Renaissance, in those classical cultures. From its original development in Italy, the Renaissance spread north and west to the rest of Europe, taking as much as a century to do so.

ITALIAN RENAISSANCE

The Italian Renaissance theatre developed innovative techniques in the areas of drama, acting, theatre architecture, and stage design, all of which had significant impact for centuries.

DRAMA

The developments in dramatic literature and criticism were initiated by the desire to revive the techniques of Greek and Roman drama. The attempt to do so ultimately resulted in two new dramatic forms.

NEOCLASSICISM

Because Italian tragedies and comedies were modeled on the Greek and Roman forms, most new plays were initially written in Latin, but by about 1500, new plays were being written in Italian. The Greek satyr play's format was eventually modified into pastoral romances featuring young shepherds and mythological creatures cavorting in forest and countryside, devoid of the overt sexuality of the Greek satyr plays.

Several critics, including **Lodovico Castelvetro** (1505–1571), codified the "rules" for drama. Those rules were derived from a combination of their interpretation of the writings of Aristotle and Horace and from their own inventions. The result was **Neoclassicism**, a style that would dominate Europe for more than two hundred years. It became firmly entrenched in France, but was not particularly prevalent in England or Spain. The essential components of neoclassicism were *decorum*, or "appropriateness," and *verisimilitude*, or "true to life." The concept of *verisimilitude* led to the unities of time, place, and action. The unities had been merely suggested by Horace based upon implications from the Greek drama, but now they were being mandated as part of Neoclassicism.

- The protagonist must be a person of high stature, who must behave according to his status.
- Plays must be written with a five-act structure.
- Plays must be written in verse.
- Plays must not mix styles—no comic portions in tragedies, for example.
- Plays must not use *deus ex machina*.
- Plays must not use a chorus.
- Plays must observe the Unities.
 - Unity of time meant the elapsed time in a play could be no more than twenty-four hours. Some even went so far as to insist that the time duration of the play and that of the plot must be identical—thus, a two-hour performance of a play could only include a two-hour time lapse in the plot.
 - Unity of place meant one location. For some, this meant one fixed location such as one room; for others, it could be several closely related locales in the same city.
 - Unity of action meant one major storyline with no subplots.

OPERA

It was known that Greek dramas contained a chorus and that there was music between each scene or episode in the play. This practice was incorporated into the writing of the new works that were based upon the classical models. Some of the Italian composers and playwrights of the time even believed—erroneously—that all of the Greek performance was sung. These musical sections, or **intermezzi**, between the dramatic scenes of the new plays got progressively more interesting and elaborate over time. After a while the *intermezzi* were more entertaining than the plays themselves. Eventually the collection of *intermezzi* became the performance and the result was what is now known as opera. The first opera, *Daphne* (1597), was composed by Jacopo Peri (1561–1633).

ACTING

The innovation in acting was the creation of **commedia dell'arte**, an improvisation acting technique that possibly had been around in various forms from the period of the Greek mimes. *Commedia dell'arte* translates closely as "comedy of the craft." Rather than using scripted dialogue in the performances, the actors made up the dialogue based upon a scenario, or outline. This was possible because actors often played the same character all their careers and incorporated repetitive business, or *lazzi*, into each performance. The *lazzi* would continue until the audience's interest in that piece of *lazzi* waned and then the cast would move to the next action with a different *lazzi*. The characters were stereotypic and wore traditional costumes and half-masks. Much of the action centered upon domestic issues and frequently included sexual and lewd gestures, such as a sword becoming a phallic symbol.

There were a number of stock characters in *Commedia*:

- **Pantalone** was a rich merchant with red tights and jacket and a hooked-nose mask.
- **Dottore** was a Doctor of Law filled with useless knowledge, wearing a short black cape, and a doctoral bonnet.
- **Capitano** was a Spanish braggart warrior, but a coward at heart, wearing extravagant military attire.
- Innamorati were young attractive lovers in fashionable attire who did not wear masks.
- Zannis were a collection of assorted servants:
 - Arlecchino (Harlequin): An amoral self-serving person wearing multicolored patches (eventually stylized into a diamond patchwork) with a black mask and wooden *batte*, or slapstick. The slapstick was made from two long thin pieces of wood separated by a small gap that created a loud smack when it hit someone.

- Scapino: A kindly trickster, wearing white trousers and jacket, traditionally playing a lute or a guitar.
- Brighella: A cruel cynical musician who's handy with a dagger.

Many *commedia* troupes traveled around making a living wherever they could find an opportunity to perform, but some troupes were able to have a more permanent performance venue. *Commedia* troupes consisted of about ten actors, including females who typically had to be the wife, sister, or daughter of a troupe member. The most famous troupe was *I Gelosi* (The Jealous Ones), headed by Francesco (1548–1624) and Isabella (Canali) Andreini (1562–1604). Isabella was a gifted and beautiful actress who died from the miscarriage of her eighth child while on tour. *Commedia dell'arte* troupes toured throughout most of Europe. In 1660, one troupe, the Comédie Italienne, took up residence in Paris for several years where it influenced **Molière's** work with its performances (Figure 20.1).

Figure 20.1 *Some Commedia dell'arte troupes traveled from town to town performing wherever they could on any available stage.*

THEATRE ARCHITECTURE

While dramatists were attempting to recreate classical drama, architects were trying to recreate the classical physical theatre. The rediscovery and publication in 1486 of Vitruvius' books of architecture provided the impetus a century later for Andre Palladio's (1518–1580) **Teatro Olimpico,** which was completed in 1584 in Vicenza. It was a Roman theatre crammed into a rectangular space and was designed to seat about 3,000. It's hard to image today how that many people could fit into it. It's major feature was a scaena frons with five arches, behind each of which was a three-dimensional forced-perspective vista (Figures 20.2 and 20.3).

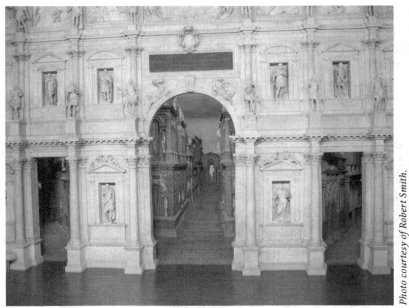

Photo courtesy of Robert Smith.

Figure 20.2 *The Teatro Olimpico had a scaena frons and five openings, each with a three-dimensional forced-perspective vista behind it. The acting space was the flat floor downstage of the openings. The inaugural performance was Oedipus Rex opening in 1585.*

Photo courtesy of Robert Smith.

Figure 20.3 *Partial view of the vista through the central doorway of Teatrico Olimpico. The stage floor rakes or slopes upward to accommodate the forced perspective scenery, which was immovable and constructed in three-dimensional plaster work.*

In 1588, Vicenao Scazzamozi (1552–1616), Palladio's student and assistant on the Teatro Olimpico, designed a smaller version, the Teatro all'Antico, at Sabbioneta that seated only 250. Though inspired by Teatro Olimpico, the space limitation permitted only a single central vista that now went from one side of the space to the other side. At Sabboineta, rather than being built in three dimensions, the scenery was painted in forced-perspective on the side walls of the stage. In the case of both theatres, the acting took place on the level forestage in front of the openings. To aid the perspective effect, the floor in the scenic area sloped, or raked up. This was the derivation of our terms "upstage" and "downstage." When the actor moved away from the audience the actor was literally moving higher, or up. When the actor moved closer to the audience the actor was moving down.

The ideas initiated in the two previous theatres were solidified in 1618 in the Teatro Farnese in Parma. There the single vista was expanded to become the whole stage for a theatre (Figure 20.4). The auditorium was much more spacious than Teatro Olimpico and could seat 3,500 (Figure 20.5). Thus, the proscenium arch theatre was created. Its use was adopted particularly for opera houses in Italy and from there it was exported to the rest of Europe. (The original Teatro Farnese was destroyed by bombing during World War II, but it was reconstructed after the war.) The proscenium arch theatre remained the most prominent theatre configuration for the next four hundred years and there is no indication that it will disappear anytime soon.

Photo courtesy of Robert Smith.

Figure 20.4 *The Teatro Farnese was the first theatre built with a full-size proscenium arch. The proscenium opening is approximately 40′ wide.*

Photo courtesy of Robert Smith.

Figure 20.5 *The auditorium for Teatro Farnese was designed to seat 3,500 and with the central flat floor filled with chairs that is possible. For a sense of scale, note the two blue chairs on the flat floor at right.*

STAGE DESIGN

There were innovations both in scenic design and in scenic shifting.

SCENIC DESIGN

The innovation in scenic design also stemmed from comments by Vitruvius, wherein he referred to tragic, comic, and satiric (or pastoral) scenes. This prompted **Sebastiano Serlio** (1475–1554), a stage designer and architect, to advocate for three types of settings in his 1545 book, *Treatise on Architecture*. Tragic settings featured formal and civic architecture. Comic settings consisted of depictions of inns and other domestic buildings. Pastoral settings were typically in a forest glade. Serlio used sets of angled wings with three-dimensional trim built in forced-perspective for the architectural wings. Each wing existed in two planes: one parallel to the audience and the other at an angle to the first flat wing and pointing upstage. The problem with angled wings on a raked stage was the great difficulty in moving them to a different stage location during scene changes.

SCENIC SHIFTING

Various techniques were tried for shifting the wings until a flat-wing-technique provided a method of easily shifting the wings. Because of Filippo Brunelleschi's (1377–1446) discovery of linear perspective and Tommaso Guidi Massaccio's (1401–1428) discovery of atmospheric perspective, designers were able to paint the flat wings to look like realistic three-dimensional objects. The reduced stage lighting made the painted scenery look very three-dimensional and real for its time period. However, the use of flat wings was labor intensive as a separate operator was needed to move each wing offstage while another person was needed to shift a new wing onstage for the next scene. Thus, twenty stagehands were needed just to change the wings of a typical five-wing setting. Additional stage hands were needed to move the borders and the backdrop. Various techniques were tried to simplify the shifting scenery. Ultimately, the problem was solved by **Giacomo Torelli da Fano's** (1608–1678) chariot and pole system for fast and synchronized scene changes.

In the chariot and pole system, each chariot ran on a track, like a trolley, in the basement of the theatre. The pole, which each chariot carried, stuck up through the stage floor and had a flat wing fastened to it. Through various combinations of ropes and pulleys all the wings in a setting could be rolled offstage together while the flats for the next setting could be rolled on stage simultaneously. Other architect designers devised techniques for flying clouds with people in them. Still other designers devised spectacular effects and described them in their books. It was a time for the preeminence of the stage designer. In many ways, the scenic techniques of the Italian Renaissance lasted until the emergence of the New Stagecraft in the very late nineteenth century.

ENGLISH RENAISSANCE

The English Renaissance theatre consisted of several individual periods: Tudor Theatre (1485–1558), Elizabethan Theatre (1558–1603), Jacobean and Carolingian Theatre (1603–1642), the Interregnum (1642–1660), and Restoration Theatre

(1660–1714). It took around a century for the full Renaissance to get to England, where Queen Elizabeth I (1533–1603 [reign 1558–1603]) had finally stabilized the social upheavals of religious conflict that had existed during the earlier Tudor period. That, coupled with the defeat of the Spanish Armada in 1588, sparked a burst of creative activity unmatched in English history.

TUDOR DEVELOPMENT

There were many different activities during the Tudor period that had significant impact on the development of both the Elizabethan drama and the development of the Elizabethan physical theatre. In many ways, Tudor England was still medieval and may of the characteristics of Chapter XIX were still prevalent in England.

Strolling players had existed to varying degrees in all European countries since the time of the Greeks. England was no different. Strolling players would perform wherever they could find paying customers. Many of the venues discussed in the following sections provided opportunities for them to perform. Officially, strolling players were considered vagabonds and could be arrested and imprisoned if they performed inside the limits of cities such as London.

Interludes originally were sophisticated debates and entertainments performed at court or in the manor homes of the aristocracy. Entertainment typically was not available outside of cities and interludes were a welcome relief. Early English Tudor Renaissance Interludes were represented by John Heywood's (1497–1578) *The Foure P.P.* (c. 1530), which was a satire on religious charlatans. The interludes and productions of Latin plays eventually led to more secular comedies such as *Ralph Roister Doister* (c. 1553), the first English comedy, and *Grammer Gurton's Needle* (c. 1553), written totally in the English idiom and showing few vestiges of Latin comedy.

© Rischgitz / Stringer/Getty Images.

Figure 20.6 *Though depicting a nineteenth century bear baiting, there is a sense of what the sixteenth-century practices may be like.*

Bear and/or bull baiting pits were used as fighting arenas in which dogs fought a bull or a bear, while the spectators wagered on the outcome. Because the baiting pits were typically located outside the London City limits, they also offered convenient locations for the performance of plays by strolling players (Figure 20.6).

The safety of the spectators necessitated a raised viewing section around some arena that was reproduced in the galleries around the inside of the public theatres.

Medieval cycle plays had continued to be done in many locations in England up until the middle of the sixteenth century when early Renaissance theatre practitioners could have seen them. Elizabeth I banned the production of religious drama as early as 1559, the year after she ascended the throne. Despite the ban, the last cycle play was performed in York as late as 1569. The staging techniques used for cycle plays with their simple platform space were similar to those used for performances at country fairs as shown in Figure 19.2 and eventually in the public theatres.

Country inns typically were not inside city limits and therefore also served as convenient performance venues for theatrical activities. The inns were way stations on stage-coach and thorough-fares for travelers, who could find safe accommodations inside the inns away from marauding bandits and highway men. The typical country inn was a multistoried building with an enclosed courtyard, surrounded by a balcony and providing a single entry way for horses and carriages (Figure 20.7).

Figure 20.7 *The Tabard Inn in the nineteenth century. Even though the original inn dates from before the Elizabethan period, it does not seem to have been used for theatre productions in the Elizabethan period. Nevertheless, it gives a good idea of the nature of other inns of the period where plays could have been performed.*

The interior courtyard was ideally suited to presenting theatrical productions. Strolling players could set up an improvised stage on one side of the courtyard by placing planks across barrels, for example. The courtyard provided space for spectators to stand, and the balconies were convenient for those who wanted preferred seating. It was a win-win for those involved in such theatrical activities. The innkeeper had a win because additional people from the surrounding locale who came to see the plays typically bought food and drink. The players had a win because those who were at the inn would likely pay to see the play.

A **manor house** was the home and administrative office for a duchy or some similar community location. Because manor houses invariably were in the country, they were outside the jurisdiction of the cities, and likewise isolated from various forms

of entertainment. Thus, it was a major event when strolling players asked to present a performance. The Great Hall of a manor house could easily accommodate a strolling player company. Often there was a raised dais, or platform, at one end of the hall where the lord and his associates normally ate meals. At the opposite end of the hall was a walled screen with one or two doors in it, above which was a kind of balcony that might also be used for theatrical productions.

Universities at Oxford and Cambridge, as early as the fourteenth century, required the Reader, or professor, of Latin and/or Greek to mount periodic theatre productions of Latin and Greek plays, done in the original languages. Oxford and Cambridge were originally founded in part to train priests for the ministry. The students, who were destined for the priesthood or in later times bound for the ministry, were required to know Latin and Greek. Both the Bible and the Catholic mass were only available in Latin, and at that time Greek was the language of the Bible's sourcebooks. Eventually, the Greek and Latin drama scripts gave way to original plays written in Latin, but still modeled on the Roman plays. The original scripts, initially done by the professors, led to productions written in English and eventually led to plays written by students. The productions often were done in the dining halls, where the tables could be pushed together to create an elevated stage area at one end of the hall. Attending the plays was quite popular among the students, and on at least one occasion, when there was insufficient seating for the undergraduate students, they rioted and broke windows. Later during the Elizabethan period, some students finished their university degrees and, being unable to enter the ministry or government service, wrote plays for the English public theatres. Those university-trained playwrights were collectively referred to as the "University wits."

The **Inns of Court**, or law schools, also had faculty members who produced Roman plays in the original language. Roman plays were produced at the Inns of Court because lawyers needed to be fluent in Latin, the official language of diplomacy and the law. There also, original English-language plays were eventually written by the students.

ELIZABETHAN DEVELOPMENT

Most of the theatrical activities of the Tudor period continued unabated into the Elizabethan period. In 1567, the first public theatre, The Red Lion, was built for strolling players doing touring performances outside London. Unfortunately, it had been built in a relatively remote and inconvenient location with the result that it did not flourish that well. Because there was no permanent company in residence, its use was sporadic.

The pivotal action that separates the Tudor Theatre activity from the Elizabethan Theatre activity was Elizabeth's Acte for the Punishment of Vagabonds in 1572. Strolling players previously had been considered vagabonds who were subject to

arrest, but now they were permitted to perform openly, provided they were sponsored by a member of the nobility. However, they still couldn't legally perform inside the London City jurisdiction. Only two years later in 1574, Elizabeth created the Master of the Revels Office, which was responsible for both court productions and for the supervision and censorship of the public theatres. Every script intended for public performance had to be submitted to the Master of the Revels Office for reading and approval before a performance permit would be issued. It was also possible for theatre companies to rent or borrow garments from the Master of the Revels Office for use in productions.

In 1576, **The Theatre** was built for long-term performance use just north of the city of London. In that same year, space at **Blackfriars**, a former monastery, was converted for the performance of plays by a boys' company. Blackfriars was physically located inside the London City limits. However, it was a royal enclave that Henry VIII had confiscated from the Roman Catholic Church decades earlier and as such was not subject to the laws of the city of London. As might be expected, the first public theatre construction and theatre performances were reflective of previous theatre activity and venues.

When The Theatre was built, it contained a number of features that were reminiscent of earlier performance venues. It was followed by other theatres, such as The Rose, The Swan, The Fortune, and The Hope, all outside the London city limits. When the land lease on The Theatre was about to expire, the owners of the building dismantled the building's timbers, hauled them across the Thames River to the south side of London, and built **Globe I** in 1599 (Figure 20.8). During a production of *Henry VIII* in 1613, the cannon-wadding from an effect caught the Globe's thatched roof on fire and it burned to the ground. A new building, known as Globe II, was built in 1614 with a tile roof.

Figure 20.8 *This detail from Wenceslas Hollar's 1647 drawing depicts an earlier time period that shows the Globe on the south side of the Thames River.*

MAJOR PLAYWRIGHTS

Literally dozens of playwrights wrote during the late sixteenth century and early seventeenth century, but we can only deal with several of the most important.

Christopher Marlowe (1564–1593) was a monument of theatrical practice until **William Shakespeare** came upon the scene. Marlowe was a student at Cambridge University, where he was involved in theatre, having written both parts of *Tamburlane the Great* before he finished his studies in 1587. Students might be interested to learn that Marlowe has the best excused absence of all time. The faculty at Cambridge did not want to award Marlowe his MA degree in part because he had missed too many classes. Queen Elizabeth I had her Privy Council write a letter to the faculty, stating that she would take it as a personal favor if Marlowe were awarded his degree. The letter explained that he had been engaged on business of the crown, an activity that most scholars interpret to mean he was spying in the Netherlands.

Marlowe's most famous play is *Dr. Faustus* (C. 1588), which deals with Faustus, a university professor, who sells his soul to the Devil for twenty-four years of extended life and the ability to learn everything that was possible to learn. Marlowe wrote soaring **iambic pentameter** poetry that became the standard for other playwrights. In one scene, after having conjured the image of Helen of Troy, Faustus asks,

> *Was this the face that launch'd a thousand ships,*
> *And burnt the topless towers of Ilium?*
> *Sweet Helen, make me immortal with a kiss! (Dr. Faustus,*
> *scene XIII).*

Because he was the first significant Elizabethan playwright, his work was the model for what Elizabethan playwriting was to become. One may only imagine what Marlowe might have written had he lived a full life. Instead, he died at 29—killed in a bar fight under suspicious circumstances. He had been summoned to the Privy Council, which did not show up for the meeting, and he was dead two weeks later.

William Shakespeare (1564–1616) is widely recognized as the most important English Renaissance playwright. Many claim he is the best playwright to ever write in the English language. Some claim he is the best playwright of all time. He grew up in Stratford-upon-Avon, where his father was an alderman, thus entitling Shakespeare to an education that would prepare him for university admission. Shakespeare married Anne Hathaway in 1582, with children following in 1583 and 1585. Little more is known of him until he shows up in London as an actor and playwright about 1590. Shakespeare was unique in that he became proficient at writing a range of plays: comedies, histories, and tragedies. His episodic dramas contain some of the most memorable, well-rounded characters in the theatre that actors and actresses alike still aspire to perform. Most of his comedies and histories, such as *The Comedy of Errors* (1592), *Richard III* (c. 1593), *A Midsummer Night's Dream* (1595), and *Henry V* (1599) were written in the 1590s, while his more mature masterpieces, such as *Hamlet* (1601), *Othello* (1604), and *King Lear* (1606), and his "problem plays," such as *Measure for Measure* (1605), *A Winter's Tale* (1611), and *The Tempest* (1612) were written after 1600. Shakespeare retired from the theatre in 1613 and returned to Stratford-upon-Avon,

where he had purchased the most expensive house in town. As an actor, shareholder in the **King's Men** theatre company, a 1/10 partner in the Globe theatre, a 1/7 partner in Blackfriars, and playwright, he had multiple sources of income that made him very well-to-do (Figure 20.9).

Many of Shakespeare's plays were published during his lifetime in pirated quarto versions. Following his death in 1616, two of Shakespeare's fellow actors collected his plays, edited them into the five-act structure we know today, and published them in the **First Folio** of 1623.

Ben Jonson (1572–1637) was born to a bricklayer father and studied at Westminster School. Though he aspired to a university education, his father apprenticed him to another bricklayer. Instead, Jonson ran away and joined the military,

Figure 20.9 *Shakespeare's engraved portrait is from the title page of the* First Folio.

© Stocksnapper/Shutterstock.com

and upon his return, educated himself and rose to become a major playwright and court poet. His major plays include *Every Man in His Humour* (1598), *The Alchemist* (1610), and *Volpone* (1606), the last generally considered his masterpiece. Unlike his contemporaries, Jonson considered his plays important literature and personally supervised the publication of his collected plays in 1616.

Jonson is also closely associated with the writing and production of court **masques**. Masques had been produced earlier in the Tudor and Elizabethan periods when they often were pastoral flattery pieces (particularly for Elizabeth I) or resembled processionals associated with royal entries into various towns. Under the influence of James I, during the Jacobean period, masques became much more elaborate productions. Jonson typically was the author of those masques, but he had very strained relations with Inigo Jones (1573–1652), the masques' designer. Eventually, Jonson stopped writing masques because he thought Jones's scenery was overpowering his scripts.

© Culture Club / Getty Images.

Figure 20.10 *The Swan Theatre drawing shows the interior of an Elizabethan public theatre. The original drawing, which is now lost, was done by Johannes de Witt. The theatre was reputed to seat an audience of about 3,000.*

PRODUCTION PRACTICES

Performances in the public theatres took place outside during the summer months. The stage was about four feet high and the audience stood on the ground (hence they were called **groundlings**) in the theatre yard on three sides of the stage. There typically were two columns that supported a roof, called the **heavens**, over a portion of the stage. Behind the stage was an arrangement of doors, windows, and recessed spaces, that typically did not vary significantly from production to production. Above the heavens was a flagpole from which a banner flew to advertise that a performance was taking place (Figure 20.10). The admission was one penny, but better and more expensive accommodations could be found in the multistoried galleries that surrounded the yard. Performances started about 2:00 in the afternoon and ran for two to three hours.

The actors, all of whom were males, frequently played multiple roles. Half a dozen or more members were sharers in the company. Other actors were hired to complete the cast for the various plays. Young female characters were typically played by the prepubescent male apprentices until their voices broke. Older female characters were played by the adult male actors. (Despite the impressions given in Tom Stoppard's [1937–] film, *Shakespeare in Love* [1998], women never performed on the public stage, even in disguise, and Queen Elizabeth I never attended the public theatre [Figure 20.11].)

The fact that there were no female actors in the Elizabethan public theatre is part of why there are so few female characters in Elizabethan dramas. That is also why Shakespeare frequently had his female characters disguise themselves as males—roles the 11- to 13-year-old boys could more easily portray. However, actresses could be seen in the masques done at court, but there the women typically were members of the court, wore masks, and theoretically were anonymous.

The private theatres, which the public could attend for six pennies, were indoor theatres at places like Blackfriars that presented productions during the colder winter months.

At Blackfriars, particularly for the boys' companies, they sometimes mounted productions in the Italian manner with scenery consisting of side wings and backdrops, called sliders. The scenic production practices used in the private theatres were similar to those used for masques, particularly in the seventeenth century. Because they were indoors, they had to use candles or lamps for illumination.

Because a theatre company had to be sponsored by a member of the nobility, sponsorship by the nobility obligated the theatre company to provide private performances for the noble, typically at the noble's palace. In addition, the theater company was subject to the constraints or censorship of the Master of the Revels Office. Queen Elizabeth I liked theatre very much and had her own Lord Chamberlain sponsor the theater company to which Shakespeare belonged—hence that company was called the **Lord Chamberlain's Men**. Elizabeth enjoyed theatre and initially saw eight or so productions a year at her palace, performed by one of the boys' companies. Later she saw a combination of performances by the boys' company or by Shakespeare's company. In addition, Elizabeth particularly liked the character of Falstaff from *Henry IV, Parts I & II* (1598–1600). Her request to see another play featuring the character of John Falstaff in love was answered when Shakespeare wrote a new play, *The Merry Wives of Windsor* (c. 1600), first performed at court.

Figure 20.11 *Tom Stoppard has written two major works dealing with Elizabethan period theatre, the film,* Shakespeare in Love, *and the play,* Rosencrantz and Guildenstern Are Dead *(1966), about two minor characters in Shakespeare's* Hamlet.

JACOBEAN AND CAROLINGIAN DEVELOPMENT

After Elizabeth I died in 1603 and was succeeded by James I (1566–1626) of Scotland, the company's name was changed to the King's Men because James liked theatre even more than Elizabeth and became a personal sponsor of the theatre company. James generally saw twenty or so performances per year.

Unfortunately, both James I and his son Charles I (1600–1649) did not get along well with the Puritans in Parliament, eventually leading to open armed conflict between Oliver Cromwell (1599–1658), a rising ultrareligious Puritan, and Charles' forces. Charles was defeated, Cromwell became Lord Protector, and Charles I was ultimately executed. Many members of the English nobility fled to France to avoid execution.

INTERREGNUM

In 1642, Parliament passed a law closing all the theatres in England, abruptly terminating the vibrant theatre of the English Renaissance. Consequently, most of the theatres in England were torn down or renovated to serve other functions. Cromwell's successor son, Richard (1626–1712), was considered unacceptable as a leader in part because he lacked military experience, and the people asked the royals to be restored in 1660, otherwise referred to as the **Restoration**.

RESTORATION DEVELOPMENT

"Restoration" technically refers to the restoration of the royals, in the person of Charles II (1630–1685), to the British throne in 1660. It also refers to the restoration of theatre to England. When theatre was restored, it was a totally new theatre style that had been imported from France. During the Interregnum, the members of the English aristocracy had fled to France where they had been exposed to and became accustomed to the French culture and to continental theatre practices in particular. When they were restored in 1660 they brought their tastes in theatre back to England with them. Continental theatre at the time of the restoration was marked by proscenium arch theatres using Italianate-type painted wing and drop settings, in some ways similar to the masques that had been done at the English court a generation earlier.

However, there were several distinctions about the new theatre. The most important was that for the first time women were permitted on the English public stage. Women occasionally had appeared in religious cycle plays during the medieval period and had appeared in masques at court, but in the masques the women typically were members of court and wore masks so that theoretically they were unidentifiable.

In addition, the new playhouses were much smaller, rarely seating as many as even seven hundred people, most of whom were members of the aristocracy or upper middle class. Now everyone was able to sit to watch the show, often with gallants sitting on the stage. Only two patent, or licensed, theatres were permitted, though theatre people frequently tried to find ways to circumvent that limitation. The overt sexuality and sexual innuendos of the restoration theatre offended some and prompted the minister Jeremy Collier (1656–1726) to write his pamphlet treatise, *A Short View of the Immorality and Profaneness of the English Stage* (1698). Even though wing and drop scenery had been used in France and Europe, the English never adopted the chariot and pole system for shifting scenery. Instead, the English moved their wings in grooves constructed on the stage floor.

A few tragedies of note were written during the period, such as John Dryden's (1631–1700) *All for Love* (1677), a reworking of the Antony and Cleopatra story from Shakespeare, and Nathaniel Lee's (c. 1649–1692) *The Rival Queen* (1677). Tragedies often employed exotic locales, heroic figures, and characters of high rank. While

there was some limited attention to the Neoclassicism ideals, England was never as committed to the neoclassical standards as France was.

It is the comedies that are the heart of the English Restoration Theatre. The two major comic forms were the comedy of intrigue and the comedy of manners. **Aphra Behn** (1640–1689) was one of several female playwrights and was considered one of the best authors for comedy of intrigue as seen in her two plays, *The Rover I and II* (1677–1680). Behn was widowed young and turned to writing to support herself, becoming the first important professional female playwright in England. The bawdiness of the times was clearly represented in her plays, creating the need for her to defend herself more than once on that issue.

The comedy of manners is best represented by the works of **William Wycherley** (1641–1716) and **William Congreve** (1670–1729). The comedy of manners depicts high society, sexuality, cynicism, and holds the aristocratic class up to ridicule for its pretentious and artificial code of conduct. In Wycherley's *The Country Wife* (1675), Horner is intent upon cuckolding his acquaintances by having sex with their wives— that is he will set horns, the symbol for cuckolding, on the heads of the husbands. In the famous "china scene," he is giving a piece of porcelain to one husband's wife behind a locked door while her husband stands on the other side of the door oblivious to the activity in the next room. A second woman arrives seeking a piece of Horner's porcelain for herself only to be told that Horner is out of porcelain. The audience knows that "porcelain" has become code among the women for sex with Horner.

Congreve's *The Way of the World* (1700) is his masterpiece and considered the masterpiece of Restoration comedy. Though the play's sexuality has been toned down compared to *The Country Wife*, it still plays an important part as Lady Wishfort, a woman well past middle age, spends much time during the course of the play preparing for a hoped-for sexual encounter. Characters' names in Restoration comedy often take on special meaning as they often describe the characters' behavior. Lady Wishfort's name may be comprehended as "wish for it." Mrs. Marwood would mar other people's reputations. Witwood, a fop, who would be a wit, thinks himself a wit, but in fact is quite dense.

PHYSICAL PLAYHOUSE

The characteristics of the English Restoration playhouses generally reflected those of the continental theatres, but there were some differences. Both had a proscenium arch with a large level forestage downstage of it, where most of the acting took place. In England, initially, there were two sets of doors downstage of the proscenium, which were typically used for all entrances and exits. The doors typically had one or more audience balconies above them. The scenery was on a raked, or sloped, portion of the stage upstage of the proscenium. In the beginning of the period, acting typically was not done in the scenery portion of the stage. It was an uncommon enough

practice that playwrights often made specific script notations when acting took place in the scenery. Toward the end of the century, more and more acting was taking place in the scenery space.

SPANISH RENAISSANCE

Early Renaissance Theatre in Spain consisted of both religious and secular plays, each type presented by different professional troupes, though there were some authors and troupes that were versatile at both. *Auto Sacramentales*, one-act allegorical religious plays that typically ended in a display of the Eucharist, were initially done in churches as part of the Catholic mass, and had distinct moral lessons. These plays developed into Corpus Christi plays that were presented on *carros*, carts somewhat similar to medieval pageant wagons in England. Secular theatre in Spain started as a charitable activity, typically associated with religion. Secular performances took place in *corrales*, in some ways similar to the Elizabethan public theatres. The *corrales* were erected in a courtyard between two buildings and had separate seating areas for males and females. Unlike the Elizabethan theatre, females were permitted to perform on the Spanish stage, due to their earlier performances in the *auto sacramentales*.

PLAYWRIGHTS

An early Spanish playwright was Lope de Rueda (c. 1507–1565), an actor who was also the first author for the secular theatre. Miguel de Cervantes (1547–1616), though best known for his novel *Don Quixote de La Mancha* (1605), wrote about thirty plays, of which sixteen are extant. Initially, Cervantes was recognized as an exceptional playwright; however, none of his plays are significant today. His prominence was eclipsed by the appearance of **Lope de Vega Carpio** (1562–1635), who is reputed to have written over eight hundred plays, of which perhaps half are extant. His *Fuente Ovejuna* (*The Sheep Well*) (1618) is famous for its use of a group protagonist. A young woman from the village of Fuente Ovejuna is raped by a member of the aristocracy and nothing is done about it until she goads the townspeople into action. They kill the lord and agree that when asked who killed the lord, they will only respond "Fuente Ovejuna." The king orders an investigation and ultimately "forgives" the villagers for killing an unjust and corrupt lord. Lope de Vega also wrote a book on playwriting, *New Art of Playwriting in Modern Times* (1609), becoming one of the very few Renaissance playwrights to do so.

Pedro Calderon de la Barca (1600–1681) was a very talented man who wrote over 180 plays for both the religious and secular theatre. For a while he was also the director of the court theatre in Spain. He is probably best known for *La Vida es Sueño* (*Life is a Dream*) (c. 1636). The play concerns the Polish king. At his son's birth there was a prophecy that the son, Segismundo, would be violent. Thus, Segismundo was imprisoned at birth. When released at age 21 the son indeed becomes violent, killing

a man and raping a woman. He is captured, drugged, imprisoned again, and told that what happened was merely a dream. He is again freed, this time by rebels. Because he is unable to differentiate which events were real and which were only dreams, he decides to behave for fear he might "wake up" back in prison. In 1651, Calderon was ordained a priest and left the secular theatre. However, he still wrote *autos* and served as theatre director for the court theatre for much of the rest of his life.

Sor Juana Inés de la Cruz (1651–1695) was a nun who spent her life in Mexico. She wanted to go to university disguised as a male, but her mother refused to let her. She eventually became the abbess of a convent and wrote both secular and religious plays, becoming one of the few female authors of the Renaissance period. One of her *auto sacramentales*, *The Divine Narcissus* (1690), was published in Mexico in 1690.

FRENCH RENAISSANCE

As had been the case in Spain, initially theatre in Renaissance France was a charitable undertaking. Eventually strolling troupes merely paid a fee to the charity to get a license to perform. As was the case in most of continental Europe, French Renaissance theatre was significantly influenced by Italian theatre. One influence was the importation of *commedia dell'arte* and the establishment of such a company in Paris. The second influence was the importing of the new Italian approach to scenery design. There were few if any theatre buildings in France, so productions were presented in colleges and noble homes. The **Hôtel de Bourgogne** theatre was built in the Hôtel de Bourgogne house in 1548. Before 1600, there were no theatre companies, only strolling troupes that would use available venues. Tennis was a popular pastime in Paris and the indoor tennis courts were frequently converted to present theatrical productions.

Cardinal Richelieu (né Armand-Jean de Plessis) (1585–1642) had significant impact on the development of theatre in France. He was an intellectual giant who became a bishop at age 22 and who formed the **Académie Française** in 1635 (Figure 20.12). The **Académie** was a select group of forty of the most prominent literary individuals in France that determined language and writing style.

© Georgios Kollidas/Shutterstock.com

Figure 20.12 *Cardinal Richelieu had significant impact on the development of seventeenth-century French drama through his creation of the* Académie Français. *In addition, one of the earliest theatres built in Paris was in his house.*

The Académie formalized the adoption of the unities of time, place, and action and called for *vraisemblance* (credibility) and **bien séance** (taste) in French theatre. It also adopted the other characteristics of Neoclassicism. This combination became French neoclassicism that reigned in France for the next two centuries. Richelieu's impact on theatre stemmed in part from the fact that in 1641 he had a theatre built in his home, the Palais Cardinal, which seated over one thousand people. After the Cardinal's death in 1642 the theatre was renamed the Palais Royale.

PLAYWRIGHTS

The early French dramatists composed plays following the Roman patterns, particularly those of Seneca. The first important French dramatist was Alexander Hardy (c. 1575–1632), who was also the first professional dramatist in France. He eliminated the chorus that had existed in the Roman dramas, unified the action, and claimed to have written about six hundred plays.

Figure 20.13 *Bas-relief of Pierre Corneille, whose play,* Le Cid, *was censured by the* Académie Française *for its improbably plot that violated the twenty-four-hour Unity of Time.*

Pierre Corneille (1606–1684) wrote a number of plays, of which *Le Cid* (1637) is the best known, though it was condemned by the Académie (Figure 20.13). As was the case for much of French drama at the time, tragedies dealt with the conflicts between personal desires and social expectations or honor.

In *Le Cid*, the two lovers are from different families, the fathers of which hold an honor feud. The young man goes away to fight a war and returns as the conquering hero the next day. This created a significant problem for the Académie Française because the unity of time limited a play to a twenty-four-hour period. The Académie met to discuss this violation of the neoclassic rules and censured the play, holding that it was not credible that a war could be waged, won, and its leader return a hero in twenty-four hours. As might be imagined Corneille was incensed by the rebuke and left theatre for a number of years.

The most popular French playwright was **Molière** (né Jean-Baptiste Poquelin) (1622–1673). Molière was raised in privilege—his father was upholsterer to the king—and Molière became a personal friend of the young future king (Figure 20.14).

While Molière was supposed to be studying law, he instead became involved with theatre, including the *commedia dell'arte* company in Paris that influenced much of his work. One of Molière's best-known plays is *Tartuffe* (1664), which attacked religious hypocrisies.

In the play, Orgon is scammed out of house and home because he is deluded about the true moral character of his new friend, Tartuffe. Only when Orgon's wife pretends to let Tartuffe try to seduce her while her husband hides under the table, does her husband see the truth about Tartuffe. The play highly incensed some people and Molière had to rewrite the play several times before it could be produced. Even at that it needed the king's personal intervention.

When Molière died following his onstage collapse during a performance of *The Imaginary Invalid* in 1673 (Figure 20.15), the king ordered that Molière's troupe and the Marais troupe be merged. Later in 1680, he ordered that the Molière–Marais troupe be merged with the Bourgogne troupe to create the **Comédie-Française**, the world's first national theatre. The Comédie-Française still exists and has been instrumental in

Figure 20.14 *Bas-relief of Molière (Né Jean-Baptiste Poquelin), who is widely regarded as the very best French playwright.*

Figure 20.15 *Eighteenth-century painting of Molière in his* The Imaginary Invalid. *Note the use of the wing and drop scenic technique that would also have been used in Molière's time.*

Figure 20.16 *The Comédie-Française became the world's first national theatre and is still one of France's most important theatre companies. Because it was created from a merger with Molière's company, it still maintains a direct linkage to Molière's acting techniques.*

Figure 20.17 *Nineteenth century drawing of a production at the Comédie-Française.*

preserving and presenting classical productions in Paris (Figures 20.16 and 20.17).

France's most highly regarded tragedian is **Jean Racine** (1639–1699), whose masterpiece is *Phèdre* (1677) (Figure 20.18). Phèdre falls in love with her stepson, Hippolytus, because he reminds her so much of her husband, Theseus.

She believes her husband is dead, as he's been away on a trip for several years. Phèdre has her maid reveal her true feelings to her stepson, who is repulsed by the idea. When Theseus unexpectedly returns, Phèdre and her maid attempt to cover up the incident by accusing Hippolytus of attempted rape, a charge that ultimately destroys all of them. Racine's plays are known for the inner psychological realism of his characters.

IMPACT OF RENAISSANCE THEATRE

There were a number of innovations of the renaissance theatre that have significant impact on our contemporary theatre: new dramatic forms, improvisation, theatre architecture, and stage design.

The Italian renaissance, in its attempt to recreate classical Greek and Roman drama, produced Neoclassicism that held a strangle hold on

much of western European drama for several centuries. The other attempt to recreate classical drama eventually resulted in opera. Today opera is so widespread that virtually every modest sized city in the world has its own opera company. In drama, the English renaissance produced William Shakespeare. He is widely regarded as the most accomplished English-language playwright of all time. Many consider him the very best playwright ever.

In acting, improvisation as developed by the *Commedia* has become a significant component of actor training in most of the western world.

Photo courtesy of Robert Smith.

Figure 20.18 *Bas-relief of Jean Racine, who is best known for his play* Phèdre.

There are also many professional improvisational theatre companies around the world. In the United States alone, there are more than fifty improvisation companies, including Chicago's famous The Second City. In the United States, improvisation also appears weekly on TV in *Whose Line Is It Anyway?*

Renaissance theatre architectural innovations produced our two most important architectural forms: the proscenium stage and the thrust stage. The proscenium theatre was created by Italian renaissance architects who were attempting to recreate the classical Greek and Roman physical theatre. The resulting proscenium arch theatre has dominated Europe for the last four hundred years and is the most frequently used form today. The second most frequently used format is the thrust stage, essentially a revival of the Elizabethan public theatre.

The innovations in stage scenery are also still with us. Originally, classical period scenery was a façade in front of which acting took place. Initially, that concept was maintained by the renaissance stage designers, but by the late renaissance acting began moving into the area occupied by the scenery so that today most theatre productions are staged so that the acting takes place in a more or less complete scenic environment rather than in front of a façade.

Key Names, Venues, and Terms

Académie Française

Auto Sacramentales

Aphra Behn

Bien Séance

Blackfriars

Bull/Bear Baiting

Pedro Calderon de la Barca

Capitano

Cardinal Richelieu

Carros

Lodovico Castevetro

Le Cid

Commedia dell'arte

Comédie-Française

William Congreve

Pierre Corneille

Corrales

The Country Wife

Dottore

First Folio

Globe

Groundlings

Heavens

Hôtel de Bourgogne

Iambic Pentameter

Inns of Court

Interlude

Intermezzi

Ben Jonson

King's Men

Lord Chamberlain's Men

Christopher Marlowe

Masque

Molière

Neoclassicism

Pantalone

Jean Racine

Restoration

The Rover

Sebastiano Serlio

William Shakespeare

Tartuffe

Teatro Farnese

Teatro Olimpico

The Theatre

Giacomo Torelli

Verisimilitude

Lope de Vega Carpio

Volpone

The Way of the World

William Wycherley

Zannis

Additional Reading

Howarth, William D., et al. (eds.). *French Theatre in the Neo-Classical Era, 1550–1789.* New York: Oxford University Press, 1997.

Mulrayne, J. R. and Margaret Shewring. *Theatre of the English and Italian Renaissance.* New York: St. Martin's, 1991.

Shergold, N. D. *A History of the Spanish Stage from Medieval Times until the End of the 17th Century.* Oxford: Clarendon, 1967.

Thomson, Peter. *Shakespeare's Theatre.* New York: Routledge, 1992.

EIGHTEENTH AND EARLY NINETENTH CENTURIES

In many ways, particularly in the arts, developments during the eighteenth century were mostly a continuation and a refinement of those activities that had started back in the Renaissance. On the other hand, the eighteenth century was also the middle of the Enlightenment and thus the beginnings of more widespread scientific and technological activities.

ENGLAND

In England, the two major playwrights for the first half of the eighteenth century were **John Gay** (1685–1732) and **George Lilo** (1693–1739). John Gay's most important script was *The Beggar's Opera* (1728), which was mounted with John Rich (1692–1771) as the producer. The show's financial success prompted the phrase that the show "made Rich gay and Gay rich." The production was a **ballad opera**, meaning that in addition to writing the script, Gay also wrote the songs, or ballads, that were included in the production (Figure 21.1). Because ballad operas used existing tunes, authors only needed to write new lyrics to fit the existing music. *The Beggar's Opera* was also satirical in that it depicted the beggars and petty thieves as every bit as oppressive as the upper classes. Interestingly enough, Bertolt Brecht, in the middle of the twentieth century, chose the same script as the basis for his own treatment of the subject in *The Threepenny Opera*.

Figure 21.1 *The drawing is a copy of William Hogarth's painting of John Gay's production of* The Beggar's Opera, *a ballad opera.*

In 1731, George Lilo wrote **The London Merchant**, *or the History of George Barnwell.* Though presumably intended as a middle-class tragedy, today it reads as **melodrama,** but of course without the musical elements. The script is one of the very first plays to deal with middle-class drama and middle-class values. In the play, George Barnwell is seduced away from his natural goodness by a woman who had been abused by men. In his infatuation for her he is driven to kill his uncle for the money she wants. At the end of the play he admonishes the audience to take moral instruction from his own downfall.

Figure 21.2 *The first Covent Garden Theatre was built in 1732. This painting depicts its early eighteenth-century configuration. Note how significant portions of the production are downstage of the proscenium arch on the apron.*

As noted earlier many times, a tendency for theatre practitioners was to do whatever they perceived as likely to increase their opportunities, particularly in selling more tickets. Thus, the number of operating theatres increased despite the official limit of only two patent theatres. In 1737, irritated by the number of political plays and satires, the government reinforced the previous limit of only two patent playhouses in London, **Covent Garden Theatre** (Figure 21.2) and **Drury Lane Theatre** (Figure 21.3). This reduction in the number of London Theatres would have significant impact on the development of the American Theatre.

The two most important English playwrights in the second half of the eighteenth century were **Oliver Goldsmith** (1730–1774) and **Richard Brinsley Sheridan**

(1751–1816). The depiction of flagrant sexuality that had been common in the Restoration plays abated and a style known as **sentimental comedy** superseded it. Such plays and characters were filled with expressions of sentiment, but the plays were pale examples of the comedy of manners that had existed in the Restoration period. Oliver Goldsmith argued for what he termed **laughing comedy** in which the audience was to laugh at its own foibles and pretensions rather than those of another class. *She Stoops to Conquer* (1773) is probably his best play. The plot has a number of hilarious situations: arranged marriages; mistaking a country house for a country inn; and a woman hiding her social class, or stooping, in order to obtain the man she wants. Because this is eighteenth-century comedy and not Restoration comedy, there is a happy ending and no one is seriously upbraided at the end.

Sheridan was born the son of an Irish actor. His two best plays are *The Rivals* (1775) and *The School for Scandal* (1777). For a time he was also the manager at Drury Lane Theatre, one of the two **patent theatres** in London, but he left it all in 1780 after obtaining a seat in Parliament. *The Rivals* is famous for the character of Mrs. Malaprop, whose behavior created the term "malaprop-ism." Mrs. Malaprop uses the wrong word, but always with the correct pronunciation. For example, she says "the pineapple of my eye," while the correct phrase is "the apple of my eye." *The School for Scandal* is equally famous for the screen scene, in which Lady Teazle hides behind a screen to avoid being discovered in another man's house. While there, she overhears her husband's expressions of true love and concern, only to be shamed when the screen is thrown down and she is discovered. Again, this is eighteenth-century comedy

© Philip and Elizabeth De Bay/Corbis Historical/Getty Image.

Figure 21.3 *Drury Lane Theatre before its burning in 1809. Note the five galleries and the one set of proscenium doors with boxes above them. The downstage door's position has been replaced with an additional box. By this time much of the acting had moved upstage of the proscenium and the stage floor was flat.*

and everything ends well for the "good" characters in the play. From this point on, eighteenth-century sentimental comedy and laughing comedy began their slow deterioration toward melodrama.

FRANCE

In France, the three most important playwrights of the eighteenth century were Voltaire (né François-Marie Arouet) (1694–1778), Pierre Carlet de Chamblain de Marivaux (1688–1763), and Pierre-Augustine Caron de Beaumarchais (1732–1799). Voltaire wrote *Oedipus* (1718), which earned him a lot of money and allowed him to live relatively comfortably for the rest of his life. He spent two and a half years in England and upon his return to France he integrated the French and English approaches to theatre, which allowed him to include more spectacle and action in his plays than would normally have been expected with French Neoclassicism. Marivaux wrote plays dealing with the psychological complexities of awakening love and fantasy, but unfortunately his plays do not translate well. Beaumarchais wrote *The Barber of Seville* (1775) and *The Marriage of Figaro* (1784), both better known today as sources for operas with the same titles. In many continental European countries, elaborate theatre productions were staged to commemorate important diplomatic events such as a royal marriage.

ITALY

Opera was the most important theatrical activity in Italy. There were seven opera houses in Venice alone. During the eighteenth century, the emphasis shifted away from the story and more toward the singing, referred to as *bel canto opera*, in which the beauty of the singing voice was the most important activity. During the eighteenth century, opera continued to be exported to the rest of Europe and America so that today virtually every major city in the world has its own opera company.

The other area of theatrical concern in Italy dealt with *commedia dell'arte*. **Carlo Goldoni** (1707–1793) and **Carlo Gozzi** (1720–1806) disagreed about the nature of the form. Goldoni was interested in refining the Italian drama. The normal process for *commedia dell'arte* productions, as noted in Chapter XX, was only to generate a scenario and to let the actors improvise the actual lines. Goldoni wanted better structure and control. Thus, Goldoni began fully writing out the dialogue for the smaller parts in the play. In one of his better known plays, ***The Servant of Two Masters*** (1743), Goldoni wrote out all the dialogue except for that of the leading character, Truffaldino, a character who was being portrayed by an accomplished actor. However, following the opening performances, even that improvised dialogue for Truffaldino was fully written out.

Gozzi, on the other hand, wanted to return to the original form and technique in which much more improvisation was left to the actors. Probably his two most important plays were *The Love of Three Oranges* (1761) and *Turrandot* (1762). *The Love of Three Oranges* was a huge success, which prompted him to turn out a number of

other scripts in the same style. Today those two scripts are better known as the source for two operas, with the same titles as the plays on which they were based.

SCANDINAVIA

Ludvig Holberg (1684–1754), a professor, wrote approximately thirty-three plays, of which the best known is *Jeppa on the Hill* (1723). Though born in Norway, he spent most of his adult life in Denmark. The more important thing that happened in Scandinavia was actually what didn't happen. King Gustav III, who reigned from 1771 to 1792 was interested in theatre, liked to act, and actually wrote six plays that were mounted at the Gripsholm Theatre, one of his royal court theatres. Unfortunately, he was assassinated and both the Gripsholm Theatre and the **Drottningholm Theatre** were closed or fell into disuse for a century or more. Because of this neglect, much of their contents was preserved to be discovered again, in one case in the early 1920s. As a consequence, two complete eighteenth-century theatres, together with their theatrical machinery and scenery were preserved. Today Drottningholm Theatre, in addition to being an important eighteenth-century theatre museum, also presents operas during the summer using production techniques and

© *Courtesy of Robert Smith.*

Figure 21.4 *Drottningholm Royal Palace Theatre is a preserved eighteenth-century theatre with about thirty sets of scenery from that time period. Note the five sets of wings. The top of the stage is masked with borders. Interestingly much of the auditorium decoration is only painted. Today the museum theatre is used to mount operas in the summer with eighteenth-century techniques and period scenery.*

scenery of the eighteenth century. Actually the scenery that is used today has been reproduced. The original scenery is considered too valuable to use and is archived somewhere else (Figure 21.4).

GERMANY

For the first half of the eighteenth century, there were no permanent theatres in Germany. During the second half of the century much of the dramatic activity

consisted of translations and adaptations imported from foreign sources. However, Germany was not without important theatrical activity. Three major German dramatists of the time were **Gotthold Ephraim Lessing** (1729–1781), Johann Christoph Friedrich von Schiller (1759–1805), and **Johann Wolfgang von Goethe** (1749–1832).

A new style, known as **Storm and Stress**, arose in Germany in the 1770s, but only lasted for about twenty years. With its romantic emotionalism being more important than reason, the style was an assault on Neoclassicism. Often the protagonist was a superior individual who was in conflict with society. The style was adopted briefly in a few other European countries, but it did not get a good foothold in the other countries and died out when its principles were subsumed by **Romanticism**.

Lessing's works include *Minna von Brarnhelm* (1767), generally considered his comic masterpiece. His serious *Nathan the Wise* (1779) was a plea for religious tolerance with its inclusion of major characters belonging to the Christian, Jewish, and Islamic faith. However, among theatre scholars he is better known today for his **Hamburg Dramaturgy** (1767), a collection of essays on theatrical criticism.

JOHANN WOLFGANG V. GOETHE

© vkilikov/Shutterstock.com

Figure 21.5 *Johann Wolfgang Von Goethe is widely recognized as the most important German playwright before the twentieth century.*

Schiller's works embrace Storm and Stress more fully than Lessing, as may be seen in his *Maria Stuart* (1800). The play is an examination of the conflict between Elizabeth I of England and Mary Stuart of Scotland, who was kept under house arrest in England. Both women invoked high emotion in the play, but it is clear that Schiller is on Mary's side.

Goethe is a monument in German theatre. We have run into him before in Chapter I when discussing the functions of art and again later on in Chapter II when discussing his three questions. Goethe was a Renaissance man, meaning he had achieved a significant degree of mastery in a number of disciplines. He was a diplomat, a scientist, a playwright, and served as director of the court theatre. Outside Germany his best-known works are *Faust*, *Part I* (1808) and *Faust*, *Part II* (1832), though those scripts are actually Romanticism (Figure 21.5).

UNITED STATES

Theatrical achievements in the United States during the eighteenth century were not significant from a world perspective. However, it is important for us to understand where and how our theatre in the United States developed before it did become important to the rest of the world. As has been noted in Chapter XVI, much Native-American theatre and precolonial theatre existed before the Europeans arrived. In this regard, probably the most important date is 1665 when *Ye Bare and ye Cubb*, written by William Darby, was presented at Cowles Tavern in Accomac County, Virginia, thus becoming the first English-language play written in America.

After London, Philadelphia was the second largest English-speaking city in the world, making it an important destination for English touring theatre companies. The reassertion of the two-patent-theatre-limit in London in 1737 had repercussions for Philadelphia. William Hallam and his brother, Lewis Hallam, arranged for their Hallam Company to tour America, arriving in 1752. The company performed in various cities in the United States for a number of years, sailed for Jamaica where Lewis Hallam died, and returned to America. Following its return, the company was renamed the **American Company** and built **Southwark Theatre** in Philadelphia, the first permanent theatre built in America in 1766. In 1767, it staged Thomas Godfrey's (1736–1763) *The Prince of Parthia*, the first professionally produced play by an American author. The company then built the John Street Theatre in New York City, the second permanent theatre in America, and built another theatre in Charleston that opened in 1774. When the American Revolution broke out, the company left for Jamaica and stayed there for about ten years before it again returned to Philadelphia.

When the company did return in 1784, Mrs. Hallam's son, **Lewis Hallam Jr.**, became the actor-manager. Initially the company was denied permission to perform, but Lewis Hallam Jr. was able to persuade the Pennsylvania Assembly to permit the company to do "lectures," complete with scenery and songs. Lewis Hallam Jr. was an accomplished actor and frequently starred in shows with his mother. The company became the premier theatre company in the United States for the next twenty years, performing in Philadelphia, New York, Baltimore, Annapolis, and Richmond. As the theatrical organization of the nation changed, the theatre center of the United States began to shift from Philadelphia to New York City, where it has remained ever since.

EIGHTEENTH-CENTURY PHYSICAL THEATRE

Generally theatres were built in two configurations starting in the eighteenth century. One configuration employed a square or rectangular plan as may be seen in the

Drottningholm Theatre in Sweden. The second theatre configuration was an oval or horseshoe arrangement, which allowed the theatre to hold more seats. In some cases, however, the boxes or small room-like compartments for audience members, had very limited viewing of the stage, particularly those boxes that were on the sides of the auditorium.

In England, at the beginning of the century, there typically were two sets of **proscenium doors** on either side of the stage. As the century progressed, theatres changed so that by the end of the century there was only one proscenium door on each side in England. On the other hand, on the continent of Europe, many theatres at the beginning of the century had started with only one proscenium door on a side and then eliminated all doors by the end of the century. As the number of proscenium doors declined, so too did the size of the apron, that stage floor space downstage of the proscenium where most acting took place in that time period. As the apron shrank in size there was a tendency for actors to move back into the space where the scenery had been, often on a raked floor. As acting moved more and more into the scenery space, there was a tendency to eliminate the raked floor altogether, so that by the end of the century most theatres had a flat stage floor.

Regardless of the theatre ground plan configuration, there typically were several stories of galleries, or balconies. It was also common practice at the beginning of the century for gallants to sit upon the stage, until David Garrick (1717–1779) the actor-manager of Drury Lane, cleared the stage of spectators in 1762. This practice was soon adopted throughout Europe and America.

PRODUCTION PRACTICES

Every time period has its own definition of natural or realistic acting. With our contemporary sensibilities we may not consider much of eighteenth-century acting to be realistic. However, there certainly were actors who were trying to be more natural than actors who used a traditional elocutionary voice and grand gestures. David Garrick, noted earlier, was one actor who used the natural approach. Over the course of the century, curtain time moved from the mid-afternoon to about 6:30 p.m. by the end of the eighteenth century. Theatre companies also got larger. In Shakespeare's time a theatre company might have up to a dozen actor-sharers, but by the end of the eighteenth century, the Comèdie-Française had a company of fifty actors and in England theatre companies could consist of eighty actors. Of course in all countries there were still smaller strolling and touring theatre companies that eked out a living as best they could.

Essentially the scenery style and techniques developed in the Italian Renaissance continued well into the nineteenth century. Most theatre companies on the continent

continued to use the chariot and pole system for changing wings, but in England and America, using grooves was more common. Scene designers began to use multiple vanishing points rather than the traditional central vanishing point that may be seen in much of the Drottningholm scenery. Multiple vanishing points allowed designers to create more fanciful and exciting stage designs. The **Bibiena family of designers** was famous throughout Europe for its designs. Ferdinando Bibiena (1657–1743) and his sons, who became equally famous stage designers and architects in their own right, developed techniques for lighting scenery from the back, which made possible affects such as lava running down the sides of volcanos. As had been the case since Shakespeare's day, indoor theatres used candles or oil lamps to illuminate productions.

EARLY NINETEENTH CENTURY

The American Revolution, the French Revolution of 1789 to 1815, and the Industrial Revolution were the major factors that impacted European and American culture at the start of the nineteenth century. Machinery did work faster, cheaper, and better. As the machines became concentrated in cities, the labor force moved from the country—where it had previously been employed in agricultural production—to the cities. This led to exploitation of the lower classes for their labor, resulting in labor ghettos and slum conditions in major cities. With regard to theatre, there was a shift from the theatrical function of instruction for the audience, often employed in eighteenth century theatre, to entertainment and escapism of the nineteenth century. Romanticism, whose beginnings could be seen in Storm and Stress drama, was a reaction to Neoclassicism where reason and decorum ruled. In Romanticism, feelings, spontaneity, individuality, and love of the primitive and the natural world were major emphases. The triumph of Romanticism took place at the Comèdie-Française, the bastion of Neoclassicism in France. **Victor Hugo's** (1802–1885) romantic production of *Hernani* (1830) had been selected as the target in order to ridicule Romanticism. Alerted to the intent to boo his show from the stage, Hugo enlisted his friends to support the production with the result that the opening night performance witnessed an audience riot. Despite that opening night riot, the production was a success and Romanticism had won the day.

Two other dramatic developments around the beginning of the nineteenth century were melodrama and the **well-made play**. Originally melodrama developed in France as plays with songs, not to be confused with opera. The form evolved to include background music, much like what we are familiar with today in films and TV. As always happens when public attention begins to wane, theatrical producers tried a variety of techniques to entice the public into buying tickets to the newest production. The result was theatre that presented simplified and idealized human experiences, external conflict beyond the control of the protagonist, and a happy ending.

Rousing action and eventually spectacle were included, regardless of plausibility. The male protagonist was typically young, brave, handsome, and none too bright. In performance, the acting and delivery was very stylized, as noted in **Charles Dickens'** writing from 1850 in which he is describing a stage production: "I ster-ruck him down and fel-ed in er-rror! . . . I have liveder as a beggar—a roadersider vaigerant, but no ker-rime since then has stained these hands!"

The well-made play also arose in France and was crafted as a piece of furniture might be made. Plays were put together using a "formula" approach. Characteristics included action that featured secrets known to the audience but not to the major characters until the end of the play. The building of tension was orchestrated by the pacing of entrances, exits, and revelations. The climax quickly followed the major crisis and the dénouement left no loose ends. The individual most associated with the well-made play was **Eugène Scribe** (1791–1861), reputed to have written about five hundred plays. Scribe and similar playwrights often had a stable of writers who contributed to the mass production approach of assembling plays according to their individual skills.

There were also a few technological theatre developments in the early nineteenth century. Gas was used to illuminate theatre productions. Pipes with holes drilled in them were hung behind each border to light the next upstage border and wing. All the gas pipes and their flames could be controlled from a central gas table. Over the next decades, many theatres burned and many lives were lost due to the open flames on stages without flameproof scenery. A technique for creating a very bright spotlight was also invented. It consisted of heating a piece of limestone with an acetylene torch, and was called "limelight" because of the limestone used. Though it provided very bright light, it required an individual operator for each instrument, making it useful only for special situations.

It was not until the early 1880s that the first theatre used electricity for illumination. The electric light bulb was invented in 1879 in the United States by Thomas Edison and in England by Joseph Swan. The significance of the invention can be gauged by the fact that it only took two years for the first theatre to be converted to electric lighting. However, theatres that had not been converted to electricity continued to burn down because of gas lighting systems. The flying of people and scenery had been done since the Italian Renaissance, but most scenery shifting consisted of moving the scenic wings offstage horizontally. During the course of the nineteenth century, there was an increased use of flying scenery, or moving the scenery vertically from the stage floor to the space above the stage. In the early 1880s, J. R. Clancy developed techniques and hardware that made the flying of scenery safer and more convenient.

The continuation of the development of theatre from this point in the nineteenth century through the twentieth century and into the twenty-first century is covered in Part II, starting with Chapter XI.

Key Names, Venues, and Terms

American Company
Ballad Opera
Ye Bare and ye Cubb
The Beggar's Opera
Bibiena Family Designers
Box Set
J. R. Clancy
Covent Garden Theatre
Charles Dickens
Drottningholm Theatre
Drury Lane Theatre
Thomas Edison
Faust
John Gay
Johann Wolfgang von Goethe
Carlo Goldoni
Oliver Goldsmith
Carlo Gozzi
Lewis Hallam, Jr.
Hamburg Dramaturgy
Hernani

Victor Hugo
Laughing Comedy
Gotthold Lessing
Limelight
George Lilo
The London Merchant
Melodrama
Patent Theatre
Proscenium Doors
The Rivals
Romanticism
The School for Scandal
Eugène Scribe
Sentimental Comedy
The Servant of Two Masters
Joseph Swan
She Stoops to Conquer
Richard Brinsley Sheridan
Southwark Theatre
Storm and Stress
Well-Made Play

Additional Reading

Baur-Heinhold, Margarete. *The Baroque Theatre: A Cultural History of the 17ᵗʰ and 18ᵗʰ Centuries*. New York: McGraw-Hill, 1967.

Londré, Felicia Hardinson, and Daniel J. Watermeier. *The History of the North American Theatre: The United States, Canada, and Mexico: From Pre-Columbian Times to the Present*. New York: Continuum, 1998.

WORK BOOK EXERCISES

There is a Work Book Exercise for every chapter in the book and all of them are collected in this section of the book. That should allow you to review some of the most important ideas that are presented in each chapter. The Work Book sheets have been perforated so that you may easily remove them and hand them in to your course professor, depending upon the structure and grading parameters of your professor. The individual Work Book sheets have questions on both sides of a single sheet for each chapter, except for Chapter XX, which uses two sheets for that chapter.

Name: _____

CHAPTER I **THE NATURE OF ART AND THEATRE**

Course Title and Code: _____ Section: _____

Professor's Name: _____ Date: _____

1. What are Goethe's Three Functions of Art and what does each mean?

 A. _____

 B. _____

 C. _____

2. Individual Arts exist in one or a combination of dimensions. List one Art that exists only in each of the following categories.

 A. First Dimension:_____

 B. Two Dimensions:_____

 C. Three Dimensions:_____

 D. Fourth Dimension:_____

3. What is the label/name given to Arts that exist in all four dimensions at the same time?

4. Supply a single different Art in each category

	Yes	No
A. Permanent	_____	_____
B. Repeatable	_____	_____

5. What specifically distinguishes Theatre from other Arts, such as the Literary Arts?

6. List the three minimal components of Theatre because of its three-dimensional character?

A. _____

B. _____

C. _____

7. Clearly define the following.

A. Willing Suspension of Disbelief: _____

B. Aesthetic Distance: _____

C. Autographic: _____

D. Allographic: _____

Name: _____

CHAPTER II **AUDIENCE AND CRITIC**

Course Title and Code: _____ Section: _____

Professor's Name: _____ Date: _____

1. What are the three functions the audience serves in Theatre?

 A. _____

 B. _____

 C. _____

2. List three demographics that are important in theatre audiences and why for each one?

 A. _____

 B. _____

 C. _____

3. What are two expectations in each of the following categories?

 A. Audience expectation of Audience

 1. _____

 2. _____

B. Audience expectation of Performer/s

 1. _____

 2. _____

C. Performer/s expectation of Audience

 1. _____

 2. _____

4. What are three functions of a critic?

 A. _____

 B. _____

 C. _____

5. What are Goethe's Three Questions that have special importance for criticism?

 A. _____

 B. _____

 C. _____

6. Give the names of two world-class Theatre critics and a *book* of theatrical criticism that each wrote.

 A. _____

 B. _____

Name: _____

CHAPTER III **THE PRODUCER**

Course Title and Code: _____ Section: _____

Professor's Name: _____ Date: _____

1. Name two different Broadway shows that lost more than $1,000,000.

 A. _____

 B. _____

2. Name two different Broadway shows that grossed more than $100,000,000.

 A. _____

 B. _____

3. List the four functions of Producers and briefly note the main aspects of those functions.

 A. _____

 B. _____

C. _____

D. _____

Name: _____

CHAPTER IV **THE PLAYWRIGHT**

Course Title and Code:_____ Section: _____

Professor's Name: _____ Date: _____

1. Name two different Playwrights or Composers, a play written by each, and their apparent motivation to write that specific play.

 A. _____

 B. _____

2. Name two different Playwrights or Composers, other than those named in Question 1 and the known source/s for a specific play written by each.

 A. _____

 B. _____

3. What book did Aristotle write about Theatre criticism and about when did he write it?

4. List the six Aristotelian Elements of Drama in the order in which he discusses them.

A. _____

B. _____

C. _____

D. _____

E. _____

F. _____

5. Give two non-Aristotelian Elements of Drama.

A. _____

B. _____

Name: _____

CHAPTER V **DRAMATIC STRUCTURE**

Course Title and Code: _____ Section: _____

Professor's Name: _____ Date: _____

 1. List Gustav Freytag's six components of dramatic structure (in order) and a brief definition of each.

 A. _____

 B. _____

 C. _____

 D. _____

 E. _____

 F. _____

 2. Give four characteristics of Climatic drama.

 A. _____

 B. _____

 C. _____

 D. _____

3. Give four characteristics of Episodic drama.

 A. _____

 B. _____

 C. _____

 D. _____

4. Who first defined Absurdism and what is the title of that book of Theatre criticism?

5. Give three characteristics of Absurdist drama.

 A. _____

 B. _____

 C. _____

6. Give the names of two different *Absurdist* dramatists and a play written by each.

 A. _____

 B. _____

Name: _____

CHAPTER VI **GENRE**

Course Title and Code: _____ Section: _____

Professor's Name: _____ Date: _____

1. Name and define four types of serious drama. If the definition changed over time, note what the change was.

 A. _____

 B. _____

 C. _____

 D. _____

2. Name and define four types of comedic drama. If the definition changed over time, note what the change was.

A. _____

B. _____

C. _____

D. _____

Name: _____

CHAPTER VII **DEVELOPMENT OF THE DIRECTOR**

Course Title and Code: _____ Section: _____

Professor's Name: _____ Date: _____

1. Who is traditionally credited with having defined, through the practices of his theatre company, the new concept of the stage director in the middle of the nineteenth century?

2. Give three production techniques of the Meiningen Players that were *different* from the practices of all other past Theatre practitioners and even other contemporary practitioners.

 A. _____

 B. _____

 C. _____

3. The Meiningen Players' tours influenced important theatre practitioners in other European countries. Give the one most important theatre person in each of the following countries who was influenced by the Meiningen Players' tours and the name of the theatre that was created in that country as a result of that influence.

France

Germany

Russia

England

Name: _____

CHAPTER VIII **DIRECTING**

Course Title and Code: _____ Section: _____

Professor's Name: _____ Date: _____

1. Give the six functions of the Director, in production order, and the
 one or two most significant activities that takes place as part of each
 function.

 A. _____

 B. _____

 C. _____

 D. _____

 E. _____

 F. _____

2. What are three qualities of good theatre directors?

A. _____

B. _____

C. _____

3. What are the three types of Directors?

A. _____

B. _____

C. _____

4. What is the Stage Manager's most important function/duty in the life of a production?

Name: _____

CHAPTER IX **ACTING**

Course Title and Code: _____ Section: _____

Professor's Name: _____ Date: _____

1. What are the major differences between role-playing on stage and role-playing in real life?

2. What are the three types of characters?

 A. _____

 B. _____

 C. _____

3. Give the *name* of an external acting system that was popular in the nineteenth century.

4. Give the *name* of an internal acting system.

5. Identify and briefly explain four of the eight components of the Stanislavski Acting System.

A. _____

B. _____

C. _____

D. _____

6. Identify and briefly explain three of the eight steps in the acting process.

A. _____

B. _____

C. _____

Name: _____

CHAPTER X **PHYSICAL THEATRES AND DESIGN**

Course Title and Code: _____ Section: _____

Professor's Name: _____ Date: _____

1. How are Arena, Thrust, and Proscenium Theatres productions distinguished from each other?

 Arena _____

 Thrust _____

 Proscenium _____

2. Name and briefly explain three of the nine design *functions*.

 A. _____

 B. _____

 C. _____

3. Briefly explain three of the six design *processes* that *ALL* designers go through.

A. _____

B. _____

C. _____

4. There are common design processes for all designers and there are processes that are *unique* for each design area. Give one major distinguishing characteristic of the design *process/product* in each of the following areas.

Scenery _____

Costumes _____

Lights _____

Name: _____

CHAPTER XI **CONTEMPORARY THEATRE**

Course Title and Code: _____ Section: _____

Professor's Name: _____ Date: _____

1. Name three different nineteenth-century scientists and briefly state how the work of each had significant impact on the development of Modern Drama.

 A. _____

 B. _____

 C. _____

2. Name the two major styles/components that comprise Modern Drama.

 A. _____

 B. _____

3. Name three different Realism playwrights (don't include Naturalism) and one play that each wrote.

 A. _____

 B. _____

 C. _____

4. What was the philosophic goal or intent of Realism?

5. What was the philosophic intent of Naturalism?

6. Name two different Antirealism theatre movements and briefly describe each.

 A. _____

 B. _____

7. What was the name of Bertolt Brecht's unique intention for his audiences' reaction?

8. Name the two dramatic styles that were the major components of Postmodernism?

 A. _____

 B. _____

Name: _____

CHAPTER XII **VARIETY OF THEATRE VENUES**

Course Title and Code: _____ Section: _____

Professor's Name: _____ Date: _____

1. What is the goal, intention, or function of the following types of theatre operations?

 Commercial Theatre _____

 Presentation Houses _____

 Professional Theatres/League of Resident Theatres (LORT) _____

 Dinner Theatre _____

 Community Theatre _____

 Academic Theatre _____

 Summer Theatre _____

 Commemorative Festivals _____

2. After Broadway shows are a hit, the production typically tours. Give three *different* types of tours.

 A. _____

 B. _____

 C. _____

3. Name the four approaches that might be used in Academic Theatre.

A. _____

B. _____

C. _____

D. _____

4. List the two different types of, or purposes for, commemorative festivals and briefly explain the difference between the two.

A. _____

B. _____

Name: _____

CHAPTER XIII **MUSICAL THEATRE**

Course Title and Code: _____ Section: _____

Professor's Name: _____ Date: _____

1. Name the "first" American musical produced in the mid-nineteenth century.

2. What were the two innovative approaches of the above show?

 A. _____

 B. _____

3. Give two other theatrical forms that had impact on the development of the American Musical and name an example show for each form.

 A. _____

 B. _____

4. Briefly describe what a "clothes-line" revue means.

5. What was the specific innovation that each of the following show's contribution to the development of the American musical?

 Show Boat _____

 Oklahoma! _____

 West Side Story _____

6. Name three different *Golden Age* musical composers and one show composed by each.

 A. _____

 B. _____

 C. _____

7. Name the *composer* of Concept Musicals and name one of his shows.

8. What is the definition of a Concept Musical?

Name: _____

CHAPTER XIV AFRICAN AND AFRICAN-AMERICAN THEATRE

Course Title and Code: _____ Section: _____

Professor's Name: _____ Date: _____

1. Name (1) two different African playwrights, (2) the country each is from, and (3) a play written by each.

 A. _____

 B. _____

2. Name the early nineteenth-century African-American Theatre in New York City and its most famous teen-aged actor?

 A. _____

 B. _____

3. Who was Thomas (Daddy) Rice and what did he do?

4. What was the three-part organization of a minstrel show?

 A. _____

 B. _____

 C. _____

5. What, where, and when was the Harlem Renaissance?

6. What's the significance of *Shuffle Along* and who were its authors?

 A. _____

 B. _____

7. Name four different African-American playwrights and one play written by each of them.

 A. _____

 B. _____

 C. _____

 D. _____

Name: _____

CHAPTER XV **ASIAN THEATRE**

Course Title and Code: _____ Section: _____

Professor's Name: _____ Date: _____

1. What are the names of the two Indian Epics that are sources for much of Indian Theatre?

 A. _____

 B. _____

2. What is the importance of the *Natyasastra*?

3. Define the following Indian Theatre terms.

 Rasa _____

 Kathakali _____

 Chhau _____

 Bollywood _____

4. Describe some of the characteristics of Chinese opera.

5. Describe the characteristics of the following in terms of (1) initial class preference, (2) when each started developing, and (3) some production practices.

Noh _____

Kabuki _____

Bunraku _____

Name: _____

CHAPTER XVI **DIVERSITY**

Course Title and Code: _____ Section: _____

Professor's Name: _____ Date: _____

1. In each of the following sections give (1) the name of different playwrights, (2) the title of one of his or her plays that is known to deal with that specific theme, and where listed, and (3) the name of one specific American Theatre Company that has noted that it has some preference for presenting plays of that theme in its season.

 European Women

 Author _____

 Play _____

 American Women

 Author _____

 Play _____

 Company _____

 European Gay

 Author _____

 Play _____

American Gay

 Author _____

 Play _____

 Company _____

Asian-American

 Author _____

 Play _____

 Company _____

Hispanic

 Author _____

 Play _____

 Company _____

Native-American

 Author _____

 Play _____

 Company _____

Name: _____

CHAPTER XVII **GREEK THEATRE**

Course Title and Code: _____ Section: _____

Professor's Name: _____ Date: _____

 1. Clearly define the following.

 Dithyramb _____

 Athens' City Dionysia _____

 Thespis _____

 Theatron _____

 Orchestra _____

 Skene _____

 Thyromata _____

 Archon _____

 Choregus _____

 Satyr Play _____

 Parados _____

 Exodos _____

Hamartia _____

Catharsis _____

2. Name four different Greek playwrights and a play written by each.

 A. _____

 B. _____

 C. _____

 D. _____

3. Name the ancient Greek Theatre critic and the name of his book of theatrical criticism.

Name: _____

CHAPTER XVIII **ROMAN THEATRE**

Course Title and Code: _____ Section: _____

Professor's Name: _____ Date: _____

1. Name three different Roman playwrights and one play written by each.

 A. _____

 B. _____

 C. _____

2. Give three different ways the Roman Theatre differed architecturally
 from the classical-period (fifth century BCE) Greek Theatre architecture.

 A. _____

 B. _____

 C. _____

3. Name the Roman Theatre Critic and the name of his book.

A. _____

B. _____

4. Name the Roman Architect who wrote about the physical Roman Theatre and the name of his book.

A. _____

B. _____

5. *Why* was there a poor attitudinal relationship between Roman Theatre and the Early Christian Church after the Christian Church was officially recognized?

Name: _____

CHAPTER XIX **MEDIEVAL THEATRE**

Course Title and Code: _____ Section: _____

Professor's Name: _____ Date: _____

1. What's the translation of the first two words *"Quem quaertis"* in the *Quem quaertis* script?

2. Who is the world's first known female playwright?

3. Briefly define the following.

 Cycle Plays _____

 Morality Play _____

 Mystery Play _____

 Miracle Play _____

 Atellan-type Farces _____

 Vernacular Plays _____

 Interludes _____

 Folk Plays _____

 Academic Theatre _____

4. Describe some characteristics of Cycle play production in the medieval period.

Name: _____

CHAPTER XX RENAISSANCE AND SEVENTEENTH-CENTURY THEATRE

Course Title and Code: _____ Section: _____

Professor's Name: _____ Date: _____

1. What were the nature of the innovations of Italian Renaissance Theatre in the following areas? If there was more than one significant innovation in each section, explain that.

Drama _____

Acting _____

Theatre Architecture _____

Stage Design _____

2. Identify four specific Tudor Theatre practices (those prior to 1558) that led to the development of the Elizabethan English Renaissance Drama and/or to the development of the Elizabethan physical public playhouse.

A. _____

B. _____

C. _____

D. _____

3. Name three different Elizabethan English Renaissance playwrights and a play written by each (authored after 1558).

A. _____

B. _____

C. _____

4. Describe some of the Production Practices of the Elizabethan Theatre.

5. How did English Restoration production practices (after 1660) differ from those during the Elizabethan period?

Name: _____

6. Name three different English Restoration playwrights and a play written by each.

 A. _____

 B. _____

 C. _____

7. Define the following terms for the Spanish Renaissance

 Auto Sacramentales _____

 Carros _____

 Corrales _____

8. Name two different Spanish Renaissance playwrights and one *play* written by each.

 A. _____

 B. _____

9. What significant contributions did Cardinal Richelieu make toward French Renaissance Theatre?

10. Define the following terms from the French Renaissance.

 Vraisemblance _____

 Bien Séance _____

11. Name three different French Renaissance playwrights and one play written by each.

A. _____

B. _____

C. _____

12. What happened to Molière's theatre company after he died?

13. Name three significant characteristics of the French Neoclassical style in drama.

A. _____

B. _____

C. _____

Name: _____

CHAPTER XXI EIGHTEENTH AND EARLY NINETEENTH-CENTURIES

Course Title and Code: _____ Section: _____

Professor's Name: _____ Date: _____

1. Name three different English playwrights from the eighteenth century and one play written by each.

 A. _____

 B. _____

 C. _____

2. Name two different Italian playwrights from the eighteenth century and one play written by each.

 A. _____

 B. _____

3. What is the theatrical significance of the Drottningholm Theatre?

4. Name three different German playwrights from the eighteenth century and one play written by each.

A. _____

B. _____

C. _____

5. What is the title of the first English-language play written in America?

6. What was the physical playhouse's architectural configuration on the continent (excluding England)?

7. How did that differ from the architectural configuration of the typical physical playhouse in England during the same time period?

8. What were the two new main types or styles of drama in the early nineteenth century?

A. _____

B. _____

INDEX

Greek theatre
 beginning of, 209–211
 drama festivals, 211–212
 "happy idea," concept
 of, 219
 physical theatre, 212–214
 playwrights, 216–219
 comic, 219
 tragic, 217–219
 production, 214–216
 tragic structure, 216
Green Grow the Lilacs
 (1931), 204
Grein, Jacob Thomas, 69, 70
Gridayu, Takemoto, 192
Gripsholm Theatre, 267
Grooves, 254, 271
Grouch, The
 (c. 317 BCE), 219
Ground plan, 112
Groundlings, 252
Grown Accustomed to her
 Face, 164
Guernica (1937), 7
Guilds, 232
Guys and Dolls (1950), 164

H

Hair (1967), 42
Hairy Ape, The (1921), 133
Hallam Company, 269
Hallam, Lewis, Jr., 269
Hallam, William, 269
Hamartia, 216
Hamburg Dramaturgy
 (1767), 268
Hamilton, 23, 167
Hamlet (1601), 47, 166, 250

Hamletmachine (1977), 138
Hammerstein II, Oscar,
 161–162
Hanamichi, 191
Hand props, 104
Hansberry, Lorraine, 178,
 179, 199
Hanuman, 182
"Happy idea," Greek concept
 of, 219
Hardy, Alexander, 258
Hargitay, Mariska, 99
Harlem Renaissance, 176
Harmon, Mark, 99
Hart, Charles, 165
Hart, Lorenz, 46
Harvard University, 31–32,
 151
Hathaway, Anne, 250
Hawthorne, Nathaniel, 46,
 139
Healing arts, 15
Heavens, 252
Hedda Gabler (1890), 45,
 50, 127
Heidi Chronicles, The (1988),
 199
Hell mouth, 232
Hellman, Lillian, 199, 200
Hello Dolly (1964), 42
Henley, Beth, 139, 199
Henry IV, Parts I & II
 (1598–1600), 253
Henry V (1599), 250
Henry VIII (1613), 153, 249
Heredity and environment,
 effect of, 127
Herman, Jerry, 165, 166
Hernani (1830), 271
Heroic drama, 62
Hewlett, James, 173

Heyward, Dorothy, 177
Heyward, Dubose, 177
Heywood, John,
 234, 246
Higgins, Henry, 164
Highway, Tompson, 204
Hikinuki, 191
Hill Cumorah Pageant
 festival, 153
Hinduism, 182
Hispanic theatre, 148,
 202–203
Histeriones, 225
HMS Pinafore
 (1878), 160
Hoffman, Dustin, 98
Hoffman, William M., 201
Holberg, Ludvig, 267
Holmes, Rupert, 55
Homecoming, The (1964),
 138
Homer, 12, 210
Hope, The, 249
Horace, 223, 240
Hôtel de Bourgogne
 theatre, 257
House Committee on
 Un-American
 Activities, 134
How I learned to Drive
 (1997), 199
How Not to Write a Play
 (1955), 32
Howe, Tina, 199
Hrotsvitha of Gandersheim,
 197, 231
Hubris, 216
Hughes, Langston, 177
Hugo, Victor, 46, 271
Humanist tradition, 150
Hwang, David Henry, 201

My Fair Lady (1956), 37, 164

Mystery of Edwin Drood, The (1985), 55

Mystery of Irma Vep, The (1984), 201

Mystery plays, 233, 234

N

Nathan the Wise (1779), 268

Native American theatre, 203–204

Native Earth Performing Arts, 204

Naturalism, idea of, 130

Natyasastra, 183–184

NCIS, 99

Nederlander Organization, 40

Negro Ensemble Company, 177

Nemirovich-Danchenko, Vladimir, 71

Neoclassicism, 240

New Art of Playwriting in Modern Times (1609), 256

New York Herald Tribune, 32

New York newspaper critics, 31–32

New York Post, 32

New York Shakespeare Festival, 42, 140, 152

New York Times, The, 28, 32

Niblo's Garden, 158

Nicholson, Jack, 92

Nietzsche, Friedrich, 56

Nigeria, theatre in, 172

'Night Mother (1983), 199

Nirvana, 182

No Exit (1944), 56, 137

Nobel Prize, 133, 135, 137–138, 172, 185, 202

Noh drama, 189

Nonprofit theatres, 148

Normal Heart, The (1985), 201

Norman, Marsha, 199

O

Oakley, Annie, 164

Oberammergau Passion Play (1634), 153, 235–236

Objective, 92

Observation, 80, 90

O'Connor, Carroll, 94

Octoroon, The (1859), 176

Odd Couple, The (1965), 46

Odéon Theatre, 70

Odyssey, 210

Oedipus (1718), 266

Oedipus at Colonus (406 BCE), 218

Oedipus Rex (429 BCE), 54, 56, 213

Oedipus Rex (1585), 149, 243

Of Thee I Sing (1932), 163

Off book, 96

Off-Broadway movement, 140

Off-Off-Broadway movement, 140

Oklahoma! (1943), 162, 167

Okuni ritual, 191

Ol' Man River, 162

Olivier, Lawrence, 88

Olympic Theatre, 67

On the Origin of Species (1859), 127

On the Street Where You Live, 164

One Flew Over the Cuckoo's Nest (1975), 92

O'Neill, Eugene, 45, 51, 133, 135

O'Neill, John, 177

One-night stands, 41, 144

Onnagata, 192

Opera, 16

Operettas, 157–161

Option (contract of production), 37

Orchestra, 213

Oresteia, 215–217

Othello (1604), 250

Ottoman Empire, 239

Oxford University, 235

Oxfordshire St. George Play, 234

P

Pageant wagons, 232

Paint elevation, 113

Painting Churches (1983), 199

Paintings, two-dimensional, 10

Palace of Eternal Youth, The (1688), 188

Palais Cardinal, 258

Palais Royale, 258

Palladio, Andre, 242

Pan Asian Repertory Theatre, 148

Pantalone, 241

Pantomime, 225

Paper Flowers (1970), 202

Paphnutius, 197, 231

Papp, Joseph, 42

Parodoi, 213, 223

Parodos, 216

Parker, Trey, 166

Parks, Suzan-Lori, 46, 139, 179, 199

Parsons, Jim, 94, 99

Passing Show, The (1894),158

Pastor, Tony, 132

Patent theatres, 265, 269

Patter song, 160

Peach Blossom Fan, The (1699), 188

Pear Garden, 186

Peri, Jacopo, 241

Peloponnesian War, 219

Penumbra Theatre Company, 177

Peony Pavilion, The (1598), 188

Periaktoi, 225

Permanence of the art, 12–13

Phaedra, 223

Phallus, 216

Phantom of the Opera, The (1986), 36, 109, 165, 168

Phèdre (1677), 260

Phlyaque, 219

Phrynichus, 212

Physical theatre, 212–214

Piano Lesson, The (1990), 179

Picasso, Pablo, 7

Pierre Pathelin (1470), 235

Pieta (1499), 12–13

Pinter, Harold, 46, 49, 138

Pinter pauses, 49

Pippin (1972), 166

Pirandello, Luigi, 133

Pittsburgh Cycle, The, 139

Platea, 231

Plato, 30

Plautus, Titus Maccius, 46, 222

Plays

 analysis, 92

 presentational, 61

 representational, 61

 satyr, 212

 tragic, 61–62

 types of, 56

Playwright, 37

 African-American, 177–179

 American, 138–139

 Aristotelian elements of drama, 48–50

 comic, 219

 conflict, 50

 as drama, 58–59

 English, 249–251

 French, 258–260

 Greek, 216–219

 Indian, 184

 limitations of, 51–52

 motivation for, 45–46

 non-Aristotelian elements, 50–51

 process of, 47–48

 Roman, 222–223

 sources of, 46–47

 Spanish, 256–257

 tragic, 217–219

Plot, 47, 48

Poetics, The (335 BCE), 16, 30, 48, 184, 209, 218

Pollio, Marcus Vitruvius, 225

Polos, 215

Popular entertainment, 131–132

Porgy and Bess (1935), 177, 179

Porter, Cole, 163

Pörtner, Paul, 55

Post Office, The (1913), 185

Postmodernism

 American playwrights

 Albee, Edward, 138

 Henley, Beth, 139

 Parks, Suzan-Lori, 139

 Shepard, Sam, 139

 Wilson, August, 139

 Wilson, Lanford, 138–139

 existentialism, 137

 move away from Broadway, 140

 theatre of the absurd, 137–138

Presentation houses, 146–147

Presentation sketch, 111

Previews, 36, 80, 97

Pride's Crossing (1997), 199

Prince, Hal, 42, 164, 165, 168

Prince of Parthia, The (1767), 269

Princess Theatre shows, 161

Private theatres, 252–253

Producer

 financial considerations, 35–37

 functions of

 finding facilities, 39–41

 hiring all staff, 38–39

 obtaining "property," 37

 raising money, 38

 general partners, 38

 limited partners, 38

 world-class, 41–42